KU-409-758

RAVILIOUS & C<u>O</u>
THE PATTERN
OF FRIENDSHIP

WITHDRAWN

www.hants.gov.uk/library

 Hampshire County Council

 Love YOUR LIBRARY

Tel: 0300 555 1387

C016375304

ANDY FRIEND

RAVILIOUS & Co
THE PATTERN
OF FRIENDSHIP

with an introduction
by Alan Powers

 Thames & Hudson

First published in the United Kingdom
in 2017 by Thames & Hudson Ltd in association
with Towner Art Gallery

Reprinted 2017

Ravilious & Co.: The Pattern of Friendship
© 2017 Thames & Hudson Ltd
Text © 2017 Andy Friend
'A Star in his Firmament' © 2017 Alan Powers

Designed by Lisa Ifsits

All Rights Reserved. No part of this publication
may be reproduced or transmitted in any form
or by any means, electronic or mechanical,
including photocopy, recording or any other
information storage and retrieval system, without
prior permission in writing from the publisher.

British Library Cataloguing-in-Publication Data
A catalogue record for this book is available from
the British Library

ISBN 978-0-500-23955-1

Printed and bound in China by C&C Offset
Printing Co. Ltd.

To find out about all our publications,
please visit **www.thamesandhudson.com**.
There you can subscribe to our e-newsletter,
browse or download our current catalogue,
and buy any titles that are in print.

CONTENTS

A Star in his Firmament .. 7

1 **South Kensington** ... 19

2 **Earls Court and Eastbourne** 55

3 **London and Metropolitan** .. 89

4 **Brick House** .. 121

5 **Furlongs** .. 149

6 **Newhaven** ... 175

7 **Paris and Mayfair** .. 209

8 **Bristol and Rye** ... 235

9 **To Iceland** ... 265

Aftermath ... 303

Notes ... 310
Bibliography ... 327
Acknowledgments .. 329
Image credits ... 330
Index .. 331

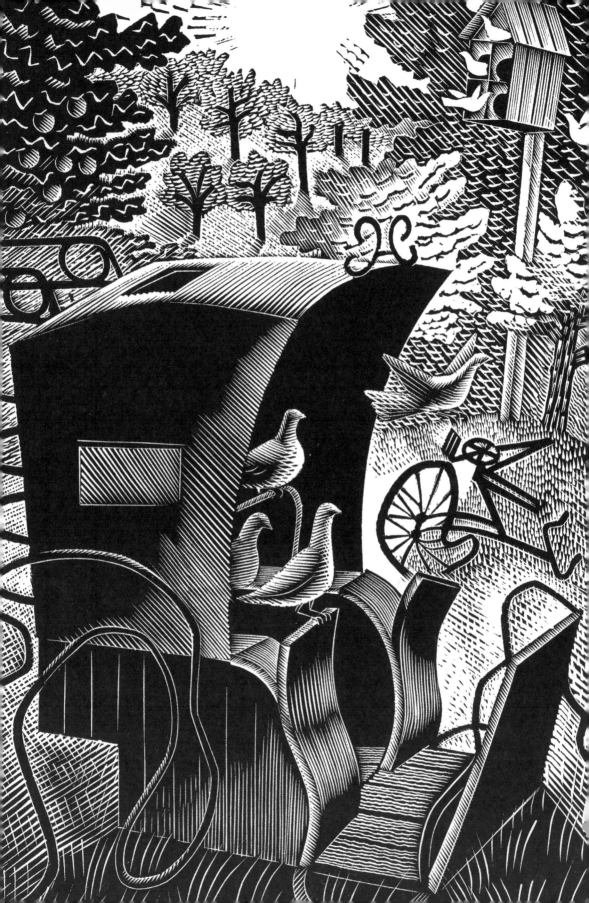

A STAR IN HIS FIRMAMENT

Alan Powers

In 1940 a group of schoolchildren in Mansfield, Nottinghamshire, were asked to give their opinion on a range of works by modern English artists. Eric Ravilious was the most popular, with Graham Sutherland, Ivon Hitchens and Ben Nicholson among the least.[1] This is the reverse of the subsequent verdict of experts, not in terms of popularity, but hierarchy in the ranking of importance. As such, this minor episode is a token of the cluster of unresolved issues about the historiography of twentieth-century British art. Two years later, in 1942, Ravilious was dead, but early death is not always a hindrance to fame. Although his reputation gave him posthumous momentum for a further decade, his delicate watercolours were on private walls or in the solander boxes of museum print rooms and rarely seen, while the wood engravings went out of fashion, with the exception of the *Wisden Cricketers' Almanack* cover, unchanged until 2003. The long eclipse of Ravilious, followed by his accelerating climb back into the public eye and heart, is in itself a fascinating phenomenon. Ravilious has now become the solar centre of an alternative artistic cult, and his light has fallen on those who were around him in the 1920s and 1930s, the group of his friends who make up 'the pattern of friendship'.

While Ravilious had a style and an imagination all his own, he did not work in isolation and, as Andy Friend shows in his detailed biographical study, the group around him deserves study as an artistic and cultural network in its own right. The core of this group were student contemporaries of Ravilious at the Royal College of Art, many of whom Paul Nash, who had taught them briefly in 1924–25, later called 'an outbreak of talent'.[2] He listed eight names, of whom four – Edward Bawden, Barnett Freedman, Enid Marx and Eric Ravilious – remained closely connected to each other as friends and would have been seen as such by outsiders. The remainder of the network included other RCA students such as Douglas Percy Bliss, Percy Horton, Peggy Angus and Helen Binyon, plus wives, friends and lovers, all of similar age.

Although they were unquestionably a group, there were quite considerable differences between them as artists, so that while some could be said to have constituted a movement, others were outside it. If one could grade

them along a scale, putting Ravilious at one end, the other end might feature Thomas Hennell or Horton – painters whose realist work was less distinctively different from the rest of their generation than that of Ravilious or Bawden. With the exception of Marx as a student, they maintained a distance from Modernism, combining progressive and conservative qualities in their work. Equally important in defining their shared characteristics is the fact that (Horton excepted) they all engaged in design-related activities, from book illustration to textiles and ceramics. The combination of these factors has been enough to marginalize or exclude them from the mainstream history of twentieth-century British art. This book builds on previous studies to provide the foundations for a revision of the prevailing orthodoxy, for, although painting is normally thought of as the superior form of artistic production, it is the design activity of the group that in many ways gives them their distinctive character.

The Principal of the RCA in the 1920s, Sir William Rothenstein, believed in the importance of artists becoming involved in the world of design on the basis that the market could not support very many independent painters or sculptors. He thought that society as a whole should benefit from the uplift that could come from jolly murals in an adult-education college tea room or from a fresh and unsentimental wood engraving advertising Green Line buses, to pick only two instances from a wide range of design activities. Continuing the convictions of the Arts and Crafts movement, Rothenstein did not see any need to create barriers between these spheres of activity. In his official role he also had to justify government funding for his College on the basis that at least some of its students would contribute to better industrial products and thus help to boost the economy by competing against imports of foreign-designed goods. Had they engaged in no other activities, Ravilious and Bawden, who were allocated by Rothenstein to the Design School when they were admitted to the College – 'habitat of the lowest of the low' as Bawden later called it – would still be remembered as painters. Despite being in the Painting School, Barnett Freedman and Enid Marx, by contrast, would not be remembered for their pleasing but unexceptional paintings, since their strengths lay respectively in illustration and pattern design, at which they excelled.

If Rothenstein was the father figure for this group, Paul Nash, their senior by fifteen or so years, was more like an older brother. His experience went back to the pre-1914 Slade School, in the time of Dora Carrington and Stanley Spencer, and he had crossed paths with the Bloomsbury Group when working briefly at the Omega Workshop. Roger Fry, who created Omega, went far

beyond being an exponent of Post-Impressionist formalism. It would not be far-fetched to see the 'outbreak of talent' group as another stage of fulfilment of Fry's campaign for cross-cultural and cross-disciplinary synthesis in art and design, involving any sources that could disrupt the complacency of academic picture-making. In his activities as exhibition-, group-maker and writer, Nash was continuing Fry's role, helping us to see how there is a chain of connection stretching back from the 1930s into more familiar artistic territory prior to the Great War.

Further back in time still, we could compare our group's journey with the similarly precocious fashion in which the Pre-Raphaelites leapt to public awareness in 1848. They too were a group of young artists who embraced graphic and decorative arts. Their aim of cleansing existing practice by deliberately choosing a naïve style closely matches the way in which Ravilious and his friends made their impact some seventy-five years later. In a similar manner to Ravilious, the Pre-Raphaelite painters, like no others before them, contributed to a reformist movement in mid-Victorian design, becoming style leaders in decorating their own homes as well as practising designers.

Both Rothenstein and Nash were among the defenders of the Pre-Raphaelites specifically because of the imaginative power and strangeness that they brought to their work, again in contrast to much that was going on in their time. From the beginning the Pre-Raphaelites had a brand name, whereas Ravilious and his group did not. Probably they would have resisted the loss of individual identity that this would have implied, but we still do not have a convenient 'handle' by which to call them, and this may partly account for the long time it has taken for them to be recognized.

In the later months of 1850, William Michael Rossetti edited a short-lived magazine, *The Germ*, that has given posterity a key to Pre-Raphaelite thinking. The Ravilious group, with the exception of Douglas Percy Bliss, seldom published essays or articles, and developed no explicit theory either at the beginning or the end of their activities. Indeed their writing, while it is now a crucial source, was, with a few exceptions, in the form of personal letters. Although their reviews were good and sometimes even ecstatic, they had no critical supporter on a par with Ruskin.

A more obvious level of comparison between the Ravilious group and both the Pre-Raphaelites and the Bloomsbury group is in their overlapping life stories. Friendship merged or sparked into love, often regardless of marriage ties, with predictable complications. Their ethos was predominantly heterosexual, rural and national, in contrast to three of the other artists named by

Nash as part of the 'outbreak of talent' – Edward Burra, William Chappell and Barbara Ker-Seymer. These, together with a few others, were members of a separate but equally tight-knit social circle with a strong gay identity, far from uncommon in the interwar years and expressed in their art and lives in a way that was sophisticated, urban and international.

In the 1935 article in which he identified the artists who comprised the 'outbreak of talent', Nash defined them partly in terms of a new freedom to practise a form of Modernism through commercial art. This he attributed to the example of Edward McKnight Kauffer, the American who came to London during the First World War and made his name as a poster artist with a widespread influence, particularly the linear character of his work and his avoidance of self-conscious mannerism.[3] There is a fine distinction between the 'trademark' style of a commercial artist and the original and creative response of a more independently-minded practitioner. Crucially, Nash encouraged in his student group a critical attitude that saved them from crossing this line. His combination of enthusiasm and denigration would certainly have contributed to forming their standards in respect of their own work and that of others. As Helen Binyon recalled, 'he was witty and jokey and often encouraging, or he might say "this is just what we are trying to get away from".'[4] In the 1980s, Enid Marx explained the community of feeling in her generation in these words: 'there was a flowering at the time due to a lot of things – sensitive clients to work for, students aware of the horrors of World War I therefore more adult and sensitive to the world around them'.[5]

They were to be sensitive without sentimentality, modern without being mechanical, historical with a firm principle of selection and an avoidance of direct pastiche, aiming always for neatness and clarity of presentation. Understanding production techniques, especially in printing, was taken for granted. In addition, Nash brought a wider awareness of the outside world than any other tutors at the Royal College, combined with an attitude of sprezzatura: perfectionism without laboriousness. There was also his lyrical and poetic search for emotional truth to counterbalance what might otherwise have been an art deco type of flippancy.

Ravilious and Bawden exhibited watercolours together in 1927 and made something of a stir. In 1930 the unveiling of the Morley College murals made them national names. Meanwhile Marx was making pattern papers for Curwen Press and beginning to print textiles. The exhibition 'Room and Book' that Nash organized at the Zwemmer Gallery in 1932 brought their design work before a select public. It was a small affair, of which no photographs have

survived. The aim of the exhibition was not to present a unified stylistic front but rather to stimulate a range of fresh creativity. The 'Room' element of the title, in Nash's view, indicated the reduced scale of contemporary living so that the design unit was often the single room. Here, Nash suggested, there was often 'a fatal *mariage de convenance* between Modernist and antique – the jazz rep cushion in the sham Jacobean chair, the "abstract" rug from Tottenham Court Road dozing by the brick hearth'.[6] Nash's remedy for bad taste follows the lines of Modernism as then practised and explained in England – a combination of functionality and better-informed judgment. But his own designs and his words had nothing in common with the wild fantasy that was then emerging in the interior decoration of Brick House at Great Bardfield, reflected in Bawden's wallpapers and Ravilious's solitary contribution, the lovably ridiculous *Design for a Plant-house*. The 'Book' element was more straightforward, and Nash pointed out how printing, typography, illustration and book production had quietly become outstanding areas of British design in comparison to the majority of consumer goods, owing to the willingness of printers and publishers to experiment – an area in which Ravilious, Bawden, Marx and Freedman had all contributed significantly and would continue to do so.

At 'Room and Book', Marx exhibited her own block prints together with Phyllis Barron and Dorothy Larcher, the artists with whom she learnt the technique. Ben Nicholson, who in 1932 was beginning to harden his opinion on the superiority of abstract art to all other forms, was exhibiting his own block-printed textiles; in this sideline he would have appeared closer to Marx than to his real peers, Henry Moore and Barbara Hepworth, the heavyweight Royal College graduates with whose sculpture his paintings and reliefs are usually grouped. The *Times* critic Charles Marriott described the dominant colours in the exhibition as 'grey, leaf-brown, russet, olive and biscuit', but found, despite variations of style in the range of exhibits, that 'they all belonged to the same time of day'.[7] The vagueness of this phrase suggests that the effect of the display was far from unified. After this, although Moore, Hepworth and Nicholson made occasional excursions into the world of design, the pathways of the two groups diverged.

The year 1934 saw the publication of Herbert Read's book *Art and Industry*, which made the case for a severe and rather unsmiling purity of form, a text that still forms one of the benchmarks for English readers in defining Modernism. As the 1930s continued, it would have become clear that there was an alternative allowing for decoration and pattern, with some regard for the

example of history. It is still controversial to include this style under the blanket definition of Modernism, and it is a subjective matter to decide whether or not it is a sub-section of art deco. This nameless in-between style was not the exclusive property of Ravilious and his group of friends, but they were certainly among its leaders, as became evident in the later 1930s when their work was increasingly employed for a range of official commissions. One of the first was Barnett Freedman's Jubilee 'King's Stamp' in 1935. Marx's seating fabric for London Underground trains in 1937 brought her patterns before, or rather beneath, a wide cross-section of the public. In that year Ravilious engraved the Royal Arms for the catalogue cover of the British Pavilion at the exhibition held in Paris and did a further version for the New York World's Fair in 1939. While he and Bawden provided painted backgrounds to exhibition stands in the Paris display, in New York their watercolours were included in the display of British art selected by Kenneth Clark. This penetration of the nation's graphic identity happened by stealth rather than with overt publicity, but something of Ravilious's standing can be gleaned from a gossip columnist writing about him in 1940, who declared 'I have heard him credited, and not by an amateur, with "the best visual taste in England"'.[8]

By 1939 the fashion for mixing 'amusing' period objects in otherwise essentially Modernis interiors, as pioneered at Brick House, was on the way to becoming the latest trend in design, helped by the eclectic but visually coherent displays to be found in Cecilia Dunbar Kilburn's Mayfair shop, Dunbar Hay.

A young supporter of the group, typographer extraordinaire Robert Harling, had set a new tone for blending past and present when he redesigned the Wisden cover, first issued in 1937, with Ravilious's wood engraving of top-hatted cricketers. This was one of Harling's many interventions in advertising, magazine and book production that were also in line with European and American trends in graphic design. This approach to the piquant combination of old and new went on to enjoy an extended life, carried forward by younger artists such as Kenneth Rowntree and Barbara Jones who followed in Ravilious's footsteps.

For his contemporaries, Ravilious's contribution to reinventing forms of applied decoration was his greatest achievement. These comments were made in obituary tributes, so they might have exaggerated his role in relation to others. Nevertheless, they help us to understand the difficulty of choosing the right path between Modernism and kitsch. The architect and industrial designer Robert Goodden described the 1930s as 'a time when the invention of significant decorative design was probably more difficult than at any

preceding period in history'.[9] In the words of Osbert Lancaster, it was 'a realm in which the shoddy, the "kitsch", and the debilitated antiquarian had for so long held the field'. Ravilious showed how decoration could be reborn with a modern eye applied to the past, and in Lancaster's view, 'with the possible exception of Edward Bawden, no one did more to re-establish the old traditional standards'. Ravilious had 'brought back into the popular art of this country a robustness, a wit, and a sense of style that, many thought, had vanished in the fifties of the last century'.[10]

Ravilious's designs for Wedgwood were the most visible examples of his posthumous fame and evidence of his seminal influence. Bernard Hollowood's *Pottery and Glass* in the series 'The Things We See', published by Penguin Books in 1947, featured two Ravilious mugs on its cover. A year earlier the curator W. B. Honey described his designs as 'rich in fantasy and resource, essentially creative in the modern manner'.[11] The rise of the group style quite closely corresponds to the years 1936–52 and can be conceived as a George VI style, a distinct phase of decoration and selective nostalgia within the longer history of Modernism that was echoed in other countries and left a permanent mark.[12] The Festival of Britain in 1951 was in many respects the fulfilment of what Ravilious and his group stood for. As the designer of fabrics for the Utility Furniture Scheme, Marx went on to gain even greater penetration of a temporarily restricted market with patterns that were unobtrusive and even drab in colour, but which added a lively shimmering surface to upholstered chairs. As Nash wrote, her design style was characterized by 'the peculiarly rigid movement of the units, which are not conceived in fluid waves or undulations, or as efflorescence, but are more like the delicate architecture of birds, building with rather awkward shaped sticks'.[13] Awkwardness can appear as simply clumsy, but it is also a sign of life in a world where things become smooth and predictable. It was with patterns of a similar character applied to tiles that Peggy Angus reached her wider public when these were used extensively in post-war schools.

In bridging fine art and design, Ravilious and his friends were unintentionally fulfilling two expectations, neither of which was of their own making. In a patriotic mood in 1934, when the Royal Academy held its popular winter exhibition of British Art, any shortcomings in high art were excused by claiming that there was a national tradition of decorative art to compensate, and that it was somehow the destiny of the British artist to move between these areas. In addition, historical surveys, such as R. D. Gleadowe's BBC broadcasts accompanying the exhibition, claimed that there was a tradition of linearity

and pattern-making in British art from the earliest times, a claim repeated in 1955 in Nikolaus Pevsner's better-known Reith Lectures, 'The Englishness of English Art'.

Of the contribution made by the group to pure painting, it is harder to get a view in relation to the work of other artists. When Laurence Binyon's *English Water-Colours* (1933) was reissued in 1944, his daughter, Nicolete Gray, the younger sister of Ravilious's lover Helen, contributed an anonymous update, claiming that Ravilious and Bawden 'evolved ... a new method of painting in water-colours of great delicacy and definition'.[14] Eric Newton rightly coupled them with their precursor John Nash and suggested in 1940 that 'these three are first-rate of their kind, and it is a kind which will need a full chapter when the history of mid-twentieth century British art comes to be written'.[15] A verdict from a greater distance comes in the catalogue of a touring exhibition of 'British Contemporary Painters', originated by the Albright Knox Gallery, Buffalo, in 1946. Andrew C. Ritchie wrote of Ravilious in association with other artists in the show, 'each ... has assimilated or modified one or another of the art movements emanating from Paris. Such movements have been made to serve these British artists' own requirements in their personal exploration of nature or the exploitation of, for want of a better word, their romantic tendencies. I wonder if this is not their great strength.'[16]

Whatever their personal proclivities for a puritanical lifestyle (Bawden and Hennell) or for engaging with the left-wing politics of the 1930s (Angus, Binyon and Horton), the collective mood of the group was one of levity and hedonism both in life and art, a release from the oppressive weight of growing up during the First World War that was noted as characteristic of a whole generation. This must surely account in large part for their renewed popularity not only in the twenty-first century but in the preceding decades of Post-Modernism. If the style and the man (or woman) are the same, as the Comte de Buffon believed, then the theme of this book is one of variations on a zeitgeist, in which an eclectic group appear to be sharing a style and thinking similar thoughts.

The women in the Ravilious group are rightly included as equals by Andy Friend, but they developed a distinctive role as a separate sub-group (comprising some others not included here). Many were involved in exhibitions, education and facilitation of amateur adult art production, with an emphasis on craft and design. These activities provided a socially oriented counterpart to the narrower focus of the men, who worked to commission, exhibited and taught in art schools. Much of this activity took place after 1942, when

Charlotte Bawden became the national organizer for pottery for the Women's Institute and Helen Binyon taught puppetry at the Bath Academy of Art at Corsham Court, one of the liveliest art schools of the post-war period that produced many future art teachers. In 1942 Muriel Rose, who stocked Marx's textiles and pattern papers, Garwood's marbled paper lampshades and Bawden's Bardfield wallpapers at the Little Gallery in pre-war London, organized the 'Exhibition of Modern British Crafts' at the Metropolitan Museum of Art in New York for the British Council. It proclaimed the gentle, locally rooted but spritely character of the group as the epitome of British values to a country whose military assistance had been desperately sought prior to Pearl Harbour. Friendships made before the war, many through the Artists' International Association (AIA), were also significant in their intersection with other networks of women active in non-vocational art education, such as Betty Rea, another RCA student of their generation, and Nan Youngman, chairman after 1945 of the Society for Education through Art.

Living in country villages became part of the character of the group, although neither Marx nor Freedman conformed to this pattern. The others tended to shuttle between London and their village houses in Essex or Sussex. On a basic level, it was cheaper and healthier to be in the country on a tight budget, but the country was also the place for weekend visits and painting excursions, a recurring theme in the collective story and an important part of their imagery and imagination – Ravilious seems to have been especially stimulated by landscape and the sense of particular places. The country added a further level of Englishness, another area in which these artists avoided falling into sentimentality by adding just enough Modernist strangeness to their depictions, while feeling that their mentor Nash had perhaps gone too far in his surrealist visions.

The reality of rural England experienced by these artists must have induced mixed feelings of pleasure and pain. At a time of prolonged agricultural depression they would have had a sense of solidarity with the declining rural workforce, which in Essex had long been especially radical and unionized, although this theme does not emerge from their work. Agricultural decline contributed to a kind of magical suspended animation caught in Ravilious's gleeful paintings of abandoned vehicles and machinery in backyards. It was Thomas Hennell, however, whose special contribution was to convey the more familiar sense of regret to a wider public. His first book *Change in the Farm* (1934) was published by Cambridge University Press, which must have given it authority. It was followed in 1939 by *Country Relics*, with a text by the

prolific and pessimistic country writer, H. J. Massingham, and then in 1943 by Hennell's own writing in *British Craftsmen*, part of the widely distributed 'Britain in Pictures' series. In his mission to define rural life without sentimentality Hennell, who might have picked up this enthusiasm from Marion Richardson, wrote of the significance of the Omega Workshops as a portent of the future, and he pleaded for a parallel continuation of traditional and 'studio' crafts, as advocated by Marx's friend, the potter Michael Cardew.

In writing about this group as a whole, Andy Friend has added the next logical piece to a historical pattern that has so far largely been made up of individual studies. His meticulous research has revealed much hitherto unseen detail and corrected some existing chronological slips. Knowing so much more about the early lives of the group will help in understanding and evaluating their work. It is too early to say whether the established lines of history, mentioned earlier, will shift to allow more space for the group and what they stood for, but perhaps this is unimportant. The fact that they modestly got on with their lives and their work without shouting about it is one of their most attractive characteristics.

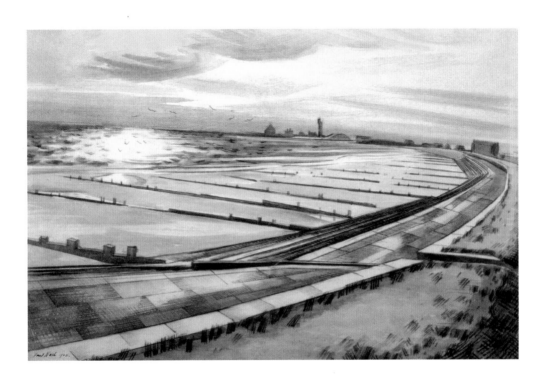

0.1
Paul Nash, *The Shore*, watercolour and pencil, 1922.
One of over fifty works based on 'the marsh and this strange shore'
completed while Nash was living at Dymchurch between 1921 and 1925.

SOUTH KENSINGTON

'I've quite firmly resigned my usher's job at the Royal College of Art & I'm not going to lecture again if I can possibly afford not to ... I'm going to settle down to paint again.' Paul Nash wrote this in April 1925, during a spell of part-time teaching he disparaged as a distraction, unable to foresee its impact on England's visual culture in the 1930s. Looking back then on the pattern of friendship and chain of achievement that had flowed from it, he realized how fortunate he was that his time at South Kensington coincided with 'an outbreak of talent'.[1]

Those he had in mind judged themselves even more fortunate. Towards the end of her life, Enid Marx reflected: 'Paul Nash was the magnet that drew us together' and 'we formed a lifelong friendship with Paul, who in turn befriended us and helped us freely with introductions to clients'. For one of her peers, Nash's arrival at the College was 'like an explosion' because his focus on ideas, literature and the arts as a whole, rather than on technique alone, 'enlarged our minds ... made us aware of beauty'.[2]

The hard-working, easily slighted Edward Bawden thought Nash was first rate because he never resorted to sarcasm, unlike older professors who tried to sound profound while being evasive. He did not 'hand out propaganda for his own point of view', and tried to bring out 'whatever seemed unique in a student'. He was 'a practising artist of great distinction who was willing to treat students as though they too were artists of distinction'.[3]

One of those students was Bawden's friend Eric Ravilious. Nash soon became confident that this slightly diffident, charming twenty-one-year-old had the design skills to make a success of commercial illustration projects. Enrolling for his second year, Ravilious had entered 'Mainly teaching' as his career aim, but shortly after Nash's arrival he responded 'Possibly book

1.1
Paul Nash, *Proud Paul*,
wood-engraved self-portrait, 1922.

decoration'; a year later Nash secured his election to the Society of Wood Engravers and introduced Ravilious to his connections at the Curwen Press.[4]

Nash's impact on a generation of students in the Design School was all the more remarkable because his time there as a visiting instructor spanned less than thirty days during late 1924 and early summer 1925, interrupted by four months in France and Italy. It was an interlude that probably would never have happened had the proceeds of a successful exhibition arrived sooner; when they did, Nash had already accepted the job offered by his old friend and supporter William Rothenstein, the reforming RCA Principal.[5]

The two had first met in April 1910 when Rothenstein, judging student work displayed at a monthly sketch club, had awarded Nash full marks for a mystical drawing and its accompanying poem.[6] As Nash later described the Bolt Court art classes, 'the students were young men who worked at various commercial jobs during the day, coming here in the evening to improve their drawing, to practise design or to learn lithography and etching. The whole purpose of the school was avowedly practical. You were there to equip yourself for making a living.'[7] Although Nash had already decided to try and earn his living as 'a black and white artist or illustrator of some sort', his mother had recently died after enduring years of depression and it was a time of great emotional vulnerability for the twenty-one-year-old. His inability to master maths had progressively ruled out the careers in the navy, architecture and banking deemed suitable for the elder son of a barrister; and, although supportive of Paul's chosen path, having met years of nursing-home costs, his father was under considerable financial pressure. So when Rothenstein advised him to study at the Slade, Nash doubted the fees could be afforded. Looking at his work, Rothenstein suggested 'Well, then, why not make them for yourself?' and, when he held his first exhibition, purchased a drawing. Years later Nash would write to him: 'you did the kindest and most impressive thing ... it was without exaggeration one of the thrills of my life'.[8]

As a schoolboy, Rothenstein, third child of a prosperous Yorkshire wool merchant, had himself demonstrated such startling mathematical incapacity at Bradford Grammar that his teacher mocked him as 'Genius!' Art classes became his refuge, but in the 1880s they mainly involved drawing cubes and cylinders; it took the natural world and expeditions to nearby quarries and moors to feed his promising early work. A year among the plaster casts of the then 'spiritless' Slade followed before he left London aged seventeen for the libertine atmosphere of Paris, meeting Verlaine, Rodin, Whistler and Degas during a four-year stay.[9] A loyal friend to the imprisoned Oscar Wilde, by 1910

Rothenstein had established himself as portraitist to Edwardian society, erudite critic, leading exhibitor with the New English Art Club and increasingly intense cultural man about town. To Nash he now became a source of generous support at critical junctures. In the years before 1914 he recommended Nash's work to collectors, and then in 1917 joined a successful, in all probability life-saving, campaign to have him appointed an official war artist before his protégé was returned to the devastated terrain of northern France.[10]

The following years were troubled ones for Nash, now 'a war artist without a war', as he sought direction and became embroiled in controversy as an art critic.[11] In June 1921 the artist Lovat Fraser died suddenly while holidaying with the Nashes at Dymchurch, and shortly after Nash found his own father comatose. As a consequence Nash himself blacked out, lay unconscious in a London hospital for a week, and was forbidden to work while recovering. Rothenstein organized a group of friends who rallied to his financial aid, and Nash's subsequent convalescence at Dymchurch became the prelude to his most prolific phase of work on 'the marsh and this strange coast', a burst of work that also saw publication of his books *Places* (1923) and *Genesis* (1924), containing two of his finest sets of wood engravings.[12]

By now Rothenstein was three years into his efforts to shake up the RCA and its four schools of Painting & Drawing, Architecture, Sculpture and Design – to which reorganization had recently added a fifth, the School of Engraving.[13] The Board of Education had appointed him hoping he would reform an institution perceived as hide-bound, overly focused on the training of art teachers rather than artists, and too academic to make a meaningful contribution to raising the quality of industrial design – an objective of the RCA and its predecessors since the early Victorian era. As Rothenstein wrote to the President of the Board of Education before his appointment: 'We have amongst us too many trivial painters and indifferent teachers and too few good and adventurous craftsmen or designers of distinction.'[14]

Rothenstein was intent on pursuing his painting career two days a week and, attracting opposition, adopted a gradualist approach at the RCA, taking advantage of – and occasionally provoking – staff departures to move things forward. He introduced greater informality, with Sunday-night 'at homes' where invited students could meet some of the many cultural figures he knew, and regularly drew on this network for outside speakers. When the unexpected resignation of the Professor of Sculpture created an opening in January 1924, Rothenstein was keen to appoint the mercurial Jacob Epstein, another artist he had supported financially, to the vacancy. It was a controversial choice and

1.2

Paul Nash, *Meeting Place*, Buntingford, wood engraving, 1921.
One of eight images cut for *Places*, 1923.

a battle he lost, but not before a tour of art schools in Paris, Prague and Berlin had suggested ideas for further change at the RCA.[15]

Increasingly conservative in his own creative instincts (he regarded abstract art as 'a cardinal heresy'),[16] Rothenstein was nevertheless radically ambitious when he engaged in any venture. A freedom he had secured from the Board was the ability to appoint practising artists as visiting part-timers; he also wanted to enliven an area that for all its inherited arts and crafts strengths exhibited 'a somewhat doctrinaire pedantry of pseudo-medieval character'.[17] Nash had given a lecture at South Kensington and had previously been teaching a day a fortnight at the Cornmarket Art School in Oxford, alternating with Rothenstein's brother Albert Rutherston as instructor to the 'sons of dons and daughters of professors' in the rudiments of wood engraving'.[18] As Bawden recalled, Nash now appeared in Exhibition Road 'at the right moment, and what is more, he came into the Design School, the habitat of the lowest of the low'. For those already looking to life beyond College, it was an inspired move destined to inspire.

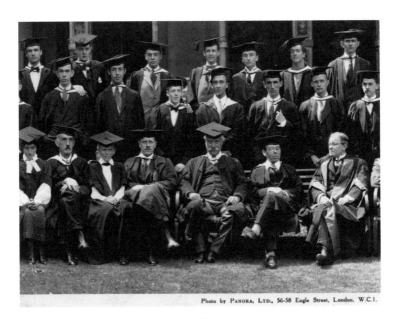

Photo by PANORA, LTD., 56-58 Eagle Street, London, W.C.1.

1.3

RCA Convocation 18 July 1924.
Top left: Ravilious, Bliss to his right, drapes a hand over the student in front.
Seated from right: Robert Anning Bell, William Rothenstein and Sir Frank Short.

The group of friends that would emerge from the RCA to enliven England's art and design in the 1930s began to coalesce on Wednesday 27 September 1922. Ranging in age from seventeen to twenty-six, they arrived in South Kensington from widely differing backgrounds, but all faced a day of form-filling and an interview with Rothenstein in his office behind the Victoria and Albert Museum. Here the College and its predecessors had existed cheek by jowl with the nation's applied art collection since the 1860s, separated only by a doorway and a short flight of stairs; and the purpose of the interview was to allocate each entrant to a School within the College.

Although convinced that 'the separation between craftsmen and artists is already too wide', Rothenstein cherished particular ambitions for the Painting School: he was keen to produce Prix de Rome contenders and outperform the Slade.[19] But he also wanted to fulfil expectations that he could nurture a new breed of designers who would 'get the rather dreary imitations of William Morris changed for a more alert spirit'[20] and had already noted the quality of the quick sketches produced by an applicant from Eastbourne. Thus the E. W. Ravilious file noting 'Entrance Test: Passed' in black was duly annotated

CHAPTER ONE

in red 'Design', and he was sent on his way to the Student Common Room situated in a courtyard of Boer War hutments a brisk walk up Queen's Gate.[21] Here it was that Bawden, following on later after confirmation that he would be studying book illustration in the Design School, noticed a group sitting at a table 'listening to one of their number, a good-looking young man, whose large dark eyes lit up with enthusiasm as he talked animatedly about Sussex'.[22]

Ravilious was talking about the landscape that had provided the horizon of his world from the age of four, when his family first took lodgings in Eastbourne; which between the ages of six and eleven could be seen from his bedroom window rising beyond open fields where he played by day; and which he began drawing while a 'Muny Boy' at the council-run Boys Secondary School during the Great War years.[23] Winning a scholarship to the local School of Arts and Crafts in December 1919,[24] he had sketched and photographed the coast and the Downs during the following two years,[25] played cricket, football and tennis,[26] and earned money as an assistant teacher in local elementary schools.[27]

But the last year had not been easy in one important respect: over four days of proceedings, starting with an initial bankruptcy hearing in early December 1921 and running to late February 1922, his family's money troubles had been mercilessly exposed in the Town Hall just a few hundred yards from the art school. On the stand his father faced lengthy cross-examinations about the previous collapse of his business in 1907, the family's flight from Acton in London to Eastbourne, why he had transferred furniture to his wife fifteen years before, and his sundry ventures since. His elder brother was then interrogated about the high living and double-dealing that had precipitated the collapse of three antique shops blazoned with the family name. Even when the hearings were over, 'The Ravilious Bankruptcy' kept delivering months of sensational headlines.[28] Eighteen-year-old Eric had long been used to sidestepping embarrassments flowing from his father's religious obsessions, but in the confined atmosphere of a once fashionable resort where class distinctions were rigid, and respectability was all, this can only have reinforced his instinct for privacy.

Now, thanks to Eric's test success and provision of a further £60 scholarship from the Borough Council, at least two years in the metropolis lay ahead. And if there was an energy about him, it was probably because the gap between Art School and his arrival in lodgings the previous day had been spent with two friends on a six-week ramble across the Sussex countryside, sleeping in barns, sketching and meeting unexpected hospitality along the way.[29]

Small wonder Edward Bawden had a sense of exhilaration on first encountering the young man who would shortly become, and remain for the next twenty years, his most intimate friend.

Although very different in personality – Bawden was cripplingly shy, especially in female company, Ravilious effortlessly gregarious among peers – the two already had much in common. Born within four months of each other, they both came from provincial retail backgrounds (albeit the Bawden household enjoyed a more stable existence), had each suffered boyhood agonies of boredom during endless chapel services, and made similar progressions from secondary to vocational art schools. They now found themselves assigned to the same classes, living in London for the first time on similar levels of barely adequate scholarship support.[30] More significantly, it soon became apparent that they also had artistic enthusiasms in common, many of which they shared with Douglas Percy Bliss, a Painting School student they met during compulsory first-term architecture classes and who became, for Ravilious in particular, a crucial early influence. For his part Bliss soon felt he was 'the luckiest of men to have found such friends'.[31]

Three and a half years older than Ravilious, Bliss had already studied Literature, History and Art History at Edinburgh University after a year in the Highland Light Infantry at the tail end of the First World War. Dark-haired and blue-eyed, schooled in Scotland from the age of six after a Raj childhood, he had confidence and quick-witted entrepreneurial spirit, could dance and was also good at sport. Early paintings led a tutor to suggest he try for the RCA and, already an eclectic bibliophile, he hoped its Design School, steeped in the traditions of Morris and Ruskin, would be his pathway to a career in illustration. But he emerged from his interview re-assigned by a Principal on the lookout for broadly educated Painting School recruits who were potentially sympathetic to his own sense of style. It was a twist of circumstance Bliss would regret as he became disenchanted with 'a course that consisted of little else but the representation of the naked human body in over-heated and under-ventilated rooms', particularly as new friendships reinforced his thwarted inclinations.[32]

But for these three the road to South Kensington had been smooth compared to that traversed by two others joining the Painting School. Barnett Freedman had overcome ill health, poverty and prejudice before gaining a place. Born in 1901 to Russian Jewish exiles five years after their arrival in Stepney, Freedman was the eldest child of a family living in overcrowded, unsanitary conditions. At nine he was hospitalized with respiratory and heart

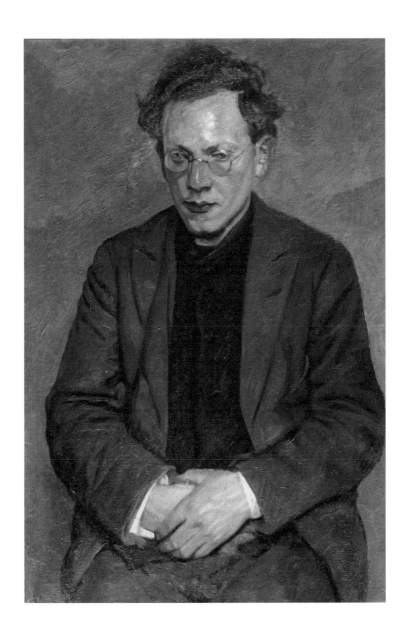

1.4
William Rothenstein, *Portrait of Barnett Freedman*,
oil on canvas, 1925.

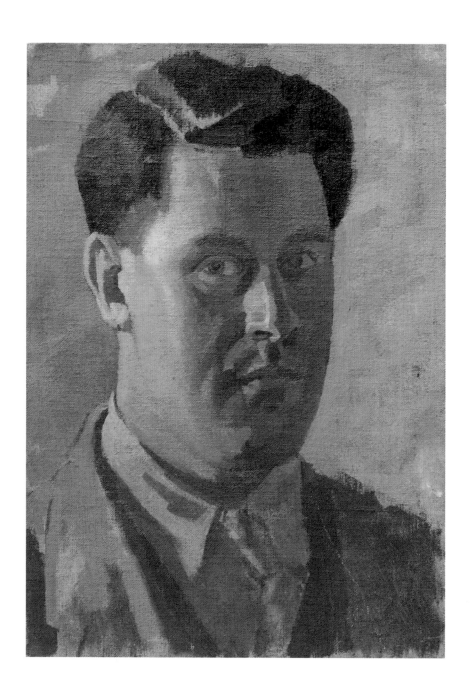

1.5
Percy Horton, *Self-Portrait*,
oil on canvas, 1925.

problems; four bedridden years followed during which he read voraciously and taught himself to draw, paint, and play the piano and violin.[33] Released from hospital, he was set to work in a monumental mason's and then an architect's office, picking up the lettering skills he would later develop in distinctive commercial designs. In parallel, he attended evening classes at the Central School of Arts and Crafts for five years, repeatedly applying for a London County Council (LCC) scholarship. Exasperated by a third refusal, he then displayed the *chutzpah* friends would soon come to know well, engineering a direct audience with Rothenstein. The portfolio Freedman presented was evidence that a great injustice had been done; Rothenstein's upbraiding of the County Hall official involved secured Freedman a £120, three-year grant.[34]

Rothenstein, who had resisted anglicizing his name during the war, was no stranger to prejudice and eighteen years before had got to know the Jewish East End at 'the time of the Russian Pogroms and my heart went out to these men of a despised race, from which I too had sprung, though regarded as a stranger among them'.[35] Over three years, he had painted a series of eight pictures in Spitalfields, one of which – *Jews Mourning in the Synagogue* – was accepted by the Tate Gallery in recognition of his emerging status as a significant British artist. It may have been this background, together with Freedman's engaging personality, that led the RCA Principal to invest particular hopes in the young East-ender, even though Freedman soon emerged as 'Soc', short for Socrates, 'the grousing genial leader of opposition to authority, the past, to everything established'.[36] Rarely in the best of health for long but with a talent for friendship, he became a great convenor of JCR events.

Of all those arriving that autumn of 1922 perhaps only twenty-six-year-old Percy Horton had overcome more severe obstacles.[37] With a mother who had been in domestic service since the age of eleven and a father who was an omnibus conductor, Horton was already a committed socialist and prize-winning student at Brighton Art College when conscription was introduced in January 1916; he and his best friend Royle Richmond joined the No-Conscription Fellowship, whose secretary was Lydia Smith, a Quaker suffragette and, although ten years older, Royle's fiancée. After applying for absolute exemption, believing anything less would render them complicit in the futile bloodletting unleashed by Europe's rulers, they were subjected to cat-and-mouse tactics by tribunals and courts martial, facing abuse in public from jingoistic crowds and extreme cruelty in private at the hands of prison authorities and the military. Richmond died in a jail cell in December 1916 and Horton, near broken in health, was not finally released until April 1918.

By then he had endured fifteen months' hard labour and solitary confinement in Edinburgh's Calton prison, during which his smuggled letters describing inhumane conditions had been used by the Fellowship to publicize their cause.

United in politics, grief and relief, Percy and Lydia became close after his release, courtship followed, and they married in 1921.[38] Although 'conchies' faced systematic discrimination, he completed a course at the Central School of Arts and Crafts and found casual work as a teaching assistant at Rugby School. However, determined to become a painter himself, Horton sat for national exams and won 'a Royal', an Exhibition worth £80 a year tenable at the RCA for three years.[39] As a married man Horton had no need to use the JCR as a home from home, but he too was a joiner and an organizer, musically talented (he played the violin in a trio with Freedman), and keen on acting (he would take the lead in RCA productions of plays by Shaw, Ibsen, Chekov and Synge). Thus it was that preparations for the Freshers' play in December 1922 first brought Freedman and Horton into close contact with Ravilious and Enid Marx who, although a painter like Freedman, would also eventually be best known for her superlative design skills.

Canteen profits financed an RCA student magazine and its June 1923 issue reported: 'The Christmas Social has dwindled so far in perspective of memory it seems a mere speck on the horizon ... Oh yes, there was a medieval play wasn't there? ... acted in the round in the centre of the Common Room. And the room itself was transmogrified and wore an air of alleged medievalism ... After supper we recovered and danced in our gay medieval costumes far into the small hours.' Eight months older, curious and generous, Marx played Queen Elvira opposite Ravilious as Pittle Pottle, a jester in parti-coloured tights, who from then on was always for her 'the country boy who enjoyed birds nesting and games, a sort of *Papageno*'.[40] Recalling both her liberal Hampstead childhood and her schooldays at Roedean – where she had benefited from excellent craft as well as art teaching before her own year at Central – she observed: 'The Sussex Downs were another love we had in common. Sussex was Rav's home county; I was a Londoner, but had spent many years of my childhood amongst the Downs, with which I feel I had an affinity.'[41]

One of the youngest Painting School entrants was Peggy Angus, a promising seventeen-year-old North London Collegiate pupil. After losing two brothers in the war, she was eligible for a charity scholarship if admitted. Despite the RCA's supposed post-graduate focus, Rothenstein was not averse to entry straight from school; he had come to see the previous year's intake, with its high proportion of older students from provincial art colleges, as resistant

to the working methods and naturalism he favoured.[42] Nevertheless, feeling Angus was just too young, he upset her by suggesting that she would benefit from a year elsewhere before re-applying; but on learning of her straitened family circumstances and fear of losing the scholarship, he relented. She lived in a Muswell Hill house with her unemployed engineer father and a mother who took in home work to make ends meet, an activity which, as Carolyn Trant has described, threatened to enslave Angus herself: 'she had to rush home to fulfil her quota of work on the knitting machine in the evenings instead of enjoying the camaraderie of the Student Common Room ... Here all the ideas of the day, especially literature and politics, were constantly under discussion, and to Peggy it seemed like a party going on every night – one that she was missing.'[43] She struggled in the Painting School, where men outnumbered women by three to one, and in the third term, attracted by the possibilities of illustration, she transferred to the Design School; seen by some as a step down, it was in fact a fortunate move to classes where women predominated and where she would gain the enduring friendship of another young student, Helen Binyon, who had also arrived straight from private school.[44]

Twelve years later, Ravilious reminded his lover Helen that they were really only on 'hat raising terms' at the College, an environment in which most young women from 'good homes' were apt to keep aloof from male students who were 'seldom gentlemen by birth'.[45] Even so their paths must have crossed reasonably frequently because, although Helen lived at home like Peggy, she lunched in the same canteen, took the same pottery and 'Mural Dec' classes in the Design School, and exhibited alongside him at the same student shows.

Surviving early work shows Helen had talent aplenty, but her RCA entry was no doubt helped by the fact that the Principal had known her from birth and her father for a quarter of a century. Laurence Binyon and Rothenstein had first met in John Singer Sargent's studio in 1896 and in the intervening years there had been frequent collaborations between the two as Helen's father became in the most comprehensive sense a fully fledged man of letters – celebrated as poet, dramatist, art historian, museum curator, editor, critic, biographer, lecturer and essayist.[46] Well known to the cultural cognoscenti of Edwardian London, Binyon had achieved national fame in the opening weeks of the Great War when *The Times* published his celebrated lines: 'They shall grow not old, as we that are left grow old: / Age shall not weary them, nor the years condemn. / At the going down of the sun and in the morning / We will remember them.'[47] An authority on Eastern art, Binyon had also focused public attention on the English visionary tradition of William Blake, Samuel

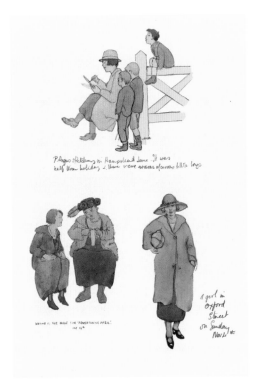

1.6
RCA memory books, *c.* 1924:
a selection of Helen Binyon's sketches (left) shows 'P. Angus sketching
in Hampstead Lane. It was half-term holiday and there were swarms of curious little boys';
a page of Peggy Angus's work (right) includes '2 Indian Ayahs in Kensington Gardens'.

Palmer and Edward Calvert, and pre-Victorian topographical watercolourists such as Thomas Girtin, J. S. Cotman and Francis Towne. He might only have been Deputy Keeper of Prints and Drawings at the British Museum, but to *Punch* he was 'Binyon of Bloomsbury' and his daughter was apparently perfectly placed to absorb the artistic zeitgeist that was soon animating her contemporaries. But like her sketching companion Peggy, she found College life not without its complications, its mildly Bohemian aspects clashing with parental expectations; Helen and her twin sister would in due course be presented at Court.[48]

Ravilious and Bawden got off to a slow start with formal studies, spending most of autumn term 1922 in the Architecture School, in line with Rothenstein's belief that a common grounding in the discipline could narrow divisions between fine and applied artists. 'An intelligent student, draughtsmanship moderate. Inexperienced in design' was the verdict on Ravilious, matched by 'Medium ability, not distinguished in design or draughtsmanship' for Bawden.[49] In the Design School the following term they took Edward Johnston's lettering course, another established feature of the RCA programme: Ravilious was a poor attender, and neither of them earned more than a perfunctory 'Satisfactory' for their performance. After Rothenstein criticized his efforts at a nude, Bawden in turn dodged the theoretically compulsory Life Drawing classes, held four times a week on a segregated basis.[50]

The College world was one where year of entry mainly determined how students socialized, and at this stage Henry Moore, Raymond Coxon, Edna Ginesi, Robert Lyon and Barbara Hepworth were part of a close knit second-year group occupying 'the Leeds table' in the canteen and most of the JCR posts. Phyllis Dodd, a highly talented portraitist from Liverpool, was part of this network and, although in the Painting School, barely knew her future husband Bliss at the College. However, sport was an occasion for mixing, and – hockey stick to hand – Ravilious appears as a slightly tentative participant in a 1923 group photograph including Moore, Coxon, and Ginesi, while a football team photograph the following year features Ravilious standing behind Moore. Despite this Moore would write to Coxon from Italy in spring 1925 as if he were meeting 'a design student called Ravilious' for the first time, and it was only in Florence that Ravilious began to enjoy any close association with the ebullient sculptor.[51]

Things began to look up in the summer term of 1923 as Ravilious and Bawden sampled activities approved by the Professor of Design, Robert Anning Bell. As an artist Bell was adept in oil and watercolour painting, pottery design,

stained glass, mosaics and book illustration, and as an educator he was an advocate of deepening craft skills. Ravilious chose pottery and also put himself down for etching classes in the Engraving School, where wood engraving was on offer. From an early age his school artwork had included repeating flat pattern designs and he now used the pottery sessions to make 'experiments in Tile Painting'. No examples survive from this single term of activity, but two years later his tile designs and engravings, in all probability selected by Bell, featured among art school exhibits chosen for display at the Paris *Exposition Internationale des Arts Décoratifs et Industriels Modernes*.[52] A perceptive term report shows Bell was also warming to Bawden: 'Exceptionally good student, excellent letterer, shows marked individuality in design flavoured with a little of the exaggeration and grotesquerie so popular now.' Bawden had now colonized his own corner of the design room, which was 'full of charming girls of whose propinquity he seemed unaware. The tutors came and went. They were wise. They knew a prize student when they saw one.'[53]

Diminutive, energetic Enid Marx played tennis with the Leeds group that summer and, seeking to improve her drawing, joined them in approaching Leon Underwood for extra-mural lessons. He had resigned following a dispute with Rothenstein who, despite recruiting him as an instructor, felt free to intervene at will, sowing resentment amid a confusion of teaching styles.[54] Meanwhile, the Principal himself was noting that Barnett Freedman: 'Has a strong character and a philosophical mind, but he is obsessed by the idea that accomplishment leads to insincerity hence he is not making the most of his artistic sensibility, which is considerable and I am disappointed with his progress.'[55] If Freedman was aware of this he was not cowed, as he now took up the cause of Albert Houthuesen, a rejected applicant with a tragic family background, and yet again succeeded in getting Rothenstein to intervene at the LCC.[56] More immediately satisfying for Rothenstein was the progress of Freedman's musical collaborator Percy Horton, a noted 'hard worker' with a more conventional approach to landscape and portraiture that now ensured him protégé status.

Meanwhile, Peggy Angus remembered being put off wood engraving when Ravilious told her 'You'll do six bad ones at first', a remark probably reflecting his own experience in the summer of 1923 when his Etching School report merely noted 'Progressing'.[57] Sir Frank Short presided over this activity, but he was more interested in mezzotint techniques than the creative possibilities of a wood-engraving revival and concluded that Ravilious was 'A clever student – experimenting a good deal, and not easy to teach.'[58] Ravilious, however,

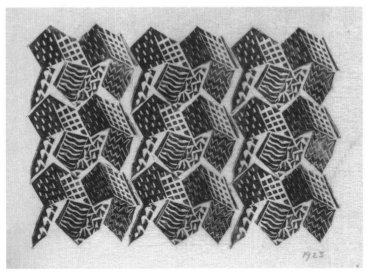

1.7
Enid Marx, *Back Garden* (above), *c.* 1923, and *Abstract Pattern* (below), 1923.
Two of Marx's earliest wood engravings, completed
after her exclusion from Frank Short's RCA classes.

was not averse to a bit of teaching himself and when Short excluded Marx from his classes on grounds of poor drawing, he promptly began sneaking his friend into the Engraving School to pass on by night what he had picked up by day.[59]

A few of Ravilious's early experiments survive, notably in Bliss's scrapbooks, showing an awareness of popular chapbook traditions and the comic possibilities of the medium.[60] They include one integrating motifs from Eastbourne and the Downs, which has been perceptively analysed as showing 'much that is to come', and a *Galleon Roundel* echoing medieval artefacts of the type housed in the Victoria and Albert Museum, which 'shows a considerable advance in technique although not in the direction Ravilious eventually took'.[61] For Ravilious it must have been satisfying to see it appear in the June 1923 Student Magazine (which additionally hailed him as a leading member of the spectacularly unsuccessful football team). That term he was also one of a select few invited to Rothenstein's home when Max Beerbohm was visiting. Ravilious was an admirer of the veteran satirist, at that moment mired in controversy for lampooning Edward VII in his latest exhibition, but was overawed by the occasion and never got to speak to him.[62] However, having managed to live in London on the breadline for a year, both Ravilious's confidence and his finances were set to improve: in the first year he had to pay fees and subsist on the £60 scholarship from Eastbourne Council which, although only tenable for another year, was now raised to £90 alongside a College fee remission granted on the basis of his progress.[63] Beyond this prospects were uncertain, so Ravilious now elected to complete his Diploma in two years with a course in the Department of Mural & Decorative Painting. This area of the Design School was overseen by the medievalist Ernest Tristram, a teacher whose gentle ways appealed.

Wood engraving, ceramic design and murals would all figure in Ravilious's future career, but there is no record of watercolour painting during his first year. This now changed, for that autumn he returned from Sussex to make his mark at the post-vacation Sketch Club exhibition with 'a set of eight or nine water-colours'. They stood out, according to Bliss, from the 'multitude of watercolour sketches, all more or less in the Sargent tradition' as 'exceptionally pure in style and certain in handling', and for 'the personal manner in which he employed the conventions of Cotman and Sandby. At that time he used to express an admiration for the sober and valuable book of Alfred Rich on water-colour painting.'[64] Ravilious was mocked for this attachment, but nevertheless he probably visited the memorial exhibition of Rich's

watercolours showing in London during the spring of 1923. This included numerous Sussex subjects and at least a dozen paintings of the very places he had traversed on his trek the previous year.[65] In the catalogue, Laurence Binyon praised Rich as a worthy successor of De Wint as a colourist, and of Cotman and Girtin in terms of firm design and structural drawing – leaders of the pre-Victorian topographical tradition that Rich himself believed could inspire a modern watercolour revival; and he had achieved all this by focusing not on the grandiloquent but 'the rivers and quiet small harbours of rural England and its coasts'. Although he never became a subscriber to artistic manifestos, Ravilious not long after would admit that his greatest ambition was 'to revive the English tradition of water colour painting'.[66]

For Rich, design was the foundation of good practice ('no amount of effective painting can hide shortcomings in drawing') and delight in the world should be its motivation ('I have always made it my rule only to do a thing I feel real pleasure in attempting'). Advocating adherence to a limited palette, he cautioned: 'The early efforts of the student when painting from Nature should always be so far as possible to express the view he has selected as simply as possible.' Equally he was not averse to selective redesign of a scene ('if the foreground is entirely void of interest, something must be introduced') and retention of elements others excised: 'If a telegraph pole comes into a picture, it should without doubt be included, for it is quite likely that its presence may have given just the right balance to the landscape which attracted.' As Binyon commented, Rich was 'not put out by modern industrial buildings, factories and chimneys if he could bring them well into a design'. Many years later Bawden recalled Rich's influence waning as Eric's student years progressed, but his affirming voice carried many specific messages Ravilious would adhere to as his art matured.[67]

Rich's writing may also have first alerted Ravilious to the existence of both Cotman's *Greta Bridge*, a lifelong favourite available to view in the British Museum Prints and Drawings Room, and the work of Francis Towne, one of whose two watercolours called *The Source of the Arviron* had been acquired for the Victoria and Albert Museum by Martin Hardie, the Keeper of Painting, Engraving and Illustration. Design School students were generally encouraged to spend time on 'museum study', drawing collection objects, partly due to poor facilities in the College proper, but it was Hardie's expertise and his willingness to guide students in their exploration of artists such as Towne and Cotman, Blake, Palmer and Calvert that now proved of the greatest value.[68] When Hardie, visiting the Sketch Club show, purchased *Wannock Dewpond*

(fig. 1.10) – a painting now in the British Museum, that on close inspection reveals direct traces of Rich's method – it must in turn have been one of the thrills of Ravilious's young life; and *Warehouses by a River*, another survival from the RCA period, could 'pass as a work by Rich with its soft light, full washes and clearly visible under-drawing'. This pencil and watercolour drawing of a location near Rye was snapped up by Thomas Bell, a leading photographer who was the visiting judge at the show where it first hung.[69]

The second year was the time when each generation impacted more on College culture, a process Bliss now furthered as elected editor of the magazine and JCR librarian – an important position as his peers were learning as much from books, journals and their own discussions in the JCR as from any formal teaching. Here Ravilious, Bawden and Bliss were now an identifiable trio on nickname terms within a broader friendship group.[70] In homage to his Karachi birth and erudition, Bliss had become 'Mahatma'; Ravilious's cheerful insouciance and beautiful whistling rendered him 'the Boy'; and Bawden's idiosyncrasies and nocturnal habits attracted the sobriquet 'Pale Spirit'.[71]

Sculpture student Cecilia Dunbar Kilburn recalled Ravilious 'floating through life with a gaiety and enthusiasm and the nicest sense of humour of anyone I have known. I never heard him offend in any way, nor was his humour at the unkindly expense of others.' Bawden, however, was comfortable with few other people and as Bliss observed 'saw no newspapers, theatres or films. He went to no student parties or dances ... He was "a little outside life" [and] had such odd habits. If a stranger approached him he got into reverse gear and backed away to the wall.' He was 'one of those melancholy people to whom laughter is medicine ... I think he only liked people with whom he could laugh, and he saw us all through a distorting glass ...' A shared sense of absurdity animated the trio, even if on occasion Bawden did not know 'where to stop his japing'. His friends, however, 'knew him for a genius' and, although sometimes provoked by wounding remarks or deflating coldness, 'decided that one had to take the good with the bad. Bawden was unique and we were lucky to have him.'[72]

Bawden in turn regarded Ravilious as 'having perfect taste in all that he did', although 'a bit of a layabout': 'We were very close friends, but I think we were rivalling each other. He was much cleverer, but never gave the appearance of working. I think I rather showed off that I was busy.' Bawden now added his penchant for unfashionable Victoriana to their visual potpourri of folk art and toy theatre sheets; he also possessed a copy of Lovat Fraser's *Luck of the Bean Rows,* the artist's last book published by the Curwen Press just before his

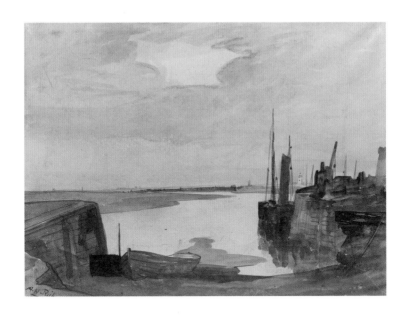

1.8 & 1.9
Alfred Rich, *Southwick Harbour* (above), watercolour, 1906.
Eric Ravilious, *Warehouses by a River* (below), pencil and watercolour, 1923.

1.10 & 1.11
Eric Ravilious, *Wannock Dewpond* (above), pencil, ink and watercolour, 1923.
Enid Marx, *The Downs above Plumpton* (below), pen, wash and watercolour, 1924.

death when his stage sets for Nigel Playfair's *The Beggar's Opera* were all the rage. Lovat Fraser's black line decorations infilled with fresh striking colours, 'heralding for the Plaistow works an era of puce, primrose yellow, viridian green and bluest of sky blue', were integral to the Curwen's 'spirit of joy' and assault on commercial drabness.[73] In a similar vein, having shed Beardsley for a richer fusion of influences, line was becoming Bawden's weapon of choice as he drew long into the night – and an elegant blend of satiric playfulness was emerging as his singular style.[74]

Ravilious and Bliss's interaction was a more straightforward matter of common inclinations, not least in relation to books. *The History of Mr Polly* and *Huckleberry Finn* were shared favourites, but Bliss also brought the imprimatur of a widely read graduate to the literary fossicking that had delighted 'the Boy' when he discovered the obscure or intriguing in his father's shops. Teenage Bliss had been fascinated by all manner of classical mythology, medieval folk-lore, legends and sagas. The journals he had created helped animate the spirit of *Gallimaufry* ('a confused jumble or delightful medley') well before it became the title of one of their most celebrated joint ventures.

Bliss was doing enough to ensure he would get his painting diploma in two years while also enthusiastically developing his own engraving skills ('the fascination is indescribable. As a student this writer could not get to bed for it,' he would later write) alongside a rare understanding of the medium's history.[75] Ravilious meanwhile was absorbing the techniques taught to 'Mural Dec' candidates, while also busy cutting three engravings for the December issue of the magazine,[76] as well as a ticket for the Christmas Social and a deco-ration for its play programme.[77] Bliss then began an illustration project based on Scottish border ballads and one of his earliest headpieces appeared in the second magazine he edited. This eventually appeared in June after assembly 'in the valley of the shadow of the Diploma', and included three further deco-rations by Ravilious.[78]

Retaining the traditional institutional cover, the magazine sparkled irrev-erently inside: Rothenstein ('The Holbein of to-day – has headhunted for a generation – few celebrities have eluded him') and Tristram ('Expert in malo-dorous media – eager to instruct in all the temperas, skim milk, egg, size, calf's foot, sardine's tail, etc') were lampooned. As were friends: 'When The Fauves Grow Old – Extract from the 1950 R.A. Catalogue' predicted that Sir Barnett Freedman, Bart., RA, would then be exhibiting 'Two Yahoos in A Pumpkin Field'. It also reported that at a recent Carnival, 'Freedman, most sophisticated of *fauves*, most civilised of primitives, gave Marx an exciting night, dancing a

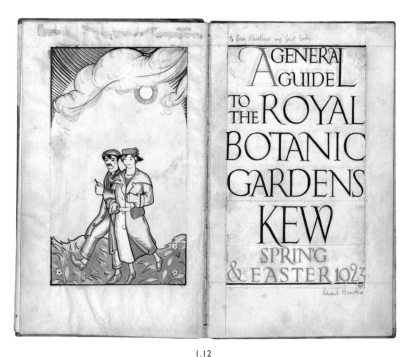

1.12
Edward Bawden, title-page design and rear illustration for *A Guide to Kew Gardens*,
pen, ink and watercolour, 1923.
Inscribed by the artist 'to Eric Ravilious, my first book'.

characteristic and very intense Tarzan Trot, which most resembled an over-turned black beetle twitching its legs.' Above Bliss's editorial, a Bawden headpiece portrayed the imminent graduation rituals as a parade of prancing horses in academic gowns led by a monkey banging a drum (fig. 1.13b).

The Convocation it foreshadowed took place on 18 July 1924. Bawden is absent from the formal photograph (fig. 1.3), although he won the year's £10 prize for design; Percy Horton was another absentee prize-winner.[79] He was hospitalized in St Thomas's when Rothenstein telegrammed 'Distinction and Ten Pound Prize' and then wrote urging him not to 'be in a hurry to get back to your easel. I took many people round the College show today and your own panel was sincerely admired.' Meanwhile Ravilious, in the back row next to Bliss, sported a deadpan expression, surreptitiously draping a subverting hand over the graduate in front.[80]

It was a triumphant end to the year for Ravilious. He had ignored various technical requirements of the course and 'slapped up a big gay painting' which confirmed Anning Bell's view that he was the year's outstanding graduate: 'An

1.13

From top: (a) Eric Ravilious, *Toys*, wood engraving for RCA Students' Magazine December 1923;
(b) Edward Bawden, *Convocation Parade* decoration for RCA Students' Magazine June 1924;
(c) Douglas Percy Bliss, wood-engraved headpiece for *Ballad of Sir Patrick Spens*, Border Ballads, 1923.

1.14
Eric Ravilious, *Sussex Church*, wood engraving, 1924.
Described by Bliss as his friend's 'first ambitious block', this piece was completed
by Ravilious prior to his departure for Italy in January 1925 and appeared in *Gallimaufry*,
published at the time of his return in 1925.

extremely able student of marked originality. He is a good executant and a very good designer. He also paints excellent watercolours.'[81] Eastbourne Council were at once informed of 'the splendid successes of Eric Ravilious' who 'has just obtained the Associateship of the College, together with one of the four travelling scholarships awarded by the College for the best work done in each of the four Schools (value £80 to £100). Furthermore he has been given a Royal College of Art Scholarship, value £60, which will enable him to stay on for a further year's postgraduate study ... A triple success in a single year, such as the above, is not often achieved.'[82] The departing Bell meanwhile signed up Ravilious as well as Bliss and Bawden for the junior branch of the Artworkers' Guild, where he was Master.

Bliss had also decided to stay on and to concentrate on wood engraving, which he saw as the coming thing, and in the lull between the Diploma assessments and graduation took Ravilious off on the 7 July 1924 for a first visit to the British Museum Prints and Drawings Room.[83] In mid-October that year, shortly after Paul Nash's arrival, Ravilious returned bright and early for a second time, and when he left for Italy a few months later had completed *Sussex Church*. Bliss later described this as 'his first ambitious block', adding that it showed a complete grasp of the possibilities of the medium and that 'he had discovered for the first time the beauties of xvth-century metal-cuts, of which the *St Christopher* of the British Museum is the outstanding example, and he was fired to emulate the great range of textures which they possess'.[84]

At its centre *Sussex Church* incorporated a fairly straightforward view of Lullington Church in the Cuckmere Valley, but by raising the horizon to create space for stippled downland and employing a gated fence-line in the foreground with a frame of flanking trees, Ravilious moves beyond a literal representation of the location to create his sense of place. Nash was sharing his enthusiasm for Samuel Palmer at this time, as was Hardie, whose plans for a major exhibition of the neglected visionary were now advancing. As he developed the design, Ravilious may well have had in mind Palmer's *A Hilly Scene* as well as Nash's newly displayed *Sandling Park*.[85] The block also marks the appearance of exaggerated foliage similar to that which Nash employed in *Places*, but although such influences are discernible, the whole is a confident amalgam of the *style Nash* and the *manière criblée* of the metal cuts, pulled off by a young artist who Bliss now observed was borrowing with 'an air'.[86]

These months were critical in developing Ravilious's wood engraving, but also for Bawden, Bliss, Marx, Binyon and others who eagerly awaited Nash's appearance in the Design School each Wednesday. According to Helen Binyon

they had already been captivated by the 'breath-taking freshness' of the latest shows of watercolours by both John Nash and Paul Nash. Paul, whose Dymchurch works had been showing at the Leicester Galleries, was now particularly helpful in demonstrating ways of laying on colours with a starved or a full brush, and washing one transparent colour over a ground of another. Both brothers were also already leaders in the world of wood engraving, having achieved prominence in successive London exhibitions of the Society of Wood Engravers (SWE) where, as Bliss put it: 'Their clarity and intensity of vision and their strong instinct for pattern [was] seen at the fullest in their prints. John Nash's work is gentler and more reticent than that of his brother and not tortured with the same daemonic urge.'

Bliss and, on the evidence of an engraving he would shortly create in Italy, Ravilious had been particularly struck by John Nash's *Wood Interior,* 'full of subtle counter changes of white, grey and black, and most beautifully designed'; but they also knew Paul's *Winter Wood* and the other seven linked images from *Places,* as well as the strikingly modernist, near abstract illustrations for the recently published *Genesis.* They were thus all aware they had access to a master – and thrilled by the interest he was taking in their work and the suggestions he made. When Bliss produced his mocked-up pages for *Border Ballads* he was steered towards Gerard Hopkins at Oxford University Press, only to return from a first meeting with a contract for publication. Meanwhile, Bawden had visited the Empire Exhibition at Wembley and completed an exercise in poster design; Nash now introduced Bawden to Frank Pick at the Underground Electric Railways Company of London – and shortly after Ravilious returned from his travels, his friend's posters were appearing all over the capital.

Enid Marx recalled Italy having 'a profound effect' on Ravilious: 'I well remember how, on his return, he visited me, and with great enthusiasm, told of the little churches in Tuscany where the altars had lovely paintings by Italian primitives Duccio and Cimabue; he gave such an excited account that I longed to see them for myself. This enthusiasm shows in the Morley College murals.' Three months later he was still conveying a sense of excitement about 'Sienese paintings, Duccios and Sassettas' on the second day of his new teaching job at Eastbourne.[87]

By contrast, after Ravilious reappeared in June 1925, Bliss and Bawden were both left with the impression that, compelled to go there, 'Italy seemed to have a listless effect. Instead of working like a beaver to copy a bit of Benozzo Gozzoli he seems to have kept fairly clear of the galleries and the

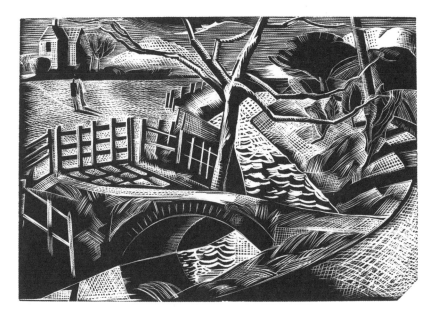

1.15 & 1.16
John Nash, *Wood Interior* (above), wood engraving, 1922.
Paul Nash, *Dyke by the Road* (below), wood engraving, 1922.

1.17
Photographs taken by Ravilious in Florence, spring 1925.
Clockwise from top left: Henry Moore and Norman Dawson; Robert Lyon sketching;
a fascist demonstration; Mabel Lyon at Fiesole; newlyweds Mabel and Robert Lyon.

churches and to have walked about in the fresh air'; and his wife Tirzah would later write 'he regretted that he had gone there because he didn't like it. It was either intolerably hot or intolerably cold or he was constipated and lonely and he saw far too many pictures and so had no desire to paint any himself.' Helen Binyon gives a similar account of Ravilious 'baffled and unsure of himself on this first visit abroad and unwilling to make the regulation copies of Italian paintings expected of travelling scholars ... (he) enjoyed most of all going for long walks by himself along the banks of the Arno, miles into the countryside. Three little wood engravings were sent home as evidence of what he had seen there.' Binyon's *Memoir* makes the interesting point that exposure to a super-abundance of Renaissance art had a similar effect on Henry Moore; but her account misleads by implying that the events took place in the summer of 1924.

Two letters from Ravilious to Hubert Wellington, the RCA Registrar, give more detail of his time away. Ravilious left the College on the last day of January 1925 for Paris, where he spent a few days ('I went to the Louvre, of course'), and then Basel ('This town I did not like, it was dull and cold; I saw the Holbeins and left'), before joining 'a College influx' in Florence. All three Travelling Scholars from 1924 were now there, Moore having travelled out via Paris with the painter Norman Dawson, and they met up in the apartment of Robert and Mabel Lyon. Best known posthumously as tutor to the Pitmen Painters, Robert was there having won the Decorative Painting Prix de Rome, aged twenty-nine, the previous October. Also in Florence was Edna Ginesi, having completed her painting diploma and won – like Barbara Hepworth who was then nearby at Siena – a West Riding Travelling Scholarship. Ginesi was engaged to Moore's friend Coxon, and all three remained friends thereafter despite her having to repel Moore's advances in Florence.[88] Photographs taken during these weeks by Ravilious and his companions show several expeditions with the Lyons into surrounding Tuscany, suggesting that much of his exploration was not solitary.

In Florence it was a time of violent political conflict and on Sunday 22 March Ravilious was part of a silent crowd watching a massive blackshirt column marching across Santa Trinita bridge.[89] It was the sixth anniversary of the formation of the fascist brigades. According to Mabel Lyon there was fear in the air, but she was unsure how much this affected the apolitical Ravilious; indeed he told Bliss later that '*Dov'è il gabinetto?*' was the only Italian he picked up during his stay, but this did not prevent him discovering, as he told Wellington, 'some delightful and obscure things in the small libraries

and collections – the Horn Museum and Laurentian Library I'm particularly grateful to'. In all he spent nearly two months in Florence before, tiring of 'its museum atmosphere' and 'monotonously perfect weather', he headed off alone to Siena and nearby hill towns; but this was not before receiving a letter from Bliss that, alas, the Junior Artworkers' Guild Mansard Gallery Exhibition had been a 'fiasco' with 'no Blisses or Raviliouses or other Collegian works sold'. Bliss added that his Easter holiday had been enlivened by the 'ardent socialist' Peggy Angus taking him to a Scots Labour club bash where he had sweated through reels, 'hobnobbed with Ramsay MacDonald', and chatted with Peggy's friend Ishbel, the former Prime Minister's daughter.[90]

In Tuscany the weather now broke, adding interest to a landscape of 'small cultivated patches as far as you can see. This in an even light all day is dull.' Volterra had that 'peculiar quality of musty dead-and-goneness that the Cast Court in the Victoria & Albert Museum has', and Ravilious endured a dark, stone-floored bedroom of 'penetrating iciness'. San Gimignano proved better, especially 'a small decorated church there – not the B Gozzoli place, the other one; it is a completely beautiful church, a miniature Santa Croce. The frescos are by Barna, a Sienese decorator I've never heard of; he fell from a scaffold and was killed there, that is perhaps why; he doesn't seem to have painted much but this one church, and I suppose someone from the town finished the process for him.'

Leaving Siena on 10 May, he found a terse letter from Wellington, but no funds, waiting at Thomas Cook's in Venice two days later: 'Regarding the forwarding of your next and last allowance, it is impossible to arrange this without a certificate from Professor Rothenstein that he is satisfied that the work you have been doing during the period of your Scholarship is satisfactory. He must see some work ...'. The next day Ravilious responded apologetically: 'I didn't know about sending a second lot of sketches; all I have sent are slight, there is nothing very substantial unless it is one or two wood engravings – they at least take a long time to do and they are the only things I have worked at at all continuously'; he added an explanatory 'I have been mainly interested in Italian painting up to about Masaccio; after him I can only partly appreciate, very rarely like fully – except the Venetians. Also even second rate followers and pupils of Giotto and Lorenzetti I can like very much, which it is hard to say of later people.'[91] He ended with a plea for funds to reach Venice by 24 May 'if Prof. Rothenstein approves'; in truth there was little choice, but under a note saying 'the works submitted by Mr E W Ravilious, Travelling Scholar, are now with you', a succinct 'Yes. W.R 20/5' tells us he did approve.

1.18

Eric Ravilious, *Woodland outside Florence*, wood engraving, 1925.
One of three engravings Ravilious sent to Rothenstein as evidence of his diligence.

Ravilious planned to revisit Paris on the way home, 'now I know a little what I want to see'. He just had time to see his own tile designs and engravings displayed at the Exposition at the Grand Palais, and Bliss believed Gothic tapestries he saw in the Musée des Arts Décoratifs influenced subsequent engravings. By early June he was back at College and temporarily flush with funds after collecting the final £40 of his RCA continuation scholarship.[92] But the end of the academic year was only six weeks away and unclear futures beckoned for all the class of 1922, Ravilious included. Required to specify his career path, Freedman was to an extent speaking for all when he responded 'I haven't the faintest idea.'[93]

Paul Nash was now winding up his teaching and he too had just visited Italy for the first and only time in his life. Looking at the three blocks Eric produced, he would have at once seen that *Road near Florence*, *San Gimignano* and *Woodland Outside Florence* displayed a marriage of design and technical finesse reminiscent of brother John's achievement with blocks such as *Gloucestershire Cottage* and *Wood Interior*, highlights of recent shows at the SWE.

1.19
Enid Marx, *Cube-iste Male Nude*, oil on canvas, *c.* 1924.
Marx's interest in German expressionism and the French avant-garde
was a factor in her being denied a diploma.

One of Ravilious's Italian blocks was immediately exhibited alongside Nash's illustrations to *Wagner's Ring* at the Redfern Gallery in mid-July, and at the first opportunity available Nash nominated Ravilious as well as Marx for SWE membership.[94]

Marx was another frequenter of Nash's cubbyhole office under the stairs and had just received the unwelcome news that her diploma piece – a painting intended to evoke the sound and feel of a merry-go-round on Hampstead Heath – had been failed; but her wood-engraved patterns (fig. 1.7) impressed Nash who, introduced to Italian pattern papers by Lovat Fraser, had become increasingly interested in both them and the possibilities of fabric design that also attracted Marx. Bawden, now a graduate awarded the Travelling Scholarship himself, had long since been spotted independently and received his first Curwen Press commission.[95] But the innovative Plaistow printing enterprise had work to hand and Nash now added his voice to that of Rothenstein in recommending Ravilious, Bliss, Freedman and Marx to Harold Curwen and Oliver Simon, a nephew of Rothenstein's who was Curwen's business partner. Shortly afterwards, Marx provided them with a woodblock for a pattern paper that would remain in production for many years.

Departing from his teaching position at the RCA, Nash left behind this message: 'if you were an artist of any sort, you were capable of doing a great variety of jobs involving decoration' and as a result Marx believed 'there can be no doubt that we all carried traces of Paul Nash in our vision, if not so much in our paintings or designs'. For Ravilious, Nash was an affirming but also a countervailing influence. As recalled by Tirzah, the College's elevation of painting over design had 'instilled an inferiority complex because he was a designer and it took years to get rid of that feeling'; but Nash's attention and approval said otherwise. Consequently his critical opinion was one of the few that really mattered to Ravilious during the seventeen prolific years that lay ahead.[96]

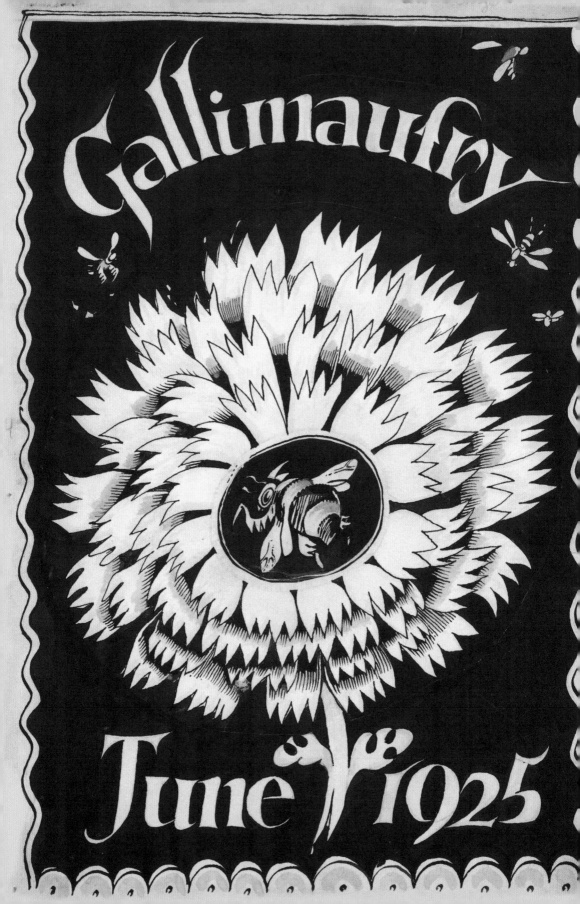

CHAPTER TWO

EARLS COURT
AND EASTBOURNE

Analysing his friend's work in late 1927, Douglas Percy Bliss explained that, after Italy, Ravilious had 'returned to London and Eastbourne (his native place) between which and the quieter parts of Sussex he has divided his time ever since.' Bliss went on to add 'He belongs to that interesting if minor body of artists who alternate between water-colour and engraving as their means of expression.'

Bliss was at this time working along the same channels, and the phrasing was simply a nod to the niche nature of their activities made in the course of an article commenting on Ravilious's working habits – 'There is no mad effort in his work, no ill-equipped intensity' – and his favoured sphere: 'He has always known that the light, the elegant, the graceful was his province; that the grand, the sublime, the woodenly serious was *not* his province.'[1]

Bliss was certainly in a position to know, as his subject's London life revolved around their shared flat-cum-studio, where he was witnessing work at the point of creation. They had also just held a joint exhibition at the St George's Gallery in Hanover Square with Edward Bawden – the trio's most substantial professional outing to date. Watercolours displayed at the exhibition illustrated Bliss's article, but he modestly avoided mention of his role as initiator of this and other shared ventures.

In a later 1932 survey of 'The Wood Engravings of Eric Ravilious', Bliss observed that a comparison between the artist's 'landscapes in watercolour' and the 'rare elegance and lyricism' of his engravings suggested he was yet to mature as a painter – a timely observation when signs of what Ravilious would shortly achieve were still tentative.[2] By now the two men's worlds were diverging: established as *The Scotsman*'s London art critic, Bliss had written a lively history of wood engraving, and in his own art was turning from illustration

to oils, and to teaching for a steady income. He moved to Blackheath that year with his wife Phyllis Dodd, and from then on he and Ravilious, also now married, saw less of each other.

Before this, however, the divided routine Bliss described held sway. It began in September 1925 when Ravilious started part-time teaching at Eastbourne Art School, and its end was signalled in July 1928 when William Rothenstein secured his and Bawden's selection for an eighteen-month commission. In between there were opportunities for painting expeditions in rural Essex with Bawden, a visit to Edinburgh with Bliss, and another rambling journey across Sussex. However, teaching meant that Ravilious had to spend half the week in Eastbourne, where he became exposed to family tensions kept at a distance during his student days; and because the Art School shared premises with his Secondary School, it also meant a daily return to the building he had been schooled in from the age of eleven.[3]

Here at the Art School he met Tirzah Garwood, and by the time he left in late 1928 his feelings for her were clear, even if he could not yet be sure of hers. In the interim his 'native place' meant juggling contradictions, even as it inspired new and increasingly distinct images – and at times it must have felt as if the London train carrying him back to the ex-student community around Redcliffe Road was transporting him to a more straightforwardly invigorating place, at the centre of which Bliss remained a lively source of ideas, reading suggestions and enthusiasm.[4]

* * *

Gallimaufry was marshalled by Bliss and coloured in his flat by many hands over a weekend. With its strikingly novel Ravilious cover, the magazine had been a considerable success. No less a figure than Campbell Dodgson, Laurence Binyon's boss at the British Museum, had put a copy on display in the Print Room and sent another to Paris's Bibliothèque Nationale. Together with *Border Ballads*, it made a great calling card for Bliss who, writing to Ravilious in Italy, had mentioned his book was already at the printers, adding 'I must go round a few publishers next term.' After *The Times* praised Bliss for concentrating 'a world of imagination in an inch or two of space', this activity bore fruit with a commission from the publisher J. M. Dent to illustrate Doctor Johnson's novella *Rasselas*. It also brought Bliss into contact with the artists' agent R. P. Gossop, who now used him to gather content for *Modern Wood Cuts and Book Decoration*, an event puffed as 'the first Exhibition to give any comprehensive idea of the work of modern artists in this media'. Bliss in

turn recruited Ravilious and Enid Marx as two of the three other participants – and, before the exhibition opened in January 1926, Ravilious had secured a commission from Jonathan Cape to provide wood engravings to illustrate *Desert*, a forthcoming novel by Martin Armstrong.[5]

The exhibition ran for six days at the Basnett Gallery in Liverpool's Bon Marché store, with Bliss on hand for the first three days, and Ravilious travelling up to demonstrate cutting techniques for the last three. Enid Marx's work was billed as showing 'the possibilities of abstract ornament; her designs have a quality that is found in the work of the most modern school of painters'; and an accompanying pamphlet, decorated with Ravilious's head of a pirate, featured 'The Story of the Woodcut', as told by Bliss, inside.

After primitive woodblock printing for fabrics had led to the printing of images on paper, Bliss explained, Albrecht Dürer and Hans Holbein had become dependent on the skills of other craftsmen – *Formschneider* – working with knives and chisels, preparing conventionally drawn images for blackline reproduction. This rested on an 'obviously bad' principle of division, which was overcome only with the eighteenth-century arrival of Thomas Bewick, an artist-engraver who by his 'engravings upon box[-wood], demonstrated its wonderful possibilities for delicate, tonal engraving'. 'He is the father of white line-engraving, which is the antithesis of the methods he flung into disuse,' wrote Bliss, before denouncing the subsequent 'dead and vast abysm of the night of Victorian technique worship'. Instead, he cited their College favourite, the 'jolly care-free work of old Joe Crawhall', as initiating the modern revival that led to 'the twentieth century and the sunshine' and, by extension, to the work his friends had mustered for exhibition.

'Perhaps the main thing to be noticed', visitors were advised, 'is the artists here showing improvise upon the block itself. They work from the slightest sketches and engrave direct upon the blackened block, using the tools, as it were, like white chalk.' The confident conclusion noted 'in our day Wood-cuts have come into their own, at last, without stigma of reproduction, recognised as an artist's medium with endless possibilities for aesthetic expression'. The *Manchester Guardian* concurred, welcoming the freshness and charm of Messrs Bliss and Ravilious, 'both of whom are establishing themselves as illustrators', as well as Miss Marx's 'abstract ornament of an extremely attractive and original genre', adding 'her work is eminently suitable for fabric printing, a field she has attacked with success'.[6] All in all, it had been a worthwhile northern foray.

Denied her painting diploma by teachers who disapproved of her 'Fauvist' inclinations, Marx had left the RCA with her enthusiasm buoyed both by

2.1
Enid Marx cutting blocks for her hand-block
'printed stuffs', early 1930s.

Nash's encouragement and the teaching of Reco Capey, a versatile Czech industrial designer who had become a Design School instructor during her last year. She was now apprenticed to the formidable duo of Phyllis Barron and Dorothy Larcher, partners in life and in business, whose hand-block printed textiles she had first seen in a gallery not far from the College. Working at their studios in Hampstead initially as a somewhat put-upon assistant (stung by a previous partner of Barron's, Phyllis and Dorothy jealously guarded trade secrets), Marx was nevertheless developing her own designs, acquiring the skills needed to set up alone, and making a name for herself – a process now furthered by Nash, who visited her when she set up her initial workroom in a nearby hayloft.

Nash had been experimenting with pattern paper and fabric design for several years and, having imported an architectural feel into recent water-colours and engravings, was now creating abstract designs with depth where 'the eye is led to look down and into the design, instead of being held up short and forced to wander about it'.[7] After failing to persuade manufacturers to

abandon their drearily conventional arabesques and florals, Nash had begun to work with 'Footprints', an artisan enterprise set up in Chelsea to produce a range of 'Modern Fabrics'; and, in the month of the Liverpool exhibition, *Artwork* published 'Modern English Textiles', his article exploring the field.

It was no accident, Nash argued, that a renaissance in fabric design was accompanying the wood-engraving revival, because historically their origins were linked. Like Bliss, he looked back to an era before artist and craftsman had divided their labours, asserting 'the ideal of course is the designer-craftsman or craftswoman who solves the problem of textile production by designing and cutting her own wood blocks, making her dyes and printing direct upon stuffs'. Illustrations of Barron and Larcher's work were complemented by one of Marx's ('a designer of real independence of vision, although her craft experiments are just beginning') and one of Bawden's first lino cuts (a student 'already well-known to a few discriminating publishers for his book illustrations and, to a certain extent, to the public by his two posters lately issued by the Underground').[8] In June the Victoria and Albert Museum included one of Marx's designs in an exhibition of textiles. Further exposure followed when *Studio* reproduced another in company with Reco Capey's, and 1926 ended with 'Footprints' in Beauchamp Place displaying 'experiments in modern textiles' by Paul Nash, Phyllis Barron, Dorothy Larcher and 'Miss Enid Marx'.[9] An old two-storey cowshed behind a gramophone shop in Heath Street now became Marx's workshop, the top level for display, the bottom for cutting blocks and printing, and 'a little yard where I dyed stuff'.[10]

* * *

Meanwhile Bliss and Ravilious sat either side of their gas fire as they worked on their respective commissions, Ravilious fresh from Eastbourne and Bliss from hours of further research in the V&A.[11] Bliss had already written a trade pamphlet illustrated with Ravilious cuts called *The Practice of Engraving on Wood*[12] and Dent now accepted his proposal to produce his history, which Dodgson encouraged and agreed to introduce. Bliss's growing expertise, itself an influence on Ravilious, and his first-hand observation of the artist at work make his recollections of this time unique. Bliss had seen how after their initial Print Room visit Ravilious was soon fashioning his own gouges from odd pieces of metal, so 'obtaining upon box-wood these qualities of dot and speck and dab in white line with which he enriches his blocks'. Now he marvelled how 'the design is schemed out, tool in hand, conceived of as a pattern far more intense in line, rich in colour, and varied in texture than anything made

with the pencil. And so complete is the skill of the engraver that very often there are no "states", no prints taken as precautions along the way. The first print is the final one.'[13]

After basing *Sussex Church* on Lullington, Ravilious now used its neighbour Litlington as the starting point for *Church under a Hill*, a block that Bliss observed showed 'a direct and uncompromising use of linear systems affording textures'. This quality is even more evident in its close contemporary *Boy Birds-Nesting*. Bliss had been investigating early medieval printed *Horae* or Books of Hours, where he found tiny cuts 'juxtaposed in a schemeless, happy-go-lucky sort of way – dances of death, saints and sibyls, shepherds dancing, boys birds-nesting, pigs playing the bagpipes, cats performing their toilets'.[14] As a ten-year-old Ravilious had played in the fields behind Hampden Park, and here he now set an image from Bliss's list in which the Downs above Willingdon form the horizon beneath the bird-nester in the tree. He created the escarpment lovingly over hours, 'covering a passage with tiny dots' – and the model for the boy aloft was Bliss himself, who obligingly draped himself over the settee dressed in rugby gear, while his friend schemed out one of his most convincing figures.[15]

Bawden had stayed put in his 'gravy coloured' room at 58 Redcliffe Road when Bliss and Ravilious moved to their space in 'Holbein Studios' at number 38. Phyllis Dodd, now commuting to teach part-time at Walthamstow College, lived at number 52, not far from her future husband, and Cecilia Dunbar Kilburn was nearby, as was Henry Moore. Other RCA friends came and went, often occupying Ravilious's bed when he was absent. As Bawden quipped, the road was temporarily full of the 'homes and manure-beds of genius'.

Bawden had Poetry Bookshop broadsheets illustrated by Lovat Fraser and Rutherston pinned up in his room and they triggered thoughts that the foundation of a 'Redcliffe Press' might be the route to supplementary income and regular publication. Accordingly Bliss and Bawden each borrowed £25 from their parents, Bliss bought type in Fleet Street, and a press was installed in a nearby garden shed. Ravilious, in no position to tap his parents, declined to join the venture, which quickly folded: 'Alas, the press betrayed us,' wrote Bliss, who cut the first two blocks. 'The inking was hopelessly uneven. No two prints were alike and no matter how we struggled with overlays we could not make good impressions. We had lost much time and energy.'[16]

In fact, Bawden had an increasing amount of work on the go and was delaying his departure from the RCA for the Travelling Scholar's mandatory twenty weeks away. Harold Curwen at the Curwen Press had warmed to his

2.2 & 2.3
Eric Ravilious, *Boy Birds-Nesting* (above), wood engraving, 1926.
Helen Binyon, *The Wire Fence* (below), wood engraving, 1935; an image
created after Ravilious encouraged her to return to engraving.

2.4

Edward Bawden, cover design for *Mandrake*, pen, ink and watercolour, 1926.
Bawden, like Ravilious before him, left behind his contribution to a forthcoming
RCA Student Magazine on his departure for Italy as a Travelling Scholar.

ingenious designs, favouring Bawden as almost a natural successor to the lamented Lovat Fraser, and was 'taking a teacher's interest in teaching him to do drawings for colour reproduction by line block'.[17] Bawden became a regular visitor to the Curwen's Plaistow works before finally taking off in the third week of February 1926.[18] He kept Hubert Wellington at the RCA informed by despatching a 'short account of my wanderings and at the same time the few drawings I have had the pleasure of making', earning from Rothenstein an enthusiastic 'the drawings sent by Bawden are excellent. I certainly approve of immediate payment.' A fortnight in Florence, where Bawden met up with ex-Collegians Charlotte Epton and Beryl Bowker, was marred by too much tramping 'along white dusty roads which lead into the thin dreary, expressionless country all around'; he then toured Tuscany and, although not enamoured of 'stiff primitives', warmed to the Simone Martinis in Siena's Palazzo Pubblico; but 'one day in Arezzo was quite sufficient to satisfy curiosity' and once in Rome he avoided all ancient ruins: 'I am not an antiquarian. Nor can I conjure up the sentimental mood and throw a rosy glow over these crumbling stones.' However, mosaics had appeal as well as Baroque monuments: 'I was fascinated by the giants who bathe in the fountains with the water splashing and trickling over their well-developed muscles.' In Naples, Bawden was struck by 'the amazing richness, profusion and fantasy of sculpture and ornamentation which covers the churches both within and without', but in Pompeii he walked 'along miles of narrow lanes bored to death, the walls on either hand glowing with a white hot heat'. His letter to the Registrar was a sardonic tour de force, written secure in the knowledge that on return he too would be an ex-RCA student.

Like Ravilious before him, Bawden had left a cover design behind. In his case it was for *Mandrake*, the successor to *Gallimaufry*, 'put together in May, MCMXXVI, the month and year of the Great General Strike'. Edited by Cecilia Dunbar Kilburn in her last year with assistance from Bliss, the magazine incorporated a Ravilious engraving, *Bedroom*, as the main feature of its frontispiece. The backdrop to the image of a naked woman asleep on a four-poster bed is evidence of how Ravilious had been 'thrilled by the cheap substitutes for tapestries, the painted cloths of the Elizabethans' seen in the V&A. That November it became one of his first exhibits at an annual Society of Wood Engravers' show, appearing alongside *Hermit* and *Grass and Flowers* and illustrations from *Desert*, which had emerged from the printers two months before.[19] Over six months, in a sustained programme of cutting, Ravilious had created thirty-three images to illustrate the narrative, roughly half involving conventionally rendered scenes,

but with others displaying a near-abstract metaphysical vibrancy, reminiscent of Nash's *Genesis* yet more delicate in execution (figs 2.5 and 2.7).

The arrival of the book itself was a source of wrenching disappointment for, as Bliss observed, 'most of these exquisitely designed little blocks were ruined by incompetent press work'.[20] Whether over-inking or under-cutting was to blame, much detail had been lost in a commercial process where artist and printer had little interaction – a situation now remedied by fellow SWE member Robert Gibbings, proprietor of the Golden Cockerel Press and an enthusiast for the aesthetics of book production. Impressed by Ravilious's engravings, he asked him to suggest a book for illustration. A few weeks later Ravilious in company with Bliss visited the Press at Waltham, and the next day he wrote accepting Gibbings' suggestion that he illustrate Sir John Suckling's *A Ballad Upon a Wedding*. This was to be the first of two Golden Cockerel commissions that would absorb many hours and much correspondence between artist and publisher during 1927.[21]

The other venture taking up time that year was initiated by Bliss following another Nash lead.[22] Back in 58 Redcliffe Road and driven as ever, Bawden was picking up all manner of minor commissions from book covers to furniture decoration; and on top of a day a week jobbing at Plaistow, he was attending an evening class in copper engraving at the Cass Technical Institute and one on bookbinding at the Central School of Arts and Crafts, emulating Helen Binyon and Peggy Angus who during their RCA days had looked elsewhere for training that the ill-equipped College struggled to provide. Meanwhile, apart from his book project and teaching duties, Ravilious was painting in Sussex and undertaking some initial commercial commissions sourced through the Curwen Press. Harold Curwen had used 'Indestructible Beauty of a Diamond', a decoration from *Desert*, as the key-block for a coloured pattern paper. This was now tipped in alongside one by Enid Marx as illustration for a Nash article in the first volume of *The Woodcut*, a journal printed at Plaistow.[23] Amid all this activity Bliss, intent on furthering his career as an illustrator and seeking a showcase for his own and his friends' work, at Nash's suggestion approached A. R. Howell, proprietor of the St George's Gallery, Hanover Square, a venue with a track record of exhibiting engravings. In the event Howell declined another engravings show, but agreed to one of the watercolours if Bliss and two friends could produce at least a dozen works each.

Martin Hardie's Samuel Palmer exhibition had been held to great acclaim at the V&A the previous autumn and, fired with enthusiasm for rural endeavours, the three friends had made a joint pilgrimage to Shoreham during the spring

2.5
Eric Ravilious, illustrations for *Desert*, wood engravings, 1926:
Suspended in the middle waters (above) and *The Two Harbours* (below).

2.6 & 2.7
Paul Nash: *Das Rheingold – Scene 1*, wood engraving, 1925;
and *Genesis – Sun and Moon*, wood engraving, 1924.

of 1927. However, the pressure was now on to work at a pace after attempts to extend a mid-September deadline came to nought. Ravilious had readied two watercolours for a Modern English Watercolour Society show in May and the St George's catalogue suggests he now quickly increased his painting output in Sussex.[24] Bawden meanwhile had been painting in villages south-east of Braintree during visits to his parents, but wrote to Ravilious lamenting 'I visit the same spots over and over again and make only more successful failures, or the horse flies drive me out of their dominions.'[25] At the time, to Ravilious's consternation, Bawden was struggling 'to paint large' and to make the transition from small-scale line-work to watercolours with breadth.

Ravilious now joined Bawden in Essex and, in an expedition that took them north-west towards their future joint home at Great Bardfield, they 'biked out to a place five or six miles away ... a small village with a fine church, in front of which stands a duck pond'. Meanwhile, up in Scotland for the summer, Bliss left Edinburgh for Skye and Barra where he found subjects to make up his twenty watercolours for the show. In late August, Ravilious was still hurriedly seeking out new subjects at Barcombe in Sussex to complete his tally, and Bawden eventually filled out his offering by including more copper engravings and drawings than he had originally intended.[26]

The exhibition opened on 23 September but, according to Binyon, 'Not one of the three artists went to the private view; they were too unsophisticated to know it was the expected thing to do.'[27] The critics attending were generally lukewarm about 'the mild and mannered modernity of Messrs Bawden, Bliss and Ravilious'.[28] Charles Marriott of *The Times* thought the 'attractive if not very exciting' fare of 'deliberately limited colour schemes' might appeal 'to those who are not repelled by a certain cool detachment in the treatment of landscape'; but he noted Ravilious's green and gold *Country House Garden* (now lost) as a particularly good drawing of 'a subject taken for what it is worth pictorially without any concern for the human associations which would have concerned older water-colourists'. Bliss's crofter scenes 'expressed decoratively with an element of caricature rather than sentimentality' also appealed, as did the vigour of Bawden's brush drawing in full tones and his 'entertaining drawings of imaginary architecture'.

For Bliss it was P. G. Konody's review in the *Observer* that rankled most. Konody waxed lyrical about how Nash's 'personality has left its mark on the students who worked under his guidance', asserting that the style of a master had degenerated into mannerism at the hands of inexperienced followers. He went on to opine 'it is where his teaching is applied in a more independent

2.8 & 2.9
Edward Bawden, *Bulford Mill near Cressing Essex* (above), watercolour, 1927.
Douglas Percy Bliss, *Highland Cattle* (below), watercolour, 1927.

2.10
Eric Ravilious, *Pond at East Dean Farm*,
pencil and watercolour, *c.* 1927.

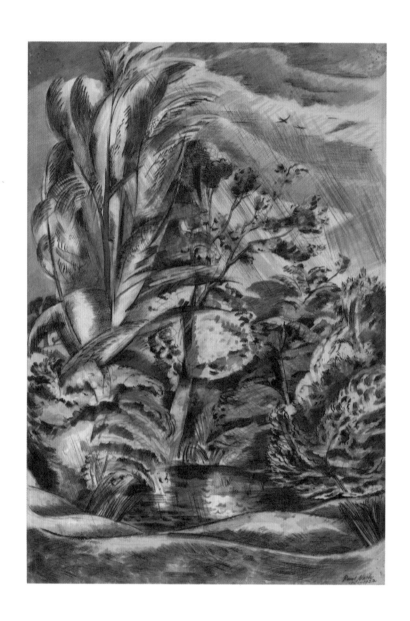

2.11
Paul Nash, *Tench Pond in a Gale*,
ink, graphite and watercolour, 1921–22.

2.12
Eric Ravilious, *Firle Beacon*,
pencil and watercolour, 1927.

spirit that the work of these young men assumes aesthetic significance. Thus
Mr Ravilious is at his best not in his exploitation of the Nash recipe for foli-
age (modified by the calligraphic use of the pen in the eighteenth-century
manner) but in the superbly designed *Wreck of a Schooner*. With all its closely
drawn forms of cliffs and wreckage, this picture ... assumes the character of a
rhythmically organised abstract design.' Bliss was seen 'at his happiest when
he added something of his own to the derivative basis of his work' and was
commended when he added his 'feeling for compact masses and solid struc-
ture' to 'the Nash formula'; and Bawden was cited by Konody as 'following
Nash closely in his watercolour landscapes and accomplished engravings.
But his most attractive contributions are his highly original decorative
illustrations to Paltock's "Flying Indians" and three drawings of "Imaginary
Architecture in medieval taste".'[29]

A few watercolour paintings were sold before the exhibition closed on
12 October, but it was hardly the hoped-for reception and the proceeds
were too slight to support further endeavours. In Redcliffe Road change
was now in the air; Bliss and Phyllis Dodd were less than six months away

from getting married, while Cecilia Dunbar Kilburn, armed with introductions from Rothenstein, was about to depart for India. Ravilious wrote to her just before she embarked, 'there aren't three people I've come across here in Eastbourne I really like talking to', but added 'I am thinking of giving up the Studio at Christmas ... then I shall live here and go up about once a month. I will get good tennis at any rate.'[30]

<p style="text-align:center">* * *</p>

Ravilious's parents, Emma and Frank, were over forty, secure and well established when their fourth child arrived in 1903, and well into their sixties by the time he returned to Eastbourne as a part-time art teacher in 1925.[31] Born into an era pre-dating the petrol engine and the telephone, let alone the aeroplane and the cinema, they had both grown up in poor rural families where manual labour was the norm. Emma was the sixth of seven children born to a market gardener and his wife near Kingsbridge in Devon, and Frank the youngest of thirteen born to an ex-marine and part-time coachman and his wife near Tonbridge in Kent. At eighteen Emma had been a live-in housemaid for a prosperous farmer before moving to Ferox Hall, the household of a Tonbridge banker.[32] There she met Frank, good looking and five years older, an apprentice in his oldest brother's adjacent coach-building business. Around this time 'he [Frank] became ill and had to go to hospital, where he became converted', subsequently leaving his brother's employment 'because he didn't pay him enough and because he gave the men their wages in a public house which seemed to Frank a dreadful thing'.[33]

Emma and Frank married in May 1888 and Catherine, fair and blue-eyed, was born the following summer, by which time Frank had moved from carpentry into upholstery. But just eighteen months later Catherine died on Christmas Day; for Frank, always anxious and convinced he was one of God's chosen, the symbolism of this infant death precipitated further change.[34] He abruptly ceased advertising his services and, shortly after, he and Emma embarked for America as emigrants. However, they returned disillusioned to Devon the following autumn, settling in the London suburb of Acton a few months later. Here, in a room above the drapery business of another of Frank's brothers, their next child, Frank Clement, was born in January 1892.

Frank senior worked in the drapers but, sensing opportunity in the rapid growth of the suburb, set up a new upholstery business, which was prospering by the time their second daughter, Evelyn Mary, was born four years later.[35] Eighteen months after Eric's birth in 1903, this venture was operating

out of four addresses, and a new furnishing business occupied another four on the High Street. Then, in May 1907, it all went wrong, because, as family memory had it, Frank over-ordered mattresses, and, lacking the nerve to trade through his difficulties, 'declared himself bankrupt and sold up'.[36] Frank's apprehensiveness may have precipitated the suddenness of the liquidation, but its genesis was a tale of expanding too fast in favourable conditions – only to be caught out by the downturn. Six weeks later the family decamped to Eastbourne where, over fifteen years, the cycle was repeated.

At first they lived in lodgings half a mile from the station and then in a nearby cottage and workshop that Eric's father used for blind-making.[37] In mid-1909, with a modicum of prosperity rebuilt, they rented a semi-detached villa in Hampden Park from the Artisans' Dwelling Company and within a year Frank had opened an upholstery shop in central Eastbourne – leasing a shop next door as the first of several acquired to trade antiques and second-hand books.[38] These shops were a source of delight for young Eric, as was his father when in the right mood, but over time Frank's idiosyncratic religiosity became more oppressive. The elder brother, Frank Clement, bore the early brunt of a strict upbringing, with enforced signing of the Pledge and twice-a-Sabbath attendance at lengthy Methodist revival meetings. It all proved an ineffective straitjacket, and significant trouble ensued as father and son became enmeshed in their increasingly convoluted business affairs.

Evelyn also found her father an intimidating figure due to his unbending sternness;[39] the much younger Eric seems to have reacted by withdrawing into his own imaginary world. In Helen Binyon's summation this capacity was an important ingredient of a happy childhood, because Eric seemed 'to have been able to abstract himself in spirit from the emotional pressures coming from his father's religious obsessions and from intermittent difficulties about money – a talent that was noticed by his companions in later life'.[40] However, Tirzah Garwood's autobiography provides a less sanguine picture of how fear at a young age, followed by teenage alienation, distorted the relationship between son and father, whose unpredictable behaviour and evangelical zeal became an embarrassing menace, and who in his turn could not comprehend his son ignoring God's message.[41] By the autumn of 1925 nothing much had changed, except that life had carried Eric and his father further apart. Confirmed in his independence, Eric now detested churches and chapels, while his previously successful father, approaching seventy as a recently discharged bankrupt and obsessed as ever by the Book of Daniel, was reduced to selling light bulbs from home.

Eric remained closer to his mother, although she too now found him perplexing. Throughout these roller-coaster years she had been a source of stability, and when in 1914 they moved again, a house in Charleston Road was bought in her name.[42] Emma hoped for steady occupations for her children and after arriving in Eastbourne had found Frank Clement work as a clerk in the Gas Office. But by 1911 his occupation was 'Assistant Antique dealer', while fifteen-year-old Evelyn was working as a 'Milliners' Assistant'. The following year Eric moved from his dame school to St Saviours, an intermediate Church school, where over two years he did well, winning a scholarship to Eastbourne Municipal Secondary School, which promised 'a sound moral, mental and physical training, and a modern education suitable for boys intended for business, engineering, or professional careers'. At a time when few stayed on at school, this success raised prospects that Eric might aim for a career in the Post Office or even higher. However, the school work now proved harder for him, and 'if he didn't like the master or the subject he didn't concentrate and so was a thorn in the side of people like the sarcastic maths master, who knew that Eric could have learned mathematics but the whole subject boring him he would never try'.[43]

Like Rothenstein and Nash before him, Eric found art classes more engaging, not least because they were taught during his first and third year by a teacher he liked and took place in the Art School, housed above the Secondary School on the top floor of the Technical Institute building. Flamboyant and sensitive, Walter Hedley Millington was an outsider; enlisting in 1915, he reappeared at the school a year later after being discharged in unclear circumstances, finally leaving for munitions work in 1917 (and survived the war despite school rumours that he had died a conscientious objector's death in jail).[44] Ravilious's homework album shows how much his facility for clear drawing developed under Millington's approving watch, as do drawings that he completed in August 1916 during a 'harvest camp' organized at Sissinghurst by the School Cadets.[45] Frank initially vetoed his son's trip, sending Emma to explain his reasons to the headmaster. But Eric did go nevertheless, producing drawings of the 'hoppers huts' used for accommodation and multiple views of Bettenham Farm beyond the estate perimeter. It was one of the first places he criss-crossed for a set of subjects and after returning he completed a watercolour of nearby Common Farm with its oast house from a sketch made on site, an early example of a practice he would frequently employ later on, following this up with a watercolour of the castle's double towers.

During the war years sundry teachers came and went from the School. Normality was just returning in December 1919 when Eric passed the Cambridge Senior Local Examination with a distinction in drawing, his ticket to the top floor of the Institute as a 'Candidate Art Teacher'. Five and a half years later he would begin making the regular walk from his parents' home to the Art School as an actual teacher, but by then the attitudes and outlook of a slightly distant young artist seemed strange to parents born halfway through Queen Victoria's reign – so strange that after first meeting her future daughter-in-law, Mrs Ravilious asked Eric whether Tirzah 'realised how queer he was'.[46]

* * *

When Eric Ravilious and Tirzah Garwood first saw each other she was seventeen and a half and had just begun taking afternoon classes at the Art and Craft School. He was twenty-two and had recently been appointed to give two days a week of 'specialist instruction in Illustrated Design and the allied craft of reproduction'.[47] She noted his diffident manners, 'not unlike a curate', and that he was 'not quite a gentleman', but also that he was tall, had large hazel-coloured eyes and long lashes. If he noted her among his almost exclusively female middle-class students, he did not at first go out of his way to show it, even after she started attending full-time in early 1926.[48]

But her talent marked her out and, while none of her peers were 'seriously intent on learning to earn a living', Tirzah, adept and intuitive, was edging towards the realization that illustration work might become her escape route from the restrictions of her upbringing and the expectations of her parents. Her father, recently retired Colonel Garwood, had been a career Royal Engineer who finished the war commanding 4,000 men in Mesopotamia prior to four years in India and a final posting in Oxford before retirement to Eastbourne in 1924. For Tirzah, her three sisters, her brother and her mother Ella, the war years had been peripatetic but comfortable, and they often stayed with relatives. More recently, while her mother undertook two visits to India, Tirzah had boarded at an Eastbourne school and holidayed with her maternal aunts in London.

With the family re-assembled at Elmwood, their substantial house in walking distance of the Art School, it would not be long before the maturing Tirzah became resentful of her mother's domineering ways and impatient with rituals such as 'The Lawns', her own Sabbath purgatory, when the upper crust of Eastbourne society paraded along the seafront to see and be seen. When her father returned from India she had been appalled at how on the walk from the

2.13 & 2.14
Tirzah Garwood, line-drawn coloured illustrations, 1926–27:
The Window Cleaner observes her father at his desk (left);
The Hypochondriac is comforted by her daughters (right).

station the family nurse had been ignored and left to trail behind. Sensitive from an early age to unfairness and injustice, Tirzah was already a shrewd observer both of social mores and the incidentals of everyday life. As her art developed, all this came into play.

Whether consciously or not, Ravilious was bringing Paul Nash's informal and egalitarian style to teaching: thus, for Diana Saintsbury-Green, 'he was never our art master, but rather the most stimulating and hardworking member of a group'. He 'never tried to dominate or show off' and was distinguished from other masters by his eager curiosity and 'a most refreshing cool judgement'. Ignoring the practice of his predecessor that had involved an excess of art nouveau style pen-and-ink work, he encouraged his students to keep sketchbooks and base their work on observation (he ruled out 'drawing out of our heads'). He also urged them to read widely, recommending contemporary authors Aldous Huxley and David Garnett as well as Richard Jeffries, and Gilbert White's *The Natural History of Selborne*.[49] He also drew directly on his own immediate experience, using photographs he had purchased in Italy as aides, and introducing a strong focus on engraving to the illustration classes at a time when he himself was cutting the designs for *Desert*.

It was an approach that enthused his pupils, but not a Board of Education concerned about 'the utility of the school to the locality'. Descending on the Art School in late March 1926, its four inspectors were unimpressed that 'at present it is almost entirely concerned with fine art and training of an aesthetic and general educational nature, and very little with art applied to local industry'. Noting that two recently appointed teachers had not been 'a sufficient time in the school to justify any statement as to their efficiency or otherwise', they nevertheless added that those studying design for illustration were 'lacking definite well-disciplined instruction'. Taking direct aim at Ravilious, they concluded: 'In particular the work in illustration is weak, and seems to present a bias towards the cutting of wood blocks to the detriment of other forms of illustrative work ... there are other forms of drawing for reproductive purposes that should not be arbitrarily neglected or set aside.'[50]

They would have been even more disturbed had they known how, in Tirzah's words, Ravilious 'flirted with most of the girls in turn; but he never went so far as to kiss any of them. He used to take sketching parties, mostly of female students, to country villages or places on the coast like Birling Gap or Cuckmere valley and we all enjoyed ourselves enormously but did very little work.'[51] Acting in the spirit of Alfred Rich ('it is better a student to wander about all day than to attempt a subject in which he feels no enthusiasm'), Ravilious was

2.15
Tirzah Garwood, *Spring* (left) and *Summer* (right),
wood engravings, 1926–27.
Two of *The Four Seasons*, exhibited at her Society of Wood Engravers debut.

taking his pupils to his own favourite locations and many of them 'began to see things with his eyes, the beauty of flints, the grandeur of Sussex barns, the volume of rounded downlands and the pattern and texture of their surfaces'.[52] What he, in turn, appreciated was the originality of Tirzah's work – which singularly did not imitate his own – and her flair for comic realism in portraying people in contemporary situations.[53] She had little interest in landscape, but these summer sketching parties became the prelude to a year when her wood-engraving skills would result in an astonishing debut, and Ravilious, to her own confusion and her parents' consternation, would begin to fall for her.[54]

In September 1926 Colonel Garwood's diary recorded his daughter as suddenly 'very keen and energetic about the School of Art' and, at the end of November, the appearance at home of 'Tirzah's first woodblock'. This may have been *Spring*, as viewed from the lower reaches of the domestic labour hierarchy, and the first of *The Four Seasons* that she created over the following months. Unconventional in subject and striking in design, these stood out from the staple fare of the wood-engraving revival and are remarkable evidence of how, in a difficult art, Tirzah almost instantly became an adept peer of her already accomplished teacher – and during 1927 began to exert an influence over his own approach.

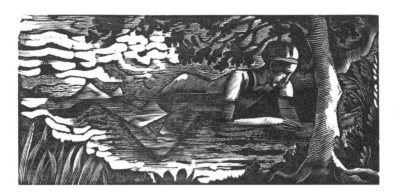

2.16

Eric Ravilious, *The Twelve Moneths*, wood engravings, 1927.
The tailpieces for *February* (top), *March* (middle) and *June* (bottom) were among the illustrations
reflecting Ravilious's new willingness to draw on his immediate surroundings.

2.17
Tirzah Garwood, *Barcombe Mill Interior*, watercolour, 1927.
This watercolour drawing seems to prefigure many of Ravilious's own
in terms of palette and precision.

Ravilious commenced work on his second Golden Cockerel commission, *The Twelve Moneths*, in June. Before then he had rarely attempted contemporary subject matter in his decorative illustrations, preferring the timeless or traditional, but now he altered the mix. April's tailpiece recreated *Boy Birds-Nesting*, reversing the image and adjusting proportions to suit the page design; for October Ravilious re-employed a slinking cat from a Curwen piano roll in company with a cat at its toilet, cats in general having been a party piece since childhood.[55] For the January header he revisited a dilapidated wooden fence from the RCA era, substituting slanting rain and a dark day for the delicate patterning of spring grasses and glimpsed meadows of his earlier version. He then utilized his childhood reservoir of line-drawn domestic objects for February's dustpan headpiece and, in similar vein, December's kitchen bench of newly baked bread. But a group of tailpieces – of shoppers in a gale, a young couple at tennis, and a young man beside a Tirzah-like girl in a hammock – drew more directly on life in Eastbourne, with February's pub scene of a young couple harangued by a bowler-hatted tippler perhaps the most striking.

He was still working on these in August at Barcombe Mills in between his duties at a sketching summer camp, which Tirzah now joined for a fortnight.[56] Photographs show how Ravilious drew on immediate events to create one of the last blocks, a tailpiece of a woman swimming in the river – itself a counterpoint to the young woman powering through the waves in Tirzah's *Summer*. The party was staying at Camois Court, a large Edwardian villa, and, feeling irked at his inconsequential flirtatiousness, Tirzah now seized the initiative one evening, teaching him the Charleston. The next evening they went walking alone for the first time.

Ravilious was under pressure to complete *Moneths* ahead of the Christmas season as well as his exhibits for Howell's show at the St George's Gallery, now only weeks away, and three of the watercolours he exhibited originated in Barcombe. One was of 'the lovely old mill', which he painted 'very dryly in pale water-colour'. A photograph shows Tirzah looking out from the upper storey of one of the mill buildings and her own watercolour drawing of its interior, superbly precise in structural drawing and mature in its handling of colour, probably stems from the day it was taken. The time at Barcombe had brought them closer together and, in one of many misspellings, her father's diary for the Friday after their return records: '*Tirzah spent the day with Reveillious the young art master, whom she brought to lunch and played tennis with after.*'[57]

Seven days after the watercolour show closed at the St George's Gallery, Ravilious's work for *Moneths* was on display at the venue again in an exhibition

of wood and copper engravings from Golden Cockerel Press. Cecilia Dunbar Kilburn wrote to him: 'I went to the Golden Cock show the other day. I like those other months you have done very much.'[58] The critical reception for the book and its 'ingenious wood cuts' was equally positive, four of them reappearing almost immediately as part of Ravilious's contribution to the year's Society of Wood Engravers Exhibition. Elected a full member in late September, Ravilious had been asked to serve on the hanging committee with Eric Gill and probably unwittingly became part of a 'somewhat drastic selection and rejection of prints' subsequently criticized by those who had paid entrance fees only to find their work overlooked.[59]

Tirzah, whose *Four Seasons* had been submitted, faced no such problem. Her delight at their acceptance was redoubled when *The Times* praised her engravings in the same breath as those of the Nash brothers. This success, and the Art School's silver medal, now helped to persuade her parents that she should be allowed to pursue art in London, although 'they thought my subjects hideous and that Mr Ravilious was perverting a nice girl who used to draw fairies and flowers into a stranger who rounded on them and did drawings that were only too clearly caricatures of themselves'.[60] In truth it was not Mr Ravilious but Tirzah's desire for independence that was driving events.

Recalling Ravilious at the RCA, Bliss wrote 'Even when he fell in love – and that was not infrequent – he was never submerged by disappointment. Cheerfulness kept creeping in ...' But Eric's fascination with Tirzah had now become something of a different order.[61] For her, however, the issue was more complex: the word 'common' had haunted her childhood and, whereas her father was prominent in town affairs and a Poor Law Guardian, Eric's father had no position and his mother had doubts about her son walking out with the daughter of 'such a high up family'. As if to emphasize this social chasm, when Eric eventually started visiting Elmwood 'he seemed to recede into his clothes and sat in our chairs with the apprehensiveness of a shitting dog'. Compounding the issue of class, there was already a tacit understanding with a neighbouring Eastbourne ex-Army family, whom Tirzah knew well and liked, that she would marry Bob Church, their highly eligible, Cambridge-educated son. Before Bob departed for Nyasaland to take up a three-year Colonial Service posting, Tirzah had promised to wait, but 'watching him go down our shingle drive for the last time ... I had a sudden feeling of certainty I could never marry him'. As the emotional tangles of the next three years ensued, it was to Bob's disadvantage that the option of marrying him became ever more associated with conventional domesticity, and Eric's attentions with its potential alternatives.[62]

With much of this still ahead Tirzah moved to London in the summer of 1928, renting a room in the Ladies National Club two streets away from her Kensington aunts, with the intention of taking classes at the Central School and seeking illustration work. Her break now came when Ravilious introduced her to the Curwen Press, leading to a BBC commission, and a 'Wonderful, wonderful evening when I was asked to do my first job, I danced round the room with joy'.[63]

Looking back at the pre-war years, Bliss would later reflect that his friends had to teach far too many hours to make ends meet, holding up their progress as practising artists. This was certainly true for Peggy Angus who, having left the RCA and finding book-illustration commissions hard to get despite some support from Gossop, had reluctantly accepted a full-time teaching post in Nuneaton. Helen Binyon meanwhile had illustrated a play of her father's and a volume of short stories, but, unsure of her direction, now went first to Paris and then New York, where she found temporary employment colouring reproductions of Blake. It was probably hardest for the newly graduated painters, despite Rothenstein's best efforts – of which there were many – to promote them; they remained outsiders in a narrow market dominated by the Royal Academy establishment. Times were hard in particular for Barnett Freedman ('I nearly starved'), whose main ambition remained to succeed as a painter in oils with a sideline in stage design. In 1926 he had married Claudia Guercio, a fellow RCA student, in a ceremony kept secret from her disapproving parents, and the late 1920s were marked by a return of Barnett's health problems that hospitalized him once again.[64] When Barnett exhibited with the New English Art Club in 1930, Bliss thought his 'spirited *London Street Scene* in which proletarians posture quaintly as though affected by the Russian Ballet' would appeal to a public 'bored by unintelligent imitations of the modern French masters'; but paid commissions remained elusive.[65]

Freedman remained close to Enid Marx, who visited him in hospital and during his convalescence, and to Percy Horton who, after a Rothenstein recommendation, had in late 1926 begun reorganizing the evening art classes at the Working Men's College in Crowndale Road, Camden. In January 1928 he wrote to Freedman, 'the committee has agreed to your employment ... so if nothing else turns up, there is that prospect ... we must meet and work out a common programme'. It was the beginning of a hugely successful arrangement that lasted for eight years.[66]

For Ravilious, down in Eastbourne, fees from one-off jobs picked up through the Curwen Press were insufficient to allow him to forgo teaching

and base himself full-time in London. It was a tempting prospect though, as the Eastbourne Art School had entered a bad patch. Student numbers were in decline and the Principal was under notice of dismissal after being caught *in flagrante* with the weaving mistress.[67] Ravilious was now the one needing a break – and once again it was Rothenstein who set wheels in motion.

On the last day of November 1927 the RCA Principal, as a Tate Trustee, had stood listening to its director Charles Aitken and his old Slade rival Henry Tonks deliver speeches at the opening of Rex Whistler's Refreshment Room murals.[68] The murals were a triumph of imagination, wit and levity, funded by the munificence of Joseph Duveen, who telegrammed his congratulations from New York. Tonks extolled a vision of a broader English school of mural decoration and dropped a hint that support from the world's leading art dealer might create further opportunities for ex-Slade students. Rothenstein's competitive instincts now came into play as he learned from Aitken that Morley College for Working Men and Women in North Lambeth was a possible site for a further project. He promptly began a concerted lobbying effort, stealing a march on Tonks by despatching Hubert Wellington to measure up the College's Refreshment Rooms and Lecture Hall, commissioning initial sketches and making approaches to Morley Committee members on behalf of his own protégés.[69]

The challenge was close to Rothenstein's heart. While Chair of Civic Art at Sheffield, he had been party to an abortive scheme for Paul and John Nash, Stanley Spencer and Edward Wadsworth to provide decorative panels for Leeds Town Hall; and in 1924 he had been dismayed when, at a very advanced stage, a project for RCA and other London art colleges to paint murals of LCC parks for the new County Hall was cancelled amid great controversy.[70] Now, however, such was the force of Rothenstein's lobbying that by late January Eva Hubback, the Morley College Principal, was enquiring of Aitken: 'Is Professor Rothenstein considering approaching [Duveen] and ... asking some of his students to do some sketches for our consideration acting in concert with you? We do not want to take or sanction any step that has not your full knowledge and approval.'[71]

Rothenstein suggested to Aitken that if the project was undertaken by ex-RCA students, Duveen's exposure could be limited to £500, with any overrun met by unnamed supporters of the College. A committee led by himself would select the artists and oversee the works. Aitken put these suggestions, with others, to Duveen in New York, but pending his arrival in London matters drifted for several months; it was not until a Tate Trustees meeting in

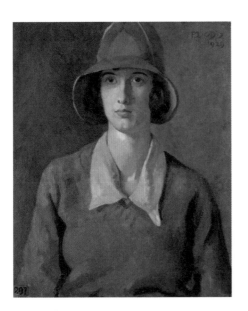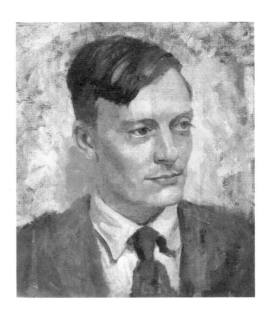

2.18 & 2.19
Phyllis Bliss: *Portrait of Tirzah Garwood* (left), oil on canvas, *c.* 1929;
Portrait of Eric Ravilious (right), oil on canvas, *c.* 1929.
One of the leading RCA Painting School alumni of her day, Phyllis Bliss painted these
portraits while living in Kennington, shortly after her marriage to Douglas Percy Bliss.

2.20 & 2.21
Phyllis Bliss: *Portrait of Edward Bawden* (left), oil on canvas, *c.* 1928,
and *Bliss* (right), oil on canvas, *c.* 1927. This portrait of her future husband, also
featuring Ravilious's tennis racket, was completed at Redcliffe Road and in
composition carries echoes of Rothenstein's well-known painting *The Doll's House*.

late June that Rothenstein learned he would get the nod. He wrote at once to Duveen thanking him for his generosity in providing further encouragement for 'the remarkable movement in decoration which has shown itself recently among young English artists' and asking whether he would like to see some available sketches. The following week Rothenstein wrote to Ravilious expressing delight at designs he had submitted, following this up five days later with confirmation that both he and Bawden had been selected to decorate the Refreshment Room.

The two friends began work in late September, each earning £1 per day for their on-site efforts. At first Ravilious persevered with his Eastbourne teaching, overnighting not far from Morley College with the newly married Blisses in Kennington. But with the murals on the go and other commissions coming in, he now had both the means as well as the motivation to refocus his life in London. On 25 February 1929 he was granted extended leave from the Eastbourne Art School and a few months later the Education Committee, in the throes of reorganizing after sacking the Principal, noted that his services were permanently unavailable.[72]

In London, Ravilious was now able to see Tirzah away from the constraints of their respective home lives. Occasionally she found his attentions disturbing, but 'he made up for this in showing me pictures and books and museums of which London has so rich a store. As I came to know him better and learned more about all his various family troubles, I admired him very much.'[73]

LONDON AND METROPOLITAN

The Principal of Morley College, Eva Hubback, told Tate Director Charles Aitken that something entertaining was needed because Morley's gloomy Refreshment Room was 'almost as bad as yours was before its transformation'. Knowing this, William Rothenstein had written to Aitken that 'a chance of getting a lively and cheerful spirit into a Working Men's College is a rare one and should not be missed'. But he was also aware that Whistler's fantastical landscape, against which any new scheme would inevitably be judged, had already set a benchmark for art created in the cause of public amusement.[1] Tate diners could follow a party of diminutive travellers on their circular odyssey 'in pursuit of rare meats', on foot, bike and horse, past follies, statues and fountains, up the hills and down the dales of a dream-like Duchy. Something equally imaginative was required to lift student spirits across the river.

Although the selection of artists was later attributed to a competitive process, Rothenstein instantly proposed, as Aitken reported to Joseph Duveen in February 1928, that 'a very able student Borden with some friends who worked with him would probably do the refreshment room with amusing scenes of London life'. Edward Bawden's track record of inventive poster design certainly suggested he would produce an entertaining take on the metropolis and Rothenstein already had his contemporary Charles Mahoney in mind for a decorative offering on 'Music and Dancing' for the lecture hall above the Refreshment Room. Getting both upgraded was Hubback's other priority, and Mahoney responded quickly with 'a noble cartoon' of a 'classical composition representing the pleasures of life in work and play'.[2]

Alive to Barnett Freedman's work on designs for *A London Ballet*, Rothenstein probably also saw his impecunious protégé as a possible collaborator for Bawden. However, Freedman was hospitalized that March, therefore

3.1
Edward Bawden, *London Bridge*, study for
Morley College Refreshment Room murals,
watercolour and pencil, 1928.

initial designs were sought only from Bawden, who based his proposal on
London Bridge, and Ravilious, who tackled Trafalgar Square.[3] Perhaps mind-
ful that worthy park scenes had found no favour at County Hall, whereas
Whistler's invented world had triumphed, Rothenstein was underwhelmed
by the results. Changing tack, he now suggested *Fantasy* as a theme: 'Morley
College had long been associated with the Old Vic Theatre, hence I suggested
that subjects from Shakespeare would be appropriate.'[4]

The notion of theatrical content treated fantastically seems to have given
licence and impetus to Ravilious in particular, who wrote to Rothenstein
'personally I am grateful to you for condemning the first lot of sketches, and
for the very helpful suggestions and criticisms you made'.[5] After an approach
from the leading typographer Stanley Morison, Ravilious had that summer
embarked on engraving a dozen designs for an almanac aimed at the print-
ing trade. Drawing on his own highly eclectic interpretation of the Zodiac,
he created imagined encounters between its mythical inhabitants and the
man-made and natural elements of the Sussex landscape. Consequently,
Rothenstein's proposal came at a time when Ravilious's confidence in his own
powers of invention and fusion were increasing.[6]

A framework was needed to carry, but not constrain, the efforts of two art-
ists while allowing a very large space and 'a vast intractable subject' to work
as a unified whole. The solution adopted was an architecture of tiered open

3.2

Eric Ravilious, *Andromeda* (left) and *Libra* (right),
wood-engraved illustrations for the *London Monotype Almanack*, 1928.

3.3
Edward Bawden, *Scenes from The Tempest*, colour photograph
of a section of the Morley murals, 1930.
This photograph was reproduced in *The Studio*, 1930.

theatres, linked by scaffolded verandas set against a continuous downland and marine landscape, above which would 'frisk and prance and sprawl the most amusing series of figures from classical mythology and other sources that perhaps have ever been assembled'.[7] In the spirit of *Gallimaufry* they also looked beyond the Bard: as an explanatory leaflet put it, 'the artists have chosen the plays for no other reason than that they like them and have allowed themselves to improvise freely, to mix observation and inventiveness and fun, and evoke an atmosphere no closer to everyday reality than the life of the stage or the life of dreams'. Staying in Kennington at the time of the rethink, Ravilious had Douglas Percy Bliss's company and library to hand as he populated his stages, and it was probably there that he consulted George Peele's *Arraignment of Paris*, Ben Jonson's *Cynthia's Revels* and *The Sad Shepherd*, and Christopher Marlowe's *Doctor Faustus*. He also proposed to include a boarding house based on a 'bourgeois doll's house' that Tirzah had made at Eastbourne, admitting later it was 'more or less irrelevant – only the colour and the architecture and the scale of the figures join it to the rest of the painting'.[8]

Bawden was soon telling Bliss: 'The Boy has sent me his Morley College decorations. They are amazing! ... I don't know how a clumsy clodhopper like myself is going to do anything like 'em'.[9] Bawden later told Rothenstein he had never read Shakespeare, but this did not stop him drawing adeptly on scenes from *King Lear*, *As You Like It*, *Romeo and Juliet* and *The Tempest* for two of his stages, and a miracle play, *Abraham and Isaac*, for a third. Tirzah thought the overall effect was rendered a touch more comic than intended by Bawden's trademark quirkiness and Bliss remembered friends' concerns that 'a mural so unusual might have been frowned on'.[10] They need not have worried. When work began on site, Aitken reported to Duveen about 'very remarkable' proposals, adding that 'the very gifted young artists and their designs strike one as on as high a level as Whistler's'.[11]

Addressing assembled dignitaries at the opening on 6 February 1930, Stanley Baldwin declared the murals were 'conceived in a spirit of happiness and joy' and that their execution had clearly given real pleasure to the young artists involved. The observation was coined by Sir Geoffrey Fry, the former Prime Minister's recently knighted private secretary, who had visited Morley College a few days earlier in order to prepare speech notes. Fry, a collector and connoisseur, had been delighted both by what he saw and by a sense of rapport on meeting Ravilious.

That morning's papers had carried equally upbeat previews, commending the way the 'storied walls' and 'rollicking sky inhabited by gods and goddesses

"LIFE IN A BOARDING HOUSE"

A Detail of the Remarkable New Frescoes by Young Modernist Artists at Morley College

HUMOUR and gay colour distinguish this amusing representation of a modern boarding house by Mr. Eric Ravilious, which is one of the outstanding panels in the interesting new frescoes recently unveiled at Morley College for Working Men and Women. The aim of the artists who painted these frescoes was to provide plenty of things interesting to look at—in the modernist manner, each section of the series of pictures "tells a story." In his mildly satirical rendering of the activities of boarding house life, Mr. Ravilious has certainly fulfilled this object. The paintings are the gift of Sir Joseph Duveen, whose benevolence to young British artists is by now proverbial

3.4

'Life in a Boarding House': coverage of a striking
section of Ravilious's Morley murals, 1928–30,
appeared in *The Graphic* on 15 March 1930.

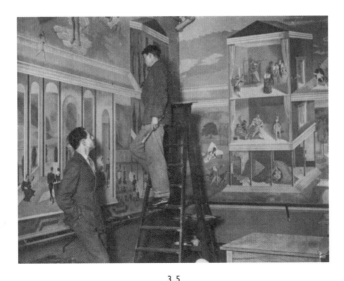

3.5
Bawden and Ravilious pictured at work on the Morley murals in
the *London Evening Standard* on 3 February 1930, three days before
Stanley Baldwin officiated at the opening ceremony.

and harliquinade figures of delicious fancy' afforded 'constant entertainment
to the eye and mind'. 'Surprises, mocking quotations and sweet devices' and
their 'nimble wit in idea and in painting' stole the limelight as 'characteristic
of the young artists of our time'.[12] Bawden's inclusion of a marine landscape
and Ravilious's boarding house attracted special mention, but they were
lauded as joint creators of a fantasy redolent of 'the whole spirit of the post-
war "cocktail" period', notable for its 'spirit of irresponsibility and bizzarrerie,
as though the artists had been working with their tongue in their cheek'.

The Morley murals were Ravilious and Bawden's most sustained collabora-
tion, but it was hardly plain sailing, and execution, at sixteen months, took
twice as long as Rothenstein had estimated. This in itself was not a problem
for two friends being paid a daily rate, and the resulting budget-wrangling
largely involved Hubert Wellington, acting as paymaster and project manager,
Charles Aitken as intermediary, and the distant Duveen. After Rothenstein's
reserve donors failed to materialize, a worried Morley Finance Committee
briefly tried to curtail the scheme. Duveen was eventually prevailed upon to
meet the shortfall, but in May 1929 Wellington was still concerned that 'pro-
gress especially in the case of Bawden and Mahoney appears to be rather slow'.
By July the original allocation of 150 days for the Refreshment Room had

been exceeded, and Wellington, forecasting another 110 days of expenditure, recorded that 'Ravilious and Bawden say they will be finished by Christmas.'[13]

At a practical level the project had begun with a saving. After initial concern about the walls, Rothenstein was soon writing to Aitken: 'Professor Tristram has inspected the plaster and he thinks we can safely dispense with canvas in the refreshment room but not the hall – washed down to remove superficial distempering, the actual surface will suit Bawden's work better than would canvas.' On his visit with Bawden, Ernest Tristram also advised using oil paints, mixed with wax and thinned with turpentine, and a layer of varnish for protection against dirt and steam. Arriving just after water pipes had been relocated, Rothenstein witnessed both artists 'drawing the outlines freely, with so sensitive a touch one almost regretted they would not so remain. Happily, in adding colour they showed no less perfect workmanship.'[14]

For more than a year the two friends were living in each other's pockets, often on site together four days a week. After Ravilious ceased teaching in Eastbourne, he moved into two rooms at 52 Redcliffe Road, above Bawden who had taken over Phyllis Dodd's ground-floor rooms.[15] Her yellow curtains were still present in Ravilious's painting of Bawden at work there, rolled cartoons for the decorations standing sentinel in the corner, and a trademark Ravilious 'cat at its toilet' beside a discarded guardsman's jacket. Painted in tempera on board, executed in late 1930, precisely detailed and highly finished, the work is an affectionate tribute to a quirky and industrious collaborator.[16] In the absence of the destroyed Morley decorations, it demonstrates why onlookers were so struck by the freshness and originality of the murals themselves. Bawden had already foreshadowed the compliment with a watercolour of Ravilious, cat asleep behind him, at work on what appears to be a Morley cartoon.

But closeness could also be irksome and Bawden, in complete contrast to Ravilious, was still shy and unsure with most women, and awkward in many social situations. His feelings for Ravilious, at once his most intimate friend and most obvious rival, were also complex. As Tirzah recalled: 'Eric found him a very difficult person to work with and painting at Morley College with him was unnecessarily complicated by a variety of troubles. He had ... the habit of sensing you were going to criticise or blame him ... and forestalled you by accusing you of this very fault, however inconsistent it might be. He was also stimulated in his work by a competitive feeling which was annoying if you didn't want to compete, and Eric didn't.' Tirzah remembered that around this time Edward 'was reading Havelock Ellis and other books on homosexuality and rather proudly came to the conclusion that was what he probably

3.6 & 3.7
Eric Ravilious, *Portrait of Edward Bawden* (above), tempera on board, 1930.
Edward Bawden, *The Boy – Eric Ravilious in his studio at Redcliffe Road* (below), watercolour, *c.* 1929.

was'.[17] Eric for his part discounted this, writing to Cecilia Dunbar Kilburn the year before of his concern for his driven friend: 'Bawden is overdoing it now I think, he will kill himself ... Do you know anyone he could marry? Perhaps God will create a wife (from a rib) for such a diligent servant as Edward. He is quite as particular a case as Adam.'[18]

In fact Bawden, unbeknown to friends, had already begun making his own moves in this direction. While in Florence he had run into their College contemporaries Beryl Bowker and Charlotte Epton. After keeping in touch with 'Eppie' while she was a teacher at Cheltenham Ladies' College, he then visited her when she moved to St Ives as assistant to the potter Bernard Leach. One weekend Ravilious was surprised by Bawden asking him whether Charlotte could stay in his room while he was away. Charlotte for her part was often perplexed by Edward who, as she would later tell Tirzah, took to 'writing her most affectionate letters and who apparently wanted to marry her in theory; but when he met her would stay on the other side of the room and look very apprehensive.'[19]

Morley's blithe spirit also belied to a large degree the emotional roller coaster that Eric and Tirzah were riding. Six months before he started on the commission they had spent the small hours of New Year's Day 1928 together. For Tirzah the price of reduced entry to the Chelsea Arts Ball at the Albert Hall was parading as a slave girl escorting the Central School of Art's elephant float. Escaping the pawing of full-price drunken revellers, she changed into a yellow Elizabethan dress that Eric had designed for her appearance in Somerset Maugham's play *The Constant Wife* at Eastbourne, and finding a quiet spot beneath the stage they talked into the small hours. In the autumn, when they were both back in London, she took life- and costume-drawing classes at the Central School, and at the BBC's nearby offices on Savoy Hill she received her first commissions as an illustrator.

In late 1928 the BBC was preparing to launch its magazine *The Listener* and to extend its activity publishing illustrated libretti for broadcast operas and 'Great Play Booklets' to accompany radio dramas. After her introduction through the Curwen Press, Tirzah provided two wood engravings for a booklet published that November marking an oratorio based on John Bunyan's *Pilgrim's Progress* and was then asked to cut armorial bearings for *The Listener*'s masthead.[20] Her drawing previewing a scene from Edmond Rostand's play *The Fantasticks* was published in its second issue and three further pen-and-ink images followed in the booklet for March's broadcast, Gabriele D'Annunzio's play *Francesca da Rimini*. Tirzah had been unimpressed by costume classes

3.8
Edward Bawden, *Redcliffe Road*,
copper engraving, 1927.

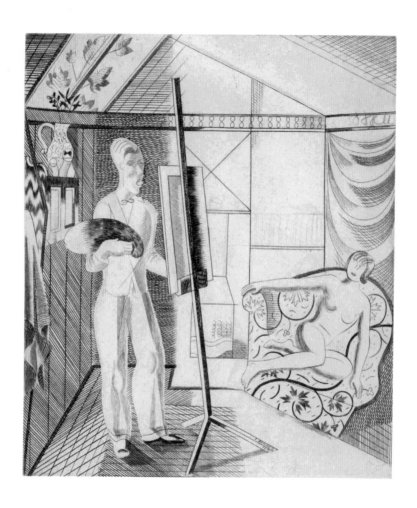

3.9

Edward Bawden, *Branson and the Nude*, copper engraving, 1927.
George Branson, nicknamed 'the Bombinator' at the RCA, often used
Ravilious's bed in Redcliffe Road when he was away in Eastbourne.

3.10 & 3.11
Helen Binyon: *The Tea Party* (above), copper engraving, late 1920s;
and *The Ste. Cécile Cafe* (below), copper engraving, late 1920s.

at the Central School, where there were never any 'normal clothes in the Art School fancy dress box' and the models 'dressed as Red Indians, Queens of the Ball, Spanish Gypsies'. But costume was now definitely the order of the day in her BBC commissions and the next request was for two pen-and-ink illustrations for the libretto of Arthur Sullivan's *Ivanhoe*, broadcast two weeks later.[21]

Competent and conventional, and not playing to her strengths as a sardonic observer of contemporary life, Tirzah's stream of work nevertheless allowed her to earn a good part of her own keep while enjoying an independent London life. Although she was yet to meet Eric's RCA friends and did not initially visit him at Kennington, he was now a frequent visitor to her attic room in Hornton Street two streets away from where he had lodged as a fresher six years before. Eighty-five steps up in the eaves, the room and its occupant are memorialized in Ravilious's engraving *The Boxroom*, shown at the Society of Wood Engravers in 1929 and used as the frontispiece for a special edition of *The Woodcut, Number IV*.

During the summer Tirzah had enjoyed a mild holiday flirtation in Switzerland, as had Ravilious on a return visit to Barcombe. Tirzah felt grateful to a Scottish Austrian girl with 'fine big breasts' whose free and easy ways had given Eric the confidence to kiss her too, although as Tirzah wrote, she remained 'faithful to my promise to Bob and my father's fears were not fulfilled in fact, even if they were in mind'.[22] Going about hand in hand with Eric, Tirzah now learned more of his family troubles: his sister Evelyn's nervous illnesses, which meant his young niece Gwen was living with his parents, and his brother Frank's dealings in London, which had led to a second more serious bankruptcy that spring and eventually to a six-month jail sentence.[23] For Tirzah, the 'rather frightening working-class world in which he lived' felt far removed from her own; but even as class threatened to divide, art was bringing them together.

When the annual SWE exhibition opened in November 1928 it included three of Tirzah's new engravings. Two were based on *Tales from La Fontaine*, of which one – *Cat into Wife* – may have also been inspired by the modern marriage fable *Lady into Fox* by David Garnett.[24] A third was a take on a seaside perennial: 'the Hall of Mirrors'. Exhibited alongside engravings by Paul and John Nash, they were further evidence that 'Miss Tirzah Garwood is a new-comer among the wood engravers, and a very welcome one, for she has humour, originality in choice and treatment of subject, and technical accomplishment ... a pupil of Mr Ravilious, and she has a streak of his tricksiness, with much irony of her own.'[25]

Eric's entry consisted of five of the forthcoming *Almanack* engravings. Drawing on the landscape of their sketching expeditions, these engravings suggest his preoccupation with their relationship and her dilemma. Taurus the Bull prances aloft above a feminized Long Man of Wilmington while a dewpond reflects the stars above; Serpentarius, the life-saver with a snake, hovers in the winds above an East Sussex oast house; and archer-centaur Sagittarius alights beside telegraph poles leading to an open barn door. In the only exhibited interior from the series (fig. 3.2a), Libra's scales gyrate wildly in the wind above a thoughtful young Tirzah reading in an armchair. Behind her is an open door through which are seen the mill buildings at Barcombe where she had been photographed at a first-floor opening the summer before. In another reference to their time in Sussex, a Tirzah-like Andromeda (fig. 3.2b), already liberated from her rock but with broken chains at her ankles, climbs a haystack draped with a tarpaulin bearing a word ending in 'ombe'. Her appraising gaze observes the viewer; perhaps – in the artist's fancy – it is turned towards Perseus, Andromeda's future husband and mythical rescuer.

But the following spring brought a crisis that threatened to end their relationship. Tirzah returned to Eastbourne to have her appendix out and subsequently convalesced in Brittany with her friend Barbara, Bob Church's sister. Bob, still in Nyasaland, aware of his rival and fearing the worst, now threatened to return early. Feeling 'a pig for causing him so much anguish', Tirzah now persuaded herself she should indeed marry her notional fiancé and wrote to Eric saying they should no longer see each other.

For Ravilious the summer of 1929 was both emotionally difficult and, murals apart, very busy. His third Golden Cockerel, *Atrocities of the Pirates*, appeared in July with ten of his engravings illustrating 'a rather square-toed narrative', and two Curwen books incorporating major woodblocks were in production.[26] Francis Meynell had commissioned leading engravers for a bulky edition of *The Apocrypha*, in which Ravilious's *Young Men in the Fiery Furnace* features a floating Angel of the Lord that echoes similar *Almanack* and Morley figures. In parallel, a fund-raising British Legion omnibus featured *Dr Faustus Conjuring Mephistopheles*, an engraving of the Marlowe scene that Ravilious was painting at Morley, foreshadowing by four years his masterly sequence of theatrical illustrations to *The Jew of Malta*.[27] A strange mixture incorporating collotypes and drawings by Rothenstein, William Nicholson, Max Beerbohm and Jacob Epstein, the *Legion Book* also included, in much lighter vein, three Bawden drawings illustrating a Caribbean travelogue, one of a theatre in Curaçao.

3.12

Pattern Paper designs for the Curwen Press by Paul Nash (left),
Enid Marx (centre) and Barnett Freedman (right), *c.* 1928–30.

The Curwen Press's *A Specimen Book of Pattern Papers*, another book printed at Plaistow during the Morley period, was much more satisfyingly coherent. Uniting efforts from Enid Marx, Ravilious, Bawden and Paul Nash, it showcased their collective flair for pattern-making as an extension of the joyous aesthetic already established by Lovat Fraser and Albert Rutherston. Conceived as a loss-leading promotion to publishers and commercial clients, it used Bawden decorations for the title page and to illustrate Paul Nash's introductory essay. Twenty-one 'Designs by Draughtsmen' followed, including seven each by Fraser and Rutherston, and one each by Bawden and Nash. Ten 'Designs From Wood Engravers' included a trio from Nash and full-size sheets of the Marx and Ravilious designs that had been tipped into Nash's article 'Woodcut Patterns' the previous year. Another four wood-engraved papers by Marx gave *The Specimen Book* some of its most striking modernist content.

At the time Marx herself felt 'wide open to ideas and only just developing my own point of view, awkwardly as a caterpillar emerges from its crysilis'.[28] Vincent van Gogh's exciting brushwork, George Braque's muted colours, the 'theories of the sur-realists', and 'Cube-ism' all attracted her, as did the ethnic art in the British Museum that so enthused Henry Moore, her former drawing-class companion.[29] Endlessly curious and energetic, Marx had not yet begun

to see herself as a designer first and a painter second. Indeed she had rejected Phyllis Barron's urgings that she give up painting – and two years later exhibited a piece called *Grandmere* in the Young Painters' Society exhibition held at the New Burlington Galleries, where it hung in the same room as *Cousin Hilda* (untraced) by Ravilious. Observation of the natural world, and her own striving to develop her drawing and painting, underpinned her approach to pattern-creation for fabric and on paper, while Paul Nash, who 'saw pattern in the movement of the waves', remained a conscious influence.[30]

While Marx and Nash's papers were those in greatest use at the Curwen, her hand-block 'printed stuffs' were among the most popular items available through the newly established Little Gallery. Set up near Sloane Square by Muriel Rose with her partner Margaret Turnbull, themselves well known to Barron and Larcher, the venture was in Marx's own words 'a new type of gallery where everything on display was the personal choice of the partners. A splendid mixture, ranging from the fine arts and the work of studio potters and other hand craftsmen, to selected items of industrial design, and work by rural craftsmen working in local traditions'.[31]

At this time the relationship between art and industrial design, and the appropriate conditions for artists to engage with industry, were of growing interest to Nash who, following disappointing financial returns from two exhibitions, was designing for glass, china and textiles, returning to art criticism for *The Listener* and *Weekend Review*, and beginning to devise posters for Shell and the new Empire Marketing Board (fig. 3.23). In early 1929 he expressed doubts to Marx about the dyes that Footprints were using for his own fabrics: 'if only I had money – how much I might do! I shall be in London towards the end of the month when we must meet.' The following New Year he wrote to her: 'My dear Enid I'm sure you must be too grown up to still be Marx – we've had a bad year right to the end but somehow one feels more kind and I am starting hopefully and I am going to design for Cresta silks – are you independent and proudly on your own or would you like to make designs for firms as well as for your own execution? Let me know.'[32]

In time, Nash's approach to artistic engagement with mass production, involving concern for detail as well as questioning of established norms, would influence both Marx and Ravilious. For the present, however, Marx was focused on working for herself and the arduous but rewarding business of hand-printing lengths to order. Her designs stood out as 'more jazzy, risk-taking and lively than those of her male friends', a reflection both of her personality and her appreciation of continental post-Impressionist experimentation.[33] This in

turn reflected her closeness to her only sibling Daisy, twelve years her senior, who knew Paris well and had been a leading light of the Institut Français in Kensington. It was the happy accident of a friendship made there that would lead to Enid meeting her own partner in life, but before this, in November 1928, she faced tragedy when Daisy, returning to London from France, was taken ill and died suddenly, aged just thirty-seven.[34] Shortly after this Enid moved her home and studio to Ordnance Road, St John's Wood.

* * *

The Curwen Press, announcing their use of the best young artists 'to add zest to our work', had developed the habit of issuing promotional calendars to its clients. The practice was inaugurated in 1922 when a 'Four Seasons Diary' illustrated by Albert Rutherston, Rothenstein's younger brother, introduced clients to his signature decorative style of thin black line drawings edged with bright but delicate colouring. In 1927 Oliver Simon had chosen Barnett Freedman as the contributing artist, resulting in a celebrated 1928 Calendar that foreshadowed important developments in Freedman's style; its scenes of the Plaistow works were executed as black-and-white pen drawings, but enriched with colour applied by hand in Harold Curwen's recently established stencilling department.[35] By early 1929 two SWE exhibitions had given notice of Tirzah's precocious ability to produce wood engravings combining great technique and a mildly sardonic take on modern life; and then, in what at the outset must have felt like an affirming accolade, Simon asked her for twelve engravings for the 1930 Calendar.

While staying in Brittany, Tirzah began an engraving of herself sitting up in bed that became *The Wife*, one of ten she completed as part of *The Relations*. Over the following months she created *The Sister-in-Law* at a dog show, *The Daughter* in a school crocodile, *The Aunt* crossing Kensington High Street, *The Cousin* with her pram, *The Grandmother* asleep in her chair, *The Niece* sashaying across a cocktail bar and *Two Sisters* sharing a bathroom. *The Husband* raincoated in his vegetable garden and *Train Journey* showing Tirzah herself and fellow passengers passing the Downs complete a series of startling originality and accomplishment, a unique offering from the wood-engraving revival.

Despite this, the Calendar was aborted at the behest of Simon. He had apparently chosen to take offence at Tirzah's line drawing of Rebecca, daughter of Isaac, the rich Jew of York, published in the BBC *Ivanhoe* libretto while Tirzah was in France. Simon, the driving force behind so much innovation at the Curwen and a great supporter to the favoured, could also easily turn, and

3.13
Tirzah Garwood, *The Wife* (left) and *The Husband* (right), wood engravings, 1929.
Two of ten images completed for the aborted Curwen Calendar.

in this case he deemed Tirzah's somewhat workaday depiction of Rebecca at the stake to be anti-Semitic, an interpretation that squares with neither the visual evidence nor the artist's lifelong sensitivity to prejudice. Around this time Bliss was also exiled from favour at the Curwen, having approached Simon about payments owing, an incident that had similar consequences for his future employment and his career as an illustrator.[36] Ravilious tried to make light of the rejection's ultimate significance but, reinforced by a negative reaction to her BBC drawings from the art critic Gerald Gould, the blow to Tirzah's confidence had longer-term consequences. There was compensatory acclaim, however, when *High Street Kensington*, *Train Journey*, *The Dog Show* and *The Crocodile* were included in the December 1929 SWE exhibition. They appeared alongside Ravilious's recent book illustrations, as well as the engravings *The Boxroom* and *The Importunate Ass*, an illustration to La Fontaine that saw Eric taking, as it were, a leaf out of Tirzah's own book.[37]

The autumn of 1929 brought further emotional turmoil. Back in London and feeling the loss of Eric's friendship, Tirzah rang him up and, in her words,

'the summer was forgotten and we resumed our friendship and love-making as though nothing had happened'.[38] In Nyasaland, however, Bob Church, jealous and distracted, applied for home leave and arrived in Eastbourne before Christmas; for Tirzah, torn between the two, 'the idea of Bob as a comfortable pipe-smoking husband' had appeal, but she knew that if she married him she would always regret Eric and the possibilities of life as an artist. At one point Eric, feeling he would make a poor husband, advised her to marry Bob. For all three, the weeks passed in such painful uncertainty that at times Tirzah felt that left to herself she might marry neither suitor, at other times that marrying either might bring peace of mind. Eventually, however, she told Bob she could not marry him.

On 9 January 1930 Tirzah wrote to her father letting him know she had made a decision, and four days later letters from her and Eric arrived in Eastbourne. To his future son-in-law's chagrin, an unhappy Colonel Garwood queried whether they might not wait until Ravilious was more established as an artist. The Morley commission and others, however, had brought in over £400 that year, sufficient for Ravilious to give his mother £50 to pay off her mortgage. With Stanley Baldwin's appearance at the mural opening signalling his arrival as an artist, objections to the marriage were now overcome. As Tirzah recalled: 'We agreed to wait until the summer and became officially engaged. Privately we didn't wait, because in the past it had been my promise to Bob and not the lack of a church service that had kept me from being Eric's lover.'[39]

3.14
Stills from a home movie: Tirzah and Eric (left)
and Colonel and Mrs Garwood (right)
at the Scots Church on 5 July 1930.

The two sets of parents met at Morley College, and two months later a *Times* announcement that 'a marriage has been arranged and will shortly take place quietly', gave 35 Stratford Road, Kensington, Eric and Tirzah's first home as a married couple, as the bridegroom's new address.[40] On Saturday 5 July, well away from Eastbourne, a ceremony at the Scotch Church in Kensington was followed by a reception at Tirzah's maiden aunts' house nearby – Eric was on tenterhooks, alert for embarrassments that might flow from the potentially awkward intermingling of family and friends, a larger gathering than originally intended. Rothenstein arrived in top hat and tails, Douglas Bliss was there with Phyllis Dodd, and Edward Bawden bravely acted as best man, having first ensured that Barnett Freedman would attend: 'Eric insists upon your coming to his wedding Saturday – two Saturday – We – that's Him and me – are both going in our ordinary clothes so there'll be no need for you to appear funereally clothed.'[41]

<p style="text-align:center">* * *</p>

Another wedding that spring was Barnett Freedman's second marriage to Claudia Guercio.[42] Four years before it had been clear that her parents would not welcome an artist of uncertain prospects as their son-in-law; now a return to the registry office signalled that Barnett's situation had begun to improve. However, income from oil painting was still elusive, as were opportunities to exhibit. This led Freedman and Percy Horton, who often painted together in Dorset, to contemplate setting up a new painters' society. Nineteen names were canvassed and Rothenstein, a veteran of such societies, offered enthusiastic encouragement, but beyond an inaugural committee meeting and pencilled rules covering subscriptions and hanging rights, the venture foundered.[43] However, other directions for Freedman were coming into focus. He had left the Royal College of Art intent on pursuing theatre design, despite a warning from Albert Rutherston that 'most of the folk to be dealt with are devils'. He must also have been encouraged when Rutherston reacted to studies for a *London Ballet* by suggesting the V&A should acquire them; subsequently they were displayed at The Literary Bookshop in May 1929 as part of Freedman's first solo exhibition. His interest in theatre production would endure and, like Helen Binyon, now back in London combining art classes at the Central School of Art with a three-day-a-week job at the College of Arms, he had a growing interest in puppetry. In her case, wood-carving classes were enabling her to construct marionettes like those that had enthralled her as a child visitor to William Simmonds's puppet theatre. In Freedman's case, giant

marionettes discovered while visiting Claudia's Sicilian relatives fired his imagination both as subjects for painting and as motifs for illustration.

The evolution of Freedman's graphic style can be traced in his three contributions to the series of thirty-eight *Ariel Poems* printed at the Curwen Press between 1927 and 1931. Initiated by Faber & Gwyer as alternative Christmas cards, the series matched previously unpublished (and often undistinguished) poems by known writers, with an illustrated cover and a main illustration by an artist selected by Oliver Simon. For the first batch Freedman was asked to illustrate *The Wonder Night* by Laurence Binyon, Helen's father, and for five guineas provided two cross-hatched line drawings of a family with 'the air of tragic puppets ... propelled by something entirely outside of their own wills', the main drawing enlivened by patterning in two colours added by use of line blocks.[44] In 1930 his second contribution was to illustrate Walter de la Mare's *News* with a full-page image suggestive of his emerging signature style of book illustration: three excerpted scenes adorn a drawing of an open page, supplemented by peripheral lettered quotations, achieving a far more intense combination of line-drawn image and printed colour. In the same year Freedman began to work on illustrations for Faber's *Memoirs of an Infantry Officer* by Siegfried Sassoon, an assignment that led to the publication of one of the icons of twentieth-century book illustration the following year. Its controversial debut was followed in November 1931 by a solo exhibition at the Zwemmer Gallery, a venue beginning to make its mark on the London scene.[45]

By 1931 the novelty of the *Ariel Poems* had worn off, but not before the series had served a generation well; Claudia Guercio, both Nash brothers, Bawden and Rutherston had all contributed as artists, often repeatedly, to a venture that at its best served as a nursery for new graphic styles. As something of an exception to this, Ravilious provided two woodcuts for *Elm Angel*, a slight offering by Harold Munro. Published in 1930, it was one of the few *Ariel Poems* to carry wood engravings, appearing at a time when economic troubles were beginning to undermine their continued use in trade publishing and put the private presses under pressure.[46] For the last issue in the series, Simon selected Freedman to illustrate Roy Campbell's *Choosing a Mast*. This resulted in a fully designed cover where hand-drawn lettering and cross-hatching reflect the style of *Memoirs of an Infantry Officer*; the cover included an image of the sea seen through pines, which in its subtle use of colour anticipates Freedman's emergence as a master lithographer. For the *Manchester Guardian* it was 'the best of the current series', serving 'magnificently to celebrate its achievement'.[47]

3.15 & 3.16
Barnett Freedman, *Choosing a Mast* (above), *Ariel Poem 38*,
line drawing and printed colour, 1931.
Edward Bawden, *Popular Song* (below), *Ariel Poem 15*,
line drawing and printed colour, 1929.

3.17 & 3.18
John Nash, *The Early Whistler* (above), *Ariel Poem 6*,
line drawing and printed colour, 1928.
Paul Nash, *Dark Weeping* (below), *Ariel Poem 19*,
line drawing and printed colour, 1929.

To the amusement of his friends, Freedman habitually railed against 'the iniquities of publishers, advertisers and other such patrons of the arts ... actuated by the single-minded determination to do down the poor artist'.[48] By contrast, Ravilious's style was disarmingly self-effacing and correspondence relating to *Twelfth Night*, his own early 1930s magnum opus of illustration, shows quite how 'ungrasping and eternally optimistic' he could be.[49] In October 1930 Robert Gibbings, owner of the Golden Cockerel Press, accepted Eric's proposal for an undertaking that would make extended use of his engraving talent, offering a fee of £200; a few weeks later Gibbings also decided to buy several of Tirzah's small-scale wood engravings, intending to transfer them to metal type as Golden Cockerel 'stock blocks' for covers and borders. During a weekend stay with Gibbings and his wife Moira at Waltham St Lawrence in Berkshire, book projects for Tirzah were also discussed and there was talk of her and Eric returning the following spring 'to camp in the orchard hut'. However, despite her initial work, these projects were abandoned by Gibbings as economic circumstances deteriorated due to the Great Depression. From January 1931 one of Tirzah's pattern designs was used in a wide range of colours to cover the Golden Cockerel's *Guinea Series* of new work from living authors, the second volume featuring fine wood engravings by John Nash.[50] More affordable to bibliophiles in straitened times, over four years the series ran to eleven volumes, eight of which were published while Gibbings was still the owner. But for Tirzah, the relationship with Golden Cockerel, although not marred by wilful misunderstanding, would eventually disappoint.

Meanwhile, Eric felt his first pages for *Twelfth Night* were emerging as 'a masterly piece of engraving if a little too Florentine in spirit!' Gibbings, looking to prepare a traveller's dummy, enthused 'this is far and away our best title page yet and I hope very much the volume is going to set a new standard for us as well as for everybody else'.[51] Over the following months, as more bookshops and private collectors became 'too broke to stand by their orders', the planned edition size of 500 at five guineas was abandoned in favour of 275 at three guineas and Gibbings, already slow to advance money on account, was soon proposing a fee reduction to £165. Changes to page size precipitated considerable reworking and the abandonment of fourteen blocks during a project that now also involved considerable labour for Tirzah, who helped with the cutting.

After a year Eric's main concern was cash flow: 'I'd be awfully grateful if you could manage the second instalment. My pass book arrived this morning

with about £7 something on the credit side so I suppose I must do something about it.'[52] Reminding Gibbings of the impossibility of taking on much other work while the job was in full swing, Ravilious nevertheless suggested 'washing out the money for these scrapped blocks', accepted the fee cut, and continued to respond positively to other requests: in particular for a 'luscious nude lady', a figure Eric based on Tirzah, riding a comic fairground Cockerel to decorate the 1932 Spring List. All the while, his enthusiasm remained undimmed: 'I was in Oxford on Wednesday and looked in at Sander's bookshop where they brought out the sample sheets of *Twelfth Night* ... I do think you have done me proud.' When Gibbings, on the point of selling up a year later, could not afford to commission another cockerel engraving for the 1933 list, he responded by making a present of the design.[53]

The economic climate also affected fine press work at the Curwen, precipitating closure of the stencilling department. This had been set up just five years before to follow an adapted version of the French *pochoir* method in which colour was brushed through the open areas of celluloid stencils which gave visibility to an artist's underlying design. After seeing Ravilious's *Desert*, Paul Nash had corresponded with author Martin Armstrong, resulting in his 1927 stencilled illustrations for *St Hercules and Other Stories*, a slight but essential trial run for 1932's *Urne Buriall and The Garden of Cyrus*. In the intervening years Curwen's female stencilling team produced notable illustrations including John Nash's for *The Shepheard's Calendar*, Bliss's for *The Spanish Lady* and McKnight Kauffer's for *Elsie and the Child*.[54] But Cassell's *Urne Buriall* was both a crowning achievement for Nash's career as an illustrator and a fitting epitaph for an activity that proved commercially unsustainable in the economic downturn. As with *Twelfth Night*, the times ensured that editions were small and buyers few: only eighty copies of 'one of the loveliest achievements of contemporary English art' were ever bound for sale.[55]

Part-time work was now essential for steady income and, with the Morley murals complete, Ravilious quickly committed to a day a fortnight teaching design and engraving at Oxford's Ruskin School of Drawing.[56] After its revitalization under Sydney Carline, Albert Rutherston had taken over as Master in September 1929, intent on broadening activity to include book illustration, typography and wood engraving. Drawing on the RCA network, he recruited Freedman to teach Drawing and Painting, and Enid Marx from autumn 1931 as a second teacher of Design and Engraving, while a panel of Visitors, making termly appearances to judge and instruct, included Bawden and both the Nash brothers. When Ravilious ceased his sessions four years

3.19 & 3.20
Eric Ravilious: *Sir Andrew's Kickshawes* (above),
wood engraving for *Twelfth Night*, 1932;
and *One Face, One Voice, One Habit, Two Persons* (below),
wood engraving for *Twelfth Night*, 1932.

JANUARY 1933 NOVEMBER 1933

3.21
Eric Ravilious, *Designs for the 1933 Lanston Monotype Calendar*,
wood engravings, 1932.

later, Rutherston reflected how his contribution had enhanced the reputation of the school and its standard of work.[57] Meanwhile Rothenstein was also actively luring favoured graduates back to the RCA, beginning with Horton in July 1929 to teach drawing, and a year later Freedman to teach still life and Mahoney painting. Shortly after, Ravilious and Bawden were hired as part-timers in the Design School along the lines originally pioneered with Paul Nash's engagement.[58] By the time Rothenstein retired in 1935, a significant proportion of the 'outbreak of talent' were returning to South Kensington at least one day a week.

Paul Nash now looked to this network as he prepared for the April 1932 opening of 'Room & Book' at Zwemmer's, an exhibition reflecting his belief that artists working 'within applied design' but 'outside the mystical circle of arts and crafts' should become civilizers of the contemporary age. Ranging widely across furniture, textiles, pottery, sculpture and painting, and accompanied by a book extending his previous articles, the initiative was part of Nash's evolving quest to promote an 'English Modernism'. Marx's fabrics, Curwen pattern papers, Moore and Hepworth's sculptures, and Bawden's wallpapers were among the items on display, the latter bringing 'humour and gracefulness into the slightly self-conscious atmosphere'.[59] As J. C. Squire, editor of the *London Mercury*, noted: 'Mr Eric Ravilious has a solitary contribution, but that one, a *Design for a Cactus House*, is outstanding in subtle humour and dexterity of treatment.'

Together with its close contemporary the *Monotype Calendar* – in which stylized acrobats strike poses across the months – *Design for a Cactus House*, intriguing and beautifully executed, is suggestive of a more urban road not taken, one that could have led Ravilious further towards the slightly surreal 'architectural rather than decorative' aesthetic advocated by Nash for the modern interior. But when Zwemmer's hosted a not dissimilar 'Artists of Today' exhibition a year later, Marx and Bawden were involved but not apparently Ravilious. By then – although he and Tirzah were temporarily engaged thinning oils 'to paint a wall' at Morecambe's newly constructed Railway Hotel – Ravilious was turning definitively towards watercolour drawing and rural motifs. Following this path he would, more than any of Nash's former pupils, come to combine his eye for the design inherent in discovered rather than imagined things with that 'peculiar bright delicacy in choice of colours' that their erstwhile College mentor characterized as intrinsically English.[60]

In June 1931, Ravilious wrote to Gibbings 'this patch of summer weather is wasted in Earl's Court'; six months later he enthused 'the new place is on the river and we were lucky I think to get it'.[61] Eric and Tirzah had moved to 48 Upper Mall, Hammersmith, by early December that year, but not before the view from their old flat had sowed the seed for *November 5th*, a large-scale joyful valediction to their first home, described by Alan Powers as 'a modern life version of the Morley College murals with groups of people revelling in back gardens on this annual occasion of licensed disorder, with a fascinating intricacy of space seen from above'.[62]

For the next three years Hammersmith was Eric and Tirzah's main home; at the same time two rural locations came into play, the first of which was Sir Geoffrey and Lady Alathea Fry's splendid and luxurious eighteenth-century country house at Oare in Wiltshire. Charmed by both Ravilious and his Morley decorations, Fry had commissioned three painted panels for his Portman Court apartment, which Ravilious filled with a mixed-doubles tennis match set in the Manor Garden, Eastbourne. He had previously depicted it in his 1927 engraving showing two young men beside a girl carrying a racquet and it was also the probable location where, playing the game in real life, he had once looked up to see Bob Church and Tirzah kissing.[63] Always prey to vivid dreams himself, Ravilious imbued the panels, which include a running Tirzah and a courting couple, with 'an element of drama, perhaps extending the suppressed sexual tension of the game itself ... the apparently anodyne content was placed on the plane of dreams'.[64] Several stays at Oare now gave access to the Wiltshire Downs as well as subject matter in the vicinity of the

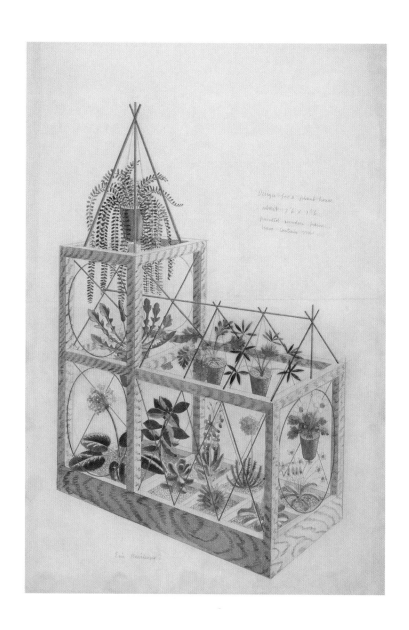

3.22
Eric Ravilious,
Design for a Plant-house,
watercolour, 1932.

3.23
Paul Nash, *Greenhouses*,
lithographed poster for the Empire Marketing Board, 1930.

house itself. In June 1932 he painted *The Strawberry Bed* (fig. 4.1) there, a water-colour drawing of delicate structural precision and tonal range suggestive of masterpieces to come. After completion it hung in the Frys' London apartment, appearing 'not for sale' at Ravilious's first one-man show.

The second destination was Great Bardfield. In August 1930, Bawden, happening on an empty house and barn near Finchingfield for rent at £40 a year, had 'addressed a pro-Essex campaign to Eric & Tirzah Ravilious, Barnett and Claudia Freedman' and their college friend Beryl Bowker.[65] The notion of getting an inexpensive shared rural retreat for use at weekends and for holidays was born and the following spring Bawden and Ravilious reprised their previous expeditionary activity, hiring bicycles at Dunmow before exploring the Essex countryside. By midsummer day 1931, half of Brick House in Great Bardfield's High Street had been rented weekly from a Mrs Kinnear, and Ravilious was asking Gibbings to write 'to my Essex address'.[66] Brick House would be Bawden's home for thirty-nine years, and, over the next three, Eric and Tirzah would spend extended periods there – the place itself an inspiration for new work, village life a counterpoint to the London scene, and the house a significant crossroads in the evolving pattern of friendship.

BRICK HOUSE

'He has formed his personal style, a style which is essentially contemporary, but owes nothing to Cezanne, Picasso and the other great forces of the modern movement.'[1] A year before making this statement, Douglas Percy Bliss had written that Ravilious, although already an engraver of rare quality, was yet to mature as a painter. But now, in December 1933, he reversed this proposition: he felt Ravilious was still achieving 'certain textures which no other engraver has devised', but also that his friend's latest designs had less impact than others appearing at a 'wonderfully good' annual SWE exhibition at the Redfern.[2]

By contrast, the week before, Bliss had found the watercolour drawings on display at Ravilious's one-man show at Zwemmer's a revelation: 'captivating in their quiet elegance, their complete absence of haste'. He was enthused that his friend was now marking out his own territory:

He draws landscape, buildings, and odds and ends. He never sits down to draw the sort of view that ninety-nine out of a hundred watercolourists cannot resist, Corfe Castle, for example, or Salute from across the Canal at Venice. Several of his best drawings here are of motor tractors, tarpaulin-coated; one is of an attic floor covered with apples, another of strawberry beds with their nets seen against the sky. He draws not as painters do, but like a designer, using clear and simple conventions, and concerning himself with line and pattern rather than with tone and form. Working over a careful pen or pencil basis, he never carries his colour to full strength; preferring to tint and to suggest, rather than to lose his grace of line under an assertive colour scheme. The only drawings that I can think of that have something akin to this gentle lyricism and clear, fastidious patterning are those of John Nash.

Bawden and Ravilious held their first one-man shows virtually back to back at the same venue, with Bliss the only critic to review both, and Bawden's,

4.1 & 4.2
Eric Ravilious: *The Strawberry Bed* (above), watercolour, 1932;
and *Talbot-Darracq* (below), watercolour, 1934.

which opened first, attracting slightly more attention.³ In *The Times* Charles Marriott welcomed Bawden as 'one of the fortunately increasing number of young English artists who are content to shape their own response – with all it implies of circumstantial interest – to the native landscape instead of forcing it into a foreign mould ... in a sense the subjects are trite – as Essex is rather trite – but the rendering of them is poetical in the same way as Crabbe is poetical'.⁴ P. G. Konody, the leading critic who in 1927 had found their work derivative of Paul Nash, was too ill to visit the gallery (Tirzah recorded his death in her diary soon after Eric's own show opened), but a stand-in *Observer* reviewer praised Bawden's 'enviable freshness of vision and poetic imagination' brought to bear on 'the most commonplace cottages, barns and backyards, village streets and country roads'.⁵

Bliss opened his review of Bawden's show noting his reputation as 'a brilliant industrial designer and book designer' who always sought 'the cleverest way of expressing a thing, and has often found it'.⁶ Having observed that London now hosted a suspiciously large number of 'primitives' affecting a 'child-like innocence of vision', he affirmed 'Bawden, emphatically, is no false "*naif*". His vision of the world is not so much child-like as narrow and detached. It is, withal, intensely individual and highly humorous ... he simply cannot resist cramming his pictures with clever mannerisms and cutting pictorial capers in every corner. He looks around his Essex landscapes wide-eyed and eagerly, but he sees it as no one else would ... preternaturally bright and clean and colourful'.

As Bliss told his readers, Great Bardfield and its immediate surroundings were Bawden's 'home country', but with subject matter for over half Ravilious's watercolours also drawn from there, the two shows testified to the extent to which it had been shared territory for two and a half years. It was a period of comradely competitiveness and unselfconscious bohemianism that had yielded a rich artistic haul.

* * *

For the first six months, beginning in mid-1931, Mrs Kinnear charged 7s 6d a week for use of two downstairs rooms and two upstairs bedrooms, shared use of the kitchen, outside toilet and large overgrown garden accessed via a long strip of land sandwiched between neighbouring properties. Behind Brick House's prim three-storied exterior 'of red and black brick with a mansard roof and a row of posts along the front connected by chains', water was pumped from the well and there was no electricity – but, with a landlady

4.3
Eric Ravilious, Kynoch Press notebook vignettes,
wood engravings, 1932.

happy to let out further rooms, there was plenty of space for visitors, a sense of freedom, a river just beyond the back boundary, and a wealth of rural subject matter to hand.[7]

One of the first visitors that summer was Charlotte Epton; by autumn she and Bawden were engaged, and by November negotiations were under way for Edward Bawden senior to purchase Brick House in his son's name for £490. Charlotte's solicitor father acted for them, with Charlotte deputed to make a plan showing a right of way through the adjacent police station and a plot of grass to the rear. The purchase was completed in December, allowing the two couples, with Bawden in the lead (but with Eric 'keeping a discrete hand over Edward's rococo spirit'), to begin putting a decorative stamp on the whole place well before the intended spring wedding. Given Edward's clandestine style of courtship, it was a sudden development, welcomed by those with his interests at heart, Harold Curwen, for example, writing: 'I'm so very glad to think of you having a mate and hope you'll bring her down ... when the first twig in the forest shows a bud.'[8]

Eric and Tirzah had spent a wet holiday at Bardfield in August and September during which there were unseasonal hailstorms, a nearby barn blew down, and a turtledove with a broken wing appeared; but there were also welcome visitors from the RCA diaspora. Ravilious sketched Beryl Bowker easel painting in the lettuce patch while 'braving the elements'; another arrival was Gwyneth Lloyd Thomas, Charlotte's friend and former colleague at Cheltenham Ladies' College, recently appointed an English don at Girton College, Cambridge. Eric engraved a bookplate for her based on a local pond – an image that he himself gently mocked as 'a last year's birds-nest growing leaves' – perhaps his first engraving completed at Bardfield and a forerunner to the series of rural vignettes, Bewick-like in scale and feel, which he would undertake the following year.

Other visitors included Barnett Freedman and George Branson, but it was Mrs Kinnear's chance letting of a room early in September 1931 that brought a new person into their lives, an artist who already knew Ravilious and Bawden's work from their St George's Gallery exhibition. As Bawden recalled many years later, Thomas Hennell arrived one evening in Bardfield on his heavy old-fashioned bike with a massive Lord's Table corn dolly attached to its frame. The next morning, when Eric and Edward entered the kitchen, they found a figure washing at the sink, stripped to the waist, who greeted them with a 'deep booming parsonic ring, which echoed even more loudly when he laughed ... our identity was divulged in a matter of seconds and friendship established immediately'.[9]

At the time Hennell was in pursuit of the ancient custom of gleaning by the rural poor after harvest and his own references to its survival in surrounding parishes allow us to date this encounter.[10] He had spent much of the previous year on the road – possessions bundled into a carrier at the back of his bike, edible and artistic supplies in his poacher's pockets – documenting disappearing agricultural ways; in a *Countryman* article that summer, he had written how 'travelling is as interesting in proportion as it is cheap'. He would start looking for lodgings at dusk – a strategy that could go awry as 'quite half of the village landlords to whom one applies will have nothing to do with casual comers who arrive late, and say either "Full up" or "Don't put up strangers here"'.[11] Consequently he had spent many nights squatting in barns under an army blanket, but still felt 'given a fairly good night, nothing is more delicious than to wake up among the fields and trees, in the twilight of a summer dawn'. Luckily for posterity, Mrs Kinnear was of a more accommodating bent than the average Essex lodging-house keeper.

4.4 & 4.5
Thomas Hennell: *Hampton Row* (above), watercolour and ink, 1932;
and *Sheepshearing at Berwick Hill Farm, Lympne, July 6 1931* (below), pen, ink and wash, 1931.
Hampton Row is a typical example of Hennell's painting style prior to his breakdown.
Sheepshearing is one of many such drawings he made while journeying
across southern England while preparing to write *Change in the Farm*.

4.6

Edward Bawden, *They dreamt not of a perishable home, who thus could build*, watercolour, 1932.
Exhibited at Zwemmer's in 1933, this watercolour depicts Elisha Parker
and Eric Townsend repairing the roof of Brick House shortly after its purchase.

The three men who met at the sink had all been born within four months
of each other in 1903. Like Bawden and Ravilious initially, they already had
much in common, although Hennell, a rural parson's child, was deeply, if
idiosyncratically, religious. His own boyhood agonies had been endured
amid the vicious hierarchies of a minor public school rather than in a chapel
setting, and, unlike his new RCA friends, he had subsequently studied at the
less fashionable Regent Street Polytechnic. Bawden would later reflect that
Hennell had no great natural facility but in time succeeded to the first rank of
watercolourists through single-minded application. He was indeed an incred-
ibly diligent student, visiting Laurence Binyon's British Museum Print Room
collection fifty-seven times in four years to garner a thorough knowledge of
art history, and the Reading Rooms to study fifteenth- to eighteenth-century
literature, enquiries marked by a delight in the obscure not dissimilar to that
of Ravilious.[12]

While qualifying as a teacher Hennell had fallen heavily under the influ-
ence of Marion Richardson, twelve years his senior and already a celebrity
known for her progressive approach to children's art; teaching in Bath,
he had kept in touch with her. Although his student nickname was 'Turner',

he too had been influenced by Paul Nash. Consequently his style of water-colour painting in 1930–31, involving under-drawing in pencil, ink additions and carefully delineated areas of colour, was probably as close as it would ever be to Ravilious's own methods. Works from these years are far removed from Hennell's later style generated by working at speed to 'surprise his subject' and capture light, the weather and the natural world by 'kissing the joy as it flies'.[13] This technique would emerge only after a period of deep personal crisis, initiated by an approaching breakdown, unheralded during seemingly carefree visits to Brick House over the following ten months. In this period he completed, in prose and precise line drawings, the record of vanishing tools, vehicles and rural practices later published as *Change in the Farm*. As the editor of his poems would later write, Hennell was unlike many ruralists: he could not only tell a plough from a harrow, he could indeed tell a plough from a plough, and the corn dolly that caught Bawden's eye on his first appearance was destined to appear as a prop during 'Men of Straw', a lecture he gave to the Newcomen Society two months later.[14]

Bawden created a well-known image of Hennell at Brick House, a line drawing of himself, Tom, Eric and Tirzah, drinks before them, sitting in the garden as if waiting for lunch to appear (fig. 4.8). Almost certainly recalling a real occasion, Charlotte's absence probably reflects her presence in the kitchen as the practised provider of delicious vegetarian food to the collective. Used as an illustration for a book published in November 1932, 'May' is one of a series Bawden created in summer 1932 drawing on life at Brick House and its Essex surrounds. Muriel Rose, for whom Bawden was producing Little Gallery promotional material, recalled visiting Bardfield that year with Enid Marx during 'perfect summer weather. We all bathed in the Pant at the bottom of the adjoining farmer's field, where a bend in the river enclosed a plantation of slender willows ... Edward made a number of drawings of our doings, which he used as decorations for Ambrose Heath's *Good Food* on which he was working.'[15] A picnic by the Pant illustrates June, and April features the same interpretation of Bardfield's pond as Bawden's watercolour drawing exhibited at Zwemmer's. Foreshadowing a later lithographed linocut, March features Braintree cattle market, and February a tarpaulined tractor recognizable from Ravilious's watercolour drawings of the time.[16] Venturing further afield, Bawden's June comic headpiece of enmeshed pickers playfully mocked Eric's recent watercolour *The Strawberry Bed*.

In her *In Memoriam* broadcast sixteen years later, Tirzah recalled how at this time the two friends 'competed with one another in conditions of various

4.7 & 4.8
Edward Bawden: *Turning While Your Bones Last* (above), watercolour, 1933;
and *Illustration for April* (below) in Ambrose Heath's *Good Food*, line drawing, 1932.
Bawden drew repeatedly on local motifs, such as the pond at Great Bardfield.

4.9 & 4.10
Edward Bawden: *Illustration for May* (above), line drawing, 1932;
and *Illustration for June* (below), line drawing, 1932.
In May, Hennell is pictured seated opposite Tirzah Garwood,
with Bawden and Ravilious in the Brick House garden. June is Bawden's
satiric take on a subject his friend had recently painted; see fig. 4.1.

hardships, such as ghastly weather or working with the sun bang in their eyes. They painted several pictures very early in the morning from the roof of their house, and on one occasion had to come down, nearly overpowered by the smell of kippers cooking for breakfast ... They always worked very hard and got up very early in the morning.'[17] Brick House was run down on purchase and roof repairs were urgent. Bawden recorded the scene in a 1932 watercolour, which shows local builders Elisha Parker and Eric Townsend at work (fig. 4.6). Views over the yard and garden from this vantage point became the subject of several works by both artists, notably Ravilious's *Prospect from an Attic* and Bawden's *Back of Brick House*.[18] Meanwhile Charlotte, seen giving a carpet a backyard beating in *Prospect*, took the major role in clearing out and setting to rights Mrs Kinnear's malodorous half of the house; soon after, as a wedding present, Eric designed a trellis gazebo, subsequently featured in his painting *Garden Path* and Edward's *Derelict Cab*.

The spring and summer of 1932 were probably the best of times at Brick House in its shared incarnation and it was to something of a honeymoon atmosphere that Hennell, sexually inexperienced and lacking his own mate, became a frequent visitor. Tirzah records Hennell drawing inside the old dovecote at Bardfield, and he found other rural subjects nearby, including at Great Lodge where Eric also painted *Friesian Bull*. An admiration for Thomas Bewick was a shared enthusiasm,[19] and Ravilious was at this time working on the forty headpieces he cut for the 1933 Kynoch Press Notebook. The vignettes not only feature many identifiable Brick House and Bardfield subjects, but are also Ravilious's most concentrated and perfect echo in modern form of his great predecessor. Intriguingly, a list in Tirzah's hand at the back of her copy of a 1932 Kynoch Press Notebook, no doubt drawn up for discussion at the outset of her husband's commission, canvasses over forty possibilities for vignettes, including Brick House at night, greenhouses and a dovecote.

Another concurrent job was the frontispiece for *Consequences – A Complete Story in the Manner of the Old Parlour Game*, one of the last books published by Robert Gibbings before he relinquished control of the Golden Cockerel Press. Playing into a passing fashion for collaborative fiction, it was a success when published in both a limited and a popular edition in autumn 1932. Home-grown parlour games were much in evidence at Brick House itself and, before Hennell's visits to Bardfield ceased in late June or July that year, a fellow visitor was Gwyneth Lloyd Thomas, a prime mover in the household's 'Lady Filmy Fern' game. Much later Bawden would encourage a recovering Hennell to write down a narrative version – and in the late 1930s Lloyd Thomas and

Hennell would correspond about literature as she herself was beset with depressive illness.[20]

One can only speculate to what degree exposure to the relatively liberated Bardfield scene, and his close involvement with newlywed couples as an observer at the feast, may have been a trigger, but something now compelled Tom Hennell, unworldly as he was, to bring matters to a head with Marion Richardson. Previously unaware of his romantic fixation and unspoken desires, she brusquely dismissed a completely unexpected proposal of marriage – 'What! Should we both sleep under the hedge?' – and this rejection proved a prelude to the major hallucinatory psychotic breakdown into which Hennell now tumbled. On 30 August 1932 police picked him up in a distressed state on the Great West Road and the next day he was transferred to St John's Hospital, an asylum near Aylesbury; from there he was returned briefly to his parents' home at Ash before entering Maudsley Hospital at the beginning of a three-year incarceration. Eventually, with Bawden's encouragement, he would vividly describe this experience in the opening chapters of his remarkable book, *The Witnesses*, but for now he disappeared from Bardfield and his friends' lives.

* * *

Many words have been written to the effect that Tirzah Garwood 'did no more engraving after her marriage' and that, once occupying the role of supportive wife and future mother, 'perhaps the medium of wood-engraving was too exacting to combine with the domestic chores which she never found easy or congenial'.[21] The tendency of the careers and reputations of accomplished women to be eclipsed by those of their equally, less or differently talented male partners was a pronounced one in interwar artistic circles. It is a phenomenon still to be comprehensively analysed, but clearly social expectation, available opportunities for teaching and commissions, and the habitual balance of power in heterosexual relationships all played their varying parts in differing situations – even in those where, unlike the Brick House milieu, more self-conscious 'experiments in living' were pursued as an article of faith.[22]

In Tirzah's case there was no sudden turning away from engraving, the medium in which she had proved so adept. Marriage in 1930, when her broader reputation as an illustrator was on the cusp of becoming established, did however coincide with a decline of private press opportunities and a retreat by general publishers. The 'gimlet, satirical eye of the young artist' was once again in evidence in her book frontispiece for L. A. G. Strong's

4.11 & 4.12
Eric Ravilious, Frontispiece for *The Hansom Cab and Pigeons* (left), wood engraving, 1935,
and Tirzah Garwood, Frontispiece for *The Big Man* (right), wood engraving, 1930;
two books authored by L. A. G. Strong.

The Big Man, one of her three exhibits at the SWE's December 1930 exhibition; another was 'The Wife' from her *Relations* series.[23] Her evocative engraving of the Brick House kitchen (fig. 4.16) probably dates from 1932 and her diary allows us to date execution of her *Cactus Plants* engraving to January 1933. This is one of her meticulous engravings of plants, insects and wild creatures bearing comparison with the celebrated John Nash horticultural series *Poisonous Plants*.[24] Another large block, *The Man Who Was Answered by His Own Self*, was cut in January 1935 – the year that Ravilious was commissioned to provide illustrations for Strong's Silver Jubilee offering *The Hansom Cab and Pigeons*.[25]

Tirzah's diaries give details of sums received by her and Eric and some insight into their changing sources of income. Eric's £54 per annum from the RCA was sufficient to pay half the rent in Hammersmith but, in the absence of any major commissions, an accumulation of smaller jobs was required for living and enjoying life in town; fortunately, Eric's reputation, boosted by the Morley College murals and his erratically remunerated Golden Cockerel work, was sufficient to win further work even in a declining market. Completed as Tirzah was working on her *Cactus* drawing, his four illustrations for *The Jew of Malta*, for example, brought in £16 10s 0d from Christopher Sandford at the Golden Hours Press two weeks later. But that was one of the larger of many one-off jobs and Eric lacked the continuing commercial income streams that Edward, now an owner-occupier increasingly anchored at Bardfield, could rely on.

Building on the success of the London Underground posters, the Curwen connection had by now added Westminster Bank, Shell, Twinings, Fortnum & Mason, the Ministry of Agriculture, BP and the BBC to Bawden's roster of clients. Between them they commissioned at least eighty-six line drawings, advertising in print his singular, playful sardonic humour. When he drew a malign grim reaper to promote their services, the Royal Assurance Company declined to repeat the experiment, but most clients, once acclimatized, became repeat customers: the thirty-five-strong *Shell on the Road* series, running from 1932, became so popular that it spawned a children's book, *Well on the Road*, sporting one of the lithographed linocut covers now regularly featured in Bawden's work.[26]

Meanwhile, in July 1932, Ravilious had his first contact with Oliver Hill, the architect supervising construction of a modernist replacement for Morecambe's Midland Railway hotel. Having hired Eric Gill to provide some sculpture and decoration in the reception areas, Hill was seeking an artist to create murals for the wall spaces in its largely steel and glass tea rooms,

a substantial commission to which Ravilious responded: 'Of course I should be delighted: work of that particular sort comes along so rarely.'[27] In October he began developing cartoons showing 'a seaside, gay with concrete steel and white concrete buildings, a circular tower with a winding staircase and numerous diving boards'; in the portion representing day 'the sun shone brightly and flags waved from the seaside architecture and at night, there was a splendid firework display in progress'. By December the designs had been accepted and, with the prospect of a lengthy assignment ahead, Eric then negotiated for Tirzah to accompany him as his assistant.

After brief stays at Bardfield in February and late March 1933 and, in London, a hectic round of teaching and jobs, openings, dinners and cock-tails, cinema and theatre trips, hosting of a Boat Race Tea and subletting of the Upper Mall flat, they arrived in a rain-soaked Morecambe on 10 April, the eve of Tirzah's twenty-fifth birthday. After a couple of false starts they found lodgings along the coast at Heysham, away from the dreary out-of-season town and the half-demolished former hotel. It proved to be the beginning of a frustrating four months, dominated by the difficulty of painting on uncured, bleeding plaster surfaces, parts of which had to be stripped and begun again no fewer than four times. Eric returned to London to teach on seven occa-sions, leaving Tirzah working alone for two days at a time, and their progress was hampered by an absent architect and builders still struggling to complete the tea-room floor and ceiling. As Tirzah remembered: 'Eric fumed at hav-ing to waste so much time when he was longing to paint watercolours and be away from this ugly place but nobody seemed to care when we complained that the painting hadn't a hope of lasting, so long as it looked all right on the opening day ... there was nothing for it but to go on drying the damp wall with our overalls before working on it and hoping for the most improbable best'.[28]

A trip to the Lakes, local walks, billiards, films and a visit from titled friends of the Frys provided diversions, and in the final days at Heysham, Ravilious got a start on four good watercolour drawings; but all in all it was a difficult time. Despite repainting the following year, the sparkling murals they had cre-ated as a foil to the seascape outside would survive for only two years. At the opening on 12 July 1933, a week after their third wedding anniversary, Eric and Tirzah concluded they had never seen 'a room full of more unattractive busi-ness toughs. Their suits were black and smart and their faces narrow and alert: money, position and success their only goal.' The speeches at least were amus-ing in that they 'almost openly said "we don't like this hotel ourselves, but we hope to attract Americans with it"'.

4.13
Tirzah Garwood and Eric Ravilious
at work on the Morecambe murals, June 1933.

Two weeks later, after visiting Eastbourne, they met Edward at Liverpool Street, returning to Bardfield by the evening bus at the outset of an extended stay. Despite summer drought, they found the garden at Brick House fecund and transformed: after benefiting from heavy digging that spring, when Edward had been helped by Charles Mahoney and Geoffrey Rhoades, it now reflected Charlotte's love of flowers and his penchant for giant architectural plants. Two days later, Tirzah noted 'Eric sketching in the Engine Yard', the first diary reference to a three-month burst of activity during which Ravilious created most of the watercolour drawings exhibited at his first one-man show, four of which featured discarded farm machinery accumulated in the nearby yard during the agricultural depression. The following week his subjects included the village school with a bungalow under construction and on August Bank Holiday Saturday *Tree at Pink Farm* (probably exhibited as *Field Elm*).

On the afternoon of Bank Holiday Monday, Robert Wellington arrived to stay the night. The twenty-three-year-old director of the Zwemmer Gallery, son of their old RCA Registrar, was well known to Eric, and an earlier visit in March was probably the occasion when firm plans had been made for one-man shows at the end of the year. The opportunity was enticing because, apart from mounting 'Room and Book', 'Artists of Today' and Freedman's first show, the Gallery in Litchfield Street was now a prominent venue, having gained additional kudos with exhibitions of contemporary continental and avant-garde English art. The previous winter Edward had been ill with mumps and influenza but had since been turning out works with his show in mind, and Eric was now clearly producing against the approaching deadline.

Wellington, however, could be tactless and as Tirzah recalled they 'were made so miserable by his attitude towards their work before their shows that the whole house was filled with gloom'; nevertheless, on the day he departed, she noted 'Eric very hard working and engrossed in water colours'.[29] Gwyneth Lloyd Thomas came to stay twice in quick succession and, to the mild annoyance of some of that autumn's reviewers, used her knowledge of George Herbert and other English poets to help Bawden select ironic quotations as titles. Appending 'Christ I have been many times to Church' to a watercolour drawing of Lindsell Church no doubt lifted household spirits, the whole exercise gently mocked on Bawden's catalogue cover with: 'My thoughts began to burnish, sprout and swell / Curling with metaphors a plain intention / Decking the sense, as it were to sell.'

The Monday following the bank holiday brought a new person to Brick House for a six-day stay and, with her arrival, a significant test of Eric's fidelity

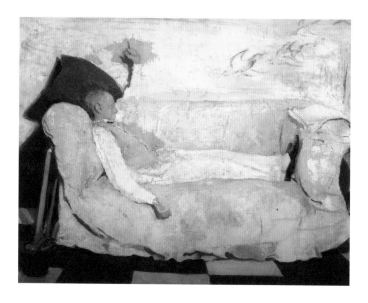

4.14 & 4.15
William Nicholson, *Portrait of Diana Low* (above), oil on canvas, 1933.
Diana Low, *Portrait of William Nicholson* (below), oil on canvas, 1932.

to Tirzah and their marriage. Twenty-two-year-old Diana Low was invited down for a holiday by Charlotte who, with Gwyneth, had taught her as a teenager at Cheltenham, and subsequently kept in touch with her while she was studying at the Slade and in Paris. As a young oil painter Diana was heavily influenced by William Nicholson, a family friend with whom she had a short-lived affair after leaving school – a liaison memorialized in his stunning portrait of her, challenging in her gaze, and her painting, in his style, of his sixty-something form slumped unappealingly on a sofa. Now living back in London, she had become part of a sophisticated bohemian set revolving around the Architectural Association, which included her sister Lolly, Humphrey Spender, her future brother-in-law, and his poet brother Stephen.[30]

Tirzah, with characteristic directness, recorded Diana's arrival in her autobiography: 'she was very attractive in a feline sort of way and she had a lovely figure and fair skin. She was full of energy and dived beautifully, but perhaps her chief charm was her naturalness and she dressed more beautifully than any other woman I have met. Eric fell in love with her at once and it seemed quite natural after what Charlotte had said (about Diana being "a naughty girl") that she should take him off in her car for a day's painting.' Tirzah was initially sanguine about how a guilty Eric subsequently showered her with criticism for being no fun, doing too much housework and lacking her own initiative. Over the course of the following six months, however, when Eric continued to see Diana in London, Tirzah arrived at a point where she felt keenly the loss of 'that feeling of being a part of him that for four years had been so precious' and that 'something had changed in our relationship to one another which would never be restored'.

At the artistic level, Diana's influence on Ravilious was manifest that summer as her own approach to colour briefly encouraged him to adopt a bolder palate in a series of pictures painted freely with quite wet watercolours.[31] Four of these, all featuring farms within striking distance of Bardfield, together with *Drought*, set in a sandpit where he painted later that August, were included in the Zwemmer's show and were probably among the nineteen works that Tirzah noted he had ready at the end of September. They were not, however, the ones that struck Bliss, Horton and other friends as signifying their friend's arrival at a style of watercolour drawing both contemporary and recognizably his own. Of these, the creation of *Apples and Walnuts* can be traced to late September and the painting of *The Stork at Hammersmith* (fig. 4.21) to a mere five days before Eric's private view in late November.[32]

4.16 & 4.17
Tirzah Garwood, *Brick House Kitchen* (above), wood engraving, *c.* 1932.
Eric Ravilious, *Two Women in a Garden* (below), watercolour, 1933.
Ravilious shows Charlotte Epton reading and Tirzah Garwood
shelling peas or beans in Brick House Garden.

Four weeks before this, Enid Marx had mounted her own private view for an exhibition displaying her latest hand-block 'printed stuffs'. Held at her studio workshop in St John's Wood, it overlapped with a display of her material at Zwemmer's accompanying Edward's show – one more event in a busy time which for Marx included a life-changing encounter of her own. Before her sister Daisy's death she had become friends with Joyce Fleming, another French linguist, and more recently had been visiting her at the Mary Ward Settlement where Joyce's father was Warden. At the time, the writer Francesca Allinson was teaching a Thursday evening Music Appreciation course at the Settlement and, as Marx later wrote of her first meeting with her life partner Margaret Lambert:

> She and Francesca Allinson had been at Lady Margaret Hall together. Etched on my memory is the first time I saw Margaret. I saw her walking across the room where we were all drinking coffee, wearing a red suit and matching toque hat, looking so well-bred and so absolutely vague, until she almost accidentally bumped into Fresca and then we all entered into conversation as though we had all known each other all our lives ... Margaret had been called in by a colleague who knew her from Oxford and knew she had made some masks. At the time I was trying to do some masks for Anthony and Cleopatra and badly needed her to show me how to make them. Margaret taught me how to do this and we together managed to put on Anthony and Cleopatra and I think the whole cast was clothed for £5 in calico, organdie and Woolworths jewellery and ornaments.[33]

Very satisfyingly, and to Wellington's pleasant surprise, twenty-four of Bawden's thirty-one watercolours, priced at 10 guineas apiece unframed, had sold by the time his three-week exhibition closed and the reviews had enhanced his reputation as a painter. It must have felt a hard act to follow. With less than three weeks to the 24 November opening, most of Ravilious's pictures were at the framers, but quite a few arrived there with barely a week to go. Preparations, aided by Tirzah, went down to the wire and RCA teaching commitments were postponed. On 17 November a private view card bearing one of Ravilious's most beautifully engraved abstract devices was posted to friends and connections – several decorations in similar spirit appearing as illustrations in *Fifty-Four Conceits*, the Martin Armstrong book he was working on in parallel. The Friday night opening was followed by a celebration dinner in Greek Street, remembered as marvellous by Tirzah, and the next

day Zwemmer's was hopeful about sixteen possible sales. Over the next three weeks this tally edged up to twenty actual purchases and was further enhanced soon after when the connoisseur Sir Michael Sadler bought one of the Heysham pictures, *Buoys and Grappling Hook*, for his private collection.

After deduction of commission, Bawden had made £158 and Ravilious £137 from their respective shows, a confidence-instilling exercise that was a precursor to a new phase in Ravilious's watercolour drawing; a year in which he would repeatedly demonstrate, as observed by Bliss, that he had now developed a unique contemporary style. By the following autumn Wellington was warming to the idea of holding a Ravilious exhibition at least every three years and holding stock in the gallery with a view to selling eight to ten pictures a year: 'there seems no reason why your drawings should not bring in a definite income each year ... it may be small, but it seems the time spent on them is not entirely a luxury, as it has rather tended to be in the past'.[34]

* * *

New Year 1934 brought another visitor to Brick House whose arrival would change the shape of days ahead. Peggy Angus had been one of the last visitors through the door at Bawden's exhibition and, although she had once bumped into Eric crossing Westminster Bridge near Morley College, it was over seven years since she had seen Edward. After the RCA and her father's death, necessity and a lack of illustration work had led to four years teaching in Nuneaton and then, soon after Ravilious had left for London, a subsequent switch to another girls' school in Eastbourne, the genesis of her own long-term attachment to the Sussex Downs. Strong-willed and already an inspiring art teacher, Peggy had continued to pursue her own painting in the interim, both her portraiture and landscapes benefiting from Percy Horton's encouragement when she joined several painting holidays he organized. Now teaching back in London, she and Helen Binyon had just rented a flat in Belsize Park, which they had livened up with a frieze of Bawden's Shell-on-the-Road drawings culled from newspapers. Now, liking what she saw at the exhibition but unable to afford to buy anything outright, she wrote to Edward asking whether she could buy one of his paintings by instalments.[35] He responded by asking her down to Bardfield, where she arrived to join a house party that included Diana Low making a return visit.

Brick House was still a work in progress (that week Tirzah was engaged in scraping and painting the bannisters), but Peggy's recollection of it, as summarized for Helen Binyon forty years later, gives perhaps the best description

4.18
Leaves from Peggy Angus's Soviet sketchbook, watercolour, 1932.
Leningrad Embankment (above) and *Musical Interlude at a Pioneer Camp* (below).

of its decorative order towards the end of its shared incarnation: 'There were lozenges of marbled papers, repeated as patchwork patterns in the hall and the passage; the dining room had a wall paper of rubbings from brasses, the parlour made her feel she was in a cane structure, with bird cages and birds everywhere, and a bedroom had become a striped tent, draped up to a centre point ... [in] the room she slept in ... Edward Bawden had made a screen of beautifully arranged pages from illustrated letters, with tantalising indiscretions here and there. It was not in the least like any house Peggy had ever been in.'[36]

Peggy herself was very different from the youngster they had known at South Kensington and much more overtly political than nearly all their close friends. Eighteen months before she had been part of a trade union delegation to the Soviet Union and, although romantic and inconsistent in her politics, she was highly aware of international developments after travels in Austria and Germany. Since returning from Russia, although the Communist Party had resisted her attempts to join up, she had contributed cartoons to the *Daily Worker* and visited Downing Street, where her friend Ishbel's father, Ramsay MacDonald, was now back in residence after Stanley Baldwin's defeat. At the Frys' country house at Oare, Tirzah had observed with distaste people whose 'fear of communism seemed to swamp their natural judgements, and [for whom] anything, even Nazis and Fascists, seemed preferable'; but that New Year she noted 'Peggy nearly converted me to communism'. The same diary entry noted 'Eric Peggy and Diana bathed', a reference to nude swimming in the Pant, by then a summer household staple, but on this occasion a pleasure shrouded in winter mists. Peggy left that day urging them all to visit her at Furlongs, the primitive shepherd's cottage she had been renting for the last six months near Lewes – an invitation Ravilious would take up exactly a month later.

Although they did not move until the following autumn, Eric and Tirzah spent progressively less time at Bardfield in 1934, as it had become clear that sharing a house had run its course. The early weeks of the year, however, were very productive artistically with Eric producing some of his best Brick House watercolours in a concentrated burst. Two days after Peggy and Diana left, Tirzah noted he had finished *Attic Bedroom*, 'a good one', and two days after that 'Eric finished *Garden Path* watercolour also good.' Foreshadowing evocative interiors to come, the first is a painting in which, as Alan Powers has written, 'the poignant potential of the objects, abandoned in a limbo between seasons, outdoor pleasures or anticipated guests, is charged with nostalgia

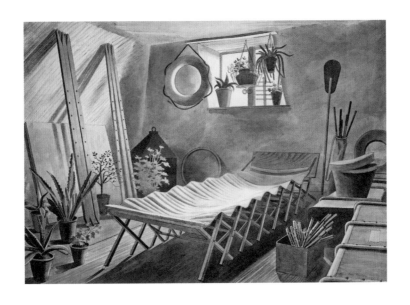

4.19 & 4.20
Eric Ravilious: *Attic Bedroom* (above), watercolour, 1934;
and *Garden Path* (below), watercolour, 1934.

4.21
Eric Ravilious, *The Stork at Hammersmith*,
watercolour, 1933.

as well as absurdity'. The second is a painting that reprises his earlier *Prospect from an Attic* with a simpler content and a tighter viewpoint centred on the backyard gazebo of his own design, resplendent in the winter light.

After success at Zwemmer's, Eric was on a creative roll but Tirzah was now also embarking upon a new path where her talents would bear extraordinary fruit. On the day between the two diary entries quoted above she noted 'marbled' – a reference to an experimental activity which had begun as a joint project with Charlotte and to which Edward's prior technical knowledge, gleaned years before at his Cass bookbinding course, made an early contribution. In recent months Charlotte, lacking pottery facilities, had begun to concentrate on quilt-making, selling over £100-worth at an event in Manchester that October, and Muriel Rose's Little Gallery seemed a possible commercial outlet for not only quilts but also patterned papers.

As Tirzah's friend Olive Cook later wrote: 'She quickly mastered the volatile medium and produced patterns the like of which had never been seen, delicate repeating designs which had nothing in common with traditional marbling. The motifs are nearly always based on natural forms, on leaves, frail flowers and grasses, and the freedom and unpredictable character of the medium imbue them with a tremulous, poetic sense of life.'[37] The year ahead was one in which she would develop great dexterity manipulating colour on the surface of deftly tinted waters before laying on Michellet paper to take the pattern. On the day Eric left Hammersmith to travel down with Peggy on his first visit to Furlongs, Tirzah went out to buy a portable tin bath for marbling, which during 1934 would see service in Essex, London and Sussex.

FURLONGS

An evocative passage from Helen Binyon's *Memoir of an Artist* describes Eric and Tirzah arriving at Furlongs for the first time in spring 1934. After alighting at Glynde station with rucksacks and painting gear, collecting milk at a farm, and crossing the main Lewes to Eastbourne road:

> They continued along a narrowing tree-lined lane, until they reached an open field, with the swelling slopes of the chalk Downs beyond, their rounded tops bare against the sky. They turned to the right, along a deeply rutted track, past a little copse, over which towered the creaking wheel of a wind pump ... Ahead and still some way off, they saw the cottage; it stood squarely above the track [and] seemed to guard the way to the Down behind ... Eric was enchanted by it all and saw subjects for his painting everywhere. The spaciousness and breadth of land and of skies excited him after the more domestic scenes he had painted in Essex, and he felt he had come to his own country ...[1]

That spring Helen was also a frequent visitor to her new flatmate Peggy's rural retreat and, early the following November, it was there she became Ravilious's lover. Her later account of both his response to the landscape and the events of the following three years drew on a mixture of sources: memories of her time with him and their conversations, the impressions of mutual friends recalled years later, and 230 vivid letters he wrote to her.[2]

Although the *Memoir* has Ravilious initially seeing Furlongs in company with Tirzah, he first stayed there alone with Peggy Angus, the two of them almost certainly arriving at twilight or after dark on Friday 9 February 1934. Tirzah recorded him returning to Hammersmith four days later with a drawing of the wind pump and already 'full of plans for future water-colour paintings which he would do there' – plans he began to pursue in early April during a second week-long stay at Furlongs with Peggy and a party including Helen and Percy Horton.[3]

Southern England had been experiencing drought conditions for over twelve months and some 'bleaching' of the downland, which elevates brown and pink at the expense of green hues, was probably already in evidence at the outset of another dry year. This would have further emphasized the unique features of a landscape where to Eric's eye 'the colour [is] so lovely and the design so beautifully obvious'. Before long he was reflecting: 'I wished I liked the Essex landscape as much as I like Furlongs, except for those rather surprising places like the sandpits, it is hard to find country that doesn't remind one of other people's painting compositions with all the ingredients.'[4] (By contrast one visit to Furlongs was enough to convince Bawden that 'the Downs are no use to me for painting'.)[5]

From November 1934, the new home Ravilious shared with Tirzah at Castle Hedingham in Essex continued to give access to 'surprising places' – an engine yard, a brick yard, a water mill, the castle's woods, poultry and pig farms providing local subjects for half the watercolour drawings in his second one-man show held at the Zwemmer Gallery fifteen months later. But it was the places he discovered during a dozen stays and 100 days spent at Furlongs in 1934, followed by five further visits in 1935, that gave birth to a distinct new body of watercolours and a cluster of images for which he is best known today.

<p style="text-align:center">* * *</p>

In spring 1932 Virginia Woolf, looking out from Monk's House in Rodmell towards her former home across the Ouse Valley, wrote: 'They've now run up 3 incredibly vast galvanised sheds at the foot of Asheham ... the entire marsh is commanded by these glaring monstrosities and all my walks that side, not only the downs, ruined ... the view I always swore was eternal and incorruptible'. As the Alpha Cement Works expanded over the next two years amid local hostility, Woolf alternately contemplated moving again, from Rodmell to Wilmington, and consoled herself that 'Maynard says they'll go smash', before becoming reconciled to their presence and writing to Lydia Keynes: 'It's a pity we can't be kissing nose to nose this evening – the cement works are looking positively sublime in the evening light.'[6]

In early April 1934, Angus took Ravilious a quarter of a mile west along the Furlongs track and a similar distance south up over the escarpment to look down on Asheham's moonscape of chalk workings, industrial buildings and dusted vegetation. Excited by the strange scene below with its internal rail system, engine sheds and gantries running from pit to river, they returned after dark to watch work continuing under arc lamps: a manager, 'surprised

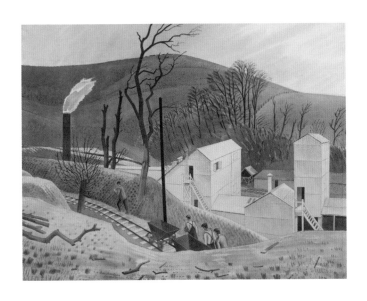

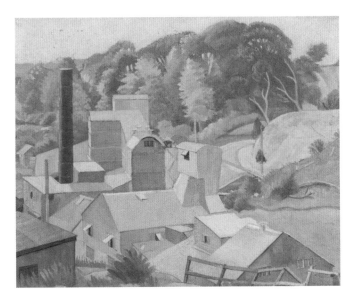

5.1 & 5.2
Eric Ravilious, *Cement Works No. 2* (above), watercolour, 1934.
Peggy Angus, *Cement Works* (below), oil on canvas, 1934.

but pleased to meet two artists who could see beauty in his works', then gave them permission to paint. Intriguingly, Helen Binyon reports Ravilious's enthusiasm in similar terms to those in which Alfred Rich extolled Strood Cement Works, as 'an ever present joy ... the cement seems to get everywhere, not only making the workers and their clothes cementy, but covering with its dust all the buildings everywhere, and even creeping up the innumerable tall chimneys ... now the chief wonder of the place is when the sun shines and the backing of it is cold blue northern sky'.[7]

Peggy and Eric made at least three joint expeditions to the works, often working side by side, two of her oils echoing the viewpoint of Ravilious's watercolour drawings *The Alpha Cement Works* and *The Dolly Engine*. Both *The Dolly Engine* and *Cement Pit* were probably completed in mid-June when Ravilious, staying on by himself after Angus left, enjoyed 'beautiful grey weather of exactly the right sort'. All but one of his five extant Asheham works feature subdued grey or brown skies, helping to emphasize the violent gouging of the chalk downland and the formal geometry of the tin buildings; they also included a new focus on working rather than abandoned machinery, with men glimpsed at work, the natural scene rent by the vast undertaking. But these paintings carry no explicit manifestos; rather, as Jan Gordon would write in an *Observer* review of the second Zwemmer's show in 1936, 'Mr Ravilious's pictures are at once placid descriptions and keen criticisms ... all seize on common things of which most might take notice though few would perceive the artistic possibilities ... witty criticism is always couched in a pictorial way; these are essentially well composed ingeniously constructed drawings of high technical ability. They should satisfy the art-for-art seekers.'[8]

This is certainly true of *Cement Works*, which shares the sharp focus of its peers but is something of an outlier in the series, featuring a chill blue sky and an engine at rest by buildings near the wharf on the Ouse. Deposited at Zwemmer's as stock for occasional sales, it was purchased in December 1934 by Manchester City Gallery. It thus became the first of his watercolours to enter a public collection, but left Eric reflecting to Helen: 'I wouldn't tell anyone else but I don't like selling pictures ... We talked about this problem and you feel the same way about it. John Nash said he hated parting with pictures, and no doubt his percentage of good ones is higher. Mine is pretty low.' Eric had, however, been very positive about Peggy's cement works paintings, two of which were exhibited that September as part of 'The Social Scene', the inaugural Artists' International exhibition held at a large Charlotte Street shop, which Paul Nash also supported.[9]

Just before his first visit to Furlongs, Ravilious had agreed a £50 fee to decorate the tea-room at a rebuilt Colwyn Bay Pier Pavilion with what turned out to be his last mural – an underwater panorama of a ruined palace with seaweed floating through its broken arches. Meanwhile the peeling hotel walls at Morecambe required attention and in early March 1934 Tirzah and Eric spent eleven days repairing substantial parts of their work. They were helped in the task by Jim Richards, a friend originally introduced to Tirzah before their marriage by an honorary Garwood 'aunt' who was a cousin of his mother. Now working at the *Architectural Review* after returning from North America, he had become a frequent visitor to their flat in Hammersmith and was set to play an increasing role in their lives as an occasionally provoking friend and collaborator. An acute observer of other people, if not always a sensitive soul himself, over forty-five years later he would recall Ravilious as a delightful companion with 'an intense appreciation of life's oddities and unpredictabilities', who was 'unusually tolerant of, although detached from, other people's foibles and insufficiencies' but 'who never lost a kind of wariness against all allegiances and personal involvements'.[10] Wariness was not one of Jim's characteristics and, back in London, Tirzah realized her enthusiastic description of Peggy and Furlongs unwittingly aroused instant interest; she and Eric shared a premonition that a relationship between Jim and Peggy was likely to be an ill-starred affair.

After his second visit to Furlongs in early April, Eric spent a week at Colwyn Bay, returning briefly to London before he and Tirzah went down to Furlongs, she for the first time, to join a gathering that included Peggy, Percy Horton, Helen Binyon and Horace Wilmot – the latest of Peggy's unrequited passions, he reminded Tirzah of an effeminate version of her old flame Bob Church. Without electricity or running water, conditions at the cottage were primitive and frequently crowded enough to require the pitching of overspill tents or, weather permitting, sleeping out under the stars on the Downs behind. Horton was a regular at Furlongs that year (he would paint in the immediate area during many of the next fifty years) and a seasoned camper whose presence, as at the RCA, reinforced musical proceedings. On this occasion Tirzah's diary notes the stir he caused by finding a Delacroix drawing marked 4/- in a Lewes shop. Disappointingly, it was subsequently revealed to be the property of Duncan Grant and there for framing, but the incident is perhaps the most tangible illustration of Bloomsbury-in-Sussex's proximity to Furlongs.[11]

From diaries and correspondence, it is clear that Virginia Woolf often passed within five yards of Furlongs' kitchen door when Angus and friends

were staying there as she cycled the five miles from Rodmell to Charleston. But there is not a trace of any social interaction between the two groups over the years – an initially puzzling fact, rendered far less surprising considering differences in age, class and the genres of Bohemianism in evidence. There was indeed a social gulf between the world of Monk's House and Charleston, where self-conscious pursuit of the literary and artistic good life was intermingled with recurrent angst about how to relate to servants and retainers, and Furlongs, where an often chaotic festival of creativity unfolded amid earthen floors, leaking well buckets, and tensions over turns to shop and cook. Both worlds enjoyed a sense of freedom which, as Tirzah put it, 'encouraged people to fall in love', and both began to feel the insistent pressure of international developments intruding on art and creativity as the 1930s progressed – but the two networks, it seems, never overlapped.[12]

'Did Block printing on curtains', Tirzah noted during her first stay, and eight days later 'Helen Binyon took us to Furlongs with my marbling tank' as she and Eric quickly returned for a further ten days. What began as a joint project with Charlotte, benefiting from Edward's suggestions and interest from Muriel Rose's Little Gallery, had now developed into a considerable enterprise for Tirzah who, taking delivery of a large batch of paper in February, had then marbled for five days in a row at the Hammersmith flat. After setting up in the scullery at Furlongs she now marbled throughout the next week and on the following Monday, the last day of her second stay, used a plum-coloured batch to wallpaper the kitchen chimney breast.[13] Helen recalled that Tirzah, although not interested in landscape like the others, was at this time making exquisite studies of found objects. Her eye for nature's patterns is, not surprisingly, evident in the papers she was now producing in abundance.

With the end of their Brick House era in sight, Eric and Tirzah were beginning to hunt for a new rural retreat of their own. That spring, during visits to Bardfield, Tirzah investigated possibilities in Essex and near Cambridge. However, Peggy had already discovered an abandoned farmhouse hidden away in a downland fold beyond the Alpha Cement Works and from Eric's first visit she was urging them to consider it as a possible permanent base in Sussex. Set back from the river valley in a steep-sided combe, Muggery Poke (or Pope) was in very poor condition – a true renovator's delight in a beautiful but highly inaccessible and impractical situation. (Virginia Woolf evidently also discovered it later that year: 'Yesterday I found a new walk, and a new farm, in the fold between Asheham and Tarring Neville. Very lovely, all alone

with the down rising behind ... all ugliness dissolved. An incredibly eighteenth century landscape, happily making me think less of Wilmington'.)[14]

For Eric and Tirzah caution prevailed, but not before Eric had progressed, then sought to destroy, a watercolour drawing of the farmhouse; its remnants promptly rescued by Peggy, it hung on her bedroom wall at Furlongs for fifty-nine years. The week after their move to Castle Hedingham that November, Tirzah noted that Eric spent a day 'clearing up years of drawings' and in her *In Memoriam* broadcast twelve years later that 'Eric showed on average only one out of every four or five paintings he produced, tearing up the failures.'[15] *Muggery Poke* (fig. 5.3) is an intriguing survival that gives us some insight into his threshold for retention at a time when his sureness of touch was rapidly evolving.

It was probably in mid-June 1934 that Peggy and Eric, passing a ditched hollow on leaving the cement works, noticed two abandoned vehicles buried under a jungle of brambles. Unsure whether they were caravans or wagons, Ravilious mentioned their existence to Diana Low when she visited him there that month. At the end of July, writing to alert her about another nearby farm for rent, he told her 'I've bought them, and if they can be put somewhere in the neighbourhood I shan't have to worry about a house for a bit, anyway till next year ... we were going to Wiltshire this week-end but can't manage it because the wagons are all I can attend to just now'.[16] Two days later a local farmer towed what turned out to be ex-Boer War army fever wagons up the track to Furlongs, and shortly after a Lewes carpenter was engaged to start making them habitable, the beginning of a large task that increasingly fell to Tirzah as Eric painted and the Furlongs encampment was further swelled by more than a dozen visitors during a very hot August.

By the end of their six-week stay her oiling, painting, whitewashing, making watertight with canvas, and curtain-making had refurbished one wagon as a studio, its desk positioned to give a prospect of Mount Caburn, and the other as badly needed overspill sleeping quarters (fig. 5.4). Meanwhile Tirzah kept her marbling output going and, ahead of the Little Gallery's Christmas season, was already manufacturing a stock of lampshades, wastepaper baskets and covered boxes; an additional direct commission at this time involved her papering wardrobes for Dorothy Elmhirst, the American heiress and founder of Dartington Hall, who had bought two of Eric's watercolours, *Apples and Walnuts* and *Farmyard*, from the Zwemmer's show.[17]

The long summer holiday at Furlongs had begun with Edward and Charlotte arriving for a five-day stay; a visit that included tea in Eastbourne with Tirzah's

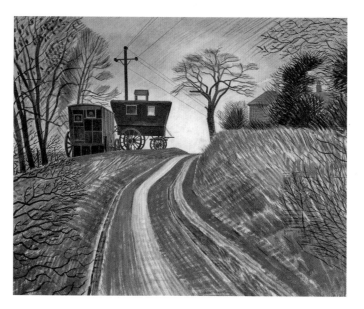

5.3 & 5.4
Eric Ravilious, *Muggery Poke* (above), unfinished watercolour, 1934;
and *Caravans* (below), watercolour, 1934.
Destroyed by the artist, *Muggery Poke* was pieced together by Peggy Angus.

family on Eric's birthday and a trip to Newhaven, a reconnaissance prior to Ravilious drawing there a few weeks later. Peggy's sister Nancy then came to stay; Percy and Lydia Horton arrived with their young daughter Kay to camp; Ishbel MacDonald, once again a resident of 10 Downing Street, and her boyfriend Bert Kelly visited; Helen Binyon was there for the month, her younger sister Nicolette and husband Basil Gray arriving one day for lunch.

Following up Eric's letter about the farmhouse, Diana Low was another weekend visitor; now distancing herself from their affair, she looked back on it, Tirzah perceived, with a degree of remorse. Diana was already close to Clissold Tuely, a young architect she had met through her sister's Architectural Association network and – despite her father's enduring hostility to the match – they married that November, after which Diana's relations with Tirzah and Eric entered a new phase. Another relationship in the making was Jim and Peggy's: 'Dear Peggy Angus,' he wrote to her in the third week of August, reminding her of a party conversation two months before and of his status as 'Tirzah's cousin presumptive'; five days later, he confirmed he would arrive at Furlongs the following Saturday, and that weekend or very shortly after, they became lovers.[18]

Amid all this, Ravilious sustained an extraordinary level of productivity that summer and on subsequent visits during 1935. Five watercolours sold at his 1936 exhibition drew on the immediate surroundings of the cottage, including *Furlongs* with its horse-drawn haywains, *Caravans*, *Shepherd's Cottage*, *Mount Caburn* and *Winter Landscape* – now known as *Downs in Winter* – probably painted in February 1935. Another, *Chalk Paths*, seen today as archetypically representative of the Downs, is reminiscent of several locations between Eastbourne and Lewes but is a realistic representation of none.[19] Rather it is an example of Ravilious the picture-maker, having chosen a specific place as motif (in this case a track immediately east of Furlongs which ascends the downland slope depicted in the middle distance of *Winter Landscape*), re-engineering the topography to achieve the pictorial balance he was seeking. A 'stunner' (which because of commercial ubiquity now struggles to achieve due impact), it has been well described by Alan Powers: 'Roads, chalk paths and chalk pits are engraved through the turf to the whiteness below, their lines helping to structure the depiction of contours, with a wire fence and occasional bushes for counterpoint. This is one of many paintings in which Ravilious makes the most use of barbed wire ... which other painters might simply have omitted as being an intrusion on nature. Its rhythmic dots were a gift for his pattern making and are among the details that help to anchor his work in his own time.'[20]

Waterwheel is another rearrangement to good effect in which Ravilious followed Alfred Rich's maxim that if something was lacking in a scene that attracted, then something should be introduced. The viewpoint along the seductively contoured downland escarpment can be found on the cement works track, evidently a favoured spot for Ravilious; turning 180° reveals it as the location of *Floods at Lewes*. However, the open tract of land depicted in *Waterwheel* never hosted a Dando water pump like the one in a coppice en route from Glynde to Furlongs that he had drawn on his first visit. Ravilious now transposed it as prime actor in an image where technically brilliant surface patterning pulls the viewer's eye horizontally across a rolling mosaic of land, then up to an audaciously patterned 'clever sky'; Tirzah remembered how pleased he was with *Waterwheel* (as were others), feeling it was his best effort to date in painting large expanses of downland.[21] *Firle Beacon*, an untraced painting of cows in a hollow of the Downs, attracted critical approval at the time and may have displayed similar properties.

That summer Peggy, ever hospitable and enthusiastic, found Eric another favoured location, a walled market garden on the Firle Estate. Two of Ravilious's celebrated greenhouse watercolour drawings were begun there that August, perhaps the best known being *Cyclamen & Tomatoes* (bought by the Frys who would a decade later present it to the Tate in memory of the artist), an 'almost impudently successful composition'. Although stripped of its glass in the storm of 1987, the structure still stands intact, bedecked in polythene; each August it nourishes ripening tomatoes amid the symmetries that no doubt elicited a characteristic 'it must be done!' from the artist when he first saw it that summer; next to it, more savagely reduced, are the remains of another greenhouse, the subject of *Cucumber House*, a painting that became the second to enter a public collection after being acquired by William Rothenstein in his role as buyer for Carlisle's Tullie House Gallery. Ravilious also sketched a third structure at this location, a tall lean-to grapehouse some fifteen yards away; two years later, it would provide the material for an early experiment in lithography, itself a try-out for the *High Street* series.[22]

* * *

Twelve years later Tirzah would look back on her lost husband as a man whose 'awareness of his own vulnerability made him careful not to hurt the feelings of other people' and who 'wasn't at all sentimental, but was tremendously healthy in both mind and body and wholly lacking in snobbishness or jealousy'. Sociable and inclined to modesty about his own achievements,

5.5 & 5.6
Eric Ravilious: *Waterwheel* (above), watercolour, 1934;
and *The Cucumber House* (below), watercolour, 1934.

5.7 & 5.8
Helen Binyon: *Farm Bridge* (above), pencil and watercolour, 1932;
and *Pollarded Willow and Shed* (below), pencil and watercolour, *c.* 1934.

Ravilious was fun to be with and made no enemies in artistic circles often riven by rivalries and disputes; both male and female acquaintances clearly delighted in his singular charm and friends were warmed by his authentic love of life. However, it is also clear that his sexuality and his own propensity to fall in love, albeit shot through with that wariness about total commitment that was equally part of his nature, was indeed capable of creating hurt for others, Tirzah in particular. As the emotional complications of the next two and a half years unfolded, there were points at which he was intensely aware that he was acting as both 'cad and butterfly'.[23]

Six months before their marriage in 1930, discussing whether they would have children, 'Eric was very against them ... but he said we might have some in about five years – five years seeming such an infinite distance away'; now in 1934, this issue and hence the future shape of their life together was, it seems, beginning to intrude more insistently. On their wedding anniversary that year Tirzah noted in her diary 'Anniversary of our wedding. Got ticked off for wishing E many happy returns of it.' Five weeks later they were at Furlongs with both Diana and Helen and, recalling this time eight years later, Tirzah remembered wondering 'if he would fall in love with her or if he was still enough in love with Diana to make this impossible'.[24]

Approaching thirty, Helen Binyon was, like her flatmate Peggy, combining part-time secondary-school teaching with her own art, diligently pursuing a wide spread of activities to a high standard without getting consistent recognition or significant income from any of them. After a year in the United States, during which she painted in watercolour, Helen had pursued a copper-engraving course at the Central School of Arts and Crafts, producing a dozen plates ranging from London shops and street scenes and a Paris café (fig. 3.10) to an interior of her twin Margaret hosting friends to tea (fig. 3.11); and a number of rural scenes included *The Ferry* (fig. 5.9), set on the Thames at Bablock Hythe ten miles west of Oxford, which was published in *Studio*.[25] Her evident skill in the medium allowed Helen to convincingly deploy precisely observed objects such as a hawser, a bicycle and background buildings alongside waiting figures based on her family nurse, an uncle and a cousin. This was no mean achievement when many contemporaries often resorted to either caricature or extreme simplification to escape the awkwardness that accompanied their use of a graver to depict the human figure.

In 1932 her skill as a white-line wood engraver led to a commission from a private press for eight illustrations to *Angelina* by Maria Edgeworth, one of which was exhibited alongside Ravilious's 'set of months' at the thirteenth

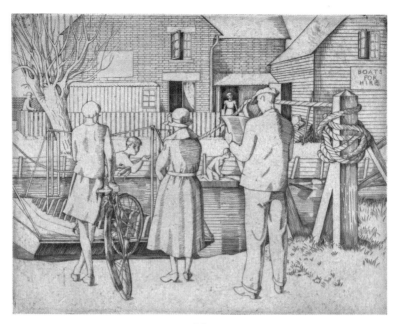

5.9
Helen Binyon, *The Ferry*,
copper engraving, 1930.

SWE exhibition in November 1932.[26] As Richard Morphet has written: 'Her prints are remarkably close in feeling to those of Ravilious and her line engravings of the period bring out at least as strongly a very similar response to the singularity of individual things. As in Ravilious, objects or people do not overlap; the isolation of each permits its structure and its feel to be appreciated. An almost physical delight is conveyed in the coil of rope, the lean and touch of a ladder, the slicing of a haystack and, precisely as in Ravilious, the sensation of crossing a bridge.'[27]

Helen had done little engraving since then, concentrating on making puppets and mounting performances with her twin Margaret, an activity that began in 1930 when they created a show to welcome their parents back from a trip to Japan. Since that time 'Jimini Puppets', with Helen acting as puppet-maker and Margaret as musical director, had become a demanding enterprise involving private and charity events and short runs of public performances. When they played a season of pieces ranging from *Jack and the Beanstalk* to *Orpheus* at a studio theatre in Sloane Square at Christmas 1933, the *Manchester Guardian* had hailed their innovative approach to traditional puppetry as

'among the delights of the town' and *The Times* highlighted Helen's skilled 'carpentry and design'.[28]

Helen had re-established contact with Peggy Angus at the end of 1932, just before a year of family change when her father left his position at the British Museum, her twin married, her younger sister became engaged, and she had to find a new place to live as a result of her parents' retirement to Berkshire. An American suitor was in the wings, but unlike Peggy she seems to have experienced no grand passions and, Tirzah detected, 'she wanted someone a little more exciting than the polite, correct, museum young men that she was constantly meeting at home'. Friends noted that moving into Belsize Park with Peggy had a liberating effect on her and soon after, as one of the earliest visitors to Furlongs in its most primitive infancy, Helen extended her watercolour painting. Her approach was to create a 'water-colour drawing' with precise pencil drawing forming the basis for subsequent colouring, combining fluid tinting with a very carefully delineated structure: from the early 1930s her subjects included landscapes and village scenes exhibiting 'a special enjoyment of interrelated roofs, fences (a key Nash and Ravilious motif) and unpretentious village homes'. She found new subjects near Furlongs: woodland, the farm pond where they went for milk, an orchard, and a smallholding with its outbuildings all feature in surviving paintings. During the summer of 1934 she began to seek Eric's advice and opinion about these 'very pale sensitive pictures'. He in his turn took to sitting next to her whenever he could and often accompanied her on the shopping expeditions that fell to her as owner of a car.[29]

On the last day of their summer stay at Furlongs in 1934 a letter arrived from Edward Bawden – Charlotte was now pregnant – with news about houses for rent in Castle Hedingham, some ten miles from Bardfield; the next day Eric travelled up to London and on to Bardfield. Eric liked one of Edward's suggestions: Bank House in the High Street, available at £50 per annum, less than half the cost of the Hammersmith flat; after Tirzah saw it a week later, they agreed to lease it. The previously postponed visit to the Frys at Oare occurred over the intervening weekend, Tirzah recording it as the possible start of her own pregnancy. When Helen wrote during that week inviting them both to visit her at her parents' house in Berkshire, Eric replied: 'Bank House was not to be missed ... We should love to come and see you. May the visit be at the end of next month when we have moved into the new house ... perhaps I'll see you in London when the teaching begins again and can ask you then. If you invite me to Belsize Park I shall make an omelette.'[30]

Eric duly visited Peggy and Helen's flat after the opening of an art show at Henrietta Barnett, the school where Peggy taught in Hampstead Garden Suburb, and then on the last weekend in October, Eric and Tirzah went with Helen to Streatley, a visit that included an afternoon when Helen and Eric removed themselves from the throng to explore the surrounding countryside. Back in London the easy sociability of the Furlongs summer continued to spill over into autumn with an evening when they all went to 10 Downing Street to look at Ishbel's film of her and her father on an official visit to Canada.[31] When Ramsay MacDonald himself entered with the week's *Punch* open at an unflattering cartoon, Eric got to shake another Prime Ministerial hand.

Peggy was asking when Eric might return to Furlongs and the newly refurbished caravans, and during October plans were evidently made for Guy Fawkes weekend, bonfire nights being enthusiastically celebrated in Sussex and particularly at nearby Lewes. Eric, Peggy, Jim and Helen travelled there on 2 November for a four-day stay during which Helen and Eric became lovers.[32] Meanwhile Tirzah, busy as ever with marbling and its offshoots, and often sick in the early stages of her pregnancy, was preparing to relinquish the Hammersmith flat. Trips to Bardfield became the occasion for auction-going and 'junking' in pursuit of second-hand furniture and eventually, in mid-November, the move to Castle Hedingham was accomplished.

Interrupted briefly by a major crisis in spring 1936, Eric's affair with Helen lasted for two and a half years until the contradictions of their respective hopes and desires finally extinguished it in April 1937. Thereafter their friendship resumed following a year of painful separation and disequilibrium, most keenly felt by Helen, and they continued to see each other until a last wartime meeting seven weeks before Ravilious left for Iceland. Few relationships can have left such a lively harvest of expressive correspondence, witness to the degree of exhilaration they felt in each other's presence and how a passionate affair was nurtured by shared experiences and mutual encouragement of artistic endeavour; despite this, they both chose at crucial points to draw back from making a full life together and, in Ravilious's case, from abandoning his life with Tirzah – a woman of extraordinary strength and forbearance. For two confused years, however, that possibility was in the balance and, while it was, Ravilious lived life in parallel dimensions: one largely focused on Castle Hedingham, day-to-day country life and work at home or in the vicinity, and his role as a conventional (that is to say only minimally engaged) 1930s father; the other – initially pursued in clandestine fashion – focused on his relationship with Helen, his London teaching schedule facilitating stays

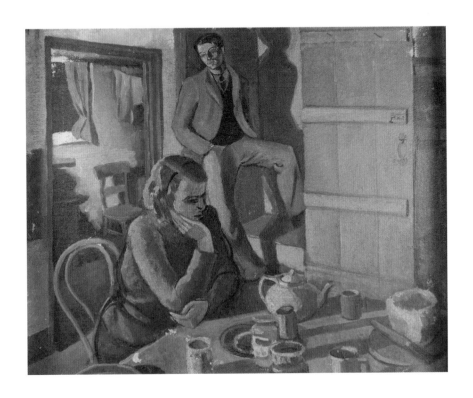

5.10
Peggy Angus, *Helen Binyon and Eric Ravilious at Furlongs*,
oil on board, 1940s.

at Belsize Park and access to Furlongs providing a venue for more extended time together.

Unusually for them, Tirzah and Eric's first Christmas at Bank House was a relatively bleak affair: she was sick, there was a lot to do putting the house to rights, and Eric was hard at work. For him family life at Eastbourne had always been associated with looming financial crises and recurrent anxieties about borrowing and debt. Now the expense of moving and the prospect of a child seem to have focused his attention on the need to earn and to accept any jobs on offer, a pressure that over the next three months led to the cutting of some of his most expressive designs, rewarded by fees equivalent to his annual RCA pay. In January 1935 he began work on the celebrated series of devices and decorations he created for Dent's Everyman Library and the following month he cut a large frontispiece and six decorations for the Golden Cockerel's royal jubilee offering *The Hansom Cab and the Pigeons* by L. A. G. Strong (fig. 4.II); shortly after, the Curwen commissioned him to illustrate *Thrice Welcome*, a Southern Railways publication for overseas visitors, for which he completed three striking headpieces of country life and a title-page decoration of Beachy Head; his 'sceptre and crown' pattern paper, cut for Heal's use during the royal Jubilee jamboree, was chosen for the cover, and in the same month he executed a header and two footers for Green Line bus advertisements. However, confirmation of a potentially lucrative second watercolour show at Zwemmer's depended on completing more paintings, so fine days often meant abandoning commercial jobs in favour of outdoor sketching. Competing for attention indoors were 'good drawings' brought back from Furlongs that required finishing.

At New Year Eric and Helen had returned to Furlongs in the company of Peggy and Jim, the only two friends then aware of their affair, and they went there again for three days at the end of January. In between Peggy and Jim made the first of three visits early that year to Castle Hedingham: 'it is fun showing them the country but how I do wish you had been here too, lord how I wanted you here all the time,' Eric wrote to Helen. Meanwhile Helen was entertaining her American suitor 'who started wanting to marry me in the middle, which made the last two days a bit of a strain'. In the first signs of what she would come to characterize as 'the strains of this double life' she was also beginning to feel 'It's a pity we can't meet each other's friends' and Eric – in response to her descriptions of sherry parties, theatres, dinners which he could not attend – would equally soon feel 'It's a pity I never meet any of these people.'[33]

In February, while Tirzah spent four days visiting her family at Eastbourne followed by a week at Brick House with a heavily pregnant Charlotte, Helen and Eric were at Furlongs again and she learned of Tirzah's pregnancy. After Joanna Bawden was born on 19 February, Tirzah returned to Bank House and when Eric returned there a week later he 'was reluctant to talk about what he had been doing. I didn't ask, thinking it was because he was tired. When we woke up in the morning I asked him again and he suddenly turned on me with such dislike in his voice and said: "You know very well, I've been making love to Helen."' Tirzah, hurt and shocked, in her own words 'quickly recovered my sense of proportion and when I once knew what was happening, things were easier than they had been when Eric had just been feeling guilty and concealing what he really felt. All the same it was sad for me, because I couldn't look forward to having my baby when I knew Eric hated the thought of being a father and all the responsibility it implied ... I couldn't blame Helen for taking him away from me, because Diana had already done so, but I worried because Helen was such a serious person.' For her part Helen wrote to Eric 'Being in love makes one horribly selfish – which applies particularly to the Easter holiday – obviously we are much less important than Tirzah – and you mustn't come to Furlongs unless it fits in with what Tirzah wants to do.'[34]

Peggy and Jim were a presence on both sides of the divide: she was both Helen's emotional confidante and a frequent visitor to Hedingham, where Eric's actions now threatened an unreal status quo. After meeting Jim in London in early March he told Helen 'I had tea and handed over the caravans with my blessing. It's a bit doubtful that they will be used for anything but writing in, but if the green canvas desk is put to good use it will be something. It surprised me Jim was so enthusiastic.' Eric clearly felt he and Tirzah would not be visiting Furlongs together with a baby (and visiting with Helen he would have no need for the caravans) and unthinkingly, as he later acknowledged, agreed to part with them for £7 without consulting Tirzah. At this point the Labour MP John Wilmot, brother of Peggy's friend Horace Wilmot, recommended Peggy for the decoration of a Workers' Travel Association hotel on the Isle of Wight and she attempted to involve Ravilious in the project.

In April she spent a weekend at Hedingham developing designs, but when she and Jim returned in May for the Jubilee holiday weekend their gauche and demanding behaviour rankled. Robert Wellington was also there and Eric was once again on tenterhooks waiting for his reaction to his paintings for exhibition. But it was Eric's action in pulling a lazing Peggy out of bed one noon that provoked a storm. After acrimonious exchanges and a tense departure, Tirzah

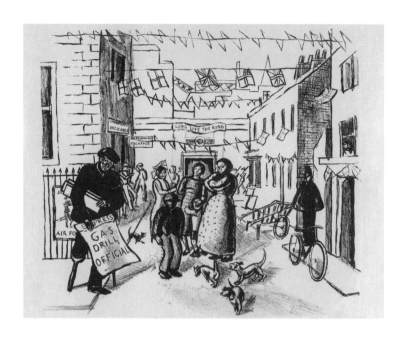

5.11 & 5.12
Peggy Angus: *Poison Gas* (above), lithograph, 1935;
and *National Labour Club Prospectus* (below), *c.* 1935.
Poison Gas was exhibited at 'Artists Against Fascism and War',
organized by the Artists' International in 1935.

wrote 'a snorter' to Jim, returning his cheque for the caravans and giving him a piece of her mind about his and Peggy's selfish behaviour, both as guests and at Furlongs. Eric, concerned lest the dispute would prevent him staying at the flat, wrote to Helen how the tensions of the weekend had reminded him of 'the early Brick House quarrels', adding that Tirzah 'doesn't blame you in the matter of the housework last summer. Far from it – it's the rest of the party who she blamed for that cheerful neglect of all but the most obvious job – I know I didn't do much and I can see it must have been not much fun for her then.'[35]

Tirzah's baby, John Ravilious, was born during a heatwave on 21 June, twelve days after the due date. Eric tried to juggle commitments both before and after the birth, alternately driven by his impatient desire to be with Helen and a sense of obligation in relation to Tirzah. During the fortnight that Tirzah remained in Braintree cottage hospital he slipped reluctantly into fatherhood, answering letters of congratulation, cycling to and from Braintree, working and teaching – but he also made time to stay with Helen, and try as they might, over the following months, the new reality inevitably began to emphasize to her his ultimate unavailability and her childlessness. Visits and rendezvous cancelled and re-arranged, a worry that pupils might notice Eric waiting near Helen's school, the difficulties of parting at tube stations, the necessity to write via Peggy lest her sister might see the envelope – all now loomed larger as irritants; but it was news that Helen's twin sister Margaret and her younger sister Nicolette were both pregnant, and that Peggy and Jim might marry ('she could of course leave here which is going to make complications for us'), that provoked waves of melancholy and longing. 'It really seems a pity I'm not having a baby too – it would be amusing comparing the three' Helen wrote to Eric, to which he replied 'What a lot of babies there are this year!'[36]

Margaret's pregnancy also meant 'no more puppets and no season for a year' at a time when Helen, urged to do more engraving by their younger sister Nicolette, felt she was doing far too little creative work of her own. She began to remedy this during a fortnight in Wales followed by ten days in September with Eric at Furlongs, where she used her previous drawing of a nearby farm pond as the basis for a new block, writing a few days later: 'I've finished the engraving more or less – I've mucked up the foreground pretty badly – I found I'd left my printing-ink as well as a lot of other things at Furlongs.' When the first issue of Oliver Simon's *Signature* carried a major survey of his own wood engraving Ravilious ordered Helen a copy and, praising her *Angelina* blocks, offered advice on tools and technique, discussing how

5.13 & 5.14
Helen Binyon: *Illustration No. 7* for Maria Edgeworth's *Angelina* (above),
wood engraving, 1932; and illustration for *Brief Candles* (below), wood engraving, 1938.

5.15 & 5.16
Helen Binyon, illustrations for *Pride and Prejudice*,
wood engravings, 1937.

they might revive the art of the wood-engraved bookplate together. In mid-October she reported 'The Redfern people want two of my engravings. This week-end I hope to really get on with the new one', adding a little later 'I've been engraving all day and tomorrow I shall take a print.' Referring to an AIA exhibition about to open, Helen asked 'What is your engraving about? ... My three engravings are to protest against War and Fascism.' Later that month the annual SWE exhibition included her *Wire Fence* (fig. 2.3; almost a companion piece to his *Boy Birds-Nesting*) and *Farm Pond*, as well as six of Eric's engravings, one of which, *Hovis Mill*, was based on one of his favoured places near Hedingham. Shortly before he wrote to her 'I am so pleased about you selling three engravings at the AIA. That is good besides some sort of reward for taking 3ds at the door for so long. I hope you sell engravings like this at the show next week.'[37]

By late 1935 prospects of war were beginning to impinge on all their friends, raising questions about political engagement. During the first year of their affair Eric had introduced Helen to *Huckleberry Finn*, P. G. Wodehouse and a book on Surrealism; she arranged for him to see a private collection of Francis Towne's paintings, lent him novels by Dorothy L. Sayers and Virginia Woolf, and a book on dialectical materialism; together they discussed Auden, Millais, Bonnard, Derain and Cézanne and – usually at her instigation – political events.

After his first weekend at Furlongs in 1934, Peggy, reading of a fascist bombardment of workers' apartments in Vienna, had written to Ravilious: 'You see I know the places they've been blowing up ... I don't see how we are to escape the same massacre ... How lucky you are to feel so remote and aloof from it all ... I can't see to paint.' Helen's friendship with Peggy and Percy meant she witnessed the early days of the AIA and, despite misgivings about interminable debates on 'what a revolutionary artist is', she had become an active supporter. After attending a public meeting on the international situation addressed by John Strachey and Harry Pollitt, she wrote 'they seriously think war is quite likely quite soon – it is frightening'. When Ravilious attended a similar rally in Cambridge soon after John's birth, Tirzah noted 'Eric back ... with horrifying report of what the next war will be like I want to clear out of England but he doesn't'. Over the next eighteen months he too would be drawn reluctantly towards engagement, hesitating not only because of an aversion to creeds but also because any political activity threatened diversion from earning a living at a time when finances were often 'in low water'. An optimist by inclination, he considered the *Daily Worker* 'a bad tempered paper ... constantly harping on

5.17
Eric Ravilious, *Downs in Winter*,
watercolour, 1935.

wars and rumours of wars'. Ravilious would cheerfully donate to its fighting fund, he told Helen, but 'I won't take it I think.'[38]

Shortly before this, he had written 'We will bump into WR [William Rothenstein] I expect one day and ... the news will spread: if it hasn't already. I can't think that we have kept a secret as long as this'. Helen in her turn reflected: 'I wish I didn't get into these silly states – it's not that I don't entirely agree that nothing can be done – except stopping – it's just that the strain of this double life comes out now and again'. At Belsize Park on 17 March 1936 his insouciance now became the trigger for Helen to denounce his lack of commitment, personal as well as political; staying at the Frys' London apartment the following evening, he sent her a note: 'now it is too difficult to think of anything to say except that I love you and I know we shall see each other again some day'. Writing a week later he added 'if it wouldn't make a complete mess on all sides I would run away with you, but that is what would happen'. Returning books to him Helen wrote 'I am recovering ... I am terribly proud of having been your mistress.' Two weeks after this – when Peggy wrote relaying news that Helen had been crying for a week – Ravilious followed her to Devon and their relationship resumed.[39]

NEWHAVEN

The copy of Oliver Simon's *Signature* that Eric gave to Helen in the autumn of 1935 carried eight pages of his best engravings and a detailed catalogue of his published work. These followed Paul Nash's article 'New Draughtsmen' in the same issue with its reference to Marx, Freedman, Ravilious and Bawden as being among the outbreak of talent he had witnessed at the RCA. In his article Nash developed a comparison between the work of Bawden and Graham Sutherland with a discussion of two watercolour drawings recently seen at the Zwemmer Gallery. Praising Bawden as a painter of irreproachable technique, he highlighted his watercolour drawing *Newhaven No. 2* (fig. 6.3) as showing a precision 'interesting in its homage – conscious or unconscious – to Seurat, even to the use of a kind of water colour "*pointellism*"'. Nash mentioned Ravilious as having made a name for himself pursuing 'applied design' but, perhaps with an eye to editorial balance, made no mention of his watercolour painting, the activity Eric now saw as central to his future as an artist.

Edward's Newhaven painting had been completed earlier that summer during the first and longer of two stays with Eric at the Hope Inn at the mouth of the Sussex port – a place selected at Eric's instigation after he had painted there the year before. Unbeknown to them, the second occasion in late September 1935 was the last substantial painting expedition they would ever share and unfortunately it ended on a somewhat acrimonious note. But by the end of that year friendly relations had been restored and their mutual affection and appreciation of each other's work remained undimmed – although Eric, fearing Edward's disapproval, was still dissembling his relationship with Helen.[1] By February 1936, when Eric included six Newhaven watercolour drawings in his second highly successful show at Zwemmer's, they could both look back on their time there as the source of much good work and many successful images.

In August 1936 one of Ravilious's paintings, *Newhaven Harbour*, became the template for his contribution to *Contemporary Lithographs*, a publishing venture

promoted by Robert Wellington, which prompted him to learn lithography. In following the trail already blazed by Barnett Freedman, he laid the groundwork for an activity that replaced wood engraving as the second string of his artistic bow as he created *High Street* and the *Submarine Lithographs,* two of his most celebrated bodies of work; but while still an enthusiastic novice it was clearly Nash's observation on Bawden that Ravilious had in mind when he sent a trial print of his first effort to Helen, adding with just a touch of competitive irony: 'Here is my *Homage to Seurat* for you – not quite the final state but only a few things to alter.'[2]

* * *

Newhaven today is a fugitive place, bypassed by the unseen Channel tunnel and overhead trails of cheap air travel. The boat trains are gone, containerization eliminated most seaborne freighters over forty years ago and the swing bridge across the Ouse opens only rarely to let a coaster through. The largest investment of recent times is a waste-burning power station – its arrival coinciding with closure of the landfill at the old Asheham cement works, five miles upstream. In the 1930s, when the lighthouse-keepers on the West Quay logged as many as fifty harbour movements a day, a major spectacle was the regular arrival and departure of four channel steamers owned by the Compagnie des chemin de fer de l'Ouest and the London Brighton & South Coast Railway, which also organized a near constant dredging of the harbour.

Ravilious dated *The James and The Foremost Prince* 'August 1934' but almost certainly settled on its title just before it was exhibited eighteen months later. By this time he evidently could recall the name of only one vessel and had forgotten, if he ever knew, that the legend *James* marked a life-buoy as the property of a dredging contractor.[3] The other painting which he started at the port that summer was actually called *Dredger*, evidently an important work, also sold in 1936. Now known only from a black-and-white photograph, it too featured *The Foremost Prince*, a newly built bucket-dredger that first arrived in Newhaven that March.[4]

For two years Ravilious had been drawing what he called 'the discarded machinery of Essex' with great success and it is easy to see how the bizarre maritime architecture of amphibious equivalents attracted his eye. What he chose to create avoided the conventional treatment of a nautical subject (which would have depicted a whole vessel in its surrounds) in favour of a close-up partial view; precisely realistic in one dimension, it emphasizes abstract qualities of the pictorial design in another by juxtaposing the cogs,

6.1 & 6.2
Eric Ravilious: *The James and the Foremost Prince* (above), watercolour, 1934;
and *Dredger* (below), untraced watercolour, 1934.

6.3 & 6.4
Edward Bawden: *Newhaven No. 2* (above), watercolour, 1935;
and *Moon Rising* (below), watercolour and pencil, 1935.

hoppers and chains of *The Foremost Prince* against the funnel and half-glimpsed superstructure of a motor yacht close behind.

The treatment is reminiscent of Paul Nash's series of Atlantic paintings that brought a modernist edge to portrayal of naval architecture and in particular his oil *Liner*, which was exhibited and reproduced by *The Listener* in 1932.[5] By 1934, Douglas Percy Bliss was critical of their mentor's recent flights of fancy and wrote in one review how 'Paul Nash ... wearies one with anaemic formal dreams. Yet in the past he painted landscapes that thrilled by the fierceness of their design.'[6] By contrast Ravilious, writing to Helen, observed 'The drawing I like so much of Nash's was called *Sea Study*. Did you note it specifically I wonder? A lovely grey green drawing of two jetties, with some tiny steps up in the middle – as far as I remember – and a wonderful sea – threshed and swept ... He is an awfully good imaginative draughtsman.'[7] *The James* is indicative of how stimulating Ravilious was still finding Nash's feel for fierce design. When a little later Eric's *Dredger*, with its boldly inclined central wooden pile, was reproduced in *Watercolour Painting Today*, its author commented: 'Only a highly sensitive mind could see a picture in this austere subject ... it is a study in lines, horizontal and perpendicular, but the whole scene is none the less realistic and true in tone values. How useful in the design is that flight of steps in the foreground.'

A brief visit to Newhaven had yielded two successes and by January 1935 Ravilious was keen to return, toying with staying at The Hope Inn and, in April, the possibility of a side-trip from Eastbourne. That month he visited a sickly Edward who had contracted jaundice after Joanna was born: 'he got out of bed for the first time in the afternoon and we went for a sort of invalid walk in the fields looking for birds' nests ... he is still the beautiful ochre'.[8] Edward was evidently keen on the idea of a joint painting expedition to Harwich and, a fortnight after John Ravilious was born, Gwyneth Lloyd Thomas took the two of them for a disappointing reconnoitre: 'we didn't like Harwich. Compared with Newhaven it is poor, and very few boats – none of those attractive jetties and dredgers I hoped to see, so that idea is off. Edward may come with me to Newhaven but it isn't likely.'[9] In the event, after Ravilious had spent a week in Eastbourne with his and Tirzah's family, and a long weekend at Furlongs with Helen, they rendezvoused at The Hope a fortnight later.

Six weeks before this, in the throes of emotional conflicts of his own making, an interaction began that shows Ravilious at his most giving. 'It was a good post anyway,' he wrote to Helen on 15 June, 'a most unexpected letter from Hennell who was said to be in some sort of mental home after an

6.5
Thomas Hennell photographed at home, *c.* 1935,
shortly after his discharge from Claybury.

unhappy love affair, instead writes in a bold hand of all the work he has been doing and will I do some illustrations for his new verse ... It is good news and I was awfully pleased about it. He is the Graeco-Roman I told you about.' Tom Hennell had spent almost three years in psychiatric hospitals, drawing and painting little, but able to find expression in penning fragmentary poetry. Now in Claybury Asylum he had recently been allowed to undertake a mural decoration and, with his release now a possibility, was beginning to contact old friends.[10]

Over the next few years the Bawdens would play a crucial role in Hennell's rehabilitation by repeatedly hosting him at Brick House. Edward encouraged him to write his revelatory book *The Witnesses*, an account of his descent into madness possessed of an almost hallucinatory vividness, which deserves to be read as a classic of the genre. Illustrated with eight drawings of his fellow patients, it was published in 1938, an essential stepping stone in Hennell distancing himself from the pain of his experience as 'Tom O'Bedlam'. In the shorter term, however, the speed and generosity of Eric's response to Hennell's request for artistic co-operation was clearly important to Hennell's transition back to independence and, by extension, contributed to his emergence as a distinctive artist of vision over his ten remaining years.

Shortly after his first letter, Hennell wrote again having received sample engravings: 'Dear Ravilious, May I first congratulate you and your wife upon

6.6

Thomas Hennell, *We Were Debtors to the Sane*, pen and ink, *c.* 1935.
A drawing of five fellow inmates at Claybury Hospital, one of eight drawings completed
while he was a mental patient there that illustrated *The Witnesses*, published in 1938.

6.7 & 6.8
Eric Ravilious: *Island* (above), wood engraving, 1935;
and *Garden* (below), wood engraving, 1935.
Two of the new engravings Ravilious completed
to illustrate Hennell's poems.

your recent acquisition, and wish him and her immediate health, long life and prosperity? I find your engravings exquisite ... I will if convenient keep them for a while, for no immediate conferences with publishers are in sight and do you in the meantime not be in any great hurry over the verses. I am much encouraged that you like them.' He requested Eric to make 'illustrations to the subjects most of your liking. I will then try to impress several publishers with them for our further common benefit. We must make the publication a success'. Ravilious wrote to Hennell with news of his progress in early July, and to Helen: 'Two engravings are done and one of them is good I think. The canary sits on my left hand when I am working and watches the chips fly – I have to shoo him off the block sometimes', adding three weeks later, 'I've managed to send off the engravings for Hennell's book which now seems to me rather a triumph. I hope he will like them.'[11]

Still in Claybury, Hennell replied: 'Thank you indeed for the three new engravings which I like very well; I find them beautiful in design and quality. The Cambridge Press has also sent back today your other engravings and my verses, with a letter which is not wholly discouraging. I shall have to take them to other publishers personally, I expect, and may have further setbacks, I am still rather awkwardly situated from a practical point of view: since a slight relapse and vertigo have prevented me for several days from working as I should.'[12] By that October, however, Hennell was discharged 'Recovered' and from now on, cared for by his old nurse, he based himself near his childhood home in Kent. After a year of false starts, a joint visit to Gerard Hopkins, poetry editor at Oxford University Press, yielded an agreement to publish both poems and engravings in a limited edition of fifty copies.

Hopkins, the nephew of Gerald Manley, wrote a foreword introducing Hennell as having 'a sensibility unfettered by the fashions of literature, and the note he strikes has not been heard in the poetry of today. The farmer, the painter, and the author combine as authors of his unequal utterance ...'. In December 1936 Eric was able to tell Helen: 'This is written with one of Geoffrey [Fry's] quill pens – I used it to sign Hennell's title pages this morning, it seemed a nice idea.'[13] It is thought that fewer than half these copies ever entered circulation. Of the four illustrations three, newly cut, exhibited an exquisite clarity prefiguring the style Ravilious would perfect two years later with Gilbert White's *History of Selborne*; the fourth, *A Cross to Airmen* (fig. 9.27), had already been published three years before. Like a harbinger, it now reappeared in a volume signed by two of the three official war artists who would lose their lives in the coming conflict.[14]

NEWHAVEN

For Hennell, meanwhile, their united efforts were an affirmation; visiting Shoreham near his home the summer after his release, he painted *Magpie Bottom* where Samuel Palmer had worked a century before, a celebratory pen and watercolour drawing in the much looser manner that would thereafter become his singular style. In 1940, after retrieving two copies of the book of poems for Ravilious when Oxford University Press remaindered its stock, Hennell wrote to Tirzah 'I wish they could have paid him for his trouble and care: but Eric's interest and encouragement were a great asset to me – and made a handsome thing of a work full of weaknesses and blemishes ... so I hope the job will not seem to him to have been a total failure'.[15]

In July 1935, four days after finishing Hennell's job, Ravilious had arrived at The Hope intent on painting and ready to see subjects all around. Over eighteen months he had accumulated roughly twenty high-quality watercolour drawings; any prospect of Wellington confirming another show rested on creating at least a dozen more. How quick he was to the task is evident in a diary entry of Tirzah's for Saturday 3 August, six days later: 'Drove with Daddy to Newhaven afternoon and saw Eric and Edward. Eric has 7 starts of watercolours.'[16] During that week blue skies and moderate breezes predominated and the conditions, recorded at four-hourly intervals in the harbour records, must have been ideal for working outside.

Among the 'starts' were, almost certainly, *Newhaven Harbour* and *Lighthouses at Newhaven*, both featuring naturalistic views of the West Pier Lighthouse; this prominent landmark stood barely a hundred yards from the pub, and Ravilious precisely recorded its mast for hoisting tide signals by day, lights by night, and its railway-style signal for authorizing passage. In *Newhaven Harbour* the fixed light at the end of the East Pier is visible; one of the West Pier lighthouse-keepers overlooks lowered tide discs in a view bedecked by ropes, some taut, some slack, their different thicknesses creating depth within the image. The shadows suggest it is late afternoon and, taken together with the lowered discs and light cloud, the harbour records suggest Ravilious may have been at work here on 1 August. Writing about her departure from Newhaven that same afternoon, Peggy Angus reported 'I looked out for you when we embarked and waved to a lanky figure near the anglers pub', to which he replied 'the lanky figure was me alright'.[17]

In *Lighthouses*, with its wider perspective from fifty yards further away, the westernmost lighthouse at the breakwater tip is visible behind a rail line that swept from quay to breakwater past a weatherboard barrack hut relocated to the spot as a refuge for a shell-shocked sculptor.[18] Between them these two

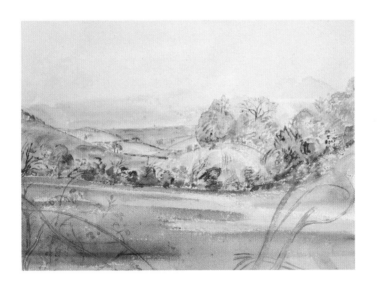

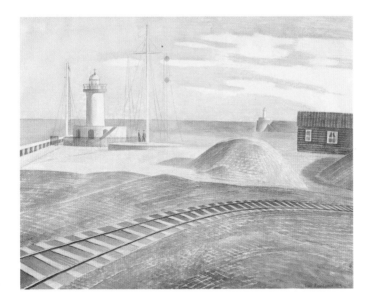

6.9 & 6.10
Thomas Hennell, *Magpie Bottom* (above),
watercolour, pen and ink, 1936.
Eric Ravilious, *Lighthouses at Newhaven* (below),
watercolour and pencil, 1935.

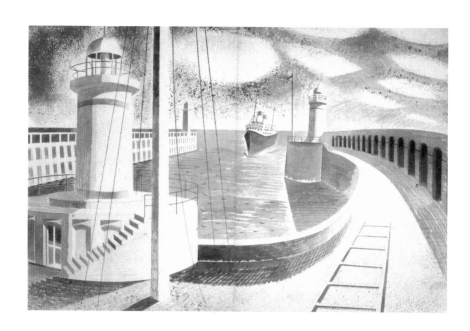

6.11 & 6.12
Eric Ravilious: *Newhaven Harbour* (above), watercolour, 1935;
and *Page from sketchbook* (below), watercolour and pencil, 1935.

6.13 & 6.14
Eric Ravilious: *Page from sketchbook* (above), watercolour and pencil, 1935;
and *Channel Steamer Leaving Harbour* (below), watercolour, 1935.

6.15

Helen Binyon photographed with *Channel Steamer
Leaving Harbour* in her London flat, late 1930s.

images cover all the harbour elements that Ravilious would simplify and re-arrange in a second *Newhaven Harbour*. Basing it on a rough watercolour sketch made on site, he completed it back in Essex three weeks later: 'The drawing of lighthouses (three of them and a ship) is just finished and now I feel rather pleased with it.'[19]

One painting Ravilious both started and finished while staying at the pub was *Channel Steamer Leaving Harbour*, which fulfilled a long-standing desire to paint a nocturne. 'The nights are so wonderfully pretty to look at – as you know well – in this place,' he wrote to Helen on bank holiday Monday, referring back to an evening outing from Furlongs the previous year. 'I can think of no harm in your sending me letters as I can usually get to the postman before Edward ... Tirzah has been over and I have told her about the arrangements – mine and yours ... I am enjoying life very much so the time should go quickly. Edward likes it too and has done two very good drawings ... Sweetie, the holiday crowd downstairs is making a great noise with concertinas and pianos and drunken song. I rather like it.'[20]

Probably the night before this letter was written he had sketched the view across Sleepers Hole – the indent where *The Foremost Prince* had been berthed the previous summer – as well as the distinctive profile of the SS *Rouen* leaving

on a scheduled 10 p.m. departure for Dieppe. The sketch (fig. 6.13) shows he was contemplating an image with a wider perspective than the finished watercolour with a lamp post to the left a key element illuminating the harbour-master's hut; a missing 5 cm of paper may suggest the painting's original layout. On his way back through London, Ravilious stayed with Helen and gave her the completed painting as a gift; it hung in the main room at Belsize Park for her remaining year there and, ten years after his death, appeared in her *Y is for Yawning*, a picture of a mother and toddler she included in her *Everyday Alphabet*.[21]

Another beneficiary of the The Hope that year was Peggy Angus, who after seven remittances of £1 over eighteen months, was still waiting patiently for her painting. Bawden had written to her a few weeks before leaving for Newhaven: 'Dear Peggy I am sure it is time I ceased to receive your pension ... I shall hate to receive your next letter because you will be asking awkward questions about the painting. Alas Miss Angus it has not been done ... However you shall have a painting this year and the best I have ever done.' In fact she did not receive *Ferryboat Entering Newhaven Harbour* (fig. 6.16) until after it was framed in February 1936; unlikely to be one of the drawings Edward completed during the balmy days of August, it depicts a steamer arriving in port through choppy seas, the weather conditions of their second visit in September. Bawden uses the elevated vantage point of Castle Hill, the same one he used for the equally panoramic *September 8.30pm* showing *The Foremost Prince* in a crowded harbour.[22]

A south-westerly gale was blowing when, after ten days with Helen at Furlongs, Ravilious returned to The Hope in driving rain shortly before Newhaven experienced its worst storm for many years: 'Seaford promenade is cracked up and almost washed away, windows smashed and lumps of concrete, pillar boxes and boats and tea huts piled up,' he wrote on the day Edward arrived back from teaching, alarming Helen with a description of an earlier walk to the furthest lighthouse: 'the spray from the breakers crashing on the weather side of the breakwater was an extraordinary sight. I got very wet and I think now it was almost dangerous, but worth it – the scene was like one of those extravagant and formless pictures of Turner's.' The weather also forced three coastal paddle steamers familiar from his childhood to seek refuge: 'The three Brighton queens are in harbour. We want to draw them tomorrow if they are still there.' However, not only was the weather not conducive to outdoor work creating marines with the precision of a Seurat, the atmosphere in the closed-in pub now also felt oppressive: 'Sweetie writing is difficult because

6.16

Edward Bawden, *Ferryboat Entering Newhaven Harbour*, watercolour, 1935.
This painting was sent to Peggy Angus in February 1936
to fulfil the bargain agreed two years before.

a young man with a harelip is banging away on the piano and a woman singing "Goodbye Sweetheart" – it is an awful noise and I can't cope with it easily.'[23]

Ravilious was now restless and concerned that he needed to get some book illustration or other jobs because 'finances are always a bit low at this time of year'. He and Bawden both made short trips to London, Tirzah noting 'Eric back from Newhaven to London fed up with Edward.' While it is unclear what occasioned their dispute, she remembered later that Eric was riled by 'some of Edward's most malicious digs', and even though the weather improved, he now left early. Still bruised, the following February he told Helen 'I won't go away with him this summer if I can tactfully avoid it. Newhaven was a strain, no doubt of that and I feel twinges of it still.'[24]

Despite this denouement, in December *The Brighton Queen at Night* became a positive product of their second stay: 'Sweetie what a good drawing the second of the ships has become now that it has at last been finished ... almost as good as yours. I wish I had tried more drawings like this (that is to say out of my head) when we were at Newhaven. They are such fun to do. The *Brighton Belle* I have always thought the Queen of ships, and such lovely colour.' Writing from Castle Hedingham soon after, he told Helen how he had just sold the painting for twelve guineas to W. H. 'Pink' Crittal, a member of the window-manufacturing family and an enthusiast for design introduced through Bawden's ironmongery connections, adding 'I feel able to go away after Christmas with an easier mind.' At that point he was still reporting 'Still no letter from Wellington' and, while working on some designs for glass and furniture, was 'titivating old drawings'.[25]

Confirmation that Zwemmer's would indeed hold his second solo exhibition arrived soon after and it opened seven weeks later, possibly the last one that Wellington organized at the gallery. In mid-January 1936 Ravilious wrote to borrow back some previous sales and ten days before the opening he was still trying to get Oliver Simon to reprint his private view card in less funereal colours. Between them, the immediate surrounds of Furlongs, locations in and around Hedingham, and Newhaven harbour provided the motifs for all thirty-five of the paintings hung at the opening of what proved a highly successful exhibition. By the third week Helen was reporting 'there are 25 drawings sold now Robert said and some of the ones you weren't sure about are now hanging up with a pile of sold ones on the floor'.[26] After costs and commission two years' work had netted just over £200.

* * *

After returning from France, Peggy Angus began renting workspace at No. 7 Camden Studios, becoming a neighbour of Percy Horton who sent a letter of welcome from Pump Farm, Assington, his and Lydia's new Suffolk version of Furlongs. Shortly after this Peggy, whose Workers' Travel Association mural design had been rejected that spring, received a message from Nicholas Davenport, a left-leaning City stockbroker and financial journalist 'anxious to have a room at my house decorated with mural paintings in the Baroque style'. By the time Barnett Freedman dropped in six weeks later, Peggy had been to Hinton Manor at Hinton Waldrist in Berkshire, worked up an outline design and agreed – in Freedman's view – a paltry £40 fee. Freedman's services were in demand after his Silver Jubilee stamp became a ubiquitous image that year and he now warmed to the task of giving Peggy an unsettling lesson in commerce: approached by a potential patron, she should do the design, get a quote from a department store decorating service for its execution, and only then negotiate a price. Hearing this, Ravilious wrote to Helen: 'That was silly of Barnett to put ideas in Peggy's head, but perhaps he doesn't know the conditions of the job and the short time it is to take ... Taking designs to Maples is a very clever idea all the same, and just like B.F.' Over three months later Helen relayed: 'Peggy wants me to go over to Hinton Manor to help her finish off her wall – the general effect isn't bad but the drawing and detail is beastly of course.'[27]

For Freedman the late 1920s had been lean times even though Rothenstein had kept faith with him as a painter of talent ('I have such belief in your painting that I have rather insisted upon that side of your gifts'). In 1931, however, the success of *Memoirs of an Infantry Officer* signalled the arrival of a look that 'with its individual grace and style, and its characteristic autographic quality, has made itself almost uniquely memorable, even to those who have never heard his name'. This cemented a relationship with Faber & Faber that would see him produce thirty-nine book covers over twelve years.[28] Execution of designs that were innovative and distinctive but 'owed nothing to the current trend for *modernism*' now brought Freedman a growing roster of clients including the BBC, the London Passenger Transport Board and the General Post Office. The other relationships that nurtured his distinctive graphic talents were with two master printers: Thomas Griffits and Harold Curwen. When Freedman first worked with Griffits in 1931 he was head of the lithographic department at Vincent Brooks, Day & Son, subsequently moving to the Baynard Press in 1934 with Freedman's encouragement; Griffits regarded Freedman as the best pupil he ever had, and Harold Curwen saw him as another Bawden, a gifted

6.17
Barnett Freedman, illustrations for *Memoirs of an Infantry Officer*,
line drawing and printed colour, 1931.
A recurring contrast between the Kentish Weald and life in the
trenches was the visual counterpart to Siegfried Sassoon's anti-war narrative.

6.18 & 6.19
Barnett Freedman: lithographed book cover (above),
reproduced in the Curwen Press *Newsletter X*, 1935;
and lithographed advertisement, *Signature No. 8* (below), 1935.

6.20
Stills from *The King's Stamp* showing Freedman
the lithographer at work. GPO Film Unit, 1935.

utility artist who could turn his hand to many tasks, but one who was further distinguished by an instinctive feel for printing as an industrial process.

Freedman for his part attributed his developing love of lithography to 'the immense range and strength of tonality that can be obtained, the clarity and precision of delicate and fine work and the delightful ease of manipulation by the artist directly on to the stone, plate, transfer paper or celluloid'; it was also a reproductive process that appealed to him as a painter through the subtlety of the colour effects that could be obtained through overlays of translucent inks, each modifying the others.[29] Ravilious, as a white-line engraver, sought out new cutting techniques and created his own tools to conjure new textures (and then transposed similar mark-making techniques to his watercolour painting). Freedman now pushed the boundaries of commercial lithography with an array of innovation, developing his own tools and new 'trickery' as a modern auto-lithographer technically skilled enough to create highly complex images. As Michael Twyman has written of this personal style: 'Freedman exposes his lithographic mark-making for all to see. Firm strokes of the crayon, thick at one end, tapering at the other, create freely drawn textures and tones; even freer crayon "calligraphy" meanders across the page; the unshaped end of a rectangular stick leaves its chunky traces; brush strokes, either made as positive marks in ink or reserved with gum arabic, appear confidently on colour workings, as do fussy textures, sometimes the result of a small piece of sponge dipped in ink or gum Arabic.'[30]

Freedman had produced a striking lithographed pattern paper for the Curwen Press in 1934, the same year Harold Curwen's *Processes of Graphic*

Reproduction in Printing highlighted his skills. The next year the first issue of *Signature* reproduced his decorative alphabet *Claudia*; its second issue carried *A Painter's Excursion*, Freedman's own account of auto-lithography. Meanwhile in the *Curwen Press Newsletter* despatched to the firm's clients and jobbing artists in June 1935, the bibliophile Desmond Flower declared 'we are privileged to have amongst us in Mr Freedman a great artist working in a medium perfectly suited to his genius ... but in England Mr Freedman remains almost in isolated splendour. While this artist continues on his way, as he is sure to do, creating fresh problems and triumphantly solving them, achieving new effects of colour and brilliantly eclipsing them, are there no others who will accept the challenge that this fascinating medium offers? ... The stones at the Curwen Press are ready and waiting.'[31]

'Barnett hasn't been received at Court yet. We are all looking forward to it', Eric wrote to Helen in an allusion to his fellow RCA teacher's new-found fame as designer of 'The King's Stamp' – a role that now saw him grace the silver screen in a film directed by William Coldstream with music by an unknown Benjamin Britten. The project was instigated by Stephen Tallents, who after the demise of the Empire Marketing Board – where he had employed Bawden and both Nash brothers – had in 1933 become GPO head of publicity and promptly recreated its film unit. In his new role he also commissioned Freedman to provide fourteen line-drawn vignettes for the *Post Office Yearbook* at a fee of 100 guineas.[32] Freedman provided Coldstream with a treatment in diary form as a basis for filming the stamp's creation and having exercised his thespian skills deployed his marketing talents by sending presentation sets of the stamps to both old friends and new contacts like Kenneth Clark, just appointed to the National Gallery. Receiving his set, William Rothenstein replied: 'My dear Barnett – no one deserves what you have won, by your talents and force of character, better than yourself. There are so many one has met who show promise, but disappointed one's hopes. You have gone steadily on, trusting to no-one but your own spirit ... I was delighted with the reproduction of the stamp – clear and emphatic, as such a thing should be, and of course beautifully designed.'[33]

By the spring of 1936 Ravilious was ready to take up the challenge of the stones and, after a dinner with Oliver Simon to talk about lithography, told Helen: 'Yesterday on the way to the bus stop I rang up Zwemmer's to send me Curwen's book on processes and lithography, so now I am eagerly awaiting the things from Chancery Lane.' Having received what were presumably lithographic crayons and inks from the art supplier Cornelissen, he spent a

day in June observing printers at the Curwen Press. Then, after some delay reclaiming the watercolour *Newhaven Harbour* from Zwemmer's, he embarked on trial colour separations for his contribution to Wellington's scheme, now set to move forward with a first issue of ten *Contemporary Lithographs* including contributions from Freedman, both Nash brothers, Sutherland and Bawden.[34]

At Zwemmer's, Wellington had observed the trade selling lacklustre reproductions of European masters to schools. The previous summer he had written to tell Ravilious he was sounding out educators like Marion Richardson (Hennell's would-be *inamorata*) and Henry Morris (the founder of the Village College movement) about the potential of a 20×30-inch poster series 'destined for children between four or five or eight and nine ... You can choose any subject you fancy, possibly something imaginary linked to objects they recognise ... I should like to have something from you by July 10th.' Just before the deadline Ravilious told Helen 'I'm working in a hurry because the drawing has to be sent off tomorrow, and after tea I must go out [to] find a monkey puzzle tree ... Edward who was here yesterday showed me his contribution ... It is a beauty.' Already practised in providing Curwen Press with lino cuts for conventional lithographic reproduction as wallpapers and book covers, Bawden had evidently swiftly developed *Cattle Market* from a subject already covered for one of his *Good Food* drawings. Whether or not Ravilious's hurried effort was useful in testing the market, it was not the image he returned to when Wellington, now ready to launch in partnership with John Piper as commissioning editor and Henry Morris as a backer, reiterated his request in the summer of 1936.[35]

Barnett Freedman's *Charade* (fig. 6.21) – a fire-lit interior peopled with fifteen partygoers – became the stand-out success of the series; but *Newhaven Harbour* was the other auto-lithograph of the highest quality. Like Freedman's it benefited from being created directly on the limestone blocks used for printing (rather than being dissected and transposed from an artist's original by the press's own 'lithographic artists'); for Ravilious it was a seminal first success. Inviting him to the works, Harold Curwen had written 'our "Summer School" was a figment of Oliver's imagination', but commuting to Plaistow from Camden studios that August, Ravilious was soon telling Helen 'the fourth stone is almost finished. I am liking lithography and have hopes the result will be good so far as a first shot at it can be.' After a leisurely Sunday spent at Curwen's house in Epping Forest, he 'finished the poster in a burst' the next morning.[36] Final touches followed shortly after: 'I told you Robert liked the poster so that is something – it was fun him trying it out on a small

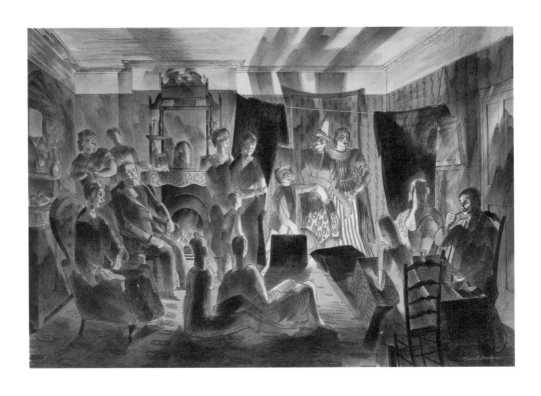

6.21
Barnett Freedman, *Charade*,
auto-lithograph, 1936.

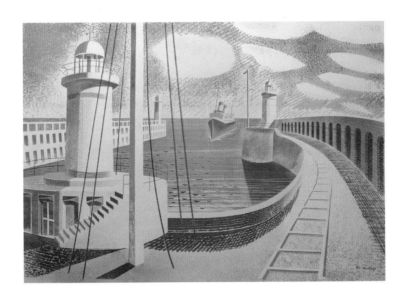

6.22 & 6.23
Eric Ravilious, *Newhaven Harbour* (above), auto-lithograph, 1936.
Edward Bawden, *Braintree Cattlemarket* (below), lithographed lino cut, 1936.

child who approved in a way but thought the railway line was a ladder: so I will alter that bit next week.'[37]

Ravilious now based his second shot, *Grapehouse*, on a Firle glasshouse sketched two summers before. Notionally a trial for 'G' in a proposed 'Alphabet of Shops', it found no place in *High Street* when it was finally published in autumn 1938. In the interim it enjoyed an alternative life, first as a Christmas gift for Diana Tuely in 1936 and then, after a direct request from Stephen Tallents the following year, as a personal Christmas card. But before then its crucial role was to encourage the notion that a series of twenty-six wood engravings he had been discussing with Helen for over a year would be better pursued via lithography.[38]

The first reference to a possible book of shops occurs in July 1935, not long after Ravilious had spotted Helen's copper engraving *The Ferry* (fig. 5.9) in an old copy of *Studio*; intriguingly two of her other copper engravings, of which Eric clearly became aware at this time, feature a baker's cart in front of a corner shop (fig. 6.24), and customers at a street vendor's refreshment stall. (In his fascinating study *The Making of High Street*, Alan Powers has also suggested that the Binyon nursery could well have had a copy of a popular 1899 *Book of Shops* covering over twenty-five examples, some of which such as a fireworks shop and a chemists by night are identical to those in *High Street*).[39] However the topic arose, shop spotting now became a shared enthusiasm, with Eric reacting to a suggestion the following November 'I can see the shop would be a beauty for this series I still hope to do. Nothing yet has happened – the idea is a pippin – anyway you had it before me so you know how good it is.' By then he was listing five possibilities, including four – the wedding-cake department, the Soho breadshop, the Hedingham butcher and the funeral furnisher – that would appear in *High Street*. A week later he was telling Helen 'On the way to the bus stop at Euston I came across a perfect addition to the series – a milk shop, a beauty altogether ... I must show it to you.'[40]

After the Zwemmer show became his priority, progress over the following six months was intermittent until, rejecting a request to illustrate 'some badly translated Russian doggerel', Ravilious took the opportunity to raise the idea with Christopher Sandford, one of the new owners of the Golden Cockerel Press. In early July he was able to tell Helen 'The Golden Cockerel wrote this morning to ask if I will do the book of shops so you see what clever ideas you have ...', adding two days later 'twenty six engravings will take time: all the same I think I'll do it – it is a great excitement ... I am pining to begin', and a fortnight after, 'Couldn't we do this alphabet of shops between us? ... the idea was

yours in the first place'. Helen was clearly pleased for him, but replied 'I'd love to do some of your shops of course – but I think it would be a better book all by the same person'; she was also less than impressed by the suggested terms, 'a speculation on both sides' involving no guaranteed fee, and urged him to look for another publisher because 'there are others that would jump at it'.[41]

Earlier that spring Ravilious had questioned what motivated him to stick with the laborious process of wood engraving. He was now enthused by lithography, but also aware that Sandford, striving to revive the near-bankrupt Golden Cockerel Press, would prefer the cheaper option of printing wood engravings in-house. So having sent off *Grapehouse* with limited expectations, in October he was heartened by Sandford's appreciation of the aesthetic potential of lithography despite its commercial downside. To offset this, they now explored the possibility of a large trade edition with the publisher Michael Joseph. This came to nothing, but in the meantime Ravilious worked swiftly to complete *The Grill Room*, *The Letter Maker* and *The Plumassier*, which appeared by way of a trailer in the March 1937 issue of *Signature*. As the magazine went to press the publishing proposition for the book was uncertain, but by the time it appeared – together with a commentary by John Piper – Noel Carrington at *Country Life* had enthusiastically stepped into the breach.

Meanwhile Helen, although receiving a lithography set from Eric for her birthday that December, was engaged on what would become her most significant wood-engraving commission. Gibbings had been hired by John Lane as art editor for a projected series of Penguin Illustrated Classics, and wrote asking Ravilious whether the prospect of illustrating a volume had any appeal, adding 'for Tirzah also if she would care to take one on'.[42] She may not have, but in any event Ravilious, mindful that Helen had recently approached Sandford for work, clearly recommended her as a possibility. On New Year's Eve she wrote: 'My Darling I am so excited – I got a letter from Gibbings this morning asking me to do "Pride and Prejudice" – isn't that lovely? It's got to be done by the end of March which will be a sweat ... sweetie thank you so much for suggesting me. It is to be published at 6d in an enormous edition – far better than the private press idea.'[43]

From this point it is possible to follow in considerable detail the genesis and execution of Helen's designs and Eric's positive critique of the emerging blocks up until the point of their despatch to Gibbings in April 1937, with the interest he takes in her work for *Pride and Prejudice* clearly paralleling her enthusiasm for the book of shops.[44] After working up the last five designs, Eric was telling her by late March: 'Carrington wants the title page for his

6.24
Helen Binyon, *Player's Navy Cut*,
copper engraving, *c.* 1930.

travellers in a hurry. Will "High Street" do for a title for the book? It does seem
to me to suggest this procession of shops rather.'[45]

The second and final phase of their relationship as lovers now had fewer
than four weeks to run. *High Street* would miss the 1937 Christmas Season
because of the illness and death of the writer selected to provide accompany-
ing text. Consequently it was over a year before, intimate friends at a distance,
they could exchange copies of their creations. Sending him a copy of *Pride
and Prejudice* in May 1938, Helen wrote: 'I thought it might amuse you to have
this – it's not too badly done is it? I'm particularly pleased with the one of
the ball ... it's beautifully light and grey ...' (fig. 5.14); he replied that he had
seen the series at a Smith's station bookstall but when he had rung up she
was not home: 'yours is simply the only one that is any good. It shines out'
(a judgment that holds good eighty years on).[46] By then Jim Richards, hired
by Carrington as a replacement writer, was near to completing his text, but
it was still late October before Eric could write: 'Here, after all this time is
High Street ... It isn't too bad I think as far as the production and Jim's writing
goes, though some of my pictures are far from good.' Helen agreed that maybe
some images were not quite as bright as she remembered them, but rattled
off a list of her favourites, terribly pleased to have such an attractive and
amusing book.[47]

* * *

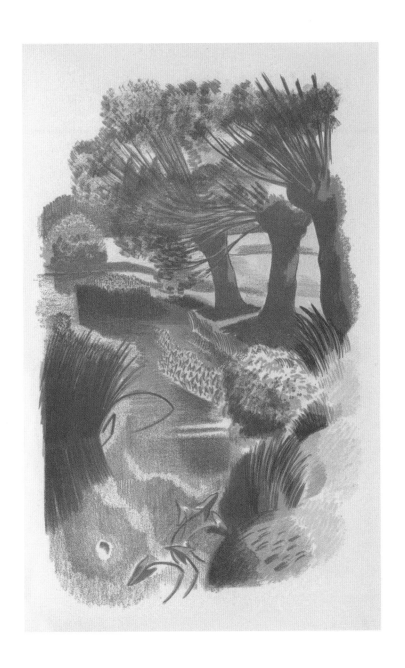

6.25
John Nash, illustration for *Men and Fields*,
auto-lithograph, 1939.

6.26
Eric Ravilious, *The Pharmaceutical Chemist*,
auto-lithograph, 1937.

Looking back in 1942 Tirzah appraised the break-up: 'the truth was when it came to the point neither of them really wanted to face the upset and trouble that their parents would create if they openly started living together, and they both felt guilty about me and little John'. What was clear in hindsight, however, had been very much in the balance in the spring and early summer of 1936 after Eric – receiving Peggy's news by letter that Helen was distraught – followed her to Devon where she was staying with one of Peggy's sisters. That spring Tirzah began her own affair with the painter John Aldridge, a resident of Great Bardfield, who had become a friend while they were still at Brick House, but it was the prospect of Eric and Helen living together in London that threatened a fundamental rearrangement of all their lives. Initially confused by the sudden turn of events and reluctant to tell her mother, Helen asked Eric to wait until her sister's baby was born. As Tirzah recalled: 'This didn't seem a very convincing reason to me and for the first time I felt angry with Helen. After all it isn't easy to give up your husband and your sense of security when you have a child to look after ... it was cruel to have Eric back when I had made the effort of parting with him'.[48]

The lease of the flat in Belsize Park Gardens was coming to an end and Peggy and Jim were moving towards marriage – in order to avoid embarrassment locally, they had already told neighbours at Furlongs they were married. So the possibility of living together as two couples in close proximity now became the subject of excited discussion, only marginally dampened when, as Helen reported, 'Peggy told her headmistress she was thinking of getting married and was told in that case she would lose her job – which she hadn't at all expected – it's rather a blow ... the more I think about it the more difficult it seems for me to stay on at North London after this term – it would be so awful to be sent away suddenly and scandalously ... I must think of other ways to earn money.' Hopes focused on a house in Camden Town available for rent and rates of £124 a year and capable of being occupied as two flats, and Helen concluded her letter; 'My Darling ... I'm beginning to realise how wonderful it will be living with you.' 'I am simply longing to live with you,' he replied, 'The house must be cheap enough for us all to be able to afford losing teaching jobs it seems to me ... we shall have to earn money other ways as you say ... The puppets for the garden theatre sounds a lovely job ...'.[49]

At this point Eric and Tirzah had agreed to separate (but not divorce), and began to announce the development to friends, all of whom were most concerned for Tirzah. 'Charlotte didn't seem to mind but Edward does very much. He would I knew though is almost certain to recover later,' Eric reported.

At Peggy's invitation Tirzah, wavering between strength and despair, now spent a weekend at Furlongs followed by a visit to Eastbourne during which she had a brief fling with her old flame Bob Church, home on leave; walking on the Downs they made love above Muggery Poke.

This could be only a brief escape and Eric, returning to Hedingham, was soon telling Helen 'how I wish [Tirzah] wasn't so worried about us and herself. She talked a lot about all our difficulties yesterday ... so much of what she says is unanswerable and however strongly I try to take a definite line the more dumb I get and the more confused ... Although she sees up to a point the truth of all that we were discussing in bed the other night – that doesn't solve the problem of living for the future. However she agrees that we can't do otherwise than go on as we are: and work, and if possible make some money.'[50] The next day Helen replied 'if you and Tirzah think it is too difficult after all – that will be alright by me – and that doesn't mean I don't want to live with you more than anything in the world'. After they saw each other the following week, she reiterated 'all the time you were here the reasonable part of me was struggling with the unreasonable and wanting to say if Tirzah goes on minding so much – hadn't we better give up this idea of running away? It's so obvious I can manage so much better by myself than she can and I won't have the feeling of being wronged or deserted either ... What hurt before was thinking you didn't really want me and now I know that's not true.'[51]

Having arrived at the point in Eric's words that 'circumstances are too much for us to be able to run away but we can see each other', they now embarked for nine months on an 'experiment in living' ('Helen do you think we will be the exception to the rule? Let's try hard to be, the experiment is a good one'), which proved by turns joyful and difficult as they pursued the chimera of a stable triangle.[52] Many friends, including Percy Horton with whom they stayed at Pump Farm later that summer, were accommodating but doubtful of the new reality, and many others, such as Charlotte, wished Tirzah could find a more enthusiastic husband. Eric wrote to Helen that November 'I'm not unhappy about us ... we won't have March all over again I love you and I am perfectly happy going on as we are, and I don't want anything else'. Underlying all this, when he reflected on his life with Tirzah, he concluded 'we aren't a bad marriage as they go'.[53]

Ultimately it was not social disapproval that now brought Helen and Eric's life as lovers to a close but a resurgence of a longing that Helen came to clearly recognize. Writing to her new lover John Nash two years later she analysed this in retrospect: 'when Eric asked me to live with him the May before last he

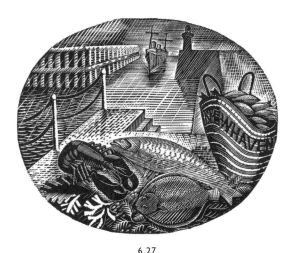

6.27
Eric Ravilious, Headpiece for February,
wood engraving for the *Country Life Cookery Book*, 1937.

talked about wanting to give me children (I hadn't really dared to think about it before) and when a little later we both agreed it was impossible for us to run away after all – I couldn't help feeling subconsciously that I had been done out of my child (both my sisters having babies that summer helped to rub it in). That's a purely instinctive and irrational feeling but it still goes on and it still hurts, although I know for certain that just getting and having things (even husbands and babies) doesn't of itself make one happy.'[54]

An unhappy stay in Wiltshire in early April 1937 was replete with distant silences and proved a prelude to their parting. In the subsequent two weeks Helen was busy with Artists' International Association activities and on 20 April she wrote 'I've just done up the last of the illustrations ready to send off to Penguin books – a great relief ... I've been lent the "Years" and am enjoying it. There is no news to tell you. Till soon then darling, your loving, Helen.'[55] At this point their hitherto almost daily exchange of letters breaks off and the next extant correspondence is Helen writing at the end of June during a long weekend in Paris to give Eric news of his catalogue cover for the British Pavilion at the International Exposition and how the tennis scene he had painted was faring as part of the display. Over the two remaining years of the peace, they would both strike out in new directions as artists, and a less pained mutual affection would gradually replace emotional turmoil.

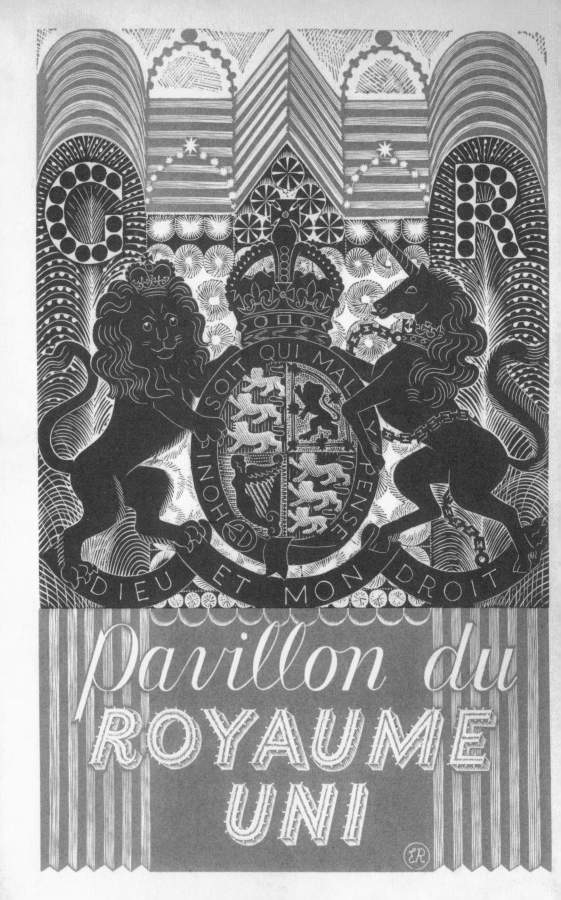

PARIS
AND MAYFAIR

On a cold day in January 1937 Ravilious received 'a remarkable post this morning ... one from the Foreign Office cutting capers of joy about their catalogue, or words to that effect. I was jolly pleased and relieved, having cut the thing again.' He had just opened a letter from the Department of Overseas Trade beginning: 'Your design for the cover of the Guide to the British Pavilion is highly commended and approved. We think you should put your name to the block, since you can have no reason to be other than satisfied with the job.'[1]

The assignment had begun with uninspiring suggestions from a catalogue sub-committee for designs based on Britannia, a rampant lion, the Union Jack and the Royal Arms, and then an official caution to be mindful of 'that level of dignity which is necessary in a government publication'. But Ravilious's response not only proved once again that 'the woodenly serious was *not* his province'; it also showed him as an artist-designer who could almost unconsciously improve on a client's requirements, however ill-conceived or poorly articulated.[2] Employing a slightly startled lion and a pert frolicsome unicorn to hold up Royal Arms against a background that shimmered between fairground tent, cinema facade and firework display (but nevertheless gave prominence to 'GR', the initials of the new monarch), he added much-needed lustre to a British effort with a narrow remit of promoting exports of 'affordable English luxury'. In Paris that summer eighteen *Fêtes de La Lumière* featuring music, fireworks and fountains were at the heart of the crisis-ridden Fourth Republic's attempt to raise national morale by providing circuses as well as industrial bread for its deeply divided populace; and Ravilious's cover, with its upbeat blend of traditional and modern elements, was perhaps the element of the British presence that best caught the spirit of the host city's agenda.

After agreeing a constrained budget and appointing Oliver Hill, who Ravilious had previously worked for at Morecambe, to design a 'modest white packing-case of a building' for the United Kingdom Pavilion in Paris, the Department of Overseas Trade delegated control of its presence at the 'International Exposition of Arts and Techniques in Modern Life' to the twenty-nine-strong Council for Art and Industry. The Council was chaired by Frank Pick, Deputy Chairman of the London Passenger Transport Board (LPTB), already well known for turning his organization into a leading patron of contemporary art and design. Introducing the United Kingdom Pavilion as 'an attempt to picture to the world those elements of the current civilisation of Western Europe which have been contributed mainly by Great Britain', Pick cited English words adopted by the French as 'an index of those elements': *le Sport, le tennis, le five o'clock (tea), le bridge, le football, le golf, le week-end*. But this apologia could not disguise the irony surrounding a national statement where 'genteel leisure was depicted as the main pre-occupation of what had once been the workshop of the world'.[3]

Although the agenda was intended as disarming, it misfired because, as Helen Binyon recalled, 'the image of an England largely rural and inhabited by comfortably off sportsmen struck many English visitors as misleadingly out-of-date and trivial, though the displays were pretty enough'.[4] Helen, who had spent a day hosting the Pitmen Painters in London the year before, could not square this projection of England with the country of the dole and the Hunger Marches; for others, such as Kingsley Martin, editor of the *New Statesman*, it was not just life 'as seen by the guests in a country house party where the servants are unobtrusively in the background' but a virtual manifestation of Cliveden Set appeasement. In the face of the gathering international storm, this was a presence 'desirous not to remind other countries that Britain still had a navy'. 'When you went in,' Martin wrote, 'the first thing you saw was a cardboard Chamberlain fishing in rubber waders and beyond, an elegant pattern of golf balls, a frieze of tennis rackets, polo sets, riding equipment, natty dinner jackets and, by a pleasant transition, agreeable pottery and textiles, books finely printed and photographs of the English countryside. I stared in bewilderment. Could this be England?'[5]

The spectacle outside was marked by the colossal endeavours of totalitarian states. Across the main exhibition axis the swastikas of Nazi Germany's granite Reichstag building confronted the clenched fists of idealized Soviet citizenry, both efforts overshadowing the modest Spanish Pavilion nearby. The Republican government's hurried assertion of its own legitimacy opened

7.1
Ravilious in London at work on his background display
for the sporting goods exhibit at the 1937 Paris International Exposition.

barely three months after two hours of German bombing had unleashed a new dimension of civilian hell in the Basque region; on entry visitors were confronted by photographs of children incinerated that afternoon – just before they turned towards *Guernica*, the freshly painted anti-war poster that Picasso had created to act as the building's central focus.[6]

Small wonder that the art critic Eric Newton felt that in a Paris 'positively bursting with art' the British Pavilion with its 'Buttery serving English Fare' and aspiration to be 'a comely and pleasant ... liberal conspectus of our English life' was 'one of the few important buildings that has missed its opportunity'.[7] With product selection committees nominally policing quality, but in reality dependent on soliciting participation from manufacturers at their own cost, the trade show aspects inevitably incorporated much undistinguished dross which, for *The Studio*'s critic, showed 'little evidence of new inspiration'.[8]

Prior inspiration was certainly evident in a 'Books, Printing and Illustration' section, which amounted to a comprehensive retrospective of notable illustrated books produced in England since Lovat Fraser's *Luck of the Bean Rows*. Unsurprisingly, given a selection committee led by Oliver Simon, it featured the most significant achievements of names familiar to the Curwen and Double Crown Club's network of bibliophiles and typographers: Ravilious's *Twelfth Night* appearing adjacent to John Nash's *Poisonous Plants*, Paul Nash's *Urne Buriall*, Freedman's *Memoirs of an Infantry Officer*, Edward Wadsworth's *Sailing Ships and Barges*, and Ravilious's 1933 Kynoch Press Notebook. Douglas Percy Bliss's 1930 *Palace of Pleasure* and his 1934 *The Devil in Scotland* were also included, while Bawden's 1937 *Country Life Gardener's Diary* provided a more up-to-date offering.

None of the artists – Ravilious, Bawden, Freedman, the Nash brothers or Marx – seem to have visited Paris that summer, but evidence of their activity as jobbing artist-designers was scattered throughout the British Pavilion, providing some of the brighter points amid over 3,000 items on display. Ravilious with a tennis frieze commissioned by Slazenger, John Nash with a rural backdrop for the shooting exhibits, and Bawden with two screens backing 'Travel Goods and Hides & Skins' in the leather area, had been recruited as display artists; Ravilious's Coronation Mug was exhibited by Wedgwood, while three chairs he had designed in 'modern Regency' style for the new London shop Dunbar Hay were displayed alongside an Albert Rutherston table, carpet and tableware in the pottery section; rayon and cotton satin designed by Diana Low appeared among the manufactured textiles, and patterned organdies by Enid Marx amid the dress fabrics, while her hand-block Hollands and

linens were shoehorned into an 'Agricultural and Rural Industries' section. The commercial graphic art on display included examples of posters produced by Bawden and Freedman for the LPTB, Ravilious's work for its *Country Walks* guides, pamphlet covers he and Freedman had produced for the BBC, book jackets by Freedman and Bawden for Faber & Faber, and Curwen Press advertisements and brochures, including those for Shell-Mex and Imperial Airways, an employer of both artists.

The exhibition occurred towards the end of a decade that had begun with the financial crash and unfolded in the shadow of industrial depression, accompanied all the while by heightened official anxiety about the low quality and poor design of British manufactures for export. It was the same concern that had in the early 1920s led the Board of Education to support William Rothenstein's attempts to infuse a new spirit into the RCA Design School and in the interim had precipitated numerous reports and commissions about the potential contribution of artist to industry, culminating in the 1932 Gorrell Report and then the formation of the overseeing Council for Art and Industry. In the early 1930s Paul Nash had been exceptionally active in this debate, not only advocating an aesthetic of 'going modern while being English' but agitating in both print and deed for a new balance in the relationship between artist and manufacturer. The evidence assembled in the British Pavilion suggested there was still a long way to go; but it also showed that his advocacy at the RCA, namely that a good artist could turn his or her hands to many things, had borne fruit.

<p style="text-align:center">* * *</p>

'I think often that the 15 years I gave to the College were years fruitless – then I think of you and a dozen others and they appear not quite sterile,' Rothenstein wrote to Barnett Freedman from Far Oakridge in Gloucestershire in December 1938. In retirement he was writing *Since Fifty*, a third volume of autobiography, and thinking further he listed twenty-two names before breaking off 'I cannot go on with the list, so many were there, and gifted in so many directions.'[9] Eric's friend Cecilia Dunbar Kilburn was the last name cited; he had first met her in 1922 when she entered the Sculpture School the year after the arrival of Moore and Hepworth. Since 1927 Rothenstein had assisted her during various twists and turns of her post-College career and just before retiring he had encouraged her willingness to join forces with his Registrar, Athole Hay, in a venture – at once both commercial and idealistic – that significantly furthered the reach of Ravilious's design activity.

Decidedly not inclined to hold herself aloof on class grounds, Cecilia had been a kindred spirit in the Junior Common Room at the RCA and subsequently a welcome neighbour of Bawden, Ravilious and Bliss in Redcliffe Road. Although expressing 'complete nauseation of College and all concerning it', she proved a worthy editorial successor to Bliss who was delighted to receive *Mandrake* for a second time: 'if it reads as well as it looks it is a better mag than the 1st Mandrake. Why not become the first lady typographer? The mag misses Bawden but that is no fault of yours.'[10] Meanwhile Ravilious and Dunbar Kilburn seem to have always found each other congenial company and were happy to exchange confidences, he sending her an extended account of a dream odyssey involving mutual friends, and she recounting her presentiment about the suicide of a fellow student.[11]

Possessed of both the urge and the means to travel, and unsure whether to pursue sculpture à la Brancusi or painting in a Blakean manner, in late 1927 Cecilia went to India armed with introductions from the Indian High Commissioner procured by Rothenstein; there in spring 1928 she visited the household of Rothenstein's friend Rabindranath Tagore, the polymath recipient of the 1913 Nobel Prize for Literature. Returning for a second longer visit in 1929, which took in Burma, Siam and the Malay States, she secured a testing bookplate commission for Ravilious from 'Raja Sithambasa Ramantha Reddiar LL.D'.[12] Eric sent her further proof of his commercial versatility in the form of 'the new initials I am cutting, to be called, I believe, "Ravilious Decorated", very exclusive and expensive'.[13]

Once back from her travels, a stay at Brick House precipitated a frustrating collaboration with Bawden who knew about her interest in gardens. Soon after her visit in February 1934 he wrote to Cecilia with a proposition: 'Do you think it would interest you to write a book on gardening? Fabers are publishing in addition to *Good Food* and *More Good Food* other books relating to goodness in food and drink and I suggested to them the ultimate necessity for having in the series a book on gardening to assist the epicure who grows his own vegetables. A second inspiration succeeded the first why not publish Cobbett's *The English Gardener* together with a longish commentary by someone who knows the condition of gardening from that day to this?'[14]

Cecilia went quickly into action after a further three-day stay at Brick House in March; but, despite talk of a joint visit to Kew and substantial drafting on her part, she now met protests from an over-committed Bawden that she was 'not the only thorn in my flesh'. Soon she was writing 'Dear E, I hope you haven't changed your mind about the book because I have been surprisingly

industrious since I saw you', to which he replied 'How often I have said to Charlotte "I must write to Cecilia" – the guilty feeling has been developing for more than a week now'.[15] Ravilious in turn tried to reassure her: 'I am sure you will get the drawings ... everyone has been clamouring for Bawdens ... if I were you I should bully him, because the book is worth it and he is only busy at the moment'.[16] If she did, it was to no avail as that September Bawden was ending a further letter of apology 'the book will take at least another year don't you think – therefore why hurry?'[17]

Hard-working Dunbar Kilburn, however, was seeking personal direction and now contemplated further travels, this time to China, getting as far as reserving a ticket on the trans-Siberian railway; news of this in January 1935 provoked for Eric an unaffordable fantasy of tagging along: 'I imagine myself painting the most alluring hill country in terra verte and grey untroubled by anything whatever,' he wrote, thanking her for a present of a blue rug she had sent to him and Tirzah for their new home.[18] But now Cecilia's contact with the Rothenstein household, through whom she already knew the thirty-three-year-old RCA Registrar Athole Hay, precipitated an opportunity of significance to both of them.

Hay, appointed to succeed Hubert Wellington as Registrar in 1932 and an Oxford friend of Rothenstein's son John, had evidently been discussing with Rothenstein how, when it came to good design, manufacturers might best be both led to water and made to drink. The proposition gradually emerged that a London-based retail shop showcasing the best of modern English design might directly source work from artist-designers, helping to sustain income and talent by selling initial runs of commissioned work. Thereafter, the thinking ran, the manufacturers involved might be motivated to produce in greater volumes for a wider market, raising industry standards by direct action and public taste by osmosis.

Cecilia had no business experience but she was energetic, personable and available, and she had, in Hay's words, 'a very selective eye', evidenced by the haul of objects she habitually brought back from her travels. Rothenstein's connections were now helpful in attracting a roster of ten shareholders and an initial capital of just under £3,000 to back what he later described as 'really Athole's child, born of the wish to help gifted young people', with Cecilia as Managing Director becoming 'the foster-mother, brain and heart with which to carry on the work'.[19] With premises yet to be secured, in July 1935 a printed prospectus appealing for stock was issued, which Tirzah received in the post six days before her father drove her to visit Eric at Newhaven. A folded copy

7.2 & 7.3
Edward Bawden, poster for London Passenger Transport Board (above),
lithographed lino cut reproduced in *Signature No. 3*, 1936.
Barnett Freedman, catalogue cover for Bowmans, auto-lithograph, Curwen Press *c.* 1935.

survives in the Ravilious archive with a pencil sketch of the tide signals seen in *Lighthouses at Newhaven* on the back, suggesting she passed it on that day. Promising to sell 'objects of applied art which in the ordinary way may be difficult to market' and promote work 'that falls into obscurity between gallery and shop', the new venture would, it was hoped, 'appeal to the many people who are shy of galleries, but who are tired of "stores" ... We should be very glad if you would show this letter to your friends.' Looking back on the venture's origins in 1979, Cecilia remembered: 'Edward Bawden and Barnett Freedman were well established. Eric Ravilious was not so well known, but he could design anything and was immensely interested in Dunbar Hay and our ideals ... From the start we paid him a small retaining fee.'[20]

<p style="text-align:center">* * *</p>

At this point Ravilious lacked handsome fees and repeat business from major public corporations like the LPTB, the GPO or the BBC (he marvelled when the broadcaster paid Freedman £105 for a design that took a day to produce). Commercial jobs picked up through the Curwen Press tended to be one-off rather than long-running like Bawden's work for Twinings, Faber & Faber, Shell and the Westminster Bank. Ravilious wrote to Helen that November, 'I am trying to design chairs, which is quite a nice job – though I know very little about it. One smallish job has arrived which is something – and the larger the job the further away it seems to be.' At this time he still had lingering but ultimately disappointed hopes that he and Bawden might reprise their Morley partnership by decorating the De La Warr Pavilion at Bexhill, a job in the gift of the architect Serge Chermayeff who was proving elusive. Although attracted to a spell of steady income, even then Ravilious had his doubts about the commitment that might be involved, remarking a few weeks later 'Mahoney's [school mural] decoration at Brockley is at last finished ... How many years work I wonder? Five I think.'[21]

Stretched finances and family life made pursuit of commercial 'jobs' an unavoidable necessity, although – as Paul Nash had often found – also a potential distraction from an artist's central purpose. Ravilious articulated this tension in the course of writing about his childhood, when it was 'so important not to be poor and have to borrow' and 'there was so often a financial crisis looming over us all in Eastbourne that we began to expect them as a matter of course ... the other reason I would like money is so that I could turn down jobs and do some serious work'.[22] But, in the juggling act of earning an artist's living, teaching could prove equally intrusive. He told Helen around

the same time 'Athole Hay wrote this morning wanting me to take on more teaching, which I'm all for refusing even if I get the sack', adding a day later that he had penned a rebuff that was 'tactful but firm' and that 'teaching would have its own reward but I don't think I could possibly do it ... jobs stretch away indefinitely and I really want to do them and not teach if I can help it – what other use being a designer (this isn't meant to be as pompous as it sounds)'.[23]

Ravilious's work for Cecilia marked late 1935 as the period when he finally shrugged off any last vestiges of the RCA notion that being a designer was a second-class calling. Responding energetically to her challenge of generating stock ahead of the shop opening at 78 Grosvenor Street in early 1936, he noted the previous December 'I'm busy designing glass and thinking about a new rocking chair for Cecilia', adding two days later 'today's output is four door plates – not very much but not bad'.[24] Designing glass was an activity he had tried when, in August 1934, building on his engraving skills with designs for the Stourbridge manufacturer Stuart Crystal, he had participated in the Harrods exhibition 'Modern Art for the Table' and then the Royal Academy's 'Art and Industry Exhibition' in spring 1935. There, working in concert with his ex-Hammersmith neighbour the modernist architect Maxwell Fry, who curated the glassware section, he designed decorative display panels and eleven pieces of glassware including a drinking jug, decanter and glasses incised with patterns recalling the abstract motifs and luminous movement of wood-engraved equivalents.[25]

Furniture design was a new venture, but an activity in which Ravilious excelled. He possibly recalled Paul Nash's *Room and Book* endorsement of the notion that 'if we are destined to pick up a thread from the past, surely the Regency style stands invitingly as a truly modern development, nipped in the bud while we built and perfected the mechanical age, to be now resumed in a renaissance which many feel to be imminent'.[26] In November 1935, while Tirzah was making marbled paper screens for Cecilia's stock ('they are awfully nice things I hope Hay and Cecilia will like them'), Ravilious developed designs featuring inlaid boxwood decorations of stars and lines for a dining table and accompanying chairs; and the following month the London cabinet-maker Henry Harris had a mahogany prototype available which met with Cecilia's approval.[27]

Possibly four sets were made, including the one featured at the Paris exhibition, and in a nice touch of collaboration another set was equipped with piped cushions covered in Enid Marx's hand-block printed fabric to accommodate their mutual RCA friend Beryl Bowker.[28] One day in June 1936,

7.4 & 7.5
Tirzah Garwood, *Marbled Paper*, c. 1936.
Ravilious-designed carver chair by Henry Harris, c. 1936.

rushing through Mayfair to catch a bus, Ravilious caught sight of one of his dining tables being hoisted, under Athole Hay's supervision, over a wall into the Grosvenor Street shop. It was evidently there that his furniture was seen by the *Country Life* reviewer who praised its designer for eschewing modernism's 'evil fashion for "stunt furniture" of all kinds' and for 'transforming a familiar model into something new and personal'.[29]

Another source of intermittent design work for Ravilious was the LPTB, where Christian Barman was his key contact. Barman had trained as an architect before becoming Frank Pick's design manager and, already an admirer of his wood engraving, approached Ravilious in early 1936 to develop a new heraldic device for corporate use and to provide illustrations for a planned range of London Transport *Country Walks* guides. The device was to be a griffin and various degrees of rampancy were employed over four attempts, Ravilious's first return to the bolder art of black-line engraving since *Twelfth Night*. A white-line suburban house he submitted for the *Walks* series was felt to have an inappropriately satiric edge, but Barman instantly approved three rural vignettes, scaled-up versions of the type of rural scenes that had graced the Kynoch Press Notebook; their classic quality ensured they would

7.6
London Passenger Transport Board *Country Walks* guides
incorporating Eric Ravilious rural vignettes, first issued in 1936.

see service for many years. In Barman's office Ravilious met Robert Harling, the twenty-six-year-old freelance designer acting as typographical consultant for the series, who had bought Ravilious's watercolour *Shepherd's Cottage* at Zwemmer's show two months before; Harling later recalled 'Barman's unabashed delight on seeing the proofs submitted by the artist; and the artist's reciprocal delight.'[30]

The following year Harling commissioned a cover decoration for a redesigned *Wisden's Almanack*, which Ravilious completed in August 1937. Five years later Harling would walk round Trafalgar Square with Eric shortly before his departure for Iceland, and after ten years he would publish the first comprehensive monograph on his lost friend's engravings. He afterwards wrote how 'At first meeting he looked more the cricketer he occasionally was than the artist he always was; tall, slim, modest, bonily handsome, mildly otherworldly, but quick to laughter, and with much of an undergraduate's carefreedom in manner and dress ... he was that rarity, an artist and an outstanding decorative designer ... at the very beginning of a career which promised exceptional – and more to the point – unpredictable versatility in the fine, graphic and applied arts'.[31]

Barman also admired Ravilious as an artist but he could be a demanding client, dismissing a later effort for a poster as 'completely useless for the purpose of attracting traffic to Greenwich. Kensal Green cemetery with a stiff East wind blowing would be just about equivalent in traffic value.' Consequently the LPTB was a far less important source of work than another that arose in the summer of 1936 after both Cecilia and Noel Carrington independently but simultaneously suggested that the Wedgwood family should consider employing Ravilious.[32]

Cecilia already knew Tom Wedgwood, a younger cousin of Josiah Wedgwood v, the current managing director named after the founding father of the Etruria works at Stoke, and as a result 'was virtually given the freedom of their showroom in Hatton Garden, and from the backs of long unopened cupboards I found a store of lovely things, which had not been made for years. I found they were willing to re-make what I wanted provided I gave a minimum order, but I doubled it before we opened as I was so sure I could sell it all.' The order was for undecorated ware in simple shapes first made fashionable by the original Josiah Wedgwood in the eighteenth century, blanks of the type that would shortly become the bearers of successful Ravilious designs; Cecilia's commercial decisiveness would prove crucial in ensuring that they entered production and, by extension, that the relationship with Wedgwood

burgeoned into Eric's most substantial partnership as a designer working for a commercial client.

<p style="text-align:center">* * *</p>

The arrival of Cecilia's shop and the patronage of the LPTB were also important for Enid Marx in these years, the former as a more prominent outlet for her handblock-printed designs, supplementing her St John's Wood studio sales and participation in exhibitions at Zwemmer's, and the latter as a client requiring her to engage with textile manufacturers and grapple with new design challenges. From 1930 to the arrival of Dunbar Hay, the Little Gallery in Ellis Street near Sloane Square had been the main retail stockist of her printed stuffs, selling items like bolster and cushion covers, scarves, shawls and bedspreads made from her materials; additionally it sold notebooks, portfolios and boxes covered with her pattern papers amid the shop's selection of visitors books, *Radio Times* covers and telephone sets.

Animated by their personal taste and a strong preference for craft production, the shop was owned and run by Muriel Rose, who Marx first met when she worked in the Three Shields Gallery, and her partner Margaret Turnbull. The stock ranged from St Ives stoneware ceramics and Swedish Orrefors glass to rural craft items in rush and wood, 'quilts from the mining areas', and at various times Bawden's wallpapers and Tirzah's marbled paper lampshades. Although Marx's own partner Margaret Lambert (known as 'Lamb') was a friend of Turnbull's, Marx would later remember her relationship with Cecilia's enterprise as being closer, possibly because the opening of Dunbar Hay coincided with or precipitated difficulties in her relationship with the Little Gallery. Marx saw Cecilia as 'one of us' and Cecilia remembered her as 'a willing and exciting contributor to our stock'.[33] Marx – who in the early war years would become a keen advocate of pressuring British industry to take good design seriously – may also have been attracted by Dunbar Hay's conscious mission of linking artist-designers with manufacturers. In later years it was Dunbar Hay she associated with Paul Nash's influence and legacy, writing that 'Cecilia and Athole's gallery owed much to Paul's vision. Amongst his aims was a liaison between painters, designers and young architects to create contemporary interiors and living rooms.'[34]

The fabric designs that Marx was producing in the late 1930s – there are more than forty examples archived in the V&A, many with Dunbar Hay labels attached – attained an arresting modernist vibrancy while still showing 'an obvious pleasure in the doing that often amounted to a sense of celebration'.

7.7
Hand-block printed fabrics displayed in Enid Marx's studio,
in front of a selection of her blocks. *c.* 1936.

7.8, 7.9 & 7.10
Enid Marx: Cover design for *The Saar* (top), ink, watercolour and newsprint collage, 1934;
Lamb in Triumph (centre), wood engraving, *c.* 1935;
and headpiece for *A Childhood* (bottom), wood engraving, 1937.

The majority showed her fascination with natural forms as a basis for creating repeating patterns, but others were now more purely and confidently abstract and a few (for example, *Underground*) were based on urban forms. Like Ravilious, however, she was 'always a designer who was also an engraver' and, in parallel with her fabric production, she pursued book illustration based mainly on wood engraving, notably her four wonderfully apposite headpieces for Francesca Allinson's *A Childhood*, published by the Hogarth Press in 1937. Allinson was then involved in an emotionally charged but sexually unfulfilled relationship with the young composer Michael Tippett, yet she was also very close to both 'Marco' and 'Lamb'.[35] This trio was every bit as vital as Ravilious, Bliss and Bawden at the RCA, and the diminutive Marx celebrated it in a wood-engraved device in which she represents herself as 'shrimp' together with Allinson as a plumed bird pulling a Lamb along in triumph. Lamb, an expert in German foreign policy, was also by now a published author – Faber & Faber having brought out *The Saar* in 1934 with a cover by Enid featuring swastikas alongside an expressionist collage, which dramatized the crisis in the disputed industrial territory.

A new field of design began to open up for Marx in 1936 as a result of an approach by Christian Barman, who reviewed her printed work that September in *Signature No. 4*. He praised her ability to 'seize the major points of a concrete problem and to provide a solution that will have something more than interest or charm: the fitness and simplicity of fine craftsmanship'. Barman was about to procure a new generation of rolling stock for London Underground. As 'interior designer of the trains' he required a range of hard-wearing 'mocquette' seating fabrics that made allowances for dirt and uneven wear, avoided dazzle in artificial and natural light, and looked good alongside both plastic and wood. Several artists including Paul Nash were approached, but it was a tenacious Marx who most enthusiastically absorbed these requirements while utilizing a mixture of cut and uncut threads (plain and terry) to create both texture and pattern.

Marx had not designed for woven fabric before, and 'mocquette' production was a specialism in itself, but in two months she submitted thirteen designs for sampling, with careful notes on desired colourways. It was the beginning of a lengthy process of negotiation with Lister & Co. of Bradford, which led eighteen months later to her reporting to Pick 'I have found it impossible to get a design faithfully reproduced and I do not think this is the fault of the designer.' She went on to explain 'when the woven samples arrived, it was apparent to Mr Barman and myself that they were very different

from the original drawings, even where the manufacturer had not tried to introduce "improvements" or "variations" ... presumably to meet technical requirements'.[36] Factory visits and successive redesigns eventually produced acceptable compromises and four striking, fit-for-purpose materials, which entered service over the next decade. The experience added design-for-manufacture to Marx's wide array of skills, and recounting hard lessons learned to Pick she concluded 'I hope this may be of some use to you in your efforts to improve design in industry.'

Ravilious visited Marx in her St John's Wood studio at this time, making a large-scale pencil sketch of her working environment with colour notations. Here she printed her own fabrics including the new range of more delicate patterned organdies which, particularly liked by Cecilia, were subsequently exhibited in Paris. With its precise recording of objects in an interior space *Enid Marx's Studio* is reminiscent of the October 1930 cartoon that preceded his tempera *Portrait of Edward Bawden*, and intersecting lines just right of the central foreground seem to indicate where the figure of Marx might have stood in a finished work. Around this time Ravilious completed a separate sketch of Marx standing, pencil in hand, and contemplated including her and the Little Gallery in the *Alphabet of Shops* as 'Q is for Quilts'. Abandoning this as *High Street* emerged in a different form, it seems he came close to memorial-izing his relationship with Marx in a large-scale work; but it was inspiration of a different kind that ultimately marked his visit to her studio. Spotting two harvest mugs painted with corn-stooks and farm implements, typical of the folk art collected by Marx and Lambert, he rushed straight off to the V&A to see more. The following spring, Wedgwood's *Persephone* (also known as *Harvest Festival*) went into production as the first full set of tableware bearing a Ravilious design, a pattern fusing traditional influences and his own sketch of a Harvest Festival display at Castle Hedingham.[37]

* * *

'This afternoon I'm going to the works again,' Ravilious wrote from Stoke in mid-August 1936. 'I am sorry to say the family think my beautiful designs above the heads of their public and that to begin with something should be done which is safer and more understandable ... I was for a clean sweep they were for a method of slow percolation; it all means that I had better think of some new designs ... old Josiah's own patterns are the most perfect pottery designs I've seen ... it is a pity I cannot raise up his ghost to help along my argument'. Four months earlier Ravilious had gained an inkling that Wedgwood were

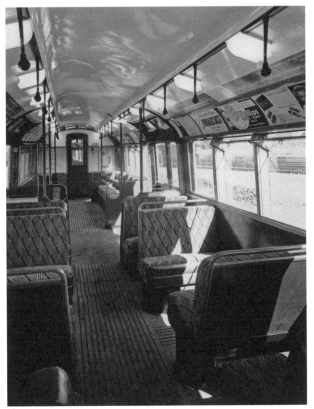

7.11 & 7.12
Enid Marx: *Mocquette materials for London's Underground* (above), 1936–38;
and below her seat covers in service, late 1930s.

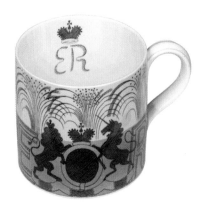

7.13 & 7.14
Wedgwood Edward VIII Coronation Mug, decorated with a 1936 Ravilious design (top);
and Wedgwood Ravilious *Harvard Boat Race* bowl,
exterior panel (centre) and internal decoration (bottom), 1938.

keen to employ him, and subsequently tea in the Euston Hotel with Josiah Wedgwood had left him enthusing that 'this job may just possibly be a really good one and produce some results: unlike glass.' 'They want me to work six weeks a year for them,' he told Helen. 'I don't know quite what the fee will be but it will be something beautifully disproportionate to the time and the effort.'[38]

The proposition was that his contemporary designs would be produced by the original eighteenth-century method of transfer printing, whereby skilled operatives in the factory would engrave his pen-and-wash designs onto copper; the resulting images printed on tissue paper would be fixed to pottery but burnt away in firing, leaving outline designs ready to receive colour prior to refiring. Ravilious was sceptical that the factory practice of several engravers working on a single set of images could work, but having mistaken the output of an early trial for the work of a single hand, he was quickly converted by Victor Skellern, who knew Ravilious from the RCA before he returned to Stoke in 1935 as the factory's Art Director.[39]

What caused more of a problem was the first batch of designs themselves: they were too avant-garde and abstract for the combined tastes of Josiah and Tom Wedgwood. This left Ravilious, returning to the task back in Essex, reflecting that 'tactful persuasion and some propaganda in the London shops' and a degree of 'bullying of the Wedgwood family and their travellers' would be required as well as 'far more time and patience than I thought necessary at first and visits to Stoke every month or so'. A fortnight later he added: 'These pottery designs take so long to draw out. One is quite good so far. Wedgwood only liked the fern plate with a border of balls. If he turns down the latest drawings I will resign, but he won't this time.'[40]

At this point Cecilia's decisiveness tipped the balance. The sketch that had met with most approval was Ravilious's exuberant proposal for a mug to celebrate the crowning of Edward VIII; seeing the design on paper during a visit to Wedgwood, Cecilia placed an order large enough for production to proceed. Spending a day at the Stoke factory on 20 October 1936, Ravilious was able to report to Helen: 'They have agreed to do the simpler patterns at last and all I have to do is steer and advise the engravers. The Coronation Mug is very large but I like a mantelpiece ornament (which is really what it is) pretty big. It is a change and I like it and felt almost excited when they brought it out – there is some clever engraving in it.' That very afternoon Stanley Baldwin confronted the new monarch at Fort Belvedere, rejecting the notion that he might marry his mistress after her imminent divorce; within a few weeks a consignment of

mugs must have arrived at Dunbar Hay in Mayfair where, possibly on the day she lunched at Claridges during the third week in November, Wallis Simpson herself purchased one during one of her last outings in London.[41] As the liaison, kept secret from the British public but extensively paraded in the foreign press for months, burst into public view, she left the country via Newhaven on 3 December and a week later Edward followed her to France after abdicating.

As the Coronation plans laid for May 1937 were hurriedly re-assigned, preparations were made at Stoke for 'ER' to be replaced by 'GR' and Eric evidently arranged for close friends like the Hortons and the Bawdens to receive unexpected Christmas presents. Edward wrote in thanks: 'When the Wedgwood box arrived and was opened I was very surprised to see the coronation mug appear and I ran shouting to the kitchen where Charlotte was mangling nappies and threw the mug in her face so to speak; she dropped the nappies and we adjourned to my room to smoke and enjoy the mug together ... Later the mug took its place on the mantelpiece where we could see and review its merits during mealtimes, and discuss the monarchical, technical, economic and aesthetic pros and cons ... it is a cheering piece of work and I am very proud to possess it (as a supporter of the monarchy – and *ipso facto* of the present vicious capitalist system – I suppose you will provide the same form of persuasive publicity for geo. 6?).'[42]

Unsurprisingly, the George VI mug was the version on display in the United Kingdom Pavilion when Tirzah and Christine Nash, taking the boat train via Newhaven the following October, caught the Paris exhibition a month before it closed. Always appreciative of historical curiosities, Ravilious had by then presented his drawing for the Edward VIII version to the V&A, a few months before the museum bought samples of Tirzah's papers for its collection, probably from Dunbar Hay.[43] During four 'all quite heavenly days' in Paris, Tirzah also visited the exhibitions at the Palais Art Moderne, which had fascinated Eric Newton, before watching fireworks from the steps of the Trocadero; after buying £2-worth of very good marbling paper at La Rue de Petit Champs on the last day, she recrossed the Channel entering Newhaven late on a foggy, moonlit night, returning a day later to an exhausted Eric and a home overrun with rats.[44]

By this point relations between artist and industrial enterprise were on a firm footing: Wedgwood had produced the Boat Race bowl with designs celebrating an aspect of London life associated with Eric and Tirzah's 'gay and lovely' times in Hammersmith and an additional Piccadilly Circus night scene suggested by Tom Wedgwood. Correspondence about technical requirements

7.15
Eric Ravilious, design for Wedgwood *Garden* series,
pencil and watercolour, 1937.

flowed back and forth, and a disappointing delay producing Alphabet Nursery designs for the 1938 Christmas season was quickly compensated for by a display entirely devoted to Ravilious designs in the company's Hatton Garden showrooms. This prompted a *Times* article extolling a trade show that the newspaper would not usually bring to public attention but for 'a collection of china – dinner and tea services and nursery mugs – with printed decorations filled in with colour from engravings by Mr Eric Ravilious, who has a special talent for designs of a linear character'. Receiving a new batch of designs Tom Wedgwood responded: 'I am delighted with them particularly the Garden pattern; you must have put in a tremendous amount of work since you were down here, and I do think you are to be congratulated on the result.' The company went on to place adverts for 'GARDEN: Modern though they are the decorations on the new table service by RAVILIOUS have an eighteenth century elegance. With the delicate charm of an aquatint they depict scenes of work and leisure in a summer garden.'⁴⁵

Ravilious Wedgwood-ware was now prominently displayed at Dunbar Hay, alongside Marx fabrics, other fabrics manufactured by Allan Walton (at least one to a Diana Low design), Tirzah's marbled paper products and wallpapers by Bawden, with whom Cecilia remained on friendly terms despite feeling

short-changed by an unsatisfactory denouement to their book project.[46]
One job Ravilious had turned down in the spring of 1936 was a proposal from
Noel Carrington that he should provide engravings for a garden-themed
Country Life publication; this subsequently became the 1937 *Gardener's Diary*
illustrated by Bawden, prompting a casual letter to Cecilia around the time
Dunbar Hay first opened: 'Do you remember the plant drawings of mine I bor-
rowed to show Noel Carrington of Country Life? I wonder if you would mind
those drawings being introduced in a CL publication called the *Gardeners
Diary*?' As the diary was already being printed, an assurance that Bawden
would call in at the shop to discuss the matter was a trifle redundant, but it was
a measure of Cecilia's generous spirit that – although annoyed – she happily
promoted his work after he wrote 'I should be very glad if you stocked some
of my wallpaper patterns and give them a gentle but steady sales publicity.'[47]

Having initially taken the tail end of a lease at 20 Grosvenor Street, new
premises were soon required; but before they could be found Athole Hay died
suddenly at the age of thirty-six. This sad turn of events and the inherent fas-
cination of the enterprise meant Cecilia now committed herself for longer
than the two years she had initially intended, and postponed further travel.
Securing larger premises at 15 Albemarle Street, she turned to Ravilious to
design a trade card that doubled as a change of address notification. In the
new phase Eric remained Cecilia's go-to designer and was as keen as ever to
respond as before: 'when we get back from Eastbourne I will try my hands at
the design. Will you let me know sometime what is the new address? ... It is a
nice idea and very amusing thing to do I think. We did enjoy your visit this
last week end ... PS what I haven't said is how helpful your criticism was about
these paintings I am doing – and it was just what I wanted.' Beautifully con-
ceived as a doll's house freighted with goods one could buy at Dunbar Hay,
the trade card was strikingly printed in two colours and playfully projected
traditional elegance with a modern edge.[48]

A project for Dunbar Hay playing cards reached an advanced stage around
this time and, although they never went into production, Ravilious was as ever
appreciative of his friend's approval: 'I am so glad to hear about the playing
card designs. Perhaps I better cut the yellow block for the star pattern now –
the colour for the lyre bird design may as well be a line block, as it is flat, but if
you like or if Waddington's prefer I can cut that too. Next week I shall be going
to Bristol to paint with John Nash, who says this is the best port in England –
and I'm looking forward to the change having sat at this table so long.'[49]

7.16, 7.17 & 7.18
Edward Bawden, *Verandah and Trees* (above left), lithographed wallpaper, *c.* 1934.
Eric Ravilious: *Cover Design* for British Pavilion at New York World's Fair (above right),
wood engraving, 1939; and *Trade Card* for Dunbar Hay Ltd (below), wood engraving, 1938.

CHAPTER EIGHT

BRISTOL AND RYE

After John Nash's teaching session at the Royal College had ended on Friday 4 November 1938, he and Ravilious travelled down to Bristol by train. Eric had spent the day in London with Diana Low, now Mrs Tuely, who had come up from Rye to meet him. Five weeks before, on the day Neville Chamberlain prepared to fly to Munich, Eric had sent her 'all the news from the Hedingham front' after a morning fitting gas masks at the vicarage: 'I won't talk about the war – I know how difficult it is to work too, and the feeling every morning on waking that something has gone wrong.'[1]

Ravilious was now looking forward to a week in Nash's company at a port where six pleasure-steamers that plied south-coast waters in the summer season were laid up for winter; he knew them from childhood and had drawn *The Brighton Queen* during his truncated stay at Newhaven with Bawden just three years before. In the interim, John Nash – with whom he already shared a considerable artistic affinity – had become one of his closest male friends as well as the painter in whose company he felt most consistently at ease.

Following an abortive attempt to take lodgings at the harbour side, they found rooms in easy reach of a cinema and a billiard hall, and on the second night, as John reported to Christine Nash, 'we got fascinated by the steamers tied up in the Hotwells, faintly illuminated by the street lights and have been out trying to draw them sitting on bollards near street lamps to the amazement of the inhabitants ... At present it is mild and fine here and working by night is really warmer than by day as the wind drops ... We seem to get on very well and I feel the move to come here was a success and a stimulus to Eric.'[2]

After early Monday evening playing billiards, a further outdoor sortie was followed by consumption of a bottle of sherry during a working session back at their lodgings. This evening probably gave rise to both Eric's *Paddle Steamers at Night* and John's *Nocturne, Bristol Docks* – two images evoking stillness and light at night painted on the day that a tormented Herschel Grynszpan, seeking to avenge the suffering of his Jewish parents, assassinated a Nazi official,

Ernst vom Rath, in Paris. Two nights later *Kristallnacht* shattered lives across Germany.[3] Leaving to fulfil his teaching duties in London, Nash would have seen the headlines on Thursday morning, 10 November; he intended to return, but having acquired a cold, it seems he did not.

Left to his own devices, Eric witnessed an extraordinary scene as fire destroyed a major brewery and a timber yard at the docks. Fought by the harbour fire-float for four hours, it also mobilized the Bristol Auxiliary Fire Service, recently formed as part of air-raid defences, in an impromptu dress rehearsal for the Blitz that would follow within eighteen months. Ravilious stood amid thousands of onlookers, in much the same way as Turner had witnessed the destruction of the House of Commons a century before, as 'with a report like an artillery gun the flames shot out of one of the ventilator shafts of the main building [and] in ten minutes the entire malthouse was burning like a blast furnace'. But unlike the feverishly productive Turner, who promptly dashed off so many watercolour studies that the leaves of his sketchbook stuck together, Ravilious admitted 'this should have been drawn but of course it was too exciting and disorganising to work that day much'.[4]

The next day he spent drawing three of the pleasure-steamers for his watercolour *Bristol Quay* and ten days later was able to tell Diana: 'The Bristol visit was rather a successful one – two or three more boat drawings; paddle steamers at night with a pink light from the left is about the best. It was a thing I would have gone a long way to draw and I'm grateful to John for thinking of it.' Like his trip to Newhaven with Bawden, Bristol had yielded a useful contribution for a forthcoming exhibition, Eric's third one-man watercolour show, to be held at Arthur Tooth & Sons the following May.[5]

* * *

Although John Nash and Ravilious had become acquainted in the 1920s at meetings of the Society of Wood Engravers, their growing friendship dated from autumn 1934 when John joined Freedman, Horton, Bawden and Ravilious as a part-time teaching colleague at the RCA. Two terms later Eric was telling Helen: 'Friday was rather a blank. I hope I taught well but that isn't likely. John Nash livened things up of course – we went out for a drink and talked about gardening (I listened) and about a pomologist (there are such) called "Apple" Bunyard, who is a rum old bachelor with a wonderful library of books of plants and fruit. Nash is very good company and I like him.'[6]

Nash, ten years Eric's senior, had fought in the trenches at Passchendaele and Cambrai when Ravilious was in short trousers; and by the time their

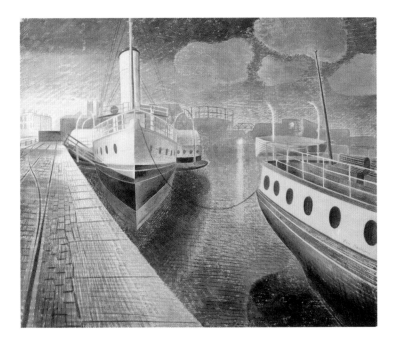

8.1 & 8.2
John Nash, *Nocturne, Bristol Docks* (above), watercolour, 1938.
Eric Ravilious, *Paddle Steamers at Night* (below), watercolour and pencil, 1938.

paths crossed, Nash was already well known for his war art (*Oppy Wood* and *Over the Top* being among the great First World War paintings), his lyrical oil *The Cornfield* (painted, he said, in sheer relief at finding himself alive in the English countryside), and his finesse as an illustrator. By 1928 Nash felt the future of the single wood-engraved image was limited, even though he valued engraving in book illustration and for decoration. Thereafter line drawings dominated his output with only *Celeste and Other Sketches* (1930) and *When Thou Wast Naked* (1931) carrying significant wood-engraved content, the latter being a Golden Cockerel Press Guinea Series volume clad in a striking Tirzah Garwood patterned paper. In 1935 Nash completed his last wood-engraved book, *Flowers and Faces*, bringing his tally of cuts since 1919 to over 140 blocks.[7]

Ravilious and Nash now began to seek out each other's company more regularly, with encounters at the RCA leading on to home visits and painting exploits in both Buckinghamshire and Essex. Pub games, parlour quizzes, billiards, the cinema and charades appealed; organized Christianity repelled, the more so for Nash who, despite beginning to cultivate an increasingly conservative image as a country gentleman, loathed the established Church; he excluded even glimpses of its buildings from a predominantly rural *oeuvre*. Once he left home, Ravilious merely avoided going into places of worship for twelve years.

Even more than Ravilious, Nash was not a natural joiner – he contributed paintings to the AIA exhibitions and offered his services to its *Portraits for Spain* initiative, but unlike Eric, he was very unlikely to frequent an AIA meeting or attend its Congress. Both men could also be intensely sociable, witty and playful – a shared quality that shines through in their equally expressive letter-writing (even if Nash is on occasion more inclined to the mordant and cynical). They were also equally capable of compartmentalizing their lives and guarding their emotions when tangled circumstances demanded it; a necessary capacity in Nash's case because, like both Ravilious and his brother Paul, he was, in John Rothenstein's phrase, always 'exceptionally responsive to the attractions of women'.[8]

In the RCA staff room, Horton was in the vanguard of popular-front activity while Freedman was master of ceremonies for the annual picnic at Burnham Beeches. For these the staff paid for up to a hundred students who had taken their Diplomas to board hired Green Line coaches for a day of innocent excess ('long noses and paper hats will be encouraged'). Writing prior to the 1936 outing, Eric recorded 'John Nash says he wouldn't do any commercial work if he could help it (unlike Edward) and not much painting: what he would do is play

8.3
Eric Ravilious, *A Rust-Coloured Feruginous Light*,
illustration for *The Writings of Gilbert White of Selborne*, wood engraving, 1938.

the piano and spend most of his time in the garden. He is 43 and feels a bit sad about it. He doesn't care much for all this activity of Paul's and thinks he should paint more than he does. Paul thinks there ought to be more interest in Surrealism at the College. God bless him.' Meanwhile Paul for his part, now much drawn in his own work to the metaphysics of 'equivalents', had doubts about his brother's painting, stating in a patronizing judgment 'it was I who encouraged Jack to be a painter and I'm not sure I did rightly; I don't know whether he has a painter's imagination.' Less pompously, around this time he signed off a letter to Freedman with the PS, 'I think you are the man to design a surrealist alphabet – what about it?'[9]

By summer 1937 Ravilious – energized as a painter after his second success at Zwemmer's, broadening his activity as a designer and enthused by lithography – was looking to shed both teaching commitments and laborious wood-engraving assignments. Having refused to take on more hours in 1936, he now submitted his resignation to the RCA, precipitating Athole Hay to respond 'I had heard about your impending desertion but never mentioned it to you in the hope that perhaps it would all be forgotten ... I do hope, however, that it won't mean I will never see you anymore. If ever you want a bed in London there is a moderately uncomfortable one in my dressing room which will always be at your disposal.' Sadly, six months later, Ravilious and his erstwhile colleagues were attending Athole's funeral.[10]

8.4
John Nash, *Chalkpits, Whiteleaf*,
oil on canvas, 1923.

One of Hay's last duties was helping fill the vacancy Ravilious created, a position for which Freedman advanced Enid Marx, suggesting she seek a reference from Paul Nash; this she did, but it emerged that Nash was backing Graham Sutherland for the position, prompting Marx to remark to Freedman 'why didn't I join the Surrealists – it seems like a fine trades union!' She succeeded in getting an interview with Percy Jowett, Rothenstein's successor as Principal, but attended feeling she had not 'a ghost of a chance' as 'being a woman is quite enough to damn me, apart from any personal disadvantages'. Jowett was not the type to appoint a woman RCA student who had been denied a diploma; establishment recognition for Marx would have to wait until she was appointed a Royal Designer for Industry in 1944.

Ironically, it was Paul Nash himself who now made a return to South Kensington, teaching two periods a week at £120 a year from January 1938 until the evacuation of the College to Ambleside in November 1940; but his presence lacked its former inspirational impact and, as Bawden observed, 'he did not go round to students personally, they came to him one by one where he sat in a dark basement with the windows barred and the walls lined with

Office of Works bookcases ... his manner was pompous and any conversation was likely to be broken by an asthmatic struggle for breath'.[11] Ravilious never seems to have regretted his choice and was able to keep in touch with College networks via Bawden, Horton and John Nash.

In a parallel move Ravilious also submitted his resignation to the SWE in early May 1937, citing remote country living and diminishing activity (he had just turned down a Christopher Sandford request to provide wood engravings for 'another unreadable Elizabethan'); but it was a prospect that dismayed the membership, and the secretary, Margaret Pilkington, wrote a letter pleading reconsideration. Fortuitously, in the interim Ravilious had received an unexpected letter from Harry Carter at the Nonesuch Press asking whether he would like to illustrate one of his favourite books, Gilbert White's *Natural History of Selborne*. An enticing brief asked for rural scenery rather than ornithological or horticultural precision, and Pilkington was soon writing again 'delighted you will withdraw your resignation'. Ravilious had been rereading White for pleasure the year before and the commission now resulted in forty-four woodcuts, which through their magnificence became a fitting denouement to his substantive career as one of England's outstanding wood engravers. It was also an exercise that he found surprisingly enjoyable having been given 'a congenial book to engrave for at last, after years of Golden Cockerel nonsense. Now I feel quite sorry not to do more which I wouldn't have believed possible last year.'[12]

Eric's pursuit of change, symptomatic of a search for artistic stimulus as well as a personal restlessness in the aftermath of his affair with Helen, had led him to plan a journey to Huckleberry Finn country in the autumn of 1937. He canvassed advice from John Rothenstein who, having lived in the Southern States, recommended Kentucky and Louisiana, also advising 'I would certainly go to Massachusetts as you suggest, for I can already see in my mind's eye the colonial architecture most aptly treated by you ... I think your project is an altogether admirable one. With cordial regards and bon voyage.' Two weeks later, however, Ravilious was telling Cecilia that 'the American visit doesn't seem likely; chiefly because the shop-book isn't coming out for Christmas now.'[13]

Although Ravilious was now attracted by the possibilities of travel, it was not until March 1939 that he left England for the first time since 1925, and then for only ten days in Normandy. There he completed *Yellow Funnel* and *Pilot Boat*, similar in vein to the two Bristol paintings, and all four featured among the twenty-seven watercolour drawings shown at Tooth's. This body

of work reflected a wider pattern of English travel than its 1936 predecessor at Zwemmer's, when subjects found near Hedingham and within striking distance of Furlongs had predominated. At Tooth's this territory made up only a slight share: one painting featured a sandpit near Hedingham, two the cliffs near Belle Tout on the Sussex coast and another the nearby Cuckmere valley, painted when Ravilious and Tirzah were staying at Eastbourne just before his departure for France.

Ports on the Essex and Suffolk coasts, locations in reach of Diana's home at Rye on the Kent border and subjects that Ravilious found near Capel-y-ffin in Brecknockshire contributed eighteen paintings to the show. All dated from 1938, a peripatetic year that began with Tirzah driving Eric to Wales on the last day of January on a painting excursion. His first visit to Tollesbury on the Essex coast took place in April with Tirzah before he returned there the following week in company with John Nash. That Easter, Nash stayed at Castle Hedingham during the latest in a series of reciprocal visits that had begun the previous March when Ravilious stayed at Meadle, the Nashes' Buckinghamshire home, and which continued whenever Christine and John visited the Stour valley near the Hortons – a regular spring and summer occurrence, which also drew the Freedmans to the area for holidays. Occasions of easy sociability ensued with Ravilious and Nash often sketching side by side and suggesting possibilities to each other, as when Eric took his visitor to 'see the sandpit (where there were so many failures last year). He was rather excited by it I think and could hardly make up his mind what to do first, and the next afternoon did two unfinished drawings which I shall be anxious to see finished, both very promising and spirited.'[14]

Nash and Ravilious responded to the same traditions in English watercolour drawing, and their affinity in terms of working methods and subjects is indeed striking. Self-taught and untutored at any art school, Nash habitually worked up paintings in the studio from observational sketches in the field. It was close scrutiny of the natural world, rather than the happenings of imagination, that was the initiating impulse of his art. He drew constantly in the open air in all seasons using pencil and wash for 'noting down the habits of particular trees and the curve of particular lanes' before retreating indoors to create watercolours of 'a light firmness and order'. This process, employing a similar combination of careful drawing and dry-brush work that Ravilious used in his watercolour drawings, involved, as Christopher Neve described in *Unquiet Landscape*, 'something that made the difference, an edge that sharpened the truthful facts seen that afternoon in the field or by the river, and set

8.5
Eric Ravilious, *The Carnation House*, watercolour, 1938.
One of two completed paintings based on Knoll House Nurseries, Wittersham.

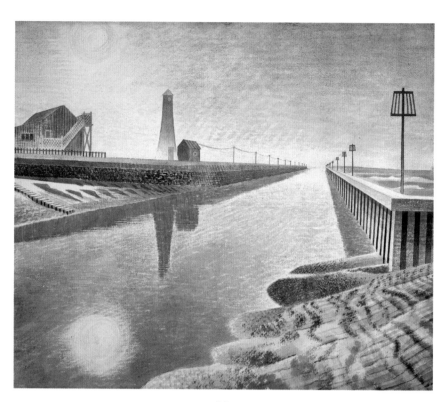

8.6
Eric Ravilious, *Rye Harbour*,
watercolour, 1938.

them down again, redesigned and slightly simplified, their romantic overtones scraped firmly out to show the sprung bones underneath'. Ravilious shared with Nash a similar but perhaps more intuitive ability to create a heightened sense of reality, often in landscapes where human presence is immanent but unseen; for Nash – a keen horticulturalist – it was a facility founded on forensic scrutiny of the natural world and a belief that 'the artist's main business is to train his eye to see, then to probe, and then to train his hand to work in sympathy with his eye. I have made a habit of looking, of really seeing.'[15]

At the end of July 1938 Ravilious returned to Tollesbury for six days of painting before moving up the coast to stay at Aldeburgh two weeks later. In the third week of August he decamped to Rye Harbour, which Eric had seen that May during a visit to Diana and Clissold; he already knew the area from childhood and, when he and Tirzah spent Christmas 1936 at the Tuelys'

new house Underhill Farm a few miles to its north, he had been struck by 'the hilly country between Rye and Winchelsea'. Accordingly, in early May 1938 he had written asking whether he could stay for about a fortnight 'it would be an exciting change of scene ... I would like to try working in your Border country very much – as you know.'[16] After arriving he discovered Knoll House nursery nearby, which gave rise to the watercolours *The Carnation House* and *Geraniums and Carnations*; on the same visit he made sketches in the back garden of Underhill Farm, which contributed to his Wedgwood *Garden Implements* designs.[17]

On his return to Rye Harbour in August, Ravilious based himself at the William the Conqueror pub, finding nearby subjects in much the same way as he had at Newhaven while staying at The Hope three years before.[18] Working hard, he captured the basis for at least three paintings in as many days, the best known of which, *Rye Harbour* – an evocation of high summer of almost surreal intensity – was already showing promise when his College contemporary Edward Le Bas bumped into him on the quay. The streamlined perpendicular form of the harbour lighthouse appears in all three watercolours (it is even prominent in the view from the bay window in *Room at the William the Conqueror*) in much the same way as the West Pier lighthouse at Newhaven was a recurring element in his paintings there.

Rye Harbour must have put Ravilious in mind of the other East Sussex port, particularly as Bawden had revisited Newhaven the previous autumn, his proffered suggestion of a joint expedition to Bath having not borne fruit. Perhaps mindful of the tensions that had overshadowed their time there, Edward wrote a long and somewhat nostalgic letter to Eric from a renovated Hope Inn: 'Newhaven is remarkably unchanged except for a sand quarry on the cliffs, which is an improvement to the view ... the Brighton pleasure steamers come in at night and moor exactly in the same place & manner as they did two years ago (curse! I left that drawing behind). The Foremost Prince & Princeling are as ever, dight in pearly mud lines, [the] swans glide wistfully under and around the anchorage ropes. The pub is splendid ... less water and more gravy with the meat ... so I admit I am enjoying myself'. After describing his troubles drawing in high winds and the havoc unfolding at Brick House where electricity was being installed, Edward concluded: 'This is a real home letter. "Dear Mother" I should have commenced and ended "love from Edward". Instead, yours ever, EB.' Writing to Diana and Clissold on Christmas day 1937, a year after the one spent at Underhill Farm, Ravilious reported: 'Edward is working very hard for his show at the Leicester Gallery in January

and it promises to be very bright and lovely, particularly the Newhaven scenes. He went there in bad weather this Summer and suffered considerably having to paint in a gale and throw his vegetarian principles to the winds.'[19]

* * *

Eric and Diana resumed their affair during his visit in May 1938. Underhill Farm was an idyllic spot, perfect in many ways for Clissold, who had no desire to practise architecture but wanted to become a fruit-grower, but too isolated to support the connections required for a woman artist in the 1930s who was also now the mother of a toddler. Tirzah had urged Diana not to abandon her painting after marriage and Diana was also developing fabric designs – some she printed herself and a few being manufactured commercially – but neither design work nor exposure for a would-be painter were easily accessed from Rye. An earlier effort by Eric urging Robert Wellington to see her work had not led to an exhibition, but before the visit was cut short she evidently showed Eric more recent material, as he wrote soon after: 'I did enjoy seeing the few paintings there was time for me to see, particularly three landscapes and one of the portraits. I wish I had asked to see them earlier but you didn't tell me there was all this collection high up in the attic.'[20]

In her autobiography Tirzah described the turn of events: 'Diana came and slept in his bed, saying that her husband wouldn't mind. Next morning Eric observed that he obviously did mind, so he left for Eastbourne where I was staying. I wrote a calming letter to them and finally [Clissold] became more reasonable about the matter and this relationship was a good thing because it is always nice to have someone love you and be truthful in criticising your pictures.'[21] When Eric confessed to Tirzah, she had made none of the criticisms he expected; her own affair with John Aldridge, started at a time when Eric's relationship with Helen was at its most threatening, was now more intermittent and had never been likely to supplant her primary relationship with Eric, whose own transgressions she seemed now to accept with clear-eyed tolerance. For Clissold, however, the resumption of Diana's relationship with a former lover, whom he had moreover got to know quite well since their marriage, was clearly more troubling.[22] He too, though, seems to have been a person of great tolerance, for example, willingly accompanying Diana on a visit to Castle Hedingham just before Eric's return to Rye Harbour (but not to Underhill Farm) that August.

By then a pattern of meeting up every couple of months was becoming established in an ongoing affair which, while clearly passionate, was to a

8.7 & 8.8
Diana Low: *Designs on Paper* (above), watercolour, late 1930s;
hand-block and printed scarf (below), late 1930s.

degree recreational for both participants. However, it did trigger emotional confusion on Eric's part as he made clear to Diana: 'Give my love to Clissold – I met him when I was catching the train. You might say to him that I really would like to have talked about you when he was here, if I could. I know this is really weak of me – the reason of course is that I feel he minds and so there is nothing I can really say. If I were married to you I'd mind probably: perhaps not ... The cucumber doesn't know. Helen always wanted you to be clear in the head about all feelings and motives and I was never clear enough.'[23] When Eric returned to the area for a third time in October a gracious Clissold drove him across the marshes at the beginning of the wintry session when he painted *Lighthouse and Fort* and *Dungeness*, two other watercolours sold at Tooth's.

Both John Nash and Ravilious were blessed in primary relationships with remarkably forgiving and exceptionally supportive women who nurtured both them and their work. Another thing they now shared, apart from a relaxed attitude towards infidelity, was the experience of having a relationship with Helen.[24] Nash met Helen Binyon in August 1936 when she and Ravilious were staying with Percy and Lydia Horton at Assington in Suffolk, not far from the Nashes' holiday cottage at Wiston. Less than a year before, tragedy had struck the Nash household when their only child William had fallen out of the front passenger seat of a car Christine was driving; hitting his head on the kerbstone, the four-year-old died almost instantly.[25] This led to a period of agony and distance between his parents. John Nash in particular struggled to come to terms with his pain at William's death and for some years consciously avoided socializing with friends who had young children (it is perhaps a measure of the companionability of his relationship with Ravilious that neither this nor the potential awkwardness of their intersecting affairs diminished their own friendship). Nash had once been deeply in love with Dora Carrington before she in turn fell for Lytton Strachey, and he subsequently married Christine Kuhlenthal, Dora's friend and fellow student at the Slade; he was a demanding husband even before Christine's own painting career was cut short by glaucoma, and from then on she devoted herself to helping him in his work, often scouting for subjects, always handling business and household matters. In the aftermath of their son's death and the loss of any comfortable intimacy between them, this supportive role extended to not merely tolerating, but facilitating, John's affairs.

By the summer of 1937 Helen and John were in a relationship, which Helen announced to Ravilious without naming Nash. By Christmas, Eric was fully in the picture, but Helen had not yet told her new lover about her prior affair.

8.9
Helen Binyon, *Shaded Stream*,
watercolour, 1942.

Learning that she might, Eric was concerned, but by March 1938 the air had been cleared with John signing off a letter to Eric 'I try to be a nice friend to Helen!'[26] That summer Helen stayed with the Nashes at Meadle and Wiston on various occasions and took John to Furlongs for a weekend before he and Eric embarked on their Bristol trip.

Helen continued her watercolour drawing in all these locations, and some vignettes subsequent to this time are very reminiscent of both the Stour valley and Nash's own style; however, in tandem with her twin sister Margaret she was definitely ploughing her own furrow when it came to puppetry. This reached a pre-war high point in June 1938 with a one-week season of hour-long performances at the Mercury Theatre in London's Notting Hill Gate with a new range of puppets and scenery made by Helen. By then both Eric and Helen had moved on from the end of their affair and their continuing relationship was becoming established on a different basis. He visited her on several occasions; writing to Christine after one such visit, Helen reflected that she was no longer the person who was so madly in love with Eric, 'who

8.10
Press Association publicity shot of Helen and Margaret Binyon
rehearsing for their Mercury Theatre season, with
(from left) Benjamin Britten and Lennox Berkeley at the piano.

was here a week or two ago ... He was very helpful with suggestions for the scene painting – and lent me drawings and brushes – as long as one makes no emotional demands he's sweet and I'm learning not to. I'm sure this seeing him is the quickest cure, even if it's been painful.'[27]

To Eric, Helen wrote: 'The puppets are going well I think – the first night has been postponed until June 22 not owing to our being behindhand but to the composers – so I feel a slight easing of the tension – I have almost finished the last puppet – a frog – then I'll be able to consider the scenes – which I haven't really done anything about yet – I may go down to Glynde station for a day to draw – perhaps I shan't need to though – Your drawings will be a great help.'[28] A drawing of Glynde Station is dated 1938 in Helen's hand and suggests she may well have made the trip down as planned. The same letter adds 'John Nash has found a charming pianist called Frank Kennard – a friend of Barnett's too – so Barnett rang up with helpful suggestions for

publicity – rather his line – it is fun being forced into an absorption in work I am enjoying it.'

With music by Benjamin Britten and Lennox Berkeley ('the music is pretty good I think') the show opened on a Tuesday and ran twice nightly to the following Saturday with a matinée on the Friday. Eric and Tirzah and Claudia and Barnett Freedman were at the opening night; Percy and Lydia Horton and John and Christine Nash went on Saturday evening. Under the heading 'Amiable Puppets' *The Times* notice was positive: 'Though they spend their private lives in a collapsed state and must suffer much anxiety which attends wire pulling of any sort ... they had no difficulty in winning over their audience [and] the programme executed at the bidding of Miss Helen and Miss Margaret Binyon was a pleasant and successful entertainment. Perhaps the best was the ballet of animals in a wood, in which a couple of frogs performed a hilarious *pas de deux* to old world measures. "The Station Master" turned rustic arguments to merriment, and in "Spain" and "the Seven Ages of Man" (poems by Montagu Slater and music by Lennox Berkeley) a more topical note was struck.'[29]

During the Mercury Theatre run, test cricket had been televised for the first time, and although there were only a few thousand sets in use, variety shows had just begun to be broadcast. Helen and Margaret appeared on television a couple of weeks later, making it probable that Helen's puppets were the first to perform on the small screen. Helen, however, was only marginally impressed: 'We went and televised the Mermaid scene last Thursday up at Alexandra Palace – it was really very amusing ... the place is like a madhouse and the work seems to me completely idiotic and futile – still we [got] £10'.[30] Helen's reaction may have coloured Eric's view as, asked to attend with some pictures after the Tooth's exhibition opened, he relayed to Diana 'they wanted me to go to Alexandra Palace and take some drawings to televise (with one of those wireless compères – Tell me, Mr Ravilious, do you prefer working by night?). I thought no, not in this heat.' Barnett Freedman by contrast had no such reservations and was soon established as a broadcaster and pundit.[31]

By the end of 1938 Helen and Margaret's focus had shifted to a proposal for a children's book; the only other traceable pre-war appearance for their puppets was the following February, as *Puppets for Spain* alongside Henry Moore's *Reclining Woman* in the sculpture section of the AIA's 1939 Whitechapel Exhibition. Although Helen's wood engravings were also included, it was the puppets that won her a favourable mention in company with Moore, Duncan Grant, Ben Nicholson and Vanessa Bell in the *Manchester Guardian*. Titled 'Art

for the People' and including a Private View card stamped with 'To be opened by The Man in the Street', a passing pedestrian plucked from Whitechapel High Street at the appointed hour, the exhibition attracted 40,000 visitors to a show of 300 works in one month.[32]

At this point Helen's affair with John was still under way, although just after his Bristol visit she had resolved to end it. In a twist worthy of any melodrama, her letter to John was intercepted by Christine and returned by her with encouragement for the relationship to continue. From now on Helen frequently discussed with Christine the emotional aftermath of her previous relationship, and her position as John's mistress: 'about John, you know I only said he wanted bed-work from me – well the other thing he wants is to be made to feel a fine fellow – I can do that at the moment (I enjoy it too – it's nice to have something demanded of one – Eric just took it all as tribute) but after all it's only an illusion – it's no real hope – and I don't want him to get dependent on it – however I think I can manage things – with consultations with you now and then ... he is much lonelier and unhappier than either of us'. In August the following year Helen impetuously asked John Nash to father a child with her. Their affair came to an end shortly after this, although they continued to see each other in the first year of the war.[33]

* * *

Percy Horton, Edward and Eric formed the selection committee for the AIA exhibition's watercolour and drawings section and on 1 February 1939 were photographed at work in their overcoats for *Picture Post*. Afterwards Eric wrote to Helen about his cold day in Whitechapel, adding 'it was nice putting up a ready hand when your engravings came round. I think I got in first – but everybody voted them in.' Most of their friends had work in the show and the engravings in question were Helen's illustrations to *Pride and Prejudice* together with a work titled *Walton-on-the-Naze*.[34] This wood engraving, a precursor to an AIA Everyman Print later that year, resulted from painting at the seaside town with Horton in the late summer of 1938.[35] Percy had been highly active for the previous three years, as the AIA had broadened out from its Communist Party roots and attracted 900 members. Shortly after their expedition Helen agreed to join him on the Committee; although she resisted becoming secretary, she would remain on it for the next five years.[36] By now Chamberlain's capitulation to Hitler at Munich had sanctioned the dismemberment of Czechoslovakia and the proud remnants of the International Brigade had left a Spanish Republic on the brink of defeat, returning to

The exhibition will be opened by THE MAN IN THE STREET

A cross-section of every form of contemporary art in Great Britain exhibited as a demonstration of the Unity of Artists for Peace, Democracy and Cultural Progress.

1939 *EXHIBITION*

An exhibition of work by members of the ARTISTS INTERNATIONAL ASSOCIATION. Advisory Council: James Bateman, A.R.A., Vanessa Bell, Misha Black, Sir Muirhead Bone, LL.D., D.Litt., Eric Gill, Duncan Grant, Augustus John, E. McKnight Kauffer, Hon. R D.I., Henry Moore, Paul Nash, Lucien Pissarro.

February 9th to March 7th

12 noon-9 p.m. Daily 2 p.m.-9 p.m. Sunday Admission Free

WHITECHAPEL ART GALLERY, HIGH STREET, E.1.

Aldgate East Underground Station adjoins the Gallery

8.11 & 8.12

All in Favour: Eric Ravilious, Percy Horton and Edward Bawden
selecting work to be hung at the 1939 AIA exhibition;
below, an invitation card for
'the exhibition to be opened by The Man in the Street'.

 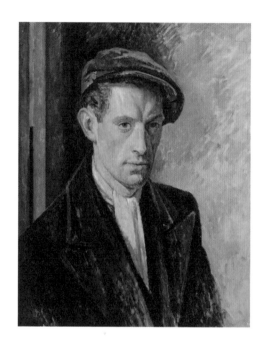

8.13 & 8.14
Percy Horton: *Woman Ironing* (left), oil on canvas, *c.* 1930;
and *Unemployed Man* (right), oil on canvas, 1929.

Newhaven on the channel steamer SS *Versailles* in December; few now believed war was avoidable.[37]

Like many of his contemporaries, Eric's uncertain progress towards a degree of activism had been triggered in part by events in Spain. Shortly after the outbreak of the Civil War in 1936 he had attended a meeting that the speakers addressed 'very clearly and well I thought, though all they could suggest is on the lines of propaganda: which was the same conclusion as the meeting at Cambridge. We could go if we like to Brussels to the Conference there. We can pledge ourselves to fight in the event of a class war here like the one in Spain: we can alternatively go to prison or be shot down. More to the point we can assist by designs and drawing for the rather bad leaflets and such that are produced, and this I mean to do if I can later. Still I don't know if the complete pacifist is the better line.' A little later he and Edward were intending 'to belong to the AI publicity gang this autumn when we are both freer'. In the event by November 1936 Bawden had signed the Peace Pledge and joined the Peace Publicity Bureau; at Brick House he cross-examined Eric about 'the AI and the Congress – so I said all I could, but of course he is a pretty determined pacifist by now and suspects the AI'.[38]

Although by nature more inclined to escape into the latest P. G. Wodehouse, Ravilious joined Helen in reading a number of Left Book Club titles. In January 1937 he wrote 'I still read *The Theory and Practice of Socialism*', with which he did indeed persevere, telling Helen a little later: 'You would like Strachey's book a lot. Some things he says have penetrated and I feel better for having finished it and after the first month or so really began to enjoy it.'[39] Shortly before this he received papers about the forthcoming AIA Congress and Exhibition ('I've said yes to everything on the questionnaire more or less and sent it off') and that January his name appeared on a list of fourteen prominent supporters including Edward Wadsworth, Dod Procter, Duncan Grant, Vanessa Bell, Henry Moore and Herbert Read (fig. 8.15). This was followed by a second list of twenty-four supporters with celebrity status (including J. M. Keynes, Eric Gill, Sir Michael Sadler and Serge Chermayeff) and a third consolidated list – including Paul Nash, László Moholy-Nagy and Jacob Epstein – which appeared on the invitations, the sending-in sheet for the exhibition, and the Congress programme.[40]

Perhaps Eric had been more persuasive at Brick House than he thought, for when the AIA Bulletin appeared that April with its banner headline '*Greetings To The Congress!*' the front page carried a statement of support from Edward. Tantalizingly, there is no trace of another statement acknowledged by

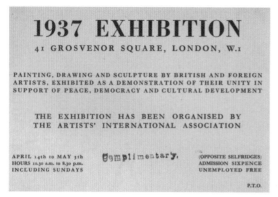

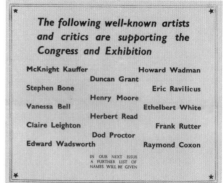

1937 EXHIBITION

41 GROSVENOR SQUARE, LONDON, W.1

PAINTING, DRAWING AND SCULPTURE BY BRITISH AND FOREIGN
ARTISTS, EXHIBITED AS A DEMONSTRATION OF THEIR UNITY IN
SUPPORT OF PEACE, DEMOCRACY AND CULTURAL DEVELOPMENT

THE EXHIBITION HAS BEEN ORGANISED BY
THE ARTISTS' INTERNATIONAL ASSOCIATION

APRIL 14th to MAY 5th Complimentary, (OPPOSITE SELFRIDGES)
HOURS 10.30 a.m. to 8.30 p.m. ADMISSION SIXPENCE
INCLUDING SUNDAYS UNEMPLOYED FREE

P.T.O.

The following well-known artists
and critics are supporting the
Congress and Exhibition

McKnight Kauffer	Howard Wadman
	Duncan Grant
Stephen Bone	Eric Ravilious
	Henry Moore
Vanessa Bell	Ethelbert White
	Herbert Read
Claire Leighton	Frank Rutter
	Dod Proctor
Edward Wadsworth	Raymond Coxon

IN OUR NEXT ISSUE
A FURTHER LIST OF
NAMES WILL BE GIVEN

8.15
Entry card and initial list of supporters
for the AIA's 1937 Exhibition and Congress.

Congress Secretary Millicent Rose: 'Dear Mr Ravilious, Thank you very much for your letter and statement on the subject of "Artists and Politics". You have said very concisely what is the opinion of many artists and we should be glad if we might print your short statement.' Eric and Tirzah attended Congress sessions and the accompanying exhibition where *Sport* – possibly his initial design for the Paris frieze – was included in the watercolours section.[41] He, along with Edward, Peggy, Percy and John Nash also signed up for the *Portraits for Spain* scheme, an AIA initiative for members to undertake commissions, donating the fees for maintenance of the Artists' Ambulance, which had been purchased the previous year from the proceeds of an auction overseen by Freedman.[42]

After the Munich Agreement of September 1938 the sense of impending catastrophe was inescapable and the Committee on which Helen joined Percy was now involved in a growing number of initiatives. As the AIA's own review of its first five years observed in December: 'The tragedy of Czechoslovakia and the renewal of the bestial attacks on the Jews in Germany, the continuance of the war in Spain and the intensification of the fighting in China, have shown even more clearly the impossibility of an artist, escaping his responsibilities to the community. The AIA formed the Artists' Refugee Committee and artists of every type have helped the schemes for assisting to escape from Czechoslovakia those German artists who thought they had found a refuge in that country.' This was not the only refugee scheme associated with Eric and Tirzah's network – but it may have been the source of 'our Czech', a refugee

directed to Castle Hedingham the following year who never arrived, and whom they feared was detained 'at the frontier for a concentration camp in Germany'. Among their friends Freedman was particularly active taking up cases of émigrés refused employment and sending funds via Stephen Tallents, now the BBC Publicity Director, to support refugee families.[43]

One AIA initiative Ravilious intended to support was the Everyman Print series launched as a fund-raiser in the last summer of the peace. It was conceived as a popularly accessible collection of auto-lithographs for sale '1/6d coloured, 1 shilling plain' through Marks & Spencer and other high street shops.[44] Helen provided three colour prints in the first batch when 3,000 were sold in three weeks, but by October Eric was writing to her: 'I feel rather a pig not to have done a lithograph for you ... I did actually get as far as starting something – the ballroom at "the Bell" with a huge Union Jack and a nice domed ceiling – but it never reached the plate you gave me.'[45] Had it done so it would have taken its place with fifty-two others in a series that reflected adjustment to wartime conditions in images of blacked-out interiors, barrage balloons ascending and evacuated children. Helen's most striking print, *The Flower Show* (fig. 8.16), was a more pacific image directly invoking a letter Eric had written to her in July 1935, the year before he urged her to take up lithography; this described 'the green tropical heat in the tents and people in summer dresses and a smell of sweet peas everywhere – a band playing of course outside – was pleasant and exactly like every Flower Show that has ever been – Lady something opened it and was perfectly true to type'.[46] Into this scene Helen introduced a figure that could be mistaken for Eric holding a child in his arms.

<p style="text-align:center">* * *</p>

Eric's paintings *Life Boat* and *Waterwheel* appeared 'n.f.s' at Whitechapel and two months later had been hung at Tooth's where they sold for eighteen guineas each; Diana was one of many friends who attended the private view. Writing to her three weeks later Eric recounted 'I went up to Stoke again this week and took the chance to explore the Derbyshire Hills but didn't like them much ... I looked in at Tooth's on the way and asked to see a list of buyers but it was taken away before I remembered who they were ... 21 or 2 have gone now.' Seven were in fact sold at the private view, fuelling 'a very gay party' at the Café Royal with Tirzah and 'John and Christine and Helen'.[47]

The show was a critical as well as a commercial success with Jan Gordon in the *Observer* writing 'In Ravilious the most marked influences are Seurat, Van

8.16
Helen Binyon, *The Flower Show*,
auto-lithograph for the Everyman Print series, 1939.

Gogh and the brothers Nash, but these have been properly dominated and emulsified into the quite different whole, Eric Ravilious ... Between the arts of seeing and perceiving a gulf lies. Of talented artists the majority do but see, clearly perhaps, hypnotically sometimes, but moments of extra-perception are rare. Of these watercolours by Ravilious one may feel that a large number of them do touch true perception.'[48] Eric Newton in *The Sunday Times* made the same point under the heading 'Personality in Watercolour': 'He paints trees as though he were a squirrel, flower-pots as though he were a gardener, mountains as though he were a sheep, cliffs and lighthouse as though he were a seagull. He makes you feel that each object matters immensely, that it has become inextricably tangled with his experience, and that he wants desperately to show you what it is really like.'[49] For Ravilious the approval of artists he knew and respected always mattered most, but the critical reception given to his third one-man show made him feel that, if he had not yet fully arrived, he was definitely getting somewhere as an artist of significance.

At the private view, Tom Hennell met up with Paul Nash for the first time in many years. Nash learned from Hennell that he was working on illustrations for the ruralist writer H. J. Massingham, editor of the Nonesuch *Selborne*. Massingham's *English Downland* had explored the ancient aspects of the same southern English landscapes that fascinated Nash and which had become central to much of his recent painting. Relaying to Massingham news of the show and Ravilious's 'work of a delicate, clear and lovely perception, and of fine design and technique', Hennell was able to effect an introduction for Nash, who undertook to visit the author at Long Creedon next time he stayed with his brother at Meadle. Two further products of the encounter were a Paul Nash book cover for Massingham's 1941 autobiography *Remembrance*, and Hennell getting to know his fellow horticulturalist John Nash.

Hennell still remained beset by intense visions which he meticulously recorded in dream accounts, but their frequency was diminishing, and he was now sufficiently distanced from past traumas to have written with considered advice in 1938 when Gwyneth Lloyd Thomas became depressed and was herself admitted to Maudsley Hospital. He spent that Christmas at Brick House before walking over to Castle Hedingham for a visit that Eric described to Diana: 'Hasn't the snow been wonderful? – Thomas Hennell who was here made a family sledge for six that rumbles as it goes and leaves tracks you can see on the Sudbury Hill for miles away. The children were out all day with it on Saturday. And we had a great snowballing party.'[50] Nine months later Eric would be serving at an Observation Post on Sudbury hill, but glimpses of

family life afforded by his letters and Tirzah's writing suggest how much happier their home had become by the time Tirzah, early that New Year, became aware she was pregnant with their second child.

In the summer of 1939, buoyed up by the reaction to his work at Tooth's, Ravilious was keen to explore landscapes across a wider territory and a spoof communication from Christine Nash headed 'The Artists Country Hunting Society' probably dates from this time: 'With reference to your esteemed enquiry concerning Country with sugar-loaf Hills in tones of brown-grey-green fawn (no purple) we beg to suggest the County of Dorset. Take a line from Bridport to Lyme Regis and work inland as far as the limits of the County. Reference to the "Shell Guide to Dorset" by Paul Nash will give you an idea of the strangeness of the Country ... If you would prefer something brown-yellower and with no trees at all, we would suggest the sand dunes called Braunton Burrows in North Devon ... We believe this is practically virgin territory as regards Painters Activities ... we remain dear sir your obedient servants the ACHS pp C Nash.'[51]

The autumn months were the genesis of four landscapes as well as a train interior, which, although distinctly different works in themselves, Ravilious linked by his inclusion of chalk figures. There were four locations, at Weymouth and Cerne Abbas in Dorset and Uffington and Westbury in Wiltshire, to which he travelled during a break from observation duties. The first to be completed was *The Wilmington Giant*, a hill figure he had known from childhood and long since introduced to both the Morley mural and the Almanack wood engravings. He drew it once again during an extended stay with Peggy Angus at Furlongs in August, when Tirzah was staying with her parents in Eastbourne during the last stages of her pregnancy.[52]

Peggy, whose relationship with Jim Richards was now more than ever a matter of concern to her friends, was also about to give birth to her second child; she had been living at Furlongs for much of the previous year, having given up her teaching post at the end of a period of maternity leave. Jim was frequently absent and as Peggy had no family to hand it was Eric who summoned help when she went into labour before giving birth in Lewes. Left alone at Furlongs for several days, it may have been now that Ravilious worked on his iconic *Interior at Furlongs* and *Tea at Furlongs*.

On the last Sunday of the peace, Diana, also now pregnant with her second child, drove over from Rye with her daughter Jane. She and Ravilious had visited Sissinghurst that February, he for the first time since the Harvest Camp of 1916, and in May they had met in Lewes and explored the country around

8.17
Eric Ravilious photographed by Serge Chermayeff
on the last weekend of the peace.

Ditchling. A plan for September was overtaken by the declaration of war seven days later. The party that afternoon at Furlongs enjoyed not only tea but claret before Diana drove back to Underhill Farm and Serge Chermayeff unexpectedly called to take Eric and the others back to his modernist house at Halland. There, in late summer evening light, in a terraced garden that enjoyed a distant view of the sinuous Downs (but which had just lost Henry Moore's *Recumbent Figure* to the Tate and the New York World's Fair) they played boules – a game Ravilious took to with relish.[53]

* * *

As war became inevitable Ravilious had consulted John Nash about the possibility of joining the Artists' Rifles, in whose ranks his friend had witnessed death and dismemberment before he became an Official War Artist in February 1918. Nash had found the transition to a world at peace less troubling than his brother Paul, who had suffered as a 'war artist without a war'. The prospect of renewed conflict sickened John Nash, but he had already signed up for the Observer Corps and part of his reply to Ravilious ('Lay your troubles before

8.18
Eric Ravilious, *The Westbury Horse*,
pencil and watercolour, 1939.

me next month when I shall be at Wiston but don't rush in') foreshadowed a discussion that encouraged his younger friend to follow suit; and as a result their phoney war experiences would have much in common.[54]

During the months that followed Ravilious reacted to his hilltop surroundings with the same enthusiasm with which he would soon confront many quotidian wartime situations, writing to his father-in-law how 'the sand bagging and duck boarding at the post have been done on Sundays with loving care and are really worth drawing, especially on some wet day with two shivering men inside with black oilskins and sou'westers'.[55] John Nash was far more downbeat: 'This beast like life makes one lazy – I mean, one seems as far as I am concerned, to live like an animal ... the life of the intellect seems curtailed. How do you find it? Is it devilish cold on your post? ... I have practically ceased to work and even take a slightly perverse pleasure in retirement into obscurity.'[56]

Ravilious had his own momentary doubts about the value of continuing artistic activity and wrote to Christine about the unreality of people 'in the set' in London, of John Piper doing a series of drawings of churches, and of publishers producing unwanted books – but somehow in his case the impetus to create always got the upper hand over the feeling that endeavour was irrelevant. But for John Nash, who could remember the egalitarian reality of slaughter, the idea of a return to war as an artist raised awkward issues: 'I think P Nash is busy in Oxford making dossiers of artists who are to be saved from war's more active pursuits and I hear is surrounded by a crowd of assistants, though why artists should be so privileged as to expect other people to fight for them I don't know. I should welcome your views on the subject.' For Eric, however, any theoretical misgivings quickly dissipated when he received a Christmas Eve letter informing him that, after discussions between the newly formed War Artist Advisory Committee and the Admiralty, 'you and John Nash have been selected to work on a part-time basis, if you should be willing ... From our point of view the sooner you get to work the better.'[57]

то ICELAND

As war was declared in September 1939, Paul Nash felt 'suddenly the sky was upon us all like a huge hawk, hovering'. He and his wife Margaret had left Hampstead for a hotel in Oxford two weeks before and there he 'turned to the solace of the Randolph bar'. Mixing with artists and intellectuals headed for 'war work to which they were more or less unsuited, and those who had nothing to do and no prospect of a job of any kind', he formulated a project for an Arts Bureau to mobilize talent behind the war effort. Persuading John Piper, John Betjeman and the University Vice Chancellor to join a 'Panel of Authorities', he embarked on a self-appointed task assembling 'Dossiers, Categories and Analyses' targeting 'a dozen different Ministries and Departments'; a quixotic effort that he described in a *Listener* article on 30 November.[1]

Seven days earlier Kenneth Clark had chaired an inaugural meeting of the War Artists' Advisory Committee (WAAC) sponsored by the Ministry of Information. He had previously contributed to a Whitehall register of artists thought suitable for camouflage and propaganda work but, in his own *Listener* article that October, he now publicly called for the government to employ the best artists on different grounds. 'I would like to see Paul Nash's picture of the balloon barrage, or Barnett Freedman's lithographs of life in an A.R.P. shelter,' he wrote, arguing 'the first duty of an artist in wartime is the same as his duty in peace: to produce good works of art.' He would admit later that his undisclosed aim was 'simply to keep artists at work on any pretext and, as far as possible, prevent them from being killed', an agenda parallelling the evacuation of art treasures he had just overseen as Director of the National Gallery. Still only thirty-six, he was already a knighted insider and by mid-November had secured Treasury approval to create 'an artistic record of the war in all its aspects'.[2]

'I do hope the plan won't founder in some department and none of us ever hear of it again,' Eric told Cecilia after seven weeks at the Observer Post on

Sudbury Hill near Castle Hedingham, an occupation embarked upon within two hours of Chamberlain's fateful broadcast. That evening he was joined in an otherwise empty Bank House by three evacuee boys and their grandmother; 'I think we shall get on well together,' he told Tirzah, who did not return from Eastbourne with John and newborn James for another eight days, but in the interim received frequent bulletins from Eric addressing her 'My Dear Tush ... my dear beast'. Edward Bawden had been in Zürich with Tom Hennell and Muriel Rose on 3 September. Once home, he wrote to enquire of Eric 'what part do you intend to play in the general mess?'[3]

It was a question preoccupying nearly all their artist friends for whom, as Clark observed, earning a living 'was hard enough in peace time but was made possible by teaching, an occasional sale or commission and a little commercial work'. Now all these options were eroding and, although 1939 had been a good year for Eric (on his own reckoning he had earned over £475), his new wage was only sixteen shillings a week. He read during lulls, wrote letters and created the basis for two good watercolours, but these activities were insufficient to see off 'nerve wracking' uncertainty: 'in an awful sort of way this is a holiday,' he told Diana Tuely. Rumours of Clark's initiative remained the great hope, but after ten weeks observing he was writing to Cecilia 'the thing is they have a fair sized list to choose from and I feel no certainty of being in the first batch ... Official war artists won't be seen at work this year.'[4]

At this juncture an approach from Noel Carrington, engaged in commissioning *Puffin Picturebooks*, led Ravilious to revive the trip he had previously planned for late August. Just before receiving his WAAC letter he explained to Diana: 'I have just returned from Dorset, having been promised a job drawing chalk figures – horses and giants – for a book. So I managed to hand my shifts [over] and went off there and then, and with a burst of work drew four, the Weymouth George III, the Cerne Giant, the horse at Westbury and the other white horse at Uffington. I hope to do others and start work on the book but it is a complicated life and so many interruptions.' Edward at this stage had not yet heard from the WAAC but writing a Christmas thank-you letter to Tirzah he clearly felt an offer was likely: 'Tell Eric that I accepted a camouflage position but have since chucked it, thereby casting my bread – nearly dry bread now – upon troubled waters – with a gesture of wild abandon. This sort of feckless behaviour on the part of one so prudent as myself cannot but move him to admiration.'[5]

CHAPTER NINE

The WAAC, which began sifting around five hundred names at its second meeting, included Percy Jowett, who as RCA Principal had previously employed Ravilious and still employed Bawden, both Nash brothers and Freedman. Given their established reputations and Clark's preferences for art that avoided abstraction, it was unsurprising that by early March they had all become attached to the various forces. Muirhead Bone, also a Committee member, was the recipient of its most lucrative contract as Official Artist to the Admiralty; however there was early agreement that Ravilious and John Nash should also be offered naval postings and six-month contracts. The Air Ministry hesitated over a suggestion that they employ both Paul Nash and Bawden, initially suspicious of their artistic and political leanings; but the War Department quickly expressed interest in Bawden's services and by March it was agreed he would join Freedman and Edward Ardizzone as war correspondents attached to the British Expeditionary Force in France. Meanwhile, Paul Nash, after closing down his Bureau, accepted a role with the Air Ministry, determined to create art with 'the character of a weapon'.[6]

All the appointments raised operational issues and in Paul Nash's case a medical board refused him permission to fly due to his asthma; while waiting for security clearances on John Nash and Ravilious, pragmatic Admiralty officials decided that making them khaki-clad Honorary Royal Marine Captains would signify neither competence nor authority at sea but would lend them sufficient status to work with a degree of independence. John immediately wrote to Eric: 'I shall be pleased to go with you to Moss Bros and then we can swank about a bit and perhaps take Helen out to lunch which I'm sure would thrill her. It isn't often that any doll has a chance of walking out with 2 Marine Captains is it?' A week later Eric wrote to Helen from Castle Hedingham: 'Now I mean to stay here in the snow until things are really fixed up with the Admiralty: but oh what a time they take. I've only just signed the contract at last, but still no word about actually beginning work. Is it possible they don't want us that badly?'[7]

He spent January 1940 in 'an acute state of restlessness'. By New Year, Bank House had frozen pipes and he and Tirzah decamped to stay with their friends Guy and Evelyn Hepher at the Vicarage; here Eric took his turn clearing snow from the roof before departing for a round of valedictory visits. After meeting Percy Horton and Beryl Bowker at the Royal Academy and celebrating at the Café Royal, he stayed with Diana at Wittersham while Clissold was in camp at Dover, revisited Dungeness ('I always loved that place'), and on his final visit to an empty Furlongs still found 'the scene from the windows as good

as ever, a wonderful tea colour with frost on the ridges'. Seeing his parents at Charleston Road coincided with the arrival of his brother Frank and he took leave of Tirzah's family at 'Elmwood Palace', writing to tell her 'I can only bear this for another day or two: on the other hand the more people I say goodbye to the fewer I'm able to see ... I feel like Lot's wife, caught on one leg, half turned to salt.'[8]

Eric's service life began on the second Saturday in February 1940 with a posting to the sprawling Chatham Dockyards full of foundries and factories. In the main it was an enjoyable culture shock, the rituals of the Officers' Mess striking him as a cross between the Frys' country house and a Wodehouse novel. Saluting seemed 'rather a business' and the conventions of a ship on dry land ('when you go out of the barrack gates you go ashore') faintly ridiculous. Officers were 'very pink' as too much gin tended to flow, but once Eric's permits were obtained and initial suspicions allayed, they also proved helpful to the artist in their midst. Within weeks, however, he would reflect 'I wish sometimes they weren't such schoolboys. Nothing is possible but the most boring sort of chat.'[9]

As if fulfilling Clark's edict that an artist's duty was the same in war and peace, he worked hard for five weeks creating the basis for eight watercolours which in subject selection and technique exhibit a high degree of continuity with those he had shown at Tooth's. Drawing on dockside scenes little removed from ports and harbours he had previously painted, a nocturne of *Destroyers at Night* reads as a companion piece to *Paddle Steamers at Night* while employing hatching and scoring reminiscent of *Beachy Head*; and the snowbound *Ship's Screw on a Railway Truck*, although reflecting Chatham's industrial function, is reminiscent of peacetime landscapes, where human presence is suggested but unseen, and far removed from martial endeavour. After finding himself attracted by an 1830 figurehead and the admiral's red bicycle, ideal subjects for the creator of *High Street*, he was soon exclaiming to Helen 'oh the still life of buoys, anchors, chains and wreckage. I must try to remember what I am here for and only do one drawing of this kind.'[10]

This was written at Sheerness in northern Kent where Eric arrived after 'an exhilarating week-end with a naval party at Whitstable', his first experience of observing men in harm's way as they defused a live mine. *Dangerous Work at Low Tide* with its watchers on the shore and sailors departing over the sands is a painting that rehearses a new facility with figures, integrating men at war into the luminous arrival of a new day.[11] Within four months he would consciously stretch himself as an artist, drawing men at work within the confines

9.1

Eric Ravilious, *Barrage Balloons at Sea*,
watercolour, 1940.

of submarines. Nevertheless, Ravilious and others would attract criticism
from some quarters that as official war artists they were merely creating art in
wartime deemed inappropriate as 'War Art'.[12]

At Sheerness, Ravilious painted *Barrage Balloons outside a British Port*, with
a toy-like launch lurching out to sea from a Regency quayside, and *Barrage
Balloons at Sea*, including a still life of chains and anchors in the foreground.
Unmistakably products of his particular vision, they could both be taken for
children's book illustrations – they are in a sense war scenes from the home
front depicted through a child's eyes. Barrage balloons featured heavily in the
Everyman Prints series and centrally in *Bulgy the Barrage Balloon*, the first of
three lithographed children's books written and illustrated by Enid Marx dur-
ing the war, a time when 'all the boys were given uniforms and I felt very left
out, and was turned down for camouflage, I fire watched, did the children's
books and fed Lamb, her brother [and] Lamb's team at the BBC, and did some

9.2
Trekkie Parsons, *Portrait of Enid Marx,*
oil on canvas, *c.* 1940.

Recording Britain In Pictures'.[13] Helen Binyon, about to take up war work in
Bath making Admiralty charts, had also developed proposals for children's
books before the war and now embarked on designing and illustrating the
first four of ten books using texts written by her sister Margaret. Founded
on Helen's aptitude evident since RCA days for drawing children at play, and
published by Oxford University Press in the summer of 1940, these included
A Day at the Sea with her two nephews, herself and Eric enjoying an imaginary
beach picnic, as well as *A Day in the Country* with boating scenes reminiscent
of the Pant in Essex (fig. 9.6). Called on to produce a design for the Cotton
Board the following spring, Eric readily adapted elements of his alphabet
mug to create a child's handkerchief.

In early April 1940, Ravilious stayed with John and Christine Nash at Meadle
in Buckinghamshire; it was a weekend enlivened by Barnett Freedman's unex-
pected appearance, 'looking like some sort of General in his top boots', and
Christine photographing the three friends play-acting General Staff on cam-
paign (fig. 9.7). Freedman crossed to France that Monday, rendezvousing with
Bawden in Arras, who had left the week before. Nash, who Christine believed

9.3, 9.4 & 9.5
Enid Marx, *Bulgy the Barrage Balloon* (above left), auto-lithograph, 1940.
Tirzah Garwood, *Eleven Parachutes* (above right), pencil and crayon, *c.* 1943.
Eric Ravilious, *Design for a child's handkerchief* (below), lithograph for the Cotton Board, 1941.

9.6
Helen Binyon, covers for the first four Binyon books,
published by Oxford University Press in 1940.

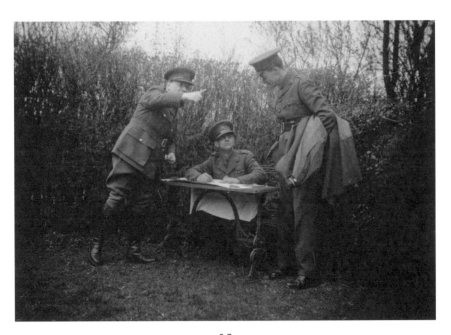

9.7
Barnett Freedman, John Nash and Eric Ravilious
preparing for action, Meadle, April 1940.

had been delaying completion of an Admiralty poster to avoid leaving his
garden in spring, now reluctantly travelled to Plymouth. His was an unhappy
return to life as a war artist, but discovering a fire station he had no doubt
what might engage Eric: 'engines and huge Figure Heads were stored together
in delightful confusion ... really wonderful and varied and would give you
much joy! ... I feel helpless and pygmy-like and wish you were here to discuss
matters and assist me by drawing somewhere near.'[14]

Even before this John Nash was speculating about the possibility of trans-
ferring to a regular commission, and in due course the contrast between his
own artistic ennui and his brother's sense of mission was made clear in a
letter he received from Paul: 'I feel ... a sort of responsibility beyond what
is naturally owed to myself, as it were, as an artist. I try to make my work
strike a blow in that much neglected field – Propaganda – a good picture
first, but if possible a picture to make you feel good (or, if you're a Nazi, not
so good).' Forbidden the air, Paul had spent several months visiting Bomber
stations and scrutinizing the 'personality of planes' such as Wellingtons and
Blenheims. After finding a permanent home in a basement flat in Oxford,

9.8
Paul Nash, *Bomber in the Corn*,
watercolour, 1940.

he made sketches at the Cowley aircraft dump preparatory to painting the powerful allegorical oil *Totes Meer*; and in watercolours such as *Bomber in the Corn*, one of the 'raider series' depicting destroyed German planes, he dramatized southern England's ancient landscape as resistant to evil. Such pictures of fascist wreckage were not to the taste of an Air Ministry official, who opined 'the hunting man prefers a picture of a horse to one of a dead fox'.[15]

When his contract was not renewed by the RAF, Nash quipped: 'They engaged me as an official artist but forgot to imagine that being an artist might mean more to me than being an official.' Clark, however, was quick to negotiate for him to work directly for the Ministry of Information 'in a very free-lance sort of way with a market for my work & eager to purchase if all's well. But no fixed salary. So long as they buy I don't mind but everything is very precarious.' It was a fix that supported creation of his monumental *Battle of Britain* in 1941, a year in which Nash also visited William Rothenstein at Far Oakridge. Although nearly seventy, Rothenstein had determined to donate his services to the RAF. Using his portraiture skills to depict pilots half a century his junior, he was producing war art of a type the Ministry favoured. As

9.9 & 9.10
Above: Edward Bawden the war artist in uniform, 1940.
Below: Paul Nash, right, visiting William Rothenstein at Far Oakridge, 1941,
possibly the last occasion on which they met.

his son John reflected: 'What a strange conjunction there was of two remote periods of time when this small figure, mentioned in the "Goncourt Journals", the familiar of Verlaine, Pater and Oscar Wilde, was out over the North Sea in a Sunderland flying boat.'[16]

* * *

Leaving Meadle, Ravilious had travelled to Grimsby in Lincolnshire, 'a treeless and smelly town of a meaty red colour', spending nearly three weeks in a soulless railway hotel hard-by the docks. Although plans to sail on a destroyer escorting fishing trawlers were delayed, then cancelled, the stay proved a prelude to embarking on more dramatic voyages the following month and the most significant art he would create during his first six months as a war artist. Working in and around docks 'covered in gobbets of fish', Eric also felt he captured 'wonderful material for lithographs', an activity he would pursue the following winter in the gap between WAAC contracts. 'Did I say I'd been out to draw a wreck, just funnel and masts sticking up, also had out the Duty boat to the Lightship,' he wrote to Tirzah in one of six letters making clear how much he now missed her and their boys John and James. Disturbed at night by railyard noise, his dreams, as he told Cecilia, were vivid: 'on Monday I was on board a paddle steamer gliding with speed and perfect stillness round hairpin bends of a river. There was a gibbous moon and a sun with six rays … and a coppery sultry atmosphere'. A hard wind blew for nearly two weeks, encouraging him to work on bridges and in engine rooms, and on the day it dropped he found a willing sitter in the harbour's diver equipped in full gear. With battle underway at Narvik in Norway, North Sea naval deployments were altering fast and as a result Eric was back at Castle Hedingham five days later; this suited him, having already abandoned painting on site in favour of 'making notes for painting in the peace and quiet of home'.[17]

He described *Light Vessel and Duty Boat* to Helen a fortnight later: 'one of a lightship today the best quite easily and really quite bright colour for me – there is a stabbing red light in the foreground'. Now known only from a photograph, this prefigured in intensity work that Ravilious would shortly produce in Norwegian waters, an imminent deployment he announced in the same letter, together with the depressing news that a lieutenant he knew at Chatham had just been killed. Conscious that he was about to go on active service Eric made a will, leaving everything to Tirzah except his painting of Edward at Redcliffe Road, which he bequeathed to its subject. Just over two years later *Light Vessel and Duty Boat* would also become a war casualty, lost to

the Atlantic en route to South America together with *Deadmarch Dymchurch*, judged at the time to be the finest of Paul Nash's raider series.[18]

Ravilious left Castle Hedingham for Hull on 16 May, a week after the German assault on the Low Countries ended 'the phoney war'. The next day he put to sea on HMS *Highlander*, finally disembarking twenty-five days later after travelling 7,500 miles as the newly commissioned destroyer made at least three round trips to Norwegian waters during the hasty repatriation of British forces. In the interim, France had fallen, Freedman had been evacuated via Boulogne and Bawden had survived Dunkirk, returning with sketches of the chaos on its beaches. In letters posted during port stops in Scapa Flow, Ravilious made relatively light of his own baptism under fire ('the excitements above and below don't interrupt much'), but on these voyages he was a witness not only to strange beauties of light and seascape but also to war, red in tooth and claw. While at Grimsby he had confessed to Tirzah that he did not want to join a convoy: John Nash, who had done so a few months before, had written to him of how 'despite the beautiful weather and calm seas there was always the feeling of possible crump, then floundering in the icy water afterwards – so I stepped on shore, or, to be more nautical "made landfall" with a sense of relief. Actually when one was not thinking of possible disaster it was rather boring and the view much restricted – a great mass in the foreground of one's own ship and then little dots in the distance representing the rest of the convoy.'[19]

Eric's unfolding artistic and personal experience on HMS *Highlander* could not have been more different: *Leaving Scapa Flow*, one of seven paintings he went on to complete, was an early success forged from the ingredients that Nash found wanting. Working conditions were difficult ('one can't keep edges and this is apt to spoil the temper'), but Ravilious displayed a steely ability to concentrate even under fire and he now found motion itself had its own fascination. Conscious that his work had been criticized as static, he wrote to Tirzah with evident delight 'the wake from a ship like this is very remarkable and I am trying to do something with it', an endeavour that bore fruit in both *Passing the Bell Rock* (fig. 9.11) and *Smoke Floats and Wake*. But it was the voyaging into northern latitudes for the first time that did most to fling open new doors of perception: 'We have been in the Arctic as high as 70° 30' ... so I've done drawings of the Midnight Sun and the hills of the Chankly Bore. I simply loved it, especially the sun. It was so nice working long past midnight in bright sunshine ... it is about the first time since the war that I have felt any peace of mind or desire to work'. *Midnight Sun*, although dated June,

9.11
Eric Ravilious, *Passing the Bell Rock*,
watercolour, 1940.

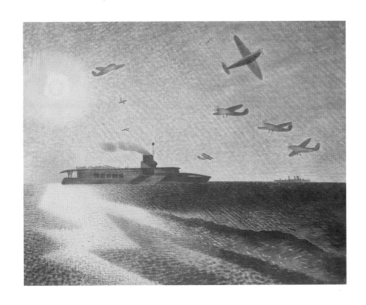

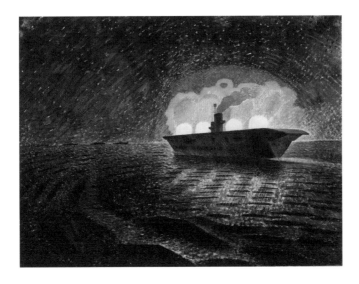

9.12 & 9.13
Eric Ravilious: *HMS Glorious in the Arctic* (above), watercolour, 1940;
HMS Ark Royal in Action No. 1 (below), watercolour, 1940.

9.14

From left to right: Barnett Freedman, Muirhead Bone,
Edward Ardizzone, Eric Ravilious, Anthony Gross,
Kenneth Clark and John Piper at the National Gallery, July 1940.

was probably begun with *Norway 1940* on the first round trip. On the last trip
Ravilious witnessed the aircraft carrier HMS *Ark Royal* in action at night, cap-
turing the basis for two watercolours, one of which, *HMS Ark Royal in Action
No. 1* (fig. 9.13), he completed with a bold technique that added an element
of 'sturm und drang' missing from its companions. For Eric Newton it was a
picture that made Ravilious one of the few war artists to capture that 'sense of
waking nightmare that is inseparable from war'.[20]

Another picture of an aircraft carrier, *HMS Glorious in the Arctic*, features
both a powerful sun and a balletic display of planes circling against an iri-
descent sky. Ravilious had probably witnessed unadapted Hawker Hurricanes
landing on the carrier in a feat of airmanship previously thought impossible.
It is a sharply defined work of patterned light and water in motion convey-
ing an exhilaration that recalls Jan Gordon's remarks about 'extra-perception',
but which in perilous times now led some observers to judge that here was an
artist who 'sometimes trembles on the brink of affectation'.

It was a dichotomy made worse by the fact that on 8 June, shortly after
HMS *Highlander* was re-assigned to escort HMS *Ark Royal*, HMS *Glorious* and
two escorting destroyers were surprised and then destroyed by the German

CHAPTER NINE

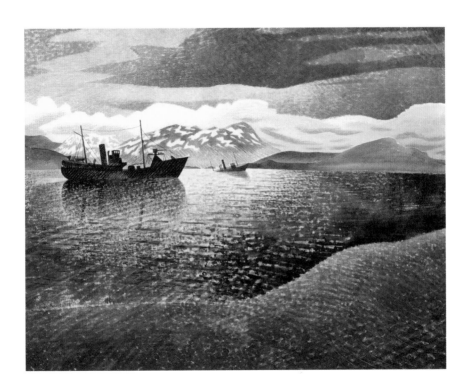

9.15
Eric Ravilious, *Norway 1940*, watercolour, 1940.
'I managed one gloomy painting in Norway.'

battleships *Scharnhorst* and *Gneisenau*; 1,519 British sailors drowned and, on the brink of the Battle of Britain, two RAF squadrons were lost. As Clark wrote a little later, 'Both Ravilious and Bawden have suffered from the fact that they were amongst the very first artists whose work was shown in exhibition and at that date their charming rather mannered watercolours seemed out of proportion to the events they recorded – the Norwegian Expedition and Dunkirk.' Eric, although stimulated artistically, was also aware of the contradiction: on the return journey an upturned empty lifeboat brought him up with a start. Writing to Helen ten days later he reflected, 'I managed one gloomy painting in Norway.' Meanwhile Edward, ten days after the fall of France, had called at the War Office asking to be posted to another field of operations; a day later he was already destined for 'the Near East'.[21]

* * *

The opening of the 'British War Artists' exhibition at the National Gallery on 3 July 1940 was an important moment for many Londoners, an assertion of national identity and cultural endeavour amid the cacophony of war. Attending the private view Ravilious felt sensitive about the prominence of his own work: the WAAC had accepted seventeen of his paintings in four months, including all those from his time aboard HMS *Highlander*, and the number displayed attracted comment from some of those attending, 'frankly or tactfully according to their nature'.[22] A photograph (fig. 9.14) shows Ravilious in conversation with Muirhead Bone in a group including Clark and Freedman; Bawden is not in shot but, if he was present, this was probably the last time he saw his closest friend. Two days later he left London for Southampton and on 7 July sailed for the Cape en route to the Middle East; it was to be thirty months before he returned.

Tom Hennell was not invited that afternoon but visited the exhibition the next day, writing to Gwyneth Lloyd Thomas, 'Edward's war records are worth going to see – to my mind they are the outstanding works in the show – Eric's drawings this time seem interesting mainly in technique and design.' Although the Committee had rejected Hennell's services when he wrote to them, Clark had suggested he contact the Pilgrim Trust which was initiating the scheme later known as 'Recording Britain'; 'the P.T. didn't keep the Dorset drawings that I thought my best – but they are letting me do further work in Kent,' Tom told Gwyneth, adding later 'I have Kentish subjects enough to last me well into the winter.' A path was gradually opening up that would lead firmly away from his mental frailties.[23]

Eric had written to Helen 'Not seeing people is the worst thing about this war'; it was a deficiency he now set about remedying. While awaiting confirmation of a posting to Portsmouth, he stayed with Diana who had relocated to the safety of Sutton Veny in Wiltshire with her toddler Jane and new baby Miles. Clissold had been released from the army to continue fruit farming at Wittersham, now in a restricted area braced for invasion, and he did not begrudge Diana the company, writing to his wife 'I'm glad Eric was able to have such a nice long stop'; during a relaxed week Ravilious cut his blithe cover design for Leonard Russell's *English Wits*, a hurried commission and his last for book illustration. Then after arriving in Portsmouth he had dinner with Peggy Angus in Chichester, where she was teaching and looking after her two children while Jim Richards was fire-watching and sustaining publication of the *Architectural Review* in London. Separation was taking a toll on their relationship and Peggy had been rebuffed by the headmistress without interview when she applied for a vacancy at her old school North London Collegiate: 'in present circumstances I think it is a good thing that both you and the babies are away from London'.[24]

In the naval mess the following night Ravilious dined with Augustin Courtauld, a friend from Essex and an erstwhile explorer of Greenland with whom, post-Norway, he now had more in common. After receiving an unhappy letter from John, Eric was soon telling Helen 'I've suggested a trip to Iceland to draw the Royal Marines in Hibernas, with duffle coats and perhaps those splendid plum skies. There are the most beautiful women with fair hair in Iceland so they say: it is pitch dark all day and the snow falls and the wind blows and you can stay in bed for twenty-four hours.' As she had done at Sheerness, Tirzah visited for the weekend, getting a glimpse of mess life just as she and Eric had confirmation that she was expecting their third child.[25]

It was early September before Ravilious could visit Helen in Bath, a city now being bombed with savage frequency. While there he showed her the drawings he had begun in the confines of submarines diving beneath the Solent and reworked after returning to Castle Hedingham. Inspired by interiors of 'blue gloom with coloured lights and everyone in shirts and braces' he was now keener than ever to return to lithography, an idea he had floated with the WAAC from the first; but he was also aware that his evolving images, intended as a much more direct tribute to naval men at war, required convincing figures: 'They ain't easy,' he reflected. 'You can do them in any position and so does Tirzah. Some of my figures have beards. Three of my figures are asleep but all the others are doing things at wheels and levers and periscopes.'

9.16 & 9.17
Eric Ravilious: *The Ward Room (1)* (above), auto-lithograph, 1941;
and *Diving Controls (2)* (below), auto-lithograph, 1941.

9.18 & 9.19
Barnett Freedman, *15 inch Gun Turrett, HMS Repulse* (above), auto-lithograph, 1942;
Thomas Hennell, *HM Submarine Rorquall in dry dock at Portsmouth* (below), watercolour, 1944.

In something of a reprise of her *High Street* role Helen was clearly encouraging, but that autumn proposals for a children's book based on the submarine service came and went as the WAAC proved reluctant to take on the risk of publication. Bomb damage also ruled out the Curwen Press, but by Christmas 1940 Eric was telling Helen 'I'm doing the lithographs myself for fun. The bill is heavy but may be worth it in the long run as the Leicester Gallery may show them ... Ipswich will print the things and I start work tomorrow.' Like Freedman with Griffits a decade before, Ravilious found in Geoffrey Smith of W. S. Cowell someone who was prepared to guide and encourage experiment; Eric would express disappointment with the final images ('they are too overworked and overdone compared with the first drawings'), but the *Submarine Lithographs* stand alongside his Norwegian watercolours, and the aerial drawings from his final year, as signal achievements of his years as a war artist.[26]

After Bath, Eric was due to travel to Newhaven, assigned to paint 'pre-invasion drawings of coast defences' as the Battle of Britain summer gave way to the autumn of the Blitz. On the way he stayed in London with Jim during a night of heavy raids before going on to Eastbourne which, as he told Tirzah, was 'a bad dream. It was like the ruins of Pompeii, and both our families gone, the town all but empty. 60,000 people have left.' He arrived at Newhaven on 19 September at the beginning of eighteen days during which, as on the deck of the *Highlander*, he would both show insouciance in the face of danger and capture the basis for six completed watercolours from the cliffs overlooking the West Quay.

'We are bombed in the afternoons ... the weather has been perfect for work and all the old Ravilious's are now on the way, some bad some good,' he told Tirzah after a week, adding a little later: 'It is a pretty quiet life here except for raids. There is so little navy to worry me and all the troops inside the fort. I draw in perfect peace of mind on this side of the moat – it is simply wonderful.' By night, however, the Ouse valley had become an aerial conduit for German bombers heading for the capital and ten days later a 2,000-pound bomb hit Morley College where 195 residents of already blitzed buildings were preparing to spend the night in the Refreshment Room; fifty-seven were killed as 'the force of the explosion broke up and threw huge sections of masonry, brickwork and reinforced concrete into the air', and Ravilious and Bawden's triumphant murals were no more. The last two casualties, 'Mrs Roberts and little Ellen Harman', were found beneath the rubble three weeks later on the day Eva Hubback wrote to Eric 'the loss of your paintings is one

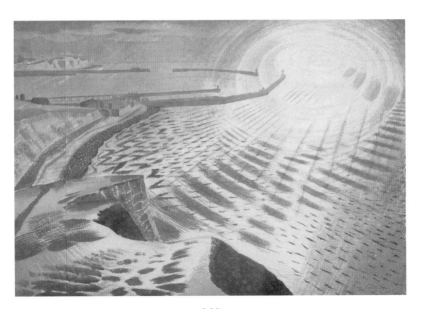

9.20
Eric Ravilious, *Cross Channel Shelling*,
watercolour and pencil, 1941.

part of a big tragedy ... When they were painted we hoped, of course, that they would remain to delight many generations.'[27]

Ravilious returned to Castle Hedingham and at the end of October Tirzah had what was thought to be a successful operation to remove a lump from her breast. Economies at the Treasury made it likely that Eric's time as a contracted war artist was coming an end and, as Tirzah explained to her father, 'Eric isn't very sorry because he has really done enough of that kind of work.' However, within weeks a new grant for the WAAC led to an immediate offer of a further six-month contract with the Admiralty, to come into effect after Ravilious had finished his lithographs. As a result a five-month break ensued, but this was followed by a return to the coast at Dover the following summer.[28] *Cross Channel Shelling* with its fireball of light is a (possibly unfinished) work of bold technique reminiscent of *HMS Ark Royal in Action No. 1*, but continuity of situation brought with it repetition in terms of subject matter.

When some Dover watercolours went on display amid 130 new works at the National Gallery, Jan Gordon chose to make a general point about repetitive war art: 'Ravilious is a delicate and lyrical artist, but enough of Ravilious is as good as a feast', suggesting it was inappropriate to keep him

recording coastal defences. By following up *Totes Meer* with *Battle of Britain*, Paul Nash had avoided monotony by 'drastically changing the dish', but, the critic suggested, the public was being offered a surfeit of Henry Moore's tube-sheltering 'catacoombers', John Piper's yellow and rust-red burnt buildings and Graham Sutherland's horror of devastated streets. Ravilious himself was alive to the danger and in autumn 1941 was quick to press for permission to seek out new possibilities in Scotland, where John and Christine Nash were living after John had declined further work for the WAAC and secured a regular commission.[29] After visiting the National Gallery himself Eric asked Helen whether she had seen 'Edward's superb drawings of Africa? My goodness he has done well.'[30]

After returning to Castle Hedingham from Newhaven, Ravilious read Cyril Connolly's *Enemies of Promise* with its famous observation that 'there is no more sombre enemy of good art than the pram in the hall' – an aside the critic made while analysing the impact of domesticity on creative heterosexual men, but a pithy expression of the constraints felt most keenly, then as now, by women artists.[31] In Tirzah's case the hall in question was rat-infested and, although Bank House was now barely habitable in winter, the prospect of any improvement was negligible as the landlord, never the best, had recently died. Tirzah completed some wonderful pencil drawings of her children during the early war years and, although Dunbar Hay and the Little Gallery no longer functioned, she still received occasional orders for her marbled papers; but with a third child imminent, wartime day-to-day existence at Bank House was far from easy.[32]

Shortages began to take a toll on many people during mid-winter 1940–41, including Eric's own parents who had returned to Eastbourne after the first invasion scare; the previous spring he had been worried about his seventy-six-year-old mother's health, writing to Tirzah 'the winds never cease to blow cold for her. She is a marvellous old woman, no one like her. God Bless the Fords.' He had visited Sussex for a week in December but now, in February 1941, received news that Emma died in her sleep after being admitted to hospital in Eastbourne. Eric found the funeral 'a sort of nightmare and I felt very low indeed', telling Helen how his mother had been 'a sheet anchor in our temperamental family'. By 1 April, however, he was reporting great happiness, first to Diana ('It is a girl. Isn't that nice? She was born in the small hours ... weighs seven pounds and has a round head like a nut') and then to Helen ('a girl. Isn't that good. And a nice date to be born on too. We shall call her Anne'). Meanwhile, lost without Emma after fifty-three years of marriage, his

9.21
Eric Ravilious, *HMS Actaeon*, watercolour over pencil, 1940–42;
Ravilious sent this picture of a torpedo school facility as a gift to Lieutenant West, who had
helped him at Chatham during his first weeks as a war artist; West was part of the
mine-clearing party featured in the Ravilious watercolour *Dangerous Work at Low Tide*, 1940.

9.22
Eric Ravilious, *Drift Boat*,
watercolour, 1941.

father had embarked on a Lear-like existence visiting children and relations by turn.[33]

'The electric light has failed as it is Good Friday and I am writing by candle. The fire is poor and the room is like a cave,' Eric told Helen ten days after Anne's birth, but by the last day of the month he was writing to her from Ironbridge Farm, Shalford: 'We have moved as you see. It had to be done at very short notice, but it is well worth the effort. The above is John Strachey's house and the country – and the river – are lovely.' The next day he told Diana 'I've done my first spell of gardening today with three rows of early purple sprouting Broccoli.' In winter Ironbridge Farm would prove as difficult as Bank House, but when Eric was on leave in spring and summer the immediate surroundings yielded a harvest of pastoral subjects, some of which provided part-payment of the rent. 'The more I think of the picture of the house across the potato field the better I like it: so may that be definitely one of my "droit de seigneur" pictures for this year?' the socialist luminary Strachey wrote to Tirzah that August, requesting airmail delivery to his wife in Vancouver.

Although Brick House in nearby Bardfield was closed up and Edward and Charlotte were elsewhere, their friends Ariel and John Crittall were immediate neighbours and Ariel became a source of support that would be much needed in the times ahead. More immediately, Shalford proved to be a situation where it was possible to imagine a future.[34]

'Yes we had thought of Essex, Clissold considers it favourably too as it has the right sort of soil for growing apples and he likes the idea of being near you and other congenial company which is what we miss down in Kent.' So Diana wrote in a letter asking Eric to become 'a sort of unofficial godfather ... a kindly influence' for her daughter Jane. 'He never bears you any resentment or me either ... he asked me to ask you if you are ever in his direction to go and stay with him'. Stationed at Dover a little later, Ravilious managed to visit a crowded Underhill Farm when Diana herself had temporarily returned from Wiltshire and where Stephen Spender, her sister's brother-in-law, and his wife were also living with Clissold. During this last period of painting on the Kent and Sussex coast, he created compelling images in *South Coast Beach* and *Drift Boat*. These watercolour drawings bear comparison to Paul Nash's raider series depicting evil things destroyed amid the natural beauty of the English landscape; Ravilious, as it were, reversed the proposition by focusing on the strange and benign presence of brightly coloured working boats marooned amid the grey desecration of barricaded beaches.[35]

* * *

Journeying north, Eric arrived in Fife on 10 October for a two-month stay during which he returned to John and Christine Nash's cottage at Crombie Point between expeditionary activity. It was a sociable and productive time that would bring his first experience of flight, signposting new subject matter. He had not seen his friends for over a year, relished John's off-duty company and was well looked after by Christine who, having suffered a miscarriage the previous year, recorded in her diary: 'he is in a mood to be attached to his new home, wife, and children, he really seems to appreciate Tirzah's hardships with two babies under 2 years, in a way I did not think likely, and tells me anecdotes of James, I am envious when I think I might have had a child older than Anne'.

The WAAC collection gained seven watercolour drawings of coastal subjects from Rosyth, Methil and May Island, the best of which – *Storm* and *Convoy Passing an Island* – are remarkable in conveying the effects of cold light and bitter weather in isolated locations. But it was John's suggestion that he work

9.23 & 9.24
Eric Ravilious, *View through the Propellor* (above), watercolour, 1942.
Paul Nash, *Target Area: Whitney Bombers over Berlin* (below), watercolour and chalk, 1941.

at the Royal Naval Air Station at Dundee that precipitated one of Ravilious's most celebrated interiors – *RNAS Sick Bay* – as well as six watercolours of Walrus aircraft in and around the base. A further painting – *View from the Rear Hatch of a Walrus* – became his first attempt to capture sky and land as seen from the air. 'These planes and pilots are the best thing I have come across since the job began ... it is a joke dressing up with flying suit, parachute, Mae West and all and climbing in over the nose,' he told Helen on 3 December, adding he was promised a trip in the rear gunner's cockpit but would have to do a number of simple mechanical things with hatches when the Walrus came down on water.[36]

Two weeks later he was back at Ironbridge Farm where Tirzah was struggling to cope with an outbreak of whooping cough, the prelude to a long season of children's illnesses. After deciding that resignation was preferable to further naval subjects, Eric wrote to the WAAC Secretary, Edward Dickey, 'I do very much enjoy drawing these queer flying machines and hope to produce a set of aircraft paintings. I hope Paul N hasn't already painted Walruses – what I like about them is that they are comic things with a strong personality like a duck, and designed to go slow. You put your head out of the window and it is no more than a windy train.' Ravilious was wary of a potential overlap with Nash because, while he was at Crombie Point, John had received a letter from his brother referring to completion of *Battle of Britain*: 'Our K [Kenneth Clark] seems very warm about it and Dicky [Dickey] is excited. I reckon myself very fortunate to have found for a second time true inspiration in the subject of war.'[37]

For Paul Nash the epic struggle between contending bomber fleets was an allegory of good and evil carrying him back to the 'happenings in the sky' of teenage works like *Angel and Devil*; determined that 'what the body is denied the mind must achieve' he was studying volumes of secondary material, particularly photographs, to distil the 'personality' of planes in flight to crystallize a vision of war where machines were 'the real protoganists'. For Eric bombers were 'repellent things' which, like ruined buildings, he had little desire to paint and the 'airoplanes' that attracted his eye were reminiscent of much earlier flying machines. Louis Blériot's plane was a sensation when displayed near one of his father's shops the week after the first Channel flight. Even if we cannot be certain that Ravilious saw it as a six-year-old, the consequential development of Eastbourne as an early aviation centre meant that as a youngster he frequently saw flying machines above Hampden Park. One of his earliest surviving drawings, astonishingly assured in detail, shows

a Blackburn monoplane taking off from the nearby St Anthony's Head airfield (fig. 9.25). Its aesthetic descendants ('the Tiger Moth is the perfect plane for drawing') were the ones he favoured during the last nine months of his life.[38]

As this phase began Paul Nash, alerted by John to Eric's intended activities, wrote requesting information on the appearance of the Short Sunderland: 'most animal of all planes, charging along the coast with its great snout thrust out'. Nash's mood was frequently dark ('Life just gets mingier and mangier – we dwindle, the lights dim, the shadows creep nearer. The only thing to do is to keep one's eye steady on the target'), but after recovering from a serious illness that February, he was preparing to paint the 'noble beast' he saw as 'the best type of coast defence'; arguably among his least successful war works, he delivered *Defence of Albion* to the Air Ministry in May 1942.[39] Meanwhile Lord Willoughby de Broke, the Ministry's representative on the WAAC, had proved both willing and hospitable in arranging RAF postings for Eric, who wrote after a lunch in a club that January: 'he is fixing up a visit to Ireland to draw planes still as a Marine Captain which is nice. I was given a categorical "No" about Russia, but still have hopes of going later by back door methods.'[40] In the event Ravilious travelled to neither destination but over the following six months traversed England, working at seven different RAF stations, some chosen for proximity to Shalford – a welcome expediency during two periods when Tirzah was first in hospital and then recuperating from operations.

A harsh January was leavened by a weekend in London when Tirzah and Eric stayed with Jim and Peggy ('what fun it was hearing you and Freedman talk about your experiences'), but frozen pipes and illnesses crimped life at Ironbridge Farm. In mid-February, Tirzah was briefly hospitalized for what was thought to be another minor procedure and, not yet fully recovered, had only just returned when Eric left for his first RAF posting at Gatwick. This proved unsuitable for a visiting artist and hopes of flying over the South Downs were disappointed. Five days later, however, after 'making circles round York Minster on a really fine day', he wrote to Tirzah from RAF Clifton: 'the people I like a lot especially the CO who flew me up and down Yorkshire this afternoon and kept pointing out abbeys and ruins, He promises to take me over Greta Bridge and Richmond next time.' John Sell Cotman's watercolour drawing *Greta Bridge* (1805) was a lifelong favourite. Ravilious had studied it at the British Museum, but probably first encountered the work in Alfred Rich's *Water Colour Painting*, the favoured manual of his student days where, in a how-to-do-it section headed *A Lesson at Richmond, Yorkshire* a watercolour was built up through four stages.[41]

9.25 & 9.26
Eric Ravilious: *Tiger Moth* (above), watercolour, 1942;
and *Blackburn Monoplane* (below), pencil, 1915.

Yorkshire also proved a worthy substitute for Sussex in providing a concentrated opportunity to begin to capture both close-up details of planes in flight and vistas below. The experience brought a new degree of artistic challenge in having to start, as Eric told Helen, 'from nothing you could call solid or substantial ... air pictures don't have enough horizontals or verticals. They are all clouds and patterned fields and bits and pieces of planes.' *Hurricanes in Flight*, *View over the Starboard Wing of a Moth*, *View through Propeller* (fig. 9.22), *View from the Cockpit of a Moth* and *Boston Bombers in the Sun* would all draw on this combination; other evident successes that summer (Ravilious still reported the rate as one in two or three) were *Tiger Moth*, *Runway Perspective* and *Elementary Flying School*, all of which placed planes in flight seen from the ground against landscape backgrounds. A larger number of drawings feature machinery at rest amid ground operations, subject matter that threatened repetition and led Eric to remark: 'I feel bored with pictures of planes on the ground and want to go flying.' Fear was rarely a limiting factor for Ravilious, but in late June at a base in Somerset he was shocked to witness the drowning of a trainee pilot; the incident was still preoccupying him during a picnic near Bath the following weekend, the last time he saw Helen. As she recalled thirty-five years later, 'I remember him almost shouting "I hate the idea" – of death he must have meant: his own?'[42]

Eric's time at York had come to a sudden end with news that Tirzah was facing a far more serious operation and on 11 March 1942, aged thirty-three, she had a mastectomy. The operation was traumatic and she required emergency blood transfusion; she later wrote that on learning this from Eric days later, 'I was surprised to find that my immediate reaction was one of regret I hadn't died. It was only a momentary regret probably caused by my bodily exhaustion ... and now I should have to face living for a year or two with fear that the wretched disease might come back'.[43] While still in hospital she drafted a politely desperate letter to John Strachey explaining that frozen pipes, water under the floorboards, a broken range and a leaking lavatory made living at Ironbridge Farm 'difficult in summer and almost impossible in winter' and how 'John and the baby nearly died of whooping cough when we all had it ... now James has just had measles and I have had a major operation, turned a startling blue and had to have a blood transformation ... I don't know if I'll be able to get some one to live in the house with me. I can't possibly manage without now because I can't lift the children.'

While Eric made arrangements to paint nearby, Tirzah's mother moved in to help, leaving him confessing 'I'm ashamed I used to dislike her so much at Eastbourne. Now I get on with her perfectly well.' In the interlude between discharge and leaving for two months' convalescence in Eastbourne, Tirzah began to write her autobiography in an exercise book. She worked on it, weather permitting, in the garden: 'I hope dear reader that you may be one of my descendants ... If you are not one of my descendants than all I ask of you is that you love the country as I do, and when you come into a room, discreetly observe its pictures and furnishings, and sympathise with painters and craftsmen.' Edited by her daughter Anne, *Long Live Great Bardfield* – an eloquent work of piercing honesty – was published for the first time in 2012, and is now assured a place as a classic testament to the lives and times that Tirzah knew.[44]

'As a sort of gesture against calamities I am trying to paint in oils,' Eric wrote the day after Tirzah's operation; Tom Hennell had suggested the experiment, sending a linen album for the purpose after receiving a drawing of her new baby from Tirzah, but a fortnight later Ravilious told Helen 'my oil painting came to nothing, it didn't strike roots at all'. As friends wrote reacting with dismay to Tirzah's illness, news arrived that Geoffrey Fry was hospitalized with depression, and after Tirzah had arrived in Eastbourne, Eric's father's health became a further cause of anxiety: 'Send me a wire if I ought to come down. It is a bit unnerving for you all this coping with emergency – how they do seem to dog our steps so that I begin to hesitate opening letters these days and brace myself.' By early June, Tirzah was back at Shalford, but still not strong when Ravilious left for Westonzoyland and Bath a few weeks later.[45]

That spring Ravilious had received a long letter from Bawden, nineteen months into his work in the Middle East, and on 3 July a farewell dinner for Edward Dickey, the WAAC Secretary, at the White Tower restaurant in Percy Street enabled him to catch up with other friends: 'The party was a great success. I got carried away in a taxi with the Clarks, Henry, Barnett and Graham Sutherland to the Hollybush to drink shandies and then to K Clark's house for more. It was a very merry party and some of us, especially Barnett, were a bit drunk. Lots of clever talk of course. How I enjoyed it. Lady C is very nice. They have some splendid pictures.' Inebriated or not, Freedman took the opportunity to suggest holding a select thank-you celebration for Kenneth Clark, and in the following days Henry Moore, Sutherland, Piper and Ravilious all accepted his invitation to reconvene on 11 August at the White Tower.[46] Before then two developments occurred: Air Ministry permission for Eric to paint in Iceland was confirmed and, apparently more fatefully, doctors recommended

9.27 & 9.28
Above: Eric and John Ravilious photographed at play, August 1942,
the Ironbridge Farm barn in the background.
Below: Picnic by the Pant, August 1942. Ravilious stands behind Tirzah,
with James on her knee and Anne seated nearby. Ariel Crittall, also pictured,
remembered this being taken one evening very shortly before Eric left for Iceland.

that Tirzah should re-enter hospital for a therapeutic abortion as, still in a weakened state, she was once again pregnant.

Shortly after Tirzah was admitted Ariel Crittall took a picture of Eric up-ended by a trike, and a few days later another showing Eric and her husband, of whom Eric wrote to Tirzah in hospital: 'John is back again but leaves definitely tomorrow. I shall miss him badly.' Simultaneously a letter arrived from Christine to say that she and John Nash were planning twelve days in Essex: 'Will E. have gone to Iceland before then? I do hope not, it's ages since we saw him, last year in fact.' On 13 August, Eric told Tirzah: 'Barnett's dinner almost surpassed the first: what with sherry and rose leaf omelettes and fine old brandy – cigars, goodness knows. Clark wanted to know when I was off and said he was particularly glad I was going to northern parts again as that was my line and he thought highly of the Norwegian pictures.' The next day Jane Clark had written to tell Barnett 'We forgot the war and everything except how lucky we are in our friends.' Kenneth Clark, waiting for a train at Reading, wrote separately 'I am a lucky man in many ways but in nothing do I count myself luckier than the friendship of some of the best living artists.' On his way to the dinner Eric had met a zoologist acquaintance who promised him introductions in Iceland, and the next day it was confirmed he would travel by passenger plane from Prestwick.[47]

'I was allowed to leave hospital about a week before Eric was due to go abroad and he arrived on a lovely morning to fetch me away.' That day they felt joy at being together again, but the prospect of parting was a strain. Tirzah was still in pain and they felt exasperated as they 'wanted to make love before Eric went away'. With the issue of how Tirzah could cope alone unresolved, there was a moment a day before his departure when 'standing in front of the mirror putting on his tie, he said "Shall I not go to Iceland?" I knew he desperately wanted to go so I said "No, I shall be alright." He seemed relieved at my answer and enthusiastically repeated all the familiar reasons for this expedition to what had almost become the promised land, but I knew he did feel a little guilty at leaving me so prostrate.' After breakfast the next morning Tirzah watched him walking down the lane, stopping at a nearby cottage where James was being looked after: 'I knew that he might never come back but there was nothing I could do but just watch him and remember what he looked like and, with an effort, I lifted Anne up to wave a final goodbye.'

In London, Eric walked around Trafalgar Square with Robert Harling before spending an evening with Jim Richards, who discerned 'a sense within him that he had come to the end of what he had to do'. Recalled forty years

later, this observation is sometimes quoted in aid of a critical perception that Ravilious had reached both his limits and his destination after seventeen years as a practising artist. Eric himself was conscious that creativity could wane, having written to Helen of 'my depressing theory about middle-aged painters' and hopes of being 'the camel that gets through the eye of the needle'.[48]

Had he read them, Ravilious would have warmed to the words of Richard Seddon, a fellow artist and friend of Paul Nash's, who had drafted an article that appeared only after its subject's death: 'Ravilious never rests on his laurels [and] can be said to have not yet reached the peak of his maturity. He invariably approaches his subject with an open mind and embodies in the work whether it is a wood engraving, a water-colour, a ceramic, or fabric design, at least one idea that arises from the needs of that particular job and no other ... He avoids any tendency to repeat successes of the past *ad nauseam* ... I stress [this] because very many artists, both distinguished and otherwise, do so.' His friend Robert Harling was similarly in no doubt that Ravilious was still at the 'beginning of a career which promised exceptional – and more to the point – unpredictable versatility in the fine, graphic and applied arts'.[49]

<p style="text-align:center">* * *</p>

Ravilious was driven overland to RAF Kaldadarnes on 1 September 1942, four days after landing at Reykjavík.[50] Approaching Iceland he had been fascinated by cratered mountain country he could see 'with shadows very dark and striped like leaves' and now at Kambar he would have looked down across a volcanic plain to the airfield situated beyond the milky melt-waters of the broad Ölfusá river. The road ahead ran down to a closely guarded bridge at the township of Selfoss, before turning west along the southern bank to Kaldadarnes.

Shortly after his arrival at the base, three of 269 Squadron's Hudsons – Aircraft L, M and R – were ordered into the air. They took off between 16.53 and 17.30 on a mission to protect a convoy menaced by three trailing submarines more than a hundred miles south.

As a captain Ravilious would have been directed to the Officers' Mess, 'a fairly primitive wooden farmhouse with a corrugated iron roof and Nissen huts attached'. Recently refurbished, it had been due to be re-opened the previous week by the Duke of Kent, but he had died in an air crash at Caithness in Scotland en route to the flying-boat moorings at Reykjavík. The fate of the king's brother prompted Christine to write to Tirzah the same day: 'I hope Eric arrives safely. John flew to Orkney the day after the Duke crashed and had a horrid feeling that he too might become The News, in a lesser fashion.'[51]

9.29
Eric Ravilious, *A Cross to Airmen*,
wood engraving, 1933.

It was almost certainly during the evening that Ravilious first met Flight-Lieutenant 'Ginge' Culver, a twenty-five-year-old with nearly 2,000 hours of flying experience who had joined the RAF in 1935 after being an apprentice motor mechanic. Having shot down a Heinkel and two Dorniers early in the war, Culver had been awarded the Distinguished Flying Medal, was in temporary command of half the squadron, and was expected to be promoted to Squadron Leader. In Iceland for six months, he had not yet met his two-month-old daughter and was about to go on leave later in September. Gregarious, a great reader, a pilot who had flown above the Arctic Circle, the base darts champion, good at table tennis – it is easy to imagine their rapport.[52]

At two minutes to midnight Aircraft L burst a tyre landing after its return journey from the submarine sweep. Aircraft R had already landed, but Aircraft M with its four-man crew had not returned. Last heard of asking for bearings at 23.39, it was then thought to be twenty-five miles south of Reykjanes, Iceland's western tip. Efforts to make contact continued for two hours, but the presumption was then made that the aircraft could no longer be airborne.

Even in good weather flying was hazardous – there was no radar and being so near magnetic north made instruments unreliable. For 269 Squadron mechanical failure and navigational error were greater dangers than enemy action and ten weeks earlier a Hudson had hit the sea after engine failure above the bay of Faxaflói, west of Reykjavík. It had sunk in three minutes, but the crew had made it into a life raft spotted later by a searching aircraft, which guided a destroyer to them. All survived.

Hours of daylight were now fewer and the weather was worse, but accounts of this success were no doubt shared as preparations were made to look for Aircraft M. Ginge Culver could authorize accompanying observers and the last entry in his flying log, left at base while on mission, records 'Cpt. Revilliers' as a passenger.[53]

The day dawned fair. Aircraft E was airborne at five o'clock. At 05.06 Aircraft V took off, with Culver, Pilot Officer Graves-Smith, Flight Sergeants Day and Barnes, and Ravilious on board. At 05.41 Aircraft P followed. They were joined by three further aircraft based at Reykjavík as weather conditions deteriorated.

Aircraft E and P, sighting nothing in the search area, returned just before noon. Aircraft V was 'not heard throughout period of sortie and did not reply to signals sent to it when it was overdue. Air search was not practised that day because of adverse weather.'

In less than twelve hours nine men from the isolated base had lost their lives. Six days later a Hudson wheel was washed up at Eyrarbakki beach south of Kaldadarnes. It was presumed to have come from Aircraft V but may have been from Aircraft M, the first to disappear.

9.30
Robin Friend, *Kaldadarnes from the air*, 2008.
The melt-waters of the Ölfusá river can be seen in the background.

AFTERMATH

At seven o'clock on 3 September 1942 the barn at Ironbridge Farm collapsed at the beginning of a tranquil autumn day. The next evening Tirzah, who had lost a lot of blood after her operation, was overtaken by an extraordinary sense of sadness, and while she was resting after lunch the following day, Evelyn Hepher brought up the Admiralty telegram announcing Eric's disappearance. Getting up, Tirzah walked with her friend to the iron bridge Eric had painted after their arrival at Shalford.

In the following weeks she came to dread the morning post. 'I had always thought of him as one of the blessed. I can still hardly believe it,' Diana Tuely wrote. Amid the letters of condolence, shock, sadness, expressions of hope that all might still be well, one arrived from Eric, written on his last night in Reykjavík, full of *joie de vivre*: 'I was taken to lunch in the town to eat Icelandic food and the spread was unbelievable, like Fortnum at its best, caviar and paté, cheese, goodness knows what. You assemble a pyramid of all this on your plate and drink milk with it.' He had seen a Narwhal horn, was promised an expedition to the geysers, and suggested she send an outline of her hand so he could buy gloves. 'Get well Tusho ... goodbye darling. Take care of yourself.'[1]

'Is Edward home yet?' Eric asked, unaware that his friend would only sail from Cape Town on a troop carrier while he was travelling to Kaldadarnes the next day. Just before crossing the equator in the early evening of 12 September the *Laconia* was hit by two torpedoes and sank; Bawden was taken into one of the few lifeboats launched, which then drifted for five days menaced by sharks amid a sea of bodies. Rescued by the French and interned in Vichy Morocco, freed by the Americans and taken to Virginia, it was four months before he learned of Eric's death.

After re-crossing the Atlantic, he wrote to Tirzah from his new posting: 'No one I know or have known seems to possess what he had, an almost flawless taste, that and our long friendship which commenced on the first day each of us entered South Kensington produced I think, by habit and intimacy, an understanding of each other that went deeper than with anyone else ... But my dear Tirzah it is so much more than all that – I simply can't tell you, or anyone else, or even myself what it is, or how much it is I miss by losing Eric – I find

10.1
Eric Ravilious, *Ironbridge at Ewenbridge*,
watercolour, 1941.

myself in tears at the moment – and hope the servant does not come in to clear the tea things for a while.'[2]

'All one's hopes of after war life in East Anglia were centred around the pleasure of living somewhere near Eric and Tirzah, and of the games one would play,' Christine Nash wrote in her diary stricken by a sense of waste after seeing Tirzah. She had arrived on 5 September 1942 at Wormingford on a house-hunting mission, and in due course nearby Bottengoms became Christine and John's home for more than three decades. Edward and Charlotte returned to Brick House after the war and during years to come Edward and John shared many summer painting expeditions, reprising the activity they had shared with their lost friend.[3]

'I must try to say how your friends share in this great trouble,' Tom Hennell wrote on 15 September. 'We treasure the perfect care and thoughtfulness of his friendship, so free and natural in him; which make it like his art, gradual and lasting in its effects ... I am so grateful to you both for your unlooked-for kindness and friendship.' The following July, Hennell arrived in Iceland, having obtained Kenneth Clark's endorsement to follow Ravilious there as a war artist; over four months he painted in freezing conditions and remote locations.[4] It was a prolific period that crystallized his own style and fifty-four of his Iceland watercolours are now in public collections. After the WAAC offered him a further contract, Hennell painted in France and the Low Countries after D-Day, achieving a level of personal confidence and artistic assertiveness that seemed impossible a few years before. A final contract took him to the Far East, where he was murdered on 5 November 1945 while sketching during civil disturbances in Surabaya.

After hearing about Eric's disappearance, Clark had written to Tirzah: 'It is a terrible tragedy for English Art; your husband had a unique place as artist & designer. But at present I can only think of what you must be feeling at having lost such a gentle, lovable and beautiful human being.' William Rothenstein's letter began: 'What a loss for you, what a loss for English painting, for art of every kind ... there was a quality of perfection in everything he did, a reflection of his own delightful nature ... believe in my devotion and affection for that rare and lively spirit'. Rothenstein's own health was now deteriorating, heart disease having brought an end to his RAF activities; he died in early 1945, the end of war in sight.

Paul Nash outlived his old mentor by a little over a year; he completed one more notable piece of war art after 1942 –*Battle of Berlin* – and, despite his own worsening health, embarked on *Aerial Flowers*, an ambitious series of richly

poetic landscapes. Over the next four years he created images freighted with symbolism and produced what many consider to be his greatest paintings. He spent the afternoon of 10 July 1946 drawing on a balcony overlooking the English Channel before writing a letter to his brother and going to bed early; at some point in the early hours he slipped away.

After John Nash had stepped down from the role, Barnett Freedman followed Eric in becoming an Honorary Royal Marine Captain. In summer 1941 he served on HMS *Repulse* producing a major oil – *15 inch Gun Turret* (fig. 9.18) – and then a matching lithograph at the Baynard Press, which was published by the National Gallery. He was deeply upset when *Repulse* was destroyed shortly after with heavy loss of life among the men he had known. In June 1943 he worked on the submarine HMS *Tribune* and wrote 'I've tried hard to depict the men doing their jobs ... I wanted to paint men guiding and controlling machines.' Although Freedman's career as a designer and illustrator continued to outpace his ambitions as a painter, in the post-war period his skills and creativity remained in demand. He died of a heart attack in his studio in 1958, having done much good quietly in the interim.[5]

Both Percy Horton, who spent the war years at Ambleside in Cumbria with the RCA, and Douglas Percy Bliss, who worked in camouflage activities, sustained post-war careers as artists and teachers of growing repute. In 1946 Bliss became head of the Glasgow School of Art and in 1949 Horton was appointed Ruskin Master of Drawing at Oxford. Both continued to paint.[6]

Cecilia had met William Forbes-Sempill, Lord Sempill, in his role as President of the Design and Industries Association: they married in 1941. Shortly after their marriage Sempill was forced to resign from the Admiralty after evidence of his espionage activities for the Japanese was uncovered. In October 1942 Cecilia wrote of Eric 'I can't contemplate a peace time world without him' and, although an active participant in many post-war arts and design bodies, she never reopened a venture equivalent to Dunbar Hay.[7]

In December 1941 Diana had written to Eric and Tirzah: 'We both pine for Essex after the war.' In the event she and Clissold would stay at Underhill Farm for three decades until her death in 1975. She continued to paint in oils, finding many subjects in the local area, also experimenting with patterns for fabrics and designs on paper of very high quality. But despite her talents and accomplishments, Rye proved too remote a location in many ways and commercial success as an artist proved elusive.[8]

Peggy Angus and Jim Richards divorced in 1947, but Peggy's friendship with Helen endured and in the immediate post-war period they once again

10.2
Thomas Hennell, *Local Coal Cart and Trawlers,
Seydisfjardur, Iceland*, watercolour, 1943.

shared a flat together in London. Subsequently Peggy spent much of her
time at Furlongs; after a long career as a teacher and community *animateur*,
she died in 1993, her artistic and political convictions intact. In 1980 Sir Jim
Richards published *Memoirs of an Unjust Fella*, notable for its description of his
friendship with Tirzah and Eric but also for making only the briefest mention
of his marriage to Peggy and his role as father of her two children.

Enid Marx and Margaret Lambert's partnership in life and art continued
until Lamb's death in 1995, with Marco surviving her by three years. For sev-
enty years after moving from the Painting School to the Design School at the
RCA, Enid had followed Nash's advice that good artists can turn their hand
to many things, bringing unique creative talents to bear from fabric to book
design, from wood engraving to lithography – as a teacher and, with Lamb, as
an authority on and collector of English folk art.

Eric had looked forward to seeing more of Helen who, shortly after their
picnic near Bath, was recruited by the Ministry of Information in London. She
remained a committee member of the AIA throughout the war years. She and
her twin sister collaborated on further children's books and revived 'Jimini

10.3
Tirzah Garwood, *The Springtime of Flight*,
oil on canvas, 1950.

Puppets' after the war. Puppetry became central to both Helen's practice as an art teacher at Corsham and her writing. Those she taught remember her as an intriguing figure who gave little away about her past experiences. She never had a child herself but remained close to Eric and Tirzah's family.[9]

Consumed by grief and responsible for three young children, Tirzah faced a prolonged nightmare of bureaucracy to obtain a war widow's pension due to the uncertain status of a war artist missing but not yet declared dead. Ironbridge Farm became uninhabitable the following winter and, after staying with friends, Tirzah moved to a smaller rented house in Wethersfield in March 1944, where she began to make captivating relief models of Essex houses in nearby villages.

Two years later a new and much happier phase of her life opened up with her marriage to Henry Swanzy, a BBC Overseas Service producer, and a further move to London. Living in Adelaide Road, Chalk Farm, they were surrounded by a community of friends including Peggy, Helen, Tom Hennell's friend Olive Cook and her future husband, the photographer Edwin Smith.

In the spring of 1948 Tirzah's cancer returned, but as Olive Cook wrote, 'it was during these years that most of her extraordinary paintings were done ... she went on working even after she had become bedridden. She amazed all her friends by her determination, courage and unquenchable gaiety. She knew her illness was mortal yet declared that this was the happiest time of her life. It was certainly the most fruitful since her student days.'[10]

In twenty late paintings Tirzah Garwood created an imaginary world peopled by toys, plants, animals and children, enthralling in its skilfully rendered detail, arresting in its juxtaposition of scales. *The Springtime of Flight* is one such work in which, from the perspective of a small child or an animal close to the ground, a flying machine of the type that used to appear above her and Eric's childhood homes is seen climbing into the air.

In January 1948 Tirzah broadcast an affectionate and revealing tribute to her lost husband. In March 1951 she died knowing that her new family and her friends would do all in their power to care for her children.[11]

Notes

Unless otherwise cited, information from correspondence between individuals is derived from the archives of Eric and Tirzah Ravilious, Peggy Angus and Percy Horton held at East Sussex Record Office, The Keep, Brighton BN1 9BP, under the following references: RAV: Eric and Tirzah Ravilious; PEG: Peggy Angus; ACC 7828: Percy Horton. For detailed lists, see http://www.thekeep.info/.

Initials used throughout:

AR Albert Rutherston
BF Barnett Freedman
CDK Cecilia Dunbar Kilburn
CN Christine Nash
CT Clissold Tuely
DPB Douglas Percy Bliss
DT Diana Tuely [née Low]
EB Edward Bawden
EM Enid Marx
EMO'RD E. M. O'R. (Edward) Dickey
EMSS Eastbourne Municipal Secondary School or The Municipal Grammar School
ER Eric Ravilious
ESRO East Sussex Record Office
GB Gordon Bottomley
GCP Golden Cockerel Press
GLT Gwyneth Lloyd Thomas
HB Helen Binyon
JN John Nash
JR John Rothenstein
MMULSC Manchester Metropolitan University Library Special Collections
NEAC New England Art Club
PA Peggy Angus
PH Percy Horton
PN Paul Nash
RCA Royal College of Art
RG Robert Gibbings
RW Robert Wellington
SWE Society of Wood Engravers
TG Tirzah Garwood [Ravilious]
TGA Tate Archive
TH Thomas Hennell
TNA The National Archives
VW Virginia Woolf
WR William Rothenstein

Introduction

1 Jan Gordon, 'Art and Artists', the *Observer*, 6.10.40, p. 2.
2 Paul Nash, 'New Draughtsmen', *Signature 1*, November 1935, p. 27.
3 Nash, 'New Draughtsmen', p. 26.
4 Helen Binyon, *Eric Ravilious: Memoir of an Artist*, Lutterworth Press, 1983.
5 Enid Marx, letter, quoted in Michael Taylor, 'Enid Marx, R.D.I., Designer and Wood-engraver', *Matrix 7*, 1987, p. 99.
6 Paul Nash, *Room and Book*, Soncino Press, 1932, p. 40.
7 'Art Exhibitions: "Room and Book"', *The Times*, 11.4.32, p. 10.
8 'Remember These?', *The Star*, 8.3.40.
9 Robert Goodden, 'Eric Ravilious as a Designer', *Architectural Review*, December 1943, p. 155.
10 Osbert Lancaster, 'Art', the *Observer*, 20.9.42, p. 2.
11 W. B. Honey, *The Art of the Potter*, Faber & Faber, 1946, p. 102.
12 See Alan Powers, 'Was there a George VI Style?', *Apollo*, October 2004, pp. 72–7.
13 Paul Nash, 'Wood Cut Patterns', *The Woodcut*, Society of Wood Engravers, 1927.
14 Laurence Binyon, *English Water-Colours*, A & C Black, revised edition, 1944, p. 169. The attribution of this passage to Nicolete Gray comes from Edmund Gray.
15 Eric Newton, 'London Art Scene', *The Sunday Times*, 15.12.40, p. 10.
16 Andrew C. Ritchie, *British Contemporary Painters*, Albright Knox Gallery, Buffalo, NY, 1946.

Chapter 1

1 PN to GB 22.4.25, Causey, 1990, p. 183; *Signature No. 1*, November 1935, p. 27.
2 EM to Anne and Louis Ullmann, Ullmann, 2008, p. 29; Marx, 1993, p. 37; Lucy Norton quoted in Bertram, 1955, p. 113; for Lucy Norton as an RCA student see also Stevenson, 2008, pp. 63ff. In 1939 Lucy joined Dunbar Hay to sell modern embroidered designs.
3 Bertram, 1955, p. 113.

4 At a meeting held on 3.10.25 PN proposed ER for election as Associate Member, SWE Minute Book.
5 Causey, 1980, pp. 125ff; the exhibition was held at the Leicester Galleries in June 1924; Paul and Margaret Nash spent from December 1924 to April 1925 in Paris, Cros de Cagnes and briefly Italy. They were in Florence at the same time as Ravilious and other RCA students but there is no record of their paths crossing; PN to GB 2.6.20, in Causey, 1990: 'I spent most of my time in London enchantingly with Will, who helps one sit without boredom, and was dear and charming to me beyond description. The longer I sat the more my affection for him increased.' The idea of PN teaching at the RCA may have been born during these sessions.
6 Causey, 1980, pp. 15, 345: The drawing, later destroyed by Margaret Nash, was *Flumen Mortis*, described in Nash, 1949, p. 81, as a 'slow-moving river flowing between fields of poppies and orchard trees. The surface of the stream was covered with human heads upturned in sleep.' Bertram, 1955, p. 62, believes inspiration for the drawing to have been derived from William Blake's *River of Life*.
7 Nash, 1949, p. 75. Bolt Court off Fleet Street was the forerunner of the London College of Printing.
8 Bertram, 1955, pp. 36, 71; Rothenstein purchased the drawing *The Falling Stars* at the Carfax Gallery.
9 Speaight, 1962, pp. 9, 23–66.
10 Bertram, 1955, p. 94; John Buchan was the Director of Information who took the decision after representations from Rothenstein, Eddie Marsh and Laurence Binyon.
11 This was the 'Derriman' affair where Nash writing under a pseudonym puffed his own and his brother's work in the pages of *The New Witness*, a fact exposed in December 1919 leading to a public apology from Nash the following month; see King, 1987, p. 93.
12 Between 1921 and 1925 Nash completed well over fifty watercolours, lithographs and engravings based on this locale; *Places*, see Nash, 1922; *Genesis*, see Nash, 1924.

13 The School of Engraving overseen by Professor Sir Frank Short covered Etching, Aquatint, Line Engraving and Dry Point, Mezzotint Engraving, Wood Engraving and Lithography.

14 For a full discussion of changes at the RCA during this period and for Rothenstein's correspondence with the Board of Education see Cunliffe-Charlesworth, 1991: 'To make then too sharp a division between the training of craftsman and artist would not appear to be wise. Nor is it desirable to define and to limit, early in a young aspirant's career, his future activities. From the practice of the arts of design a fine artist may develop naturally ...'.

15 The proposal was brought to an end by a slap on the wrist from the Departmental Under-Secretary: 'To appoint Epstein would be a very perilous experiment and might cause considerable embarrassment. For a Professor we would want not only a genius (as to which I am no authority) but also character: and I am not sure that character in a place of this kind is not of greater importance.' L. A. Selby-Bigge to WR 13.8.24, Cunliffe-Charlesworth, 1991. For Rothenstein's support to Epstein see Rose, 2002, pp. 40–45.

16 J. Rothenstein, 1952, p. 131.

17 WR to Fisher 18.6.20, NA ED 24/1595. Pressure on the Design School to better address the needs of industry led Anning Bell, who believed in the Renaissance ideal of a craftsman as the aim of educational achievement, to resign in 1924; Bell to Board of Education NA ED 23/545 1924. He was replaced by Professor E. W. Tristram, a specialist in medieval church murals, already teaching in the School as Head of the Department of Mural and Decorative Painting.

18 See PN to GB July 1920 in Causey, 1990, p. 122, for the background to this teaching.

19 WR to Fisher 18.6.20, NA ED 24/1595; WR rejected the suggestion of Fisher, President of the Board of Education, that the area of fine art might be 'shrunk' and amalgamated with either the Slade or the Royal Academy Schools; instead he added the Professorship of Painting to his part-time portfolio on the departure of Gerald Moira in 1922 and from the first ensured that vacancies were filled largely from NEAC ranks, a club that was no longer avant-garde but whose adherents (such as Randolph Schwabe and Allan Gwynne-Jones) sat well with the strong figurative tradition of the School.

20 WR to L. A. Selby-Bigge 23.7.20, NA ED 24/1595. At an interview earlier in 1922 Rothenstein had advised 'Your quick sketches are better than your other work', suggesting that Ravilious try for the Design School six months later. In the interim he benefited from the teaching of Lilian Lanchester, an ex-Slade student employed at Eastbourne who encouraged a simpler style of drawing; see Ullmann, 2012, p. 79, and Powers, 2013, p. 14.

21 These large wooden structures housed not only the JCR but also the sculpture studios. See Berthoud, 1987, p. 60: 'The Sculpture School was a brisk ten to fifteen minute walk from the main buildings, located then as now halfway down Queens Gate in some hutments built to receive casualties from the Boer War and used for the same purpose in the First World War.'

22 Binyon, 1983, p. 20. Binyon's description of the scene appears to draw on an amalgam of her own memories and Bawden's recollections provided to her in the 1970s.

23 Eastbourne Rate Books indicate the family moved to 'Hilsea', 11 Glynde Avenue, Hampden Park from 7 Watts Lane in July 1909, ESRO DE/B1/145 Assessment 300; Eric attended Eastbourne Municipal Secondary School (EMSS: 'The Municipal Grammar School') from 17.9.14 to 18.12.19.

24 Ravilious won one of two scholarships on offer as 'Candidate Art Teacher', which covered fees and an allowance of £10 during the first year, rising to £15 and then £30 in successive years, ESRO RE/3/3/17.

25 Photography: A Camera Club was formed during Ravilious's last year at EMSS 'to improve the work of the camera owners of the School, and to foster an appreciation of art in photography'; the second monthly prize was won by E. Ravilious for the photograph *The Winding Road*. EMSS and the Art School shared premises and during 1920 Ravilious was still participating in the Club's expeditions to Rye, at Easter, and villages near Eastbourne; in July 1920 the school magazine's 'Camera Club' entry noted that 'E Ravilious has devoted himself to stereoscopic photography'; the following December a visiting lantern lecturer from a Photographic Chemists was particularly impressed by the nature photographs of 'E Ravilious'. EMSS school magazines 1919–20, private collection. In December 1921 Ravilious and Donald Towner spent time in Rye 'painting boats, the harbour, the marshes, old buildings', Towner, 1979, p. 24.

26 Sport: the EMSS magazine noted in March 1920, 'Ravilious attends the Art School, so that he will be able to play for two more years. He has a strong kick and always clears at the right moment'; the Cricket Team also benefited from his bowling as he took 8 for 23 on 5 June 1920, following it up with 4 for 17 the following weekend, to top the season's averages by conceding only 3.81 runs per wicket.

27 RCA Student File: ER's initial RCA Registration form records 'Employment of Student prior to joining RCA: Taught at elementary schools 1919-1922 (Part Time)' and in ER's hand 'In capacity of assistant teacher have taught children from various local elementary schools – subjects taught being quite general 1919-1922'.

28 See *London Gazette*: 28.10.21, p. 8,597, 24.4.23, p. 3,029, 2.5.24, p. 3,613; *Eastbourne Chronicle*: 10.12.21, 21.1.22, 25.2.22, 20.5.22; *Eastbourne Gazette*: 7.12.21, 18.1.22, 22.2.22, 17.5.22. Questioned by the Official Receiver about why he had formed a limited liability company in 1906, Frank insisted that he made the move for 'want of capital. The business was a growing one, and there was the prospect of it developing', and that he did so 'with a view to developing and enlarging the business'. Under cross-examination Frank firmly denied the

move was made because his existing business was already in financial difficulties, but pressed still further he had to admit that around this time, on the advice of his solicitor and 'in case of accident', he had transferred rights over his own domestic furniture to his wife Emma as a gift in a ceremony whereby 'Mr Davidson came to the house and took a piece of furniture and asked me to present it to Mrs Ravilious, and he drew up a document which was stamped.' Frank insisted this 'was an ordinary and natural thing to do, without suspicion of any kind', but it seems to have been the first of several moves whereby Emma over the years took increasing control of the household's possessions and financial affairs in order to insulate them from the potential impact of her husband's erratic ventures. Creditors were paid 6d in £1 as a result of the 1921 bankruptcy and Frank and his son, Frank Clement, were discharged from bankruptcy on 2.5.24. Frank Clement was declared bankrupt again in 1928.

29 ER lodged at 1 Blithfield Street, Marloes Road, South Kensington, for the first RCA year; Binyon, 1983, p. 24, describes this walking tour, drawing on descriptions from both Donald Towner and John Lake, ER's companions. Their route followed the Downs from Eastbourne to Shoreham, then up the Adur Valley, across country and then down the Arun Valley to Amberley, Arundel and Bosham. Towner, 1979, pp. 22–24, also describes a trip by the Art College Sketch Club to Kirdford, West Sussex, in August 1921.

30 EB lived at 8 Lilyville Road, Fulham, London SW, for the first year; EB had been awarded a three-year Royal Exhibition valued at £80 per annum; ER had a £60 municipal scholarship for the first year, but also received some extra support from his mother.

31 Bliss, 1979, p. 19; DPB was born on 28 January 1900 at Karachi, then part of British India, the son of Joseph Bliss, pharmacist, and Isabel Douglas Percy.

32 Bliss, 1979, p. 18, continues: 'Looking back I regret that I had not been banished from the Paradise

of the Painters (for we considered ourselves to be the Elect) into the Purgatory of the Design School.'

33 Mayne, 1948, p. 10.

34 This enabled Freedman both to contribute at home and to concentrate on art full time. He lived with his parents at 15 Maryland Street, Commerce Road, London E1, during his three years at the RCA; notwithstanding the level of his scholarship, he still seems to have remained chronically short of money and a frequent borrower, perhaps because his contribution was a significant proportion of the household income.

35 W. Rothenstein, 1934, pp. 35–36, 99; see also Speaight, 1962, pp. 162–66.

36 See Charles Spencer, 'Barnett Freedman', in *The Studio*, November 1958, vol. 156, no. 788, p. 130; Mayne, 1948, p. 14.

37 PH was born on 8 March 1897.

38 PH first wrote to Lydia in November 1917 while temporarily transferred to hospital for medical treatment on his wrist; she replied on 20.11.17 requesting that her first commission on release should be a miniature of 'Tiny', Royle Richmond, her deceased fiancée. PH married Lydia Smith at St Pancras Registry Office on 21.7.21.

39 He was appointed in April 1920 under a system whereby the Art Master reimbursed assistants he hired out of his own pocket; in the year above those holding Royals included Henry Moore and Bliss's future wife, Phyllis Dodd.

40 Marx, 1993, p. 36.

41 Marx, 1993, p. 36.

42 Quite a few of them were more attracted to the primitivism and post-Impressionist ideas expounded by his old adversary Roger Fry in *Vision & Design*, a volume much favoured at the time by members of the northern student contingent including Moore and Hepworth.

43 Trant, 2004, p. 29.

44 See Cunliffe-Charlesworth, 1991, p. 86, and appendices: thirty-two women and twenty-six men graduated with Diplomas in 1924 (the year ER became ARCA), twenty-five from the Painting School and twenty-three from

Design. In 1923 seventeen women and four men graduated from the Design School, and fifteen men and nine women from the Painting School. Helen had been a student at St Paul's.

45 ER to HB 10.12.35: 'Have I known you well for one year and fairly well for two years and on hat raising terms for ten? Is that right?' HB to ER 12.12.35. 'I think the hat raising stage might be more than ten years – eleven I think'; Ullmann, 2012, p. 101, observed that Cecilia Dunbar Kilburn and Betty Rea were exceptions to this tendency.

46 Hatcher, 1995, provides the most comprehensive coverage of Laurence Binyon's career. Twenty years before, Binyon had commissioned Rothenstein to write a book on Goya; the illustrations for Binyon's 1917 book *For Dauntless France*, a survey of Red Cross activities in France, included a Rothenstein painting of the battlefields.

47 'For The Fallen' was first published in *The Times*, 21 September 1914. Although its lines now read as an elegy for the entire slaughtered generation of 1914–18 (and since the 1920s have been used as such on countless war memorials and from then on as part of most remembrance services), they were in fact well known from the first months of the war.

48 'The Fourth Court', *The Times*, 30.6.24, p. 20, reported on HB's presentation at Court three days before.

49 Student Files, RCA Archives. Cunliffe-Charlesworth, 1991, p. 107, suggests that by 1922 the course structure had altered so that first-year students studied architecture a day a week for the whole of the first year; the Ravilious and Bawden files suggest otherwise.

50 Bliss, 1979, p. 21.

51 Binyon, 1983, p. 32; Ray Coxon was in fact in London while Edna Ginesi was in Florence at the same time as Moore, see Berthoud, 1987, pp. 79–80. Another second-year figure who appealed from afar to the unsophisticated Eric was painting student Basil Taylor with 'his bravado and his mistresses and his magnificent appearance', Ullmann, 2012, p. 175.

52 See *The Times*, 17.6.25, p. 19; they formed part of an eight-room applied arts display in the Grand Palais where Anning Bell himself designed a mural depicting English textile towns. As a Master of the Artworkers Guild he would have been involved in the overall organization of the display and in a September 1925 letter thanking Ravilious for the gift of a wood engraving, he wrote: 'Those things you have in Paris would be just the sort of thing to show Mr Wild, didn't you have one or two others in the Students show a year ago at the RCA – little clouds and a balloon or was that Bawden?' (Ullmann, 2008, p. 43). It probably was Bawden.

53 Bawden RCA file; and Bliss, 1979, p. 21.

54 Christopher Neve, *Leon Underwood*, Thames & Hudson, 1974, p. 74; Binyon, 1983, p. 26.

55 Freedman Student File, RCA Archives.

56 J. Rothenstein, 1974, p. 72.

57 Prudence Bliss, unpublished interview with Peggy Angus, 6.1.85.

58 Term Report for 1922–23, ER student, RCA Archives. Short had taught at the College and its predecessor, the South Kensington Schools, since 1891; he was made Professor in 1913 and was a leading figure of the art establishment, Treasurer of the Royal Academy and Master of the Art Workers Guild; he retired at the same time as Anning Bell in July 1924.

59 Marx, 1993, p. 38.

60 Bawden and Ravilious had recently discovered the remains of Lovat Fraser's library in a Chelsea bookshop and bought books by Joseph Crawhall. See EB to EM, undated letter quoted in Marx, 1985, p. 37.

61 RCA Student Magazine, June 1923, p. 114; Powers, 2013, p. 16; Greenwood, 2008, p. 20.

62 The incident is described, but not dated, in accounts by both EM and DPB; however Beerbohm, resident in Italy, visited London only twice during ER's RCA years; on the second occasion, April–May 1925, ER was himself in Italy. By way of contrast, when Moore met Ramsay MacDonald

at Airlie Gardens, 'I wasn't awed or anything; so Rothenstein gave me the feeling that there was no barrier, no limit to what a young provincial student could get to be and do, and that's very important at that age'; quoted in Berthoud, 1987, p. 67.

63 ER student file, RCA Archives.

64 Bliss, 1928b, p. 64.

65 Rich, 1917, includes a specific chapter (IX: 'The Watercolour Painters Country: Sussex') with descriptions of the Arun Valley and Pulborough Brooks. Works exhibited at Walkers Gallery, Bond Street, 9 April–5 May 1923, included *The Sussex Downs*, *The Sussex Weald*, *A Sussex Farm*, *A Road in Sussex* and many more with similar titles, as well as ones completed at Angmering, Arundel, Chichester Harbour, Ditchling, Shoreham, Rye, Lewes and other locations Ravilious knew.

66 Binyon, 1983, p. 43.

67 Rich, 1917, pp. 26, 28, 34, 39, 56 and 57.

68 ER's chalk *Study of a Sussex Woodland* clearly shows the influence of Calvert.

69 Powers, 2013, p. 69. On a prior occasion, December 1921, Ravilious had spent several days in Rye 'painting boats, the harbour, the marshes, old buildings': Towner, 1979, p. 23. Thomas Bell FRPS frequently worked for the *Illustrated London News* and was also Advertising Manager for Kodak Ltd.

70 It included Beryl Bowker, Cecilia Dunbar Kilburn, Sam Heiman and Anthony Betts. Houthuesen and Towner arrived in ER's second year.

71 Bliss, 1979, p. 24, suggests that he and EB began to share lodgings in Redcliffe Road in the second year, but College records show that Bawden lived at 4 Winchendon Road, Fulham, from October 1923, moving to 58 Redcliffe Road, Earls Court, with Bliss after the previous occupants Robert Lyon and Ted Halliday, two Prix de Rome winners, left for Italy in autumn 1924. At the beginning of his second year Ravilious moved to 42 Tournay Road, Walham Green, where his Eastbourne friend Donald Towner also lodged, and returned there for one term in the third year

prior to his departure for Italy in February 1925. In his memoir Towner erroneously implies that he and Ravilious went up to the RCA at the same time in 1923, but in fact he arrived a year after Ravilious.

72 Cecilia Dunbar Kilburn quoted by Seddon in Memorial Exhibition catalogue, Graves Gallery, Sheffield, 1958; Bliss, 1979, p. 26; see also Tirzah Garwood's description of Bawden, Ullmann, 2012, p. 90.

73 Herbert Simon, *Song and Words – A History of the Curwen Press*, George Allen & Unwin, 1973, p. 137.

74 Bliss, 1979, p. 21: 'He had made up his mind not to be a painter ... He was a draughtsman rather. Line was the weapon he would use, not solid form, not tone, not atmosphere.'

75 Bliss, post-1946, p. 2.

76 These were the frontispiece decoration (a winter scene viewed through a sash window, which may possibly be the view from ER's room in Tournay Road); a not entirely successful chapbook-style decoration, *Drunk Beneath A Tree*, which nevertheless incorporates possibly his earliest use of manière criblée cutting in the foreground; and a headpiece used to illustrate an article on 'A National Toy Industry' by Reco Capey (the RCA instructor most alive to issues of industrial design at the time).

77 *Shakespeare on a Stool*, Bliss, c. 1926, p. 17.

78 It also included three engravings by ER, one of which was used in the Bliss, Marx, Ravilious exhibition of woodcuts held in Liverpool in January 1926; another of which – of a fence – was later reworked as the headpiece for January in *The Twelve Moneths*, Golden Cockerel Press, 1927; and the third of which – a child riding a pig – indicates that the publication had been delayed by two months, as suggested in the tone of Bliss's editorial.

79 Nor did Bawden attend the following year when he was made ARCA.

80 The College records note that on 4 March 1924 PH was recovering from influenza in Brighton, having been away from 22 February until 17 March, and then from 30 April to 6 June. WR

NOTES

to PH in Henry ward, St Thomas's Hospital, 18.7.24 PH ESRO Archive.

81 ER RCA student file.

82 Eastbourne Council Education Committee Minutes, 21.7.24 ESRO.

83 DPB first visited the Prints and Drawings Room on 12.1.23, returning there with ER on 7.7.24; ER visited again on 13.10.24 when his name was the first in the Register. BM P&D Visitors Books, vol. 27.

84 *Sussex Church* was first published in *Gallimaufry*, which had been printed and was being hand-coloured by the time ER returned; he had completed the cover design in January before his departure, see Bliss, 1979, p. 27. Correcting the date of ER's Italian blocks in line with the new evidence that he was in Florence in spring 1925, not 1924 as previously thought, makes sense of DPB's description of *Sussex Church* as his first ambitious block and the evident progression in technique between it and the Italian blocks.

85 See William Vaughan in Vaughan and Harrison, 2005, p. 16, n. 16, and Colin Harrison therein, p. 60. Martin Hardie had been in extended negotiation with Palmer's son A. H. Palmer for many years prior to the mounting of the exhibition in October–December 1926. As Harrison commented: 'Few exhibitions have had such a decisive impact, both on the history of a single artist, or an artistic movement, and on the creative impulses of living artists. Visitors flocked to see this wholly new artist, and the exhibition was an enormous success.'

86 Bliss, 1933, p. 53.

87 Marx, 1993, p. 37. For Morley College Murals see Chapters 2 and 3 below; Diana Saintsbury-Green quoted in Ullmann, 2008, p. 45.

88 ER to Hubert Wellington 29.4.25 and 13.5.25, Student File, RCA Archives; DPB recalled 'Rothenstein gave him a letter of introduction to Bernard Berenson at Fiesole, and Eric went along and heard the great BB discourse on some Giottecso, Taddeo di Bartolo Gaddi or some such person, whose work was utterly unknown to him', Towner catalogue for Minories Exhibition 1972; *The Times*, 8.10.24;

Berthoud, 1987, pp. 79–80. Soon after Ravilious left, Hepworth married John Skeaping in the Palazzo Vecchio in Florence.

89 La Nazione, 21.3.25, p. 4, gives a detailed preview of the arrangements for the following day. Ravilious may also have witnessed demonstrations a few days later commemorating the death in 1921 of Giovanni Berta, a young fascist who had been thrown into the Arno by communists.

90 Ullmann, 2008, p. 47, attributes the date of Tuesday 13.4.[26] to this letter, but internal references make clear it was written in April 1925.

91 The reference suggests that while in Florence he probably saw Masaccio's frescoes in the Brancacci Chapel in the church of Santa Maria del Carmine.

92 Although reported as £60 in the Eastbourne Minutes, RCA records show it was actually valued at £80.

93 BF student file, RCA Archives.

94 L. Archier Leroy, *Wagner's Music Drama of the Ring*, Noel Douglas, 1925; on 3 October Nash attended the next SWE committee meeting, see Society of Wood Engravers Minute Book, MMULSC. The *Times* review of the Redfern Summer Exhibition, 15.7.25, cited *Landscape Near Florence* by 'Mr E. Ravilious', almost certainly one of the three extant Italian woodcuts, most likely the one now known as *Woodland near Florence*.

95 Harold Stabler of the firm Carter, Stabler and Adams had seen his work at the RCA and arranged for him in 1924 to produce a calendar and then illustrate *Pottery Making at Poole*, printed by the Curwen Press in 1925. Albert Rutherston, Rothenstein's brother, had already been designing for the Curwen Press. Harold Curwen, like Harold Stabler, was a founder member of the Design and Industries Association.

96 *Matrix 16*, p. 149; Ullmann, 2012, pp. 102, 223.

Chapter 2

1 *Artwork*, January–March 1928, p. 64.
2 Bliss, 1933, p. 53.

3 Although ER was employed for two days a week, he often spent longer in Eastbourne. See ER to Robert Gibbings 23.2.27: 'I go down to Eastbourne every week-end until Tuesday night', Harry Ransom Collection, University of Texas; George Branson had regular use of his London bed at weekends.

4 Ullmann, 2008, p. 62: ER to CDK, 6.11.27: 'I stay at home for such long periods, Bliss is as pleased when I go up as if I had been abroad, so I am pleased really. His conversation simply can't be replaced, not by anyone here at any rate. It is dreadfully priggish to say so, but there aren't three people I've come across here in Eastbourne I really like talking to; if they are informed on anything it is something like military fortifications, or the Book of Daniel, or perspective ...'.

5 Gossop also held an exhibition of DPB's *Satyrs in Stones* at his Henrietta Street, Covent Garden, premises. *The Times*, 7.11.25, reviewed *Border Ballads*; the fourth participant was Molly Bateman, Edward Johnston's assistant at the RCA and 'a decorator and maker of patterns for book decorations with a very personal style'. DPB had written to ER in Italy, 13.4.25; 'Folk miss you at the dances. Miss Bateman inquires for you ...'. See Chapter 1, note 90, for dating of this letter.

6 *Manchester Guardian*, 20.1.26, p. 18.

7 'The Textile Designs of Paul Nash', Darcy Braddell, *Architectural Review*, October 1928, p. 161.

8 P. Nash, 'Modern English Textiles', *Artwork*, January 1926, pp. 80–87.

9 *Studio*, December 1926, p. 400.

10 In her handwritten, unpublished memoir, EM dated the move to 1927, and her subsequent move to Ordnance Hill, St John's Wood, as soon after the death of her sister Madeleine, which occurred in November 1928.

11 DPB told his daughter Prudence he 'practically lived in the V&A' while writing his history, Prudence Bliss interview 8.7.2015; by contrast he seems to have only visited the BM on two occasions in 1927, 26.1.27 and 30.9.27, giving his address as 38 Redcliffe Road SW10 on both occasions.

12 Bliss, *c.* 1926.

13 Bliss, *c.* 1926.

14 Bliss, 1928a, p. 65.

15 See Bliss, 1933, p. 53, for a description of ER's technique; author's interview with Prudence Bliss 6.7.2015.

16 Bliss, 1979, p. 29.

17 Simon, 1973, p. 178.

18 The RCA Edward Bawden file, containing the correspondence quoted, indicates he left on 19.2.26.

19 Bliss, 1933, p. 54; no cuts by Ravilious or Marx were included in the ninety-seven works displayed at the Sixth Annual SWE exhibition, which opened in November 1926 (though they had both been made Associate Members in October).

20 Bliss, 1928a, p. 225.

21 ER to Robert Gibbings 19.1.27, quoted in Joanna Selborne, 'Eric Ravilious and the Golden Cockerel Press', *Matrix 14*, p. 19. Before this Ravilious had floated the sixteenth-century poet Fletcher, *The Golden Ass of Apuleius* and Samuel Butler's *Erewhon* as possibilities; Marie de France's *Lays* were also discussed during the visit. On 23.1.27 ER wrote 'I am enjoying cutting these things, I have not tried anything quite like it.' As Selborne notes: 'Frequent references in Ravilious's letters to the depth of cutting, and to the printing, of his engravings show an increasing interest in the appearance of his blocks on the page.'

22 Bliss, 1979, p. 55.

23 On 29.3.28, Hubert Furst, editor of *The Woodcut*, wrote to ER: 'Miss Garwood's cuts are a great joy and I should certainly like to include one in the next number', also offering to invite publishers to a small exhibition of TG's work as 'I think a number of collectors would be sure to buy and the show would give her useful publicity.'

24 This show also took place at the St George's Gallery and included work by Paul and John Nash as well as two watercolours by Ravilious, which *The Times*, 27.5.27, p. 14, noted as combining 'observation of Nature and the use of symbols which, as in a child's drawing convey the idea of a house or a tree and no more'. At Easter ER undertook a journey through Sussex as far as Kirdford, taking in Ditchling and Horsham among other places.

25 EB to ER n.d., Ullmann, 2008, p. 60.

26 Bliss, 1979, p. 56; Ullmann, 2008, p. 59.

27 Binyon, 1983, p. 41; for the date of the opening as September rather than October, see Greenwood, 2008, p. 56, ER to GCP.

28 Gerald Reitlinger quoted in Bliss, 1979, p. 56.

29 P.G. Konody, 'Art and Artists', *The Observer*, 25.9.27, p. 14; EB to ER, Ullmann, 2008, p. 59, refers to Dent's having suggested 'Paltock's Fighting Indians' as a potential book that EB could illustrate. The 'Flying Indians' appear in Robert Paltock, *The Life & Adventures of Peter Wilkins*, J. M. Dent, 1928, EB's first published illustrated book.

30 See note 4 above.

31 Frank was born on 9.8.1858 at Cage Green just north of Tonbridge; Emma on 15.7.1863; Eric was born on 22.7.1903 at 11 a.m., as recorded by Frank on the flyleaf of the family Bible.

32 In 1881 she was at South Allington House in Chivelstone, a village just across the Kingsbridge estuary a few miles from where she was born; the household was headed by the farmer and magistrate Thomas Pitts, who employed six men and a boy on the farm, and four indoor servants looking after himself, his wife and their six-year-old daughter. Emma's sister Elizabeth, four years her junior, was also working as a servant in the household of another local farmer; Ferox Hall was home to banker Arthur Beeching, his wife Ellen, ten children and nine live-in servants, and the Tonbridge firm of Beeching, Hodgkin and Beeching, with branches in Tunbridge Wells, Hastings, St Leonards and Folkestone – and its connection to Barclay, Bevan and Co. of Lombard Street – was at the height of its pomp. Shortly after Emma left, speculation by one of the partners led to a crisis and in 1890 Arthur Beeching had to arrange a hurried takeover by Lloyds Bank. The next year he vacated Ferox Hall, which was acquired as a boarding house by neighbouring Tonbridge School.

33 Mixed motives, combining religious zealotry and the more mundane, often seemed to impel Frank to action. Having taken to wayside evangelism with his brother Albert, Frank convinced himself 'he was one of God's saved and this subconsciously gave him licence to behave in a rather unorthodox, and sometimes quite dubious manner'. Ullmann, 2012, p. 73.

34 On Catherine's birth certificate he recorded his occupation as 'Cabinet Maker and Upholsterer (Master)' and thereafter began promoting his new line of work by inserting a weekly advertisement in the Tonbridge and Tunbridge Wells Free Press: 'F RAVILIOUS, UPHOLSTERER, &c, 19 London Road, Tonbridge, Mattresses Cleaned & Re-Made'. The advertisement first appeared on 31 May 1890 and ran in unchanged form until 31 January 1891; Catherine Ravilious was buried on 29 December in grave 1236, plot 15, Tonbridge Cemetery. More than twenty years later this lost infant daughter was still on Frank's mind, as the 1911 Census return for 11 Glynde Avenue has a line in his hand recording Catherine's existence and her place of birth along with the details of his other living children; one of Frank's adult brothers, Edward, had died before this on 3.12.1881, in Stockwell Small Pox Hospital.

35 Evelyn Mary was born on 27 August 1896; the birth was registered on 2 October. Acton at the beginning of the last decade of the nineteenth century was in the course of shedding its identity as a neighbourhood known for canal-side dirty industries, laundries, piggeries and brick-making, and being transformed into a developed suburb connected to the metropolis by train and horse-drawn tram. The population had burgeoned from 17,000 to 25,000 over a decade, and over the next twenty years would reach 57,000 as speculative house-building boomed,

while the arrival of the electric tram in the High Street added a further spur to local trading.

36 This rate of expansion required considerable working capital and, as a prelude to raising additional finance, Eric's father incorporated Frank Ravilious and Company Limited in February 1906. Under an Agreement approved by the Companies Registrar on 23 February 1906, £166 in cash, and plant, machinery and vans valued at £1,033, were transferred to the new venture. For Liquidation see *London Gazette*, 17 May 1907, p. 3,462, and 6 March 1914, p. 2,088. TNA BT31/11321/86666.

37 At the beginning of June 1907 they moved into rooms at Thurlestone Lodge, a villa situated at 25 Upperton Road, half a mile north of the station. The Eastbourne Rate Book for the half-year ending March 1908, based on an assessment made on 1 October 1907, notes 'leaving' against the entry for 'Ravilious, Frank'; Assessment 1172, p. 68, ESRO DE/B1/139. By April 1908 the family had moved to 7 Watts Lane, a house owned by Mrs Emily E. Hart, who also owned numbers 9–17 odd in the same street. ESRO DE/ B1/141.

38 The Eastbourne Rate Book for the half-year ending September 1909 notes 'Ravilious, Mrs Emma' as the occupier of 7 Watts Lane, but against her crossed-out name is noted 'Left July'. Assessment 300, p. 15, ESRO DE/ B1/145; the assessment is dated 5 April 1909.

39 Interview with Gwen Ledger 20.5.2008.

40 Binyon, 1983, p. 21.

41 Ullmann, 2012, p. 76.

42 46 Charleston Road was the only owner-occupied house registered in a woman's name in the newly constructed road; the house was purchased with a mortgage, and later references to ER helping his mother buy it from his Morley College earnings probably refer to paying off this loan finance.

43 Ullmann, 2012, p. 50; the maths master was William George Jeeves, who taught ER's form from October 1914 before enlisting in December 1915.

44 The Public Library and Technical Institute building had been completed in 1904 and was destroyed by bombing in June 1943. It housed the Art School (from 1905), the library and Eastbourne Municipal Secondary School during Ravilious's time there. Although Ullmann, 2012, p. 77, states 'Mr Millington was a conscientious objector and because of this he was arrested and sent to prison where he died', he actually lived on in Wolverhampton after the war until 1922, when he died in a nursing home following an operation for appendicitis.

45 A Cadet Corps had been formed in April 1916 'with the enthusiastic support of the boys and parents, and in August a party of 35–40 boys spent a month at Sissinghurst in Kent, in what was probably the first Harvest Camp in the Country'. These camps became numerous in 1917 and were encouraged to offset labour shortages due to conscription. Brother Frank Clement was a stretcher-bearer in the RAMC at the time, and it is not clear why Frank senior opposed Eric taking part.

46 Ullmann, 2012, p. 99.

47 The appointment was for two days a week, thirty-eight weeks a year, at two guineas a day and £30 per annum travelling allowance. The Art and Craft School was staffed by t hree full-time and three part-time teachers.

48 Tirzah attended evening classes during the autumn term of 1925 before leaving West Hill School at Christmas.

49 Ullmann, 2008, p. 45; this list, derived from Diana Saintsbury-Green's reminiscences, is interesting evidence that ER was very alive to new authors. Garnett had recently had a hit with *Lady into Fox*, illustrated with engravings by his wife Ray Garnett, and this novel may have suggested to Tirzah the subject she engraved in *The Cat Wife*.

50 Board of Education Report of Inspection of Eastbourne School of Art held on 22, 23 and 24 March 1926, HMI Report, ESRO.

51 Ullmann, 2012, p. 60.

52 Ullmann, 2008, p. 46.

53 Ullmann, 2012, p. 61: 'He liked my work because it was personal and did not imitate his own.'

54 Lieutenant-Colonel Garwood's 1926 diary recorded Tirzah at all-day sketching expeditions on 15 June, 22 June and 19 July, and on 23 June, 11 July and 18 July in 1927. Wilmington, Folkington and Exceat are among the places mentioned.

55 Edgar Bartlett, a childhood friend, recalled that Ravilious aged nine 'had a very lively imagination and was amusing to be with, but above all, he could draw. In those days everyone had autograph albums, and everyone wanted Eric to draw something in their books. He loved cats, and loved to draw them.' Edgar Bartlett to Mrs Gurney 20.8.92, Ullmann, 2008, p. 21.

56 Colonel Garwood's diary, private collection, records her departure for a fortnight on 15.8.27.

57 Colonel Garwood's diary 2.9.27.

58 The exhibition of engravings on wood and copper from books published by the GCP was held at the St George's Gallery from 19 October to 3 November 1927; it subsequently transferred to the Whitworth Gallery, Manchester, where it was showing in March 1928.

59 SWE Minutes 27.9.27, then 8.3.28: 'Following the somewhat drastic selection and rejection of prints sent into the last exhibition it had been proposed that non-members entrance and hanging fees be re-considered. It was resolved that the entrance fee be 2/6 instead of 5/- and that the hanging fee per frame be 7/6 inclusive of the entrance fee.'

60 Ullmann, 2012, p. 70; July 28 Eastbourne Education Committee Minutes – R/E3/3/25.

61 DPB in catalogue of *Eric Ravilious*, an exhibition held at The Minories, Colchester, 1972.

62 Ullmann, 2012, p. 98.

63 Ullmann, 2012, p. 70.

64 BF married Claudio Guercio on 14.6.26; a further ceremony with parents took place on 13.4.30.

65 WR to BF 24.6.29; *Scotsman*, 12.11.30, p. 10.

66 PH to BF 24.1.28, BF Archive, MMULSC. PH began teaching at the

Working Men's College in September 1926; see Laver *Museum Piece*, Andre Deutsch, 1963, p. 106. In December 1936 the College held a dinner to celebrate the long-running services of PH, BF and Geoffrey Rhoades.

67 Ullmann, 2012, p. 64; Eastbourne Council Higher Education Sub-Committee, Minutes 12.9.29, ESRO.

68 'Tonks, used to his word being law at the Slade, liked it to be the law elsewhere. I wanted a larger room, with more window space. Tonks would do anything, would spare himself neither time nor trouble, for his students at the Slade. He was less generous to those unwise enough to study elsewhere. Like the Inquisitors of old, he sincerely believed in the wholly catholic Slade; all outside were heretics.' W. Rothenstein, 1934, p. 166.

69 TGA 17/3/3/10.

70 Under WR's watch RCA students were often encouraged to take on projects of civic relevance: Phyllis Dodd's final 'Decorative Painting' task, for example, involved designing murals for a nurses' dining room.

71 Eva Hubback to Charles Aitken, 26.1.28. TGA 17/3/3/10.

72 Leslie Snowden to Chairman of Eastbourne Council Higher Education Sub-Committee, Minutes 12.9.29, ESRO.

73 Ullman, 2012, p. 71.

Chapter 3

1 Eva Hubback to Aitken 26.1.28; WR to Aitken 15.2.28, TGA 17/3/3/10.

2 W. Rothenstein, 1934, p. 90; J. Rothenstein, *Studio*, June 1930, p. 429.

3 In March 1929 ER wrote to Moira Gibbings that he was 'spending a great part of the week in London painting some decorations in a restaurant, a job I have been working on for just a year now', Selborne, 1994, p. 33.

4 W. Rothenstein, 1934, p. 90.

5 ER to WR 8.7.28, Ullmann, 2008, p. 69.

6 Morison, acting for the Lanston Monotype Corporation (manufacturers of typesetting machinery), approached Ravilious with a brief to cut thirteen blocks for

a fee of forty guineas, equivalent to a quarter of Ravilious's annual earnings at Eastbourne and almost certainly his most remunerative commission to date. Although not a Curwen employee, Morison was very much part of that network, having shared an office with Oliver Simon in St Stephen's House, Westminster, and then at 102 Great Russell Street between autumn 1922 and early 1925. Simon used these as a London base to promote Curwen to clients, develop the book-publishing side of the business, and launch his editorship of *The Fleuron*, which first appeared in spring 1923 and had been admired in the RCA Common Room.

7 Binyon, 1983, p. 46; Bliss, 1979, p. 37, quoting from his own review in *The Scotsman*.

8 Ullmann, 2008, p. 76.

9 Bliss, 1979, p. 38.

10 Ullmann, 2012, p. 94; Bliss, 1979, p. 38.

11 Aitken to Duveen 2.10.28. TGA 17/3/3/10.

12 *The Times*, 6.2.30, p. 12; *Manchester Guardian*, 6.2.30, p. 10; *The Times*, 7.2.30, p. 16.

13 TGA 17/3/3/10.

14 W. Rothenstein, 1934, p. 90.

15 ER used the Bliss's Sancroft Street address as his London base from December 1928 to late April 1929, then he had a room at 52 Redcliffe Road, as did Bawden.

16 A preparatory drawing held at ESRO is dated October 1930 in ER's hand.

17 Ullmann, 2012, pp. 93 and 91.

18 Ullmann, 2008, p. 62 (ER to CDK 6.11.27).

19 Ullmann, 2012, p. 109.

20 *The Pilgrim's Progress* with music by Granville Bantock for Six Solo Voices, Full Chorus and Orchestra was broadcast from the Queen's Hall on 23.11.28.

21 *Ivanhoe* was broadcast on 25.3.29 and 27.3.29.

22 Ullmann, 2012, p. 81.

23 Ullmann, 2012, p. 80; as a result of a failed venture in London, Frank Clement was declared bankrupt for a second time in early 1928, *London Gazette* 28.2.28 and 3.4.28, this time at the behest of creditors; the newspaper

report of the case referred to by TG has not been traced, and uncertainty surrounds the timing of his appearance in court and sentencing.

24 David Garnett had published *Lady into Fox* to acclaim in 1922, a fable about a man whose wife is transformed into a fox. Lost to him temporarily when she mates in the wild, she is finally pulled from his arms to her death by hounds. Dedicated to his former lover, Duncan Grant, it was illustrated with twelve wood engravings by R. A. Garnett, née Rachel 'Ray' Alice Marshall, his wife. The following year it became the first book to win the Hawthornden and the James Tait Black Memorial Prize – a unique feat. Well known to Ravilious's RCA common-room generation, the wood engravings are a mixed bag of white-line and black-line vignettes, some in a naïf chapbook style, others reminiscent of Lovat Fraser's style.

25 *The New Wood Cut*, Studio Special Spring Number, 1930, p. 20; the survey reproduced TG's engraving as *The Cat Wife*, p. 38, and was probably prepared before the December 1929 SWE show.

26 Selborne, 1994, pp. 30 and 35. Letters quoted between RG and ER are reproduced here. ER was originally approached to illustrate *Atrocities* on 25.10.28; he received his £50 fee on 30.7.29.

27 *The Famous Tragedy of the Rich Jew of Malta* by Christopher Marlowe, The Golden Hours Press, 1933.

28 *Handwritten autobiographical notes*, EM, Private Collection. Spelling was never EM's strong suit.

29 EM attended Leon Underwood's classes in Moore's company and stayed in contact with him. Shortly after November 1928 she was once again in close proximity, having moved her studio to Ordnance Road, St John's Wood, where Moore also had a studio.

30 Enid Marx, 'The Grand Design for Britain', the *Guardian*, 19.5.98.

31 Enid Marx, 'The Little Gallery', *Matrix 7*, p. 103.

32 TGA: TAM 38 1–10 is a microfiche of original correspondence.

33 Alan Powers, 'Enid Marx RDI', *Matrix 18*, p. 187.

34 *The Times*, 8.11.28, p. 21.

35 Oliver Simon, *Printer and Playground*, Faber & Faber, 1956, pp. 85ff.

36 DPB recalled that both he and EB were owed fees and agreed to write to request them; however, only DPB did, at which Simon subsequently took great offence. Interview, Prudence Bliss, 6.7.15.

37 Greenwood, 2008, p. 74. The engraving was used as a header for an advertisement for the Lanston Monotype Corporation in volume 6 of *The Fleuron*, published in early 1929.

38 Ullmann, 2012, p. 86.

39 Ullmann, 2012, p. 97.

40 *The Times*, 23.5.30, p. 19.

41 Ullmann, 2008, p. 88. EB to BF n.d., but in the week prior to the wedding.

42 The first marriage took place at St Pancras Registry Office on 14.6.26; the second at Holborn Registry Office on 13.4.30, witnessed by Barnett's father and Claudia's mother.

43 In addition to BF and PH the prospective membership included F. Barber, B. Casson, R. Horton, A. Houthuesen, E. Jones, H. Jones, R. Keevil, M. Kestelman, C. Mahony, E. Mollo, E. Payne, A. Poulter, S. Rabinovich, G. Rhoades and D. Towner; WR to PH 22.1.29: 'I need not say how glad I shall be to be of any use to your new Society. I shall be most pleased to meet you any time you suggest.' PH Archive ESRO.

44 Mayne, 1948, p. 15.

45 Zwemmer Gallery, 'An Exhibition of Fifty-two Drawings by Barnett Freedman. Including Drawings and Sketches for "Memoirs of an Infantry Officer" by Siegfried Sassoon', 18.11.31–2.12.31.

46 Blair Hughes Stanton illustrated two *Ariel Poems*, and Eric Gill and Gertrude Hermes one each, with wood engravings.

47 *Manchester Guardian*, 17.12.31, p. 5.

48 Osbert Lancaster, quoted by Rogerson, 2011, p. 126.

49 Selborne, 1994, p. 18.

50 T. F. Powys, *When Thou Wast Naked*, Golden Cockerel Press, 1931. The first volume was published in January 1931, the last in March

1935, and all bore TG's handsome cover pattern. *Heartsease and Honesty*, published in September 1935, used a border engraving by TG.

51 Selborne, 1996, RG to ER 4.2.31; ER to RG 2.3.31.

52 Selborne, 1996, ER to RG 3.9.31.

53 Selborne, 1996, ER to RG 27.2.32; ER to RG 1.2.33.

54 Robert Graves, *Saint Hercules and Other Stories*, in *The Fleuron*, 1925; Sir Thomas Browne, *Urne Buriall and the Garden of Cyrus*, Cassell, 1932; Edmund Spenser, *The Shepheard's Calendar*, Cresset Press, 1930; Miguel de Cervantes, *The Spanish Lady*, Oxford University Press, 1928; Arnold Bennett, *Elsie and the Child*, Cassell, 1929.

55 Herbert Read, *Philosophy of Modern Art*, Faber & Faber, 1952, p. 80; Clare Colvin, *Paul Nash Book Designs*, The Minories, 1982, p. 57.

56 The Ruskin prospectus for the forthcoming Trinity Term, published in February 1930, lists ER as a staff member.

57 AR to ER 26.7.34 and 22.8.37.

58 R. S. Wood, Board of Education Director of Establishments, to BF 4.6.30, BF Archive, MMULSC.

59 *London Mercury*, vol. XXVI, no. 151, May 1932, p. 4.

60 Paul Nash, *Unit One*, ed. Herbert Read, Cassell, 1934, p. 80.

61 Selborne, 1996, ER to RG 13.12.31; at the time of the move, 48 Upper Mall bore the address 8 Weltje Road; ER and TG held onto it until late 1934, subletting it for various periods in 1933 and 1934.

62 Probably completed in early 1932, the painting was exhibited at 'Modern Designs for Mural Decoration', an exhibition held in Soho the month after 'Room and Book', *The Times*, 25.5.32, p. 12; see also DPB's review, *The Scotsman*, 5.5.32, p. 14, and for evidence of the exhibition in 1932 see Powers, 2013, p. 25.

63 Ullmann, 2012, p. 67.

64 Powers, 2013, p. 25.

65 EB to Charles Mahoney, n.d. but August 1930, Tate Archive, Charles Mahoney Archive, quoted by Peyton Skipwith, 'Edward Bawden', *Bawden, Ravilious and the Artists of Great Bardfield*,

ed. Gill Saunders and Malcolm Yorke, V&A Publishing, 2015, p. 57.

66 Selborne, 1996, ER to RG 20.6.31.

Chapter 4

1 'Art in London', *The Scotsman*, 29.11.33.

2 'Art in London', *The Scotsman*, 5.12.33.

3 Bawden's show ran from 4 to 25 October, Ravilious's from 24 November to 16 December; Bliss's review of the latter appears to be the sole one.

4 'Art Exhibitions: Mr Edward Bawden', *The Times*, 7.10.33, p. 10.

5 'Mr Edward Bawden', the *Observer*, 22.10.33, p. 14.

6 'Art in London, Essex in Water-Colours', *The Scotsman*, 9.10.33, p. 15.

7 TG in Ullmann, 2012, p. 129.

8 Correspondence between Edward Bawden Sr and Robert Epton, 24.11.31, 25.11.31, 10.12.31; Harold Curwen to EB, n.d.; Higgins EB Archive. Binyon, 1983, p. 60,

9 Edward Bawden in Peyton Skipwith's introduction to *Lady Filmy Fern*, Hamish Hamilton, 1980.

10 See Thomas Hennell, *Change in the Farm*, Cambridge University Press, 1934, pp. 32–134. Saffron Walden, Dunmow, Braintree and Sible Hedingham are mentioned in his account of the remnants of the gleaning tradition in the area.

11 'Tramping on the Cheap', *The Countryman*, July 1931, pp. 335–37.

12 British Museum, Prints and Drawings Visitors Books, 1922–30.

13 *In Memoriam: Thomas Hennell*, broadcast by Vincent Lines, BBC Third Programme, 3.5.47: the script can be found at TGA 9512.4.2.

14 Gerard Hopkins in his introduction to *Poems by Thomas Hennell*, Oxford University Press, 1936; see TGA 9512.1.2. The lecture was delivered at the Chartered Institute of Patent Agents on 25.11.31.

15 See Marx, 1987, for The Little Gallery background.

16 Ambrose Heath, *Good Food*, Faber & Faber, 1932.

17 TG, *In Memoriam: Eric Ravilious*, broadcast, BBC Third Programme,

20.1.48: p. 80 in the script printed in Christopher Sandford, *Cockalorum*, Golden Cockerel Press, 1950.

18 This watercolour is known from a black-and-white reproduction in Bliss, 1979, p. 63, where it is clearly dated 1932.

19 A posthumous inventory of Hennell's effects showed he owned Bewick's *Quadrupeds*, *The Chase*, *British Birds* and *Memoirs*.

20 Thomas Hennell, *Lady Filmy Fern*, illustrated by EB, Hamish Hamilton, 1980.

21 Cook, 1990. It is surprising to find these statements in an otherwise wonderfully acute and sympathetic account by a commentator who knew Tirzah personally; however, TG herself on occasion felt that she had substantially given up her art after marriage, notwithstanding the evidence of what she went on to produce.

22 Virginia Nicholson, *Among the Bohemians*, Viking, 2002.

23 L. A. G. Strong, *The Big Man*, William Jackson, 1931; frontispiece by TG.

24 *Poisonous Plants: Deadly, Dangerous and Suspect*, wood engravings and introduction by John Nash, Etchells and Macdonald, 1927.

25 TG diaries 2.1.35.

26 Christopher Bradby, *Well on the Road*, George Bell and Sons, 1935.

27 Ullmann, 2008, p. 117, ER to Oliver Hill, 24.2.32.

28 Ullmann, 2012, p. 146.

29 Ullmann, 2012, p. 150; TG diary 8.8.33.

30 For an account of this circle see John Sutherland, *Stephen Spender*, p. 160. Tirzah Garwood believed the talk of an affair to be 'quite untrue', but Humphrey Spender's account, recorded by the British Library, had the benefit of Lolly his wife's inside knowledge and is more compelling. According to Spender, her parents 'were great friends with Sir William Nicholson, really great friends, to the extent that their young and very pretty daughter was told nothing was better for her than to go and have lessons in painting from William Nicholson ... Nicholson, who was an

extremely sexy man ... immediately fell in love with Di, and when she, when he was sixty-eight, and she was seventeen, maybe he was sixty-four, and she was seventeen, bewitched Di and they started an affair... The parents never knew, and went on loving William Nicholson and loving their daughter. It was incredible that they didn't ever know ...' If HS is right, 1928 was the year when the affair began.

31 Ullmann, 2012, p. 151.

32 TG diaries: '15.9.33 Friday 15th Sept attic cleared out and cleaned for apples; 24.9.33 picked nuts and blackberries; 19.11.33 Eric finishes picture *High Tide* of the Stork through the window.'

33 Student Days at the RCA, *Matrix 16*, pp. 146–47; although Marx herself does not give a date for the encounter, the Mary Ward Settlement records in the London Metropolitan Archive show that the overlap between Francesca Allinson's teaching and Fleming's wardenship was eight months beginning in Sept 1933.

34 Ullmann, 2008, p. 157.

35 There is some confusion surrounding this arrangement. James Russell, *Peggy Angus*, Antique Collectors Club, 2014, p. 39, states she travelled down to Bardfield to collect *Ferryboat Entering Newhaven Harbour*, which he therefore dates as 1933; but correspondence from EB to PA, reviewed in Chapter 6, makes clear she did not receive it until March 1936, subsequent to its completion and framing. From its subject matter, moreover, *Ferryboat* was clearly produced as a result of Bawden's painting trips to Newhaven in the summer of 1935 and not in 1933.

36 Binyon, 1983, p. 62.

37 Cook, 1990, p. 6.

Chapter 5

1 Binyon, 1983, p. 64.

2 ER to HB 5 and 6.11.35 and 2.11.36, ESRO, for references to the bonfire long weekend of 2–6 November 1934, which Helen and Eric spent at Furlongs in the company of Peggy Angus and Jim Richards.

3 TG diary 13.2.34 and Ullmann, 2012, p. 155.

4 ER to PA 15.5.39; ER to HB 24.5.35.

5 EB visited Furlongs in July 1934; when in July 1937 Jim Richards invited him to return, he replied: 'If I came it would be alone ... the only trouble I see is that the Downs are no use to me for painting, and I must paint vigorously all the summer if I am to get enough frames filled for a show next spring'. EB to JR 21.7.37, ESRO.

6 VW to Ethyl Smyth 1.4.32; VW to Vanessa Bell 11.4.32; VW to Lydia Keynes 5.6.37; all in *The Letters of Virginia Woolf*, vols 4 and 5, Hogarth Press, 1979–80.

7 Binyon, 1983, p. 67; Rich, 1917, p. 90.

8 ER to PA 21.6.34; 'Art and Artists', the *Observer*, 9.2.36, p. 14.

9 ER to HB 19.12.34; TG diaries 15.12.34; TG diaries 29.8.34 notes 'Peggy's picture for Artists International'; no catalogue seems to have survived, but press reports cited in L. Morris and R. Radford, *AIA: The Story of the Artists' International Association*, Oxford, 1983, p. 14, refers to 'Two Paintings of Cement Works' by Margaret Angus.

10 J. M. Richards, *Memoirs of an Unjust Fella*, Weidenfeld & Nicolson, 1980, p. 95.

11 TG diaries 28.4.34.

12 Ullmann, 2012, p. 160; in the post-war period it is thought that Duncan Grant and PA came to be on calling terms, somewhat to Vanessa Bell's approval.

13 TG diary 14.5.34; Ullmann, 2012, p. 66.

14 PA to ER 16.2.34; *The Diary of Virginia Woolf*, 30.8.34, vol. 4, Hogarth Press, 1982.

15 TG, *In Memoriam: Eric Ravilious*, broadcast, BBC Third Programme, 20.1.48: p. 80 in the script printed in Christopher Sandford, *Cockalorum*, Golden Cockerel Press, 1950; TG diary 21.11.34.

16 ER to DT 31.7.34.

17 TG diaries 6, 8 and 27.6.34; 24.10.34; 7.11.34. The American heiress Dorothy Payne Whitney had married Leonard Elmhirst in 1925 and, after purchasing the Dartington Estate

in Devon the same year, they founded a community based on progressive education and encouragement of the arts – an approach to reviving the rural economy modelled on the teachings of Rabindranath Tagore, the polymath Indian poet-philosopher who was also a close friend of WR.

18 They married in November 1934, setting up house at 11 Queens Mansions, Brook Green, in a flat previously occupied by Stephen Spender, Diana's sister's brother-in-law. Her sister's husband, Humphrey Spender, recollected that Diana's father refused to speak to her or Clissold for many years after the marriage: *Humphrey Spender*, British Library National Life Stories Audio Collection, C466/101/07 F8794A; JR to PA 24 and 28.8.34.

19 Including the Downs behind the Long Man of Wilmington, the hills behind Willingdon and the path up to Kingston Ridge, as well as the ascending track near Furlongs.

20 Powers, 2013, pp. 90–91.

21 The week before the 1936 exhibition John Rothenstein wrote to Ravilious, 28.1.36, from Sheffield: 'I will despatch – with keen regret – "The Watermill" to Zwemmer's today.' As Director of The Graves it seems he may have borrowed the picture for exhibition; Ullmann, 2012, p. 168.

22 'Art and Artists', the *Observer*, 9.2.36, p. 14; Speaight, 1962, p. 369: In 1933 WR was appointed by the Carlisle Art Gallery (Tullie House) to buy pictures on its behalf, and in the course of ten years they acquired seventy-nine paintings and drawings in this way.

23 TG, *In Memoriam: Eric Ravilious*, broadcast, BBC Third Programme, 20.1.48: p. 80 in the script printed in Christopher Sandford, *Cockalorum*, Golden Cockerel Press, 1950; ER to HB 28.6.36.

24 Ullmann, 2012, pp. 97 and 160; TG diaries 5.7.34.

25 ER to HB 28.5.35; HB to ER 30.5.35.

26 Maria Edgeworth, *Angelina or L'Amie Inconnue*, Swan Press, 1933; *The Times*, 'Wood Engravings', 26.11.32,

p. 8; HB's illustrations show some stylistic affinities to ER's for *Twelfth Night* published by the GCP the previous year. In October 1935 (after ER has given her *Channel Steamer Leaving Harbour*), Helen gave Eric a print of the engraving that appears on p. 22 of the book.

27 Morphet in Binyon, 1983, p. 13.

28 'The Binyon Puppet Show', *Manchester Guardian*, 16.1.34; *The Times*, 10.1.34, drew attention to the self-playing harp in *Jack and The Beanstalk* and the trees and animals in *Orpheus* as most attractive puppets 'from the point of view of carpentry and design'; HB's 'beautiful puppets' also attracted the *Guardian*'s attention, 22.10.34, at the British Puppetry and Model Theatre Guild annual exhibition. These are identified in *The Times*, 19.10.34, as a set of four puppets called 'The Three Ages of Man' and described as 'very elegant and refined'.

29 HB to PA 23.11.32; ER to HB 15.9.36; Ullmann, 2012, pp. 159–60; Morphet in Binyon, 1983, p. 13.

30 ER to HB 20.9.34.

31 TG diary 30.10.34.

32 ER to HB 18.11.34; 5.11.35; 2.11.36.

33 ER to HB 13.1.35; HB to ER 19.1.35; HB to ER 5.2.35; ER to HB 19.3.35.

34 Ullmann, 2012, p. 168; TG diaries 26.2.35 indicate she met him on his return in Braintree that night and more generally indicate this timing is the only one that accords with TG's description of his absence; HB to ER 31.3.35, ESRO.

35 ER to HB 8.3.35; The WTA General Secretary wrote to PA on 15.4.35, 'I am sorry to say that no-one was at all enthusiastic about the scheme in general or the designs in particular'; ER to HB 7 and 9.5.35; TG diary 9.5.35; Ullmann, 2012, p. 170.

36 HB to ER 6.6.35; 24.10.25; 25.10.35; ER to HB 25.10.35.

37 HB to ER 14.10.35; ER to HB 5.11.35; HB to ER 14.10.35; HB to ER 10.11.35. The AIA exhibition was held 'In protest against Fascism in Abyssinia'; ER to HB 5 and 19.11.35; the sixteenth SWE Annual Exhibition ran from 5.12.35 to 4.1.36; *Signature: A Quadrimestrial of Typography and Graphic Arts*, ed. Oliver Simon, no. 1, November 1935.

38 PA to ER 16.2.34; HB to ER 3.3.35; HB to ER 23.5.35; ER to HB 24.5.35; TG diary 18.8.35.

39 ER to HB 5.3.36; ER to HB 18.3.36; Ullmann, 2012, p. 185.

Chapter 6

1 ER to HB 9.12.35, ESRO: 'I shall of course kill the fatted calf and may even give him my firework poster for a Christmas card. This is not because I have a nice nature at all, but simply because I can't keep up a resentment for long.'

2 ER to HB 18.9.36, ESRO. As frequent exhibition-goers, they were probably very familiar with Seurat; that autumn *The Channel at Gravelines, Evening*, Seurat's last landscape, hung as no. 123 in the exhibition entitled 'Masters of French Nineteenth Century Painting' at the New Burlington Galleries, Piccadilly. Ten years earlier, two of its companions *The Channel of Gravelines, Petit Fort Philippe* and *The Channel of Gravelines, Grand Fort Philippe* were at Alexander Reid & Lefevre in an exhibition that had introduced Seurat to the post-war generation. Then in the early months of 1932, *Petit Fort Philippe* reappeared as *Le Port de Gravelines* in the exhibition of French art held at Burlington House.

3 There is no record of a dredger or any other vessel called *The James* entering Newhaven harbour. However, *The Foremost Prince*, built on the Clyde in 1933, was stationed at Newhaven from 24.3.34 in the ownership of the James Contracting and Dredging Company; it survived the war and after service in Singapore and New Zealand was broken up in Yugoslavia in 1981.

4 Adrian Bury, 'Watercolour Painting Today', *Studio*, 1937, fig. 193; purchased by T. Balston from Zwemmer's in 1936, it remains untraced and was not among the paintings he left to public collections on his death.

5 Exhibited at the Leicester Galleries it was reproduced in *The Listener*, 9.11.32.

6 *The Scotsman*, 16.4.34, p. 16.

7 ER to HB 9.5.35.

8 ER to HB 11.4.35.

9 ER to HB 8.7.35; TG diary 7.7.35.

10 See Part IV of Thomas Hennell, *The Witnesses*, Peter Davies, London, 1938.

11 ER to HB 24.7.35; ER to HB 12.8.35.

12 TH to ER n.d.

13 ER to HB 9.12.36.

14 Thomas Hennell, *Poems*, Oxford University Press, 1936; *A Cross to Airmen* was first published in Martin Armstrong, *Fifty-Four Conceits*, Martin Secker, 1933.

15 TH to TG 9.2.40.

16 ER to HB 24.5.35; TG diary 3.8.35.

17 PA to ER 26.8.36; ER to PA 27.8.36.

18 Interview with Major Gooden, the sculptor's son, May 2007; the hut had been purchased at Portsmouth by his mother in the 1920s and relocated to the beach for use as a holiday home.

19 ER to HB 23.8.35.

20 ER to HB 5.8.35.

21 The SS *Rouen* was built in 1912 at Le Havre at the Société Nouvelle des Forges et Chantiers de la Mediterranée shipyard. Originally coal fired, by 1935 it had been converted to oil, its open promenade decks had been plated in, and a single slanted oval funnel had replaced its original double funnels. This gave it a distinctive profile very similar to that of the SS *Worthing* – also used on the Dieppe service, but not on the night service during these weeks – and one quite distinct from the SS *Newhaven*, the other ship then on nights. It sailed for France shortly after 10 p.m. on the Wednesday, Friday and Sunday nights during the first week of the stay.

22 EB to PA 22.6.35; the more precise title of the painting previously owned by PA is *Newhaven 19th September, 8.30*.

23 ER to HB 17 and 21.9.35.

24 ER to HB 9.2.36, ESRO; Ullmann, 2012, p. 201; TG diary 14.9.35.

25 ER to HB 3.10.35 and 13.12.35.

26 HB to ER 25.2.36.

27 Nicholas Davenport to PA 17.9.35; HB to ER 6.11.35; ER to HB 7.11.35; HB to ER 24.2.36, ESRO; see *Memoirs of a City Radical*, Nicholas Davenport, Weidenfeld & Nicolson, London 1974, p. 81, for purchase of Hinton Manor; Davenport was a friend of Labour MP

John Wilmot, Horace's brother, who famously won Fulham in a by-election in October 1933; Wilmot had also recommended PA to the WTA.

28 Jonathan Mayne, *Barnett Freedman*, English Masters of the Black-and-White, Art and Technics, 1948, p. 9.

29 *Signature 2*.

30 Ian Rogerson, 'Barnett Freedman, Master Lithographer', in *Barnett Freedman – The Graphic Art*, Fleece Press, 2006, p. 209.

31 Desmond Flower, 'Auto-Lithography', *Curwen Press Newsletter 10*, July 1935.

32 ER to HB 19.5.35; Stephen Tallents to BF 25.7.34, MMULSC.

33 WR to BF 24.4.35, MMULSC.

34 ER to HB 30.5.36, ESRO; TG's diary indicates ER dined with Simon on 19.3.36 having told HB it was to talk about lithography.

35 RW to ER 2.7.35; ER to HB 8.7.35, ESRO; Ambrose Heath, *Good Food*, Faber & Faber, 1932, p. 57.

36 ER to HB 12.8.36; Harold Curwen to ER 25.8.36.

37 ER to HB 7.10.36.

38 For many years it functioned as a roundel in a door light at Underhill Farm, the Tuely home where Eric, Tirzah and John stayed at Christmas 1936; Stephen Tallents to ER 24.9.37 proposed several ideas including a well-grown cricket bat willow, a weeping willow and a mulberry tree as subjects for a directly commissioned Christmas Card, but ER had *Grapehouse* to hand.

39 Alan Powers, *Eric Ravilious: The Story of High Street*, Mainstone Press, 2008, p. 139; the volume cited incorporated verses by E. V. Lucas and illustrations by Francis Donkin Bedford.

40 ER to HB 19 and 27.11.35.

41 ER to HB 9.7.36, 11.7.36 and 25.7.36; HB to ER 24 and 27.7.36.

42 RG to ER 20.11.36.

43 HB to ER 31.12.36; there is also a marginal PS: 'You would have done it if you hadn't been in love with me, wouldn't you?'

44 See, for example, ER to HB 17.1.37; 19.1.37; 20.2.37; 25.2.37; 26.2.37; 30.3.37; and HB to ER 11.1.37; 18.1.37; 19.1.37.

45 ER to HB 27.3.37.

46 HB to ER 21.5.38; ER to HB 2.6.38.

47 HB to ER 2.11.38.

48 Ullmann, 2012, p. 194.

49 HB to ER 11.5.36; ER to HB 12.5.36.

50 ER to HB 30.5.36.

51 HB to ER 4.6.36.

52 ER to HB 14.6.36.

53 ER to HB 19.11.36; ER to HB 24.3.36, ESRO. Although written immediately prior to the first break with Helen, this phrase seems to encapsulate ER's attitude to his marriage at the time of their affair.

54 HB to JN 6.4.38, TGA.

55 HB to ER 20.4.37.

Chapter 7

1 Department of Overseas Trade to ER 23.1.37.

2 ER to HB 24.9.36 and 20.11.36, ESRO.

3 Piers Brendon, *The Dark Valley*, Jonathan Cape, 2000, p. 493.

4 Binyon, 1983, p. 96.

5 HB to ER 12.2.36: 'they all go to an evening class at the Newcastle School of Art – run by Lyon who has come up too, and has arranged for Halliday to come and help too, it may be fun, I expect the miners will be charming'. The programme included a visit to Laurence Binyon's Chinese exhibition at the RA and lunch at the Tate; Kingsley Martin, *Editor: A Volume of Autobiography 1931-1945*, Hutchinson, 1968, pp. 209-10.

6 At about 16:30 on Monday, 26 April 1937, warplanes of the German Condor Legion, commanded by Colonel Wolfram von Richthofen, bombed Guernica for about two hours. Germany had lent material support to the Nationalists and Hitler was using the war as an opportunity to test out new weapons and tactics.

7 Undated press cutting *Art at the Paris Exhibition*, inserted in author's copy of *Guide to the British Pavilion*.

8 *The Studio*, June 1937, p. 333.

9 WR to BF 7.12.38, MMULSC; William Rothenstein, *Since Fifty: Men & Memories, Volume 3*, Faber & Faber, 1939, pp. 236-37.

10 DPB to CDK n.d. but 1928 as the letter refers to publication of *History of Wood Engraving* that year.

11 ER to CDK 24.4.27, TGA 8424.76; CDK to ER 1 and 5.5.27; Ravilious's original pencil-written note of his Horsham dream is now TGA 8424.77, perhaps attached by HB to ER's letter to CDK and returned to CDK when HB was researching her book, and thence to Tate Archives when CDK's papers were deposited. In her second letter CDK undertook not to publish 'A Dream of Ravilious' in the second *Mandrake* she edited.

12 ER to EB 13.8.30; Ullmann, 2008, p. 93n; Greenwood, 2008, p. 284.

13 ER to CDK 29.9.30, TGA 8424.95.

14 EB to CDK 28.2.34, TGA 8424.7.

15 CDK to EB 12.4.34; EB to CDK 27.5.34, TGA 8424.11.

16 ER to CDK 30.6.34, TGA 8424.91.

17 EB to CDK 12.9.34, TGA 8424.12.

18 ER to CDK 26.1.35, TGA 8424.78.

19 WR to CDK 26.6.38, TGA 8424.108.

20 'Cecilia Sempill, Dunbar Hay: Notes for a Lecture', ed. Alan Powers, *Decorative Arts Society Journal*, no. 27, 2003, pp. 56–57.

21 ER to HB 6.10.35; 21.10.35; 23.10.35; 27.1.36.

22 ER to HB 19.11.36.

23 ER to HB 8.10.36.

24 ER to HB 10.12.35.

25 *The Studio*, April 1937, p. 211, reviewed, in the course of an article on 'The New Glassware', two ER sand-blasted panels for Eaton, Parr and Gibson Ltd.

26 *Room and Book*, p. 17; PN was quoting John Rogers's article 'The Real English Tradition', *Architectural Review*, November, 1931.

27 ER to HB 11, 15 and 16.12.35; ER to CDK 19.11.35, TGA 8424.39; TG had a meeting with CDK in London on 25.10.35, which was probably the inception of this activity. ER to CDK, 26.1.35, TGA 8424.78, discusses production of furniture further and 24.3.36, TGA 8424.94, the design of seat covers for Bowker.

28 ER to CDK 24.3.36, TGA 8424.94; in a letter ascribed to 7.4.35 in Ullmann, 2008, p. 194, referring to Harris's fee of fifteen guineas for a first-class job, Ravilious states 'I am longing to see

your shop when it comes along'; this was surely written in April 1936.

29 ER to HB 4.6.36; Ralph Edwards, 'Modern Furniture', *Country Life Supplement*, 10.10.36, pp. 36–37.

30 In Robert Harling's 'Eric Ravilious – A Memoir', in Richard Dennis (ed.), *Ravilious & Wedgwood*, Dalrymple Press, 1986, p. 9, Harling refers to having bought Ravilious paintings since the artist's 'first exhibition at Zwemmer's' and to the artist's 'second exhibition ... at Tooth's'; however, Harling did possess *Shepherd's Cottage* sold at the 1936 exhibition as well as others; the provenance of other paintings forming part of the Harling estate suggests he was not a purchaser in 1933.

31 Harling, 'A Memoir', p. 10; Robert Harling to ER 30.8.37, ESRO; Robert Harling, *Engravings by Eric Ravilious*, Shenval Press, 1946.

32 Noel Carrington's account of his extended dialogue with Josiah Wedgwood concerning the deficiency of the company's modern designs and his suggestion that Ravilious be employed, cited in Powers, 2013, was broadcast in 'An Artist Who Saw Life Whole', *London Calling*, no. 309, BBC Overseas Service, September 1945. Carrington had met Wedgwood at the British Industries Fair in February 1936.

33 ER to HB 19.11.36: 'this morning I have been drawing quilts and have put Marx into the foreground, which she may mind a little having quarrelled with the Little Gallery. It shall be a riot of patterns up to the ceiling.'

34 Enid Marx wrote (with her inimitable spelling) to Anne and Louis Ullmann in 1991: 'Paul Nash was the magnet that drew us together at the RCA, Cecilia Semphill was the amalgam after we left the RCA and we designed for her shop, also Muriel Rose and the Little Gallery, but Cecilia was one of us so the relationship was closer', Ullmann, 2008, p. 29.

35 Ian Kemp, *Tippett – The Composer and his Music*, Eulenburg, 1984, p. 36.

36 EM to Frank Pick 25.10.37, quoted in Cynthia Weaver, 'Enid Marx: Designing Fabrics for the LPTB in the 1930s', *Journal of Design History*, vol. 2.1, 1989.

37 EM to Anne Ullmann 20.10.92 in a letter (Private Collection), enclosing EM's sketch recreating the creamware designs that enthused ER.

38 Although Binyon, 1983, p. 86, states ER was summoned to a meeting with Wedgwood in 1935, the correspondence record suggests it was the following year, ER to HB 18.5.36, ESRO, being the first reference. Albert Rutherston had been keen to involve ER and Bawden in a collective project with the Foley China Works the previous year, but this was a much more substantial proposition, AR to ER 26.7.34, Ullmann, 2008, p. 148.

39 Alison Kelly, *The Story of Wedgwood*, Faber & Faber, 1975, p. 62.

40 ER to HB 23.8.36 and 9.10.36, ESRO.

41 Susan Williams, *The People's King*, Allen Lane, 2003, p. 111.

42 EB to ER 14.1.37, ESRO.

43 An acknowledgment of the gift on file in ESRO is dated 9.4.37; TG diary noted on 11.8.37 receipt of '£50 for Paris Exhibition. Eric says Peter Flood bought some of my marbled paper for V&A Museum.'

44 TG diaries 15–19.10.37.

45 *The Times*, 23.2.38, p. 19; Tom Wedgwood to ER quoted in Binyon, 1983, p. 89; *Studio* advertisement August 1939.

46 HB to ER 15.4.37 reports the Dunbar Hay window 'tastefully arranged to match your red and green mug'.

47 Noel Carrington to ER 26.2.36, ESRO; EB to CDK, TGA 8424.23.

48 ER to CDK n.d., TGA 8424.85.

49 ER to CDK 26.10.38, TGA 8424.83.

Chapter 8

1 ER to DT 28.9.38.

2 JN to CN dated 'Monday Night', TGA 6910.8.2.401.

3 Von Rath died of his wounds on 9 November, the anniversary of Hitler's failed 1923 putsch; that night an estimated 7,500 Jewish-owned businesses and numerous synagogues were destroyed in Germany and Austria amid great loss of life; in

Vienna alone 680 Jews committed suicide in the following four days.

4 *Bristol Evening News* 10.11.38, p. 1; ER to DT 20.11.38.

5 The Tooth's show ran for three weeks from 11.5.39 and featured twenty-seven watercolour drawings. Tooth's had written to ER on 29.7.37 to alert him to the fact that they were setting space aside for one-man shows. The gallery had also become Paul Nash's dealer. ER to DT 20.11.38.

6 J. Rothenstein, 1983, p. 109, refers to a letter from Bawden covering 'their first meeting at the Royal College of Art in 1934, their shared interests in flowers and gardening, their summer painting expeditions and their visits to one another's homes'; ER to HB 19.5.35.

7 John Nash was born on 11 April 1893; Paul Nash was nearly four years his senior, having been born on 11 May 1889; JN's view was included in his review of DPB's *History of Wood-Engraving*, published in the *London Mercury* in November 1928; for the definitive catalogue of JN's engraving see Greenwood, 1987.

8 J. Rothenstein, 1983, p. 27: 'Until the end of his life John Nash was exceptionally responsive to the attractions of women. For many his emotions were transitory. There were two however for whom they were enduring and intense. The first was Dora Carrington. The second was his wife.' For JN's relationship with both Christine Kuhlenthal and Dora Carrington, see Blythe, 1999.

9 BF to ER 7.7.36; ER to HB 10.5.36; J. Rothenstein, 1983, p. 15; PN to BF n.d. MMULSC BF archive.

10 Athole Hay to ER 27.7.37; *Daily Telegraph* 27.1.38; Hay's funeral service was attended among many others by Percy Horton, Barnett Freedman, William Rothenstein and his sons, Cecilia Dunbar Kilburn, Edward Rutherston, Martin Hardie, Gilbert Spencer and William Staite-Murray.

11 EM to BF 1.11.37, n.d. and 29.1.37 MMULSC BF archive; EB to James King 4.9.81, in King, 1987, p. 189.

12 Pilkington to ER 25.6.37 and 23.7.37; Harry Carter to ER 7.5.37; ER to HB 31.1.38.

13 JR to ER 8.9.37; ER to CDK 29.9.37, TGA 8424.95.

14 TG diaries record her visiting Tollesbury on 11.4.38; ER to HB 18.4.38 evidences he and Nash returning there to paint a week later; CN to TG n.d. from The Thatched Cottage, Wiston, Suffolk: 'Claudia and Vincent are at Barry's cottage, B for week-ends. Percy Horton also in residence and is now quite mad on fishing. He and J caught 9 perch between them'; ER to HB 10.2.37 and 30.3.37.

15 J. Rothenstein, 1983, p. 24; Christopher Neve, *Unquiet Landscape: Places and Ideas in 20th Century English Painting*, Faber & Faber, 1990, p. 42; Blythe, 1999, p. 66.

16 ER to DT 1.5.38; ER to HB 24.12.36.

17 The former owner of Knoll House nursery believes the greenhouses depicted by ER were constructed in 1929; they were destroyed in the great storm of 1987 after which the business closed, letter to author from former proprietor, 8.7.2007; ER to DT 1.6.38: 'Now there is the pottery design to finish and today has been a good start for the month and two small drawings finished, your wood-chopper and the tree trunk will look well I think. It is a finicky job but I like it'; this activity continues in Essex with ER to DT 13.6.38 describing ER collecting material for a gardener's jug at the back of The Bell pub.

18 TG's autobiography (Ullmann, 2012) infers ER began working at Rye Harbour in May; but the phraseology of ER to DT 23.8.38 suggests Diana introduced him to the place in May, and he began substantively working there in August; the fact that in May Clissold objected to the resumption of Eric and Diana's affair, when Eric was clearly working at Wittersham and Underhill Farm, was also probably relevant to his decision to stay at the harbour for the second visit.

19 EB to ER 13.1.37: 'It would be fun if we could all go to Bath sometime later in the year – for perhaps a week ... Let me know when you will be at Castle Hedingham again: I would very much like to see you'; EB to ER 16.9.37; ER to DT and CT 25.12.37.

20 TG to DT 20.4.36: 'That's lovely about the picture – I hope you won't stop working because of being married. I always regret I stopped working because it is difficult with a house to think about'; this exaggerates the degree to which TG had stopped working but gives an interesting insight into her perception of her own situation; see *Studio*, 'How Textiles are Made', February 1937, p. 89; ER to DT 30.3.35. 'I've written him a letter to tell him how good your pictures are and that he ought to go and see them and I've said you'll be in touch with him so don't leave it too long. Galleries are things that get booked up for years ahead'; ER to DT 1.6.38.

21 Ullmann, 2012, p. 204.

22 Eric visited the Tuelys in Hampshire on the third weekend of March 1936 while Tirzah, who originally planned to go, stayed in Eastbourne to look after a poorly baby, John; at Eric's prompting the party visited both the vicarage and Gilbert White's House at Selborne and later, in June 1937, after having spent the previous Christmas at Underhill Farm, ER was keen for Clissold to know about the Nonesuch's offer to illustrate White's book; writing to Diana in August 1937, 'if I go down to Eastbourne this holiday I'll ring you up if I can, come and see you and the family – love to Clissold'. For CT's reaction to the affair see in particular ER to DT 1.6.38 and 3.9.38.

23 ER to DT 3.9.38.

24 For CN's support of JN see J. Rothenstein, 1983, p. 53: 'In the early years of her marriage she felt frustrated by the difficulty of reconciling her desire to resume painting with her devotion to John, a demanding husband. But this quickly passed and she showed her devotion in every way. She withheld facts liable to disturb his peace of mind: assumed complete responsibility for his financial affairs, for his health (apart from the fact that like her he was a heavy smoker) and mended clothes. Moreover she chose precisely landscapes for him to represent, often going to explore some distant place in which he had expressed interest.'

NOTES

25 HB to JN 8.11.70, TGA 8910/1/2/242: 'I expect you saw in *The Times* that dear old Percy had died – isn't that sad? – it was so nice for us that he and Lydia had settled in Lewes and could get over here quite easily – he was such good company and I will miss his silly laugh and good stories – and in other days he was so very much part of our lives – Eric was so fond of him, and it was really at his cottage at Assington that you and I first met'; William Nash died on 13.11.35; John Ravilious had been born in June that year.

26 ER to HB 18.7.37, thence: HB to ER 7.1.38; ER to HB 8.1.38; JN to ER 6.3.38.

27 HB to CN 17.5.38.

28 HB to ER 21.5.38.

29 *The Times*, 23.6.38, p. 14.

30 See ER to HB 9.7.38: given that there were only 9,300 television sets in service in the UK by the end of 1938, it is not surprising that Eric did not see the broadcast – although if it had been repeated he had intended to see it at Halstead where he knew a family who had a set.

31 ER to DT 3.6.39.

32 This exhibition, subtitled 'Unity of Artists for Peace, Democracy and Cultural Development', was held at the Whitechapel Art Gallery between 9.2.39 and 3.7.39; Lynda Morris and Robert Radford, *The Story of the Artists International Association*, Museum of Modern Art, Oxford, 1983, p. 54, quote Nan Youngman's description: 'He was unemployed. We went up to him and said "Would you mind opening this exhibition?" "Oh", he said, "don't mind if I do". And he didn't pause, really, he just walked into the gallery and took a look around and got up on a chair and said, "I've got pleasure in declaring this exhibition a great and wonderful success", and got down and went off with the pound we paid him.'

33 HB to CN 22.11.38 and 1.8.39, TGA 8910: 8.2.22 and 8.2.26; JN to ER 20.1.40.

34 HB's works were for sale at 2 guineas and 1 guinea respectively; among 297 catalogued items were Peggy Angus (*Cabbages by Moonlight* 10

guineas, *Vegetarian Cookery* 4 guineas, *Sussex Harvest* 10 guineas), Edward Bawden (*Pains Hill, Finchingfield* 10 guineas) Paul Nash (*Metamorphosis* £85) John Nash (*In a Beech Wood* £57 15s) and Percy Horton (*Suffolk Cornfields* £31 10s).

35 HB to TG 1.9.38.

36 HB to ER 2.11.38 and 7.12.38.

37 The Brigade crossed from Dieppe to Newhaven, disembarking at 5 p.m. on 7.1.38. See Edwin Greening, *From Aberdare to Albacete*, Warren and Pell, 2006, p. 109.

38 ER to HB 12.8.36 and 23.8.36 ; the AIA had formed the Peace Publicity Bureau in June 1936: see brochure *AIA: The First Five Years 1933–1938*, ESRO Percy Horton Archive; ER to HB 20.1.37.

39 ER to HB 24.1.37; John Strachey, *The Theory and Practice of Socialism* (November 1936); he was the most popular author published by the New Left Book Club. His books included *The Coming Struggle for Power* (September 1937), *What are We to Do?* (March 1938) and *Why You Should Be a Socialist* (May 1938). He was also a member of the Selection Committee – which included Victor Gollancz and Harold Laski; on the last day of 1936 HB finished reading *Spain in Revolt* by Harry Gannes and Theodore Repard, the Left Book Club offering for that month, and ten days later she told Eric that the January offering – Stephen Spender's *Forward from Liberalism* – had arrived and 'looks very good'.

40 ER to HB 7.12.36; AIA Bulletins January–April 1937, Percy Horton Archive, ESRO.

41 HB's contribution to the AIA 1937 Exhibition, which opened on 14 April, nine days before the three-day Congress, was her wood engraving *The Wire Fence*. In the room set aside for Surrealists, Paul Nash exhibited *Correlation*, *The Archer Overthrown* and *Event on the Downs*; next door John showed the oils *Hampden Common* and *Beech Trees in Winter*. Angus once again contributed a *Cement Works* and also *Near Cockermouth*. Horton contributed two oils, *Devonshire Landscape* and *Little Cornard, Suffolk*, and a watercolour *The Rhubarb Bed*.

Bawden had work in the display of peace publicity issued by the Peace Publicity Bureau, which occupied a separate room, and also exhibited a recently completed watercolour. Helen intended to visit the separate Handicrafts Exhibition, having heard it was 'beautifully arranged by Edward'; on 20.4.37 (in the final extant letter before the end of their affair) ER wrote to HB: 'Tirzah will be coming up on Friday but I don't know about the dance. I don't much want to go again besides there are all the Congress meetings and we do want to get to one or two if we can.' ER and TG had been to a previous AIA dance, referred to in ER to HB 15.4.37.

42 Others among the 121 participating artists included Edward Bawden ('a house, 10 gns'), Cyril Mahoney ('a house, 10gns'), Peggy Angus ('sitter with cat, 6 gns'), Percy Horton ('drawing, 5gns') as well as Jacob Epstein ('25 gns'), Mark Gertler ('50gns'), Henry Moore ('10gns') and Viscount Hastings ('head and shoulders, 60 gns; full length 100gns') – but it was Augustus John who secured the biggest donation for a 'head and shoulders, 500gns'. The original funds had been raised at an auction. Ravilious painted Lord Farringdon's house, netting £10 guineas for the fund, and in early July was able to write to Helen telling her 'The country house for the AI is painted and approved.' Elizabeth Watson, AIA Secretary, to BF 28.1.37, MMULSC BF archive, enclosed a drawing by Felicia Browne, the first AIA member killed in Spain, as a token of the Committee's gratitude.

43 Percy Horton Archive, ESRO. The AIA First Five Years 1934–38; ER to DT 31.3.39; 20.4.39; 27.4.39; 8.5.39; 16.5.39; Stephen Tallents to BF 16.7.36, 24.11.36, 4.7.36. MMULSC BF archive.

44 The promotional opened 'AIA Everyman Prints are intended for every home. To-day, thanks to cheap production of books and gramophone records, everyone can cultivate a personal taste in what they read and the music they hear. Everyman Prints now widen the range from which the visual taste can be gratified, by

NOTES

324

offering the direct work of living artists at a price so reasonable that the outlay need not involve anxious consideration, and the collecting of prints is now within the possibilities of every purse. *Everyman Prints are not reproductions.* In each case the artist has drawn on the metal plate from which are pulled, the prints exhibited for sale. The life of a plate is limited; at the first sign of wear the edition will be closed. The Everyman Print owner, therefore need not fear that his chosen prints will be on every wall; his collection, whether framed or in portfolio, will represent his own selection.' Quoted in Morris and Radford, *The Story of the Artists International Association*, p. 56.

45 ER to HB 19.11.39.

46 ER to HB 23.7.35.

47 ER to DT 16.5.39 and 3.6.39: 'Eddie Marsh has bought two, which pleased me a lot. And Le Bas has the Rye picture you liked, and the V&A the double bed'; ER had previously told DT that Horace Wilmot (Harold's brother) had bought 'B Head at night'.

48 Jan Gordon, 'Influences and Fusion', the *Observer*, 14.5.39, p. 14.

49 Eric Newton's review in *The Sunday Times* was reprinted in Eric Newton, *In My View*, Longmans, 1950, p. 108.

50 ER to DT 2.1.39; on 18.12.39 ER had written to DT 'Snow is on the way and John is promised a large snow man on the lawn when it comes. He is excited about Christmas and talks of nothing else.'

51 CN to ER n.d., but probably summer 1939.

52 ER to DT 23.8.39: James Ravilious, 'a boy fair hair and blue eyes 7lbs 15oz', was born at 10 p.m. on 22.8.39.

53 Berthoud, 1987, pp. 155–6; the Hornton stone figure Chermayeff commissioned was delivered, but not fully paid for, in September 1938. It had been purchased by Kenneth Clark on behalf of the Contemporary Art Society and, after Chermayeff had returned £100 to Moore, the figure was presented to the Tate Trustees earlier that summer, who promptly sent it for display to New York, where it was trapped at the outbreak of war.

54 JN to ER 27.10.39.

55 ER to Lt. Col. Garwood 29.10.39.

56 JN to ER 27.10.39.

57 R. Gleadowe to ER 23.12.39.

Chapter 9

1 Paul Nash, 'Letter from Oxford', *The Listener*, 30.11.39, p. 1,065.

2 Kenneth Clark, 'The Artist in Wartime', *The Listener*, 26.10.39, p. 810; Kenneth Clark, *The Other Half*, John Murray, 1977, p. 22.

3 ER to TG 3.9.39; ER to DT 3.9.39; ER to CDK 23.10.39, TGA 8424.87; EB to ER 9.9.39; for Zurich see MacLeod, 1988, p. 75.

4 ER to TG 15 and 17.4.40, written from Grimsby when TG was sorting out ER's tax return, gives details including £170 from paintings sold at Tooth's, £125 from overseas trade for the NYC map, other commercial jobs £40, while Wedgwood provided approx. £145 that year; ER to CDK 16.11.39, TGA 8424.88.

5 Noel Carrington had been offered this role by Allen Lane at a Double Crown Club meeting; he had probably seen the completed *Wilmington Giant* prior to making the suggestion; ER had originally hoped that DT would accompany him to Dorset, see ER to DT 3.9.39 and 23.12.39; the expedition led to completion of four paintings remarkable for their power and diversity, but the book never progressed beyond a very preliminary dummy; EB to TG 29.12.39; the WAAC had written to EB on 27.12.39, but on 11.12.39 the Home Office had offered him a position as camouflage officer in the Civil Defence Camouflage Establishment at Leamington Spa at £400 per annum, and on 22.12.39 it wrote requesting him to report for duty on 1.1.40; on 30.12.39 his withdrawal from the appointment was acknowledged, Higgins Archive.

6 PN to EMO'RD 18.11.40, WAAC archive.

7 JN to ER 20.1.40; ER had previously lunched with JN and HB on his way to Weymouth, ER to CN 11.12.39; ER to HB 27.1.40.

8 ER to DT 14.1.40; ER to DT 12.1.40; in Genesis 19 Lot's wife looked back and became a pillar of salt fleeing Sodom's impending destruction, perhaps not really an apposite comparison for ER to make.

9 ER to TG 15.4.40.

10 ER to HB 28.2.40.

11 Being the work of this phase closest to war art, as understood by his commanding officer, it was ironic that it attracted the censor's attention after despatch to the WAAC.

12 ER to HB 28.2.40.

13 EM to Anne Ullmann and Louis Ullmann 31.12.91. Private Collection.

14 JN to ER 28.4.40; Ullmann, 2002, p. 85.

15 Bertram, 1955, p. 250.

16 J. Rothenstein, 1952, pp. 134–35.

17 ER arrived in Grimsby on 8.4.40 and, apart from a side trip to see his sister Evelyn at Oldham on his second weekend there, remained in Grimsby until at least 26.4.40; ER to TG 9 to 23.4.40.

18 *Grimsby Trawlers* is in the Potteries Museum and Art Galleries Collection; ninety-six WAAC pictures were lost as a result of a torpedo sinking in August 1942, a few weeks before ER left for Iceland.

19 JN to ER 20.1.40. After sailing from Hull, HMS *Highlander* escorted the battlecruiser HMS *Renown* to Scapa Flow and arrived there on 24.5.40; *Highlander* was an H-Class Fleet Destroyer ordered in 1938 by the Brazilian Navy from Thornycroft and Company of Woolston, Hampshire, requisitioned by the Admiralty after launch in October 1939, but only commissioned on 18.3.40, thus ER found the ship 'bright as a new pin'.

20 Providing notes on his career to Richard Seddon in early 1942, ER included 'Interest chiefly in the static (so they say!)', see Ullmann, 2002, p. 206; Eric Newton, 'Warpainters Again', *The Sunday Times*, 11.8.40, noted JN's pictures were like ER's in having 'the same hard dryness and insistence on meticulous detail, but the nightmare is not there'; Ravilious, Ardizzone, Anthony Gross and 'to a less extent Eric Kennington' were commended by Newton as 'the only artists who have produced war pictures'.

21 Clark went on to say that the two friends' work had 'a personal lyrical quality of more value than generalised heroics' in 'War Artists at the National Gallery', *The Studio*, January 1942, pp. 5–6 ; ER to HB 19.6.40; on 6.6.40 Colin Coote wrote to EB from the War Office, 'it is still uncertain when or where official war artists can be further employed', and the following day 'I have now discovered that it will be possible to send an artist to the Near East', EB correspondence files, Higgins Archive.

22 ER to EMO'RD 5.7.40: 'I had a feeling there were too many and one or two people said so, frankly or tactfully according to their nature: so if you can and would like to replace some of those drawings for the new ones that may come along I shall feel better about it', quoted in Ullmann, 2002, p. 103.

23 TH to GLT 10.7.40 and 31.10.40, TGA 9512.2.18 and 19.

24 Miles was born by 6.3.40; CT quoted in Ullmann, 2008, p. 104; I. M. Drummonck to PA 3.6.40 while PA was working in Chichester for the LCC Government Evacuation Teachers Scheme.

25 ER to HB 29.10.40; ER to TG 8.7.40.

26 The WAAC first discussed ER's proposition that he work on lithographs at a meeting on 31.1.40 but suggested returning to it 'when the time is ripe', EMO'RD to ER 1.2.40, IWM; ER to HB 23.12. 40; ER to DT 1.4.41.

27 *Report of an incident on night of 15 October 1940 at 19.45 hours*, No. 3 ARP Post Kennington, typescript in Morley College Archive; Eva Hubback to ER 5.11.40.

28 TG to Col. Garwood 10.10.40, Ullmann, 2002, p. 129; prior to Dover, ER spent much of April painting a series of underground control rooms in London for a separate Ministry of Home Security commission worth £54.

29 Jan Gordon, 'Art and Artists', the *Observer*, 1.2.42, p. 7.

30 ER to HB 20.7.41.

31 Cyril Connolly, *Enemies of Promise*, Routledge, 1938, p. 153; ER to HB 29.10.40.

32 ER to TG 20.10.41 refers to a fifty-sheet sale-or-return order from Dunn's of Bromley, suggesting she charge 2s 6d a sheet, 'which seems a reasonable wartime addition'; Dunn and Sons to TG 5.11.41.

33 ER to TG 10.4.40; ER to HB 11.4.41; ER to TG 27.7.41: 'My father writes that already he is back with Frank and talks of going either to Evelyn or Eastbourne again ... Poor old man there is never any room for him in the West country.' Eric's father stayed at Shalford that September and October.

34 ER to HB 11 and 30.4.41; ER to DT 1.5.41; the rent for Ironbridge Farm was £70 per annum plus £70-worth of ER pictures.

35 DT to ER 14.8.41.

36 CN diary quoted in Ullmann, 2002, p. 184; ER to TG 20.10.41; ER to HB 3.12.41 and subsequently 24.12.41, which recounted 'that flight wasn't altogether a success as I couldn't get the hatch open properly and nor could the pilot. The inside of the fuselage got fearfully hot and oily therefore and I'd come up prepared for December winds. However I managed to draw from the side window. I opened my parachute by mistake it is an easy thing to do, but very disconcerting as there is so much silk and string in such a tangle.'

37 He left Crombie Point on Monday 15.12.41, Ullmann, 2002, p. 200; ER to Dickey 11.12.41 quoted in Ullmann, 2002, p. 198; PN to JN quoted in Bertram, 1955, p. 256.

38 P. Nash, 'The Personality of Planes', *Vogue*, March 1942; ER to HB 8.6.42; he drew the Blackburn monoplane on 5.10.15.

39 Binyon, 1983, p. 127, misdates PN's approach to 1939–40; Ullmann, 2002, p. 216, sequences the undated letter as early 1942; PN's forward reference to 'the spring' and to his recovery from bronchitis makes February 1942 the most likely date.

40 ER to HB 18.1.42; ER to PA 26.1.42 in Ullmann, 2002, p. 209.

41 Rich, 1917, Chapter XIII; each stage is the subject of a separate colour plate.

42 ER to TG 9.5.42; ER to HB 12.7.42; Binyon, 1983, p. 136.

43 Ullmann, 2012, p. 238.

44 TG to Strachey 18.3.42; the letter, possibly a draft or possibly never sent, is headed W. J. Courtauld Hospital Braintree.

45 ER to HB 13 and 27.3.41; TH to TG 17.8.41; ER to TG 9.5.42.

46 ER to HB 12.7.42; see correspondence in MMULSC BF archives from Henry Moore, n.d., Kenneth and Jane Clark, 12.8.40.

47 ER to TG 4 and 13.8.42; CN to TG 5.8.42; Binyon, 1983, p. 137, misinterprets the incident as occurring while ER was on his way to the dinner for EMO'RD.

48 Ullmann, 2012, p. 244.

49 Richards, 1980, p. 106; Richard Seddon, *The Artist*, vol. XXV, March–August 1943, pp. 13–14; Harling in Batkin and Dalrymple, 1986 and 1995, p. 8.

50 TNA AIR 28/408 SHQ Kaldadarnes Operations Record Book records his arrival; a road journey is indicated because there were no flights from Reykjavík to Kaldadarnes that day; the flight from Prestwick had been delayed by a day after ER wrote to TG on 26.8.42 expecting 'to go tomorrow'.

51 CN to TG 1.9.42; the news also prompted Tirzah's Aunt Edith to ring up to assure her that Eric had stayed with her in Kensington, London, on the night in question, Ullmann, 2012, p. 245; TNA AIR 27/1566, sheet 56, Detail of Work Carried Out 1.9.42 by No. 269 Squadron, RAF, Kaldadarnes.

52 I am deeply indebted to Carol Lockwood for sharing her father's story with me.

53 Group Captain Hugh Eccles, who served at Kaldadarnes (but was not there at the beginning of September 1942), has commented in a 2008 letter to the author: 'the refurbished Officers Mess at RAF Kaldadarnes (a fairly primitive wooden farmhouse with a corrugated iron roof and Nissen huts attached) was mostly a DIY effort ... Knowing the intimate atmosphere of the farmhouse mess, with the bar as the only place to sit, I am sure Ravilious would have been made most welcome and, over a few drinks, been offered a flight the next morning ... In those days the Captain of the aircraft could, without reference to higher

NOTES

authority, take with him anyone of military rank, provided he told the Ops. Room before take-off or made a record in the flight authorisation Book.'

Aftermath

1 DT to TG 10.9.42; ER to TG 30.8.42.
2 EB to TG 17.3.43. Edward died in 1989.
3 EB to John Rothenstein 24.4.79, quoted in J. Rothenstein, 1983, p. 83: 'on five occasions we shared a painting expedition in Wales on the Gower Peninsula and again near Haverfordwest at Littlehaven; in Cornwall during a cold wet spell of misery in the De Lank Quarry at Blisland; at Dunwich in Suffolk and in Shropshire at Ironbridge.' John Nash died in 1977.
4 TH to TG 15.9.42; Thomas Hennell, 'War Artist in Iceland', *The Geographic Magazine*, August 1945, pp. 144–54; Edward Bawden also published an extensive two-part account of his experiences in the Middle East in *The Geographic Magazine* in 1945: 'The Marsh Arabs of Iraq' appeared in the January issue, pp. 382–93, and 'An Arabian Journey' in the May issue, pp. 16–23.
5 Barnett Freedman, 'Looking at Submariners', *The Listener*, Issue 860, 5.7.45, p. 7.
6 Horton died in 1970 and Bliss in 1984.
7 Cecilia died in 1984.
8 DT to TG 29.12.41. Diana died in 1975.
9 Helen died in 1979.
10 Cook, 1990, pp. 8–9.
11 TG broadcasting as Mrs Henry Swanzy, BBC Third Programme, 20.1.48, text printed as 'In Memoriam', Tirzah Ravilious, in *Cockalorum*, The Golden Cockerel Press, 1950, pp. 79–81.

Bibliography

Batkin and Dalrymple, 1986 & 1995
Maureen Batkin and Robert Dalrymple, *Ravilious & Wedgwood: The Complete Wedgwood Designs of Eric Ravilious*, Dalrymple Press, 1986 / Richard Dennis, 1995

Berthoud, 1987
Roger Berthoud, *The Life of Henry Moore*, Faber & Faber, 1987

Bertram, 1955
Anthony Bertram, *Paul Nash: The Portrait of an Artist*, Faber & Faber, 1955

Binyon, 1983
Helen Binyon, *Eric Ravilious: Memoir of an Artist*, Lutterworth Press, 1983

Bliss, c. 1926
Douglas Percy Bliss, *Woodcuts or the Practice of Engraving and Cutting upon Wood*, Dryad Handicrafts, Leicester, c. 1926

Bliss, 1928a
Douglas Percy Bliss, *A History of Wood-Engraving*, J.M. Dent, 1928

Bliss, 1928b
Douglas Percy Bliss, 'The Work of Eric Ravilious', *Artwork*, Spring 1928

Bliss, 1933
Douglas Percy Bliss, 'The Wood Engravings of Eric Ravilious', *Penrose Annual: Review of the Graphic Arts, vol. XXXV*, Lund Humphries, 1933

Bliss, post-1946
Douglas Percy Bliss, *Wood-Engraving (Dryad leaflet no. 146)*, Dryad Handicrafts, Leicester, post-1946

Bliss, 1979
Douglas Percy Bliss, *Edward Bawden*, Pendomer Press, Godalming, 1979

Blythe, 1999
Ronald Blythe, *First Friends*, Viking, 1999

Causey, 1980
Andrew Causey, *Paul Nash*, Oxford University Press, 1980

Causey, 1990
Andrew Causey (ed.), *Poet and Painter: Letters between Gordon Bottomley and Paul Nash 1910–1946*, Redcliffe Press, 1990

Cook, 1990
Olive Cook, 'The Art of Tirzah Garwood', *Matrix 10*, Whittington Press, Andoversford, 1990

Cunliffe-Charlesworth, 1991
Hilary Cunliffe-Charlesworth, *The RCA: Its Influence on Education, Art and Design, 1900–1950*, MA thesis, Sheffield City Polytechnic, 1991

Greenwood, 1987
Jeremy Greenwood, *The Wood-Engravings of John Nash*, Wood Lea Press, Liverpool, 1987

Greenwood, 2008
Jeremy Greenwood, *Ravilious: Engravings*, Wood Lea Press, Woodbridge, 2008

Hatcher, 1995
John Hatcher, *Laurence Binyon: Poet, Scholar of East and West*, Clarendon Press, Oxford, 1995

King, 1987
James King, *Interior Landscapes: A life of Paul Nash*, Weidenfeld & Nicolson, 1987

MacLeod, 1988
Michael MacLeod, *Thomas Hennell – Countryman, Artist and Writer*, Cambridge University Press, 1988

Marx, 1985
Enid Marx, 'The Running Stationer or the Chapman's Wares', *Matrix 5*, Whittington Press, Andoversford, 1985

Marx, 1987
Enid Marx, 'The Little Gallery', *Matrix 7*, Whittington Press, Andoversford, 1987

Marx, 1993
Enid Marx, 'Recollections', *For Shop Use Only: Eric Ravilious, Curwen & Dent*, Garton & Co., Devizes, 1993

Marx, 1996
Enid Marx, 'Student Days at the RCA', *Matrix 16*, Whittington Press, Andoversford, 1996

Mayne, 1948
Jonathan Mayne, *Barnett Freedman*, Art and Technics, London, 1948

Nash, 1922
Paul Nash, *Places: 7 Prints Reproduced from Woodblocks, Designed and Engraved by Paul Nash*, Heinemann, 1922

Nash, 1924
Paul Nash, *Genesis: Twelve Woodcuts by Paul Nash with the First Chapter of Genesis in the Authorised Version*, Nonesuch Press, 1924

Nash, 1949
Paul Nash, *Outline: An Autobiography and Other Writings*, Faber & Faber, 1948

Powers, 2013
Alan Powers, *Eric Ravilious: Artist and Designer*, Lund Humphries, 2013

Rich, 1917
Alfred W. Rich, *Water Colour Painting*, The New Art Library, Seeley, Service & Co., London, 1917

Richards, 1980
J. M. Richards, *Memoirs of an Unjust Fella*, Weidenfeld and Nicolson, 1980

Rogerson, 2011
Ian Rogerson, *Tone, Texture, Light and Shade*, Fleece Press, 2011

Rose, 2002
June Rose, *Daemons and Angels: A Life of Jacob Epstein*, Constable / Carol & Graff, New York, 2002

Rothenstein J., 1952
John Rothenstein, *Modern English Painters: Sickert to Smith*, Eyre & Spottiswoode, 1952

Rothenstein J., 1974
John Rothenstein, *Modern English Painters*, MacDonald, 1974

Rothenstein J., 1983
John Rothenstein, *John Nash*, Macdonald & Co., 1983

Rothenstein W., 1934
William Rothenstein, *Men and Memories: 1900-1922*, vol. 2, Faber & Faber, 1934

Selborne, 1994
Joanna Selborne, 'Eric Ravilious and The Golden Cockerel Press: Correspondence with Robert Gibbings 1926-29', *Matrix 14*, Whittington Press, 1994

Selborne, 1996
Joanna Selborne, 'Eric and Tirzah Ravilious and The Golden Cockerel Press: Correspondence with Robert Gibbings [December 1926-February 1933]', *Matrix 16*, Whittington Press, 1996

Simon, 1973
Herbert Simon, *Song and Words: A History of the Curwen Press*, George Allen & Unwin, 1973

Speaight, 1962
Robert Speaight, *William Rothenstein: The Portrait of an Artist in his Time*, Eyre & Spottiswoode, 1962

Stevenson, 2008
Jane Stevenson, *Edward Burra*, Random House, 2008

SWE Minute Book
Committee Minutes, Society of Wood Engravers, Special Collections, Manchester Metropolitan University, July 1925

Towner, 1979
Donald Towner, *Recollections of a Landscape Painter and Pottery Collector*, Born-Hawes, New York, 1979

Trant, 2004
Carolyn Trant, *Art for Life: The Story of Peggy Angus*, Incline Press, Oldham, 2004

Ullmann, 2002
Anne Ullmann (ed.), *Ravilious at War*, Fleece Press, Upper Denby, 2002

Ullmann, 2008
Anne Ullmann, Christopher Whittick and Simon Lawrence (eds), *Eric Ravilious: Landscape, Letters & Design*, 2 vols, Fleece Press, Upper Denby, 2008

Ullmann, 2012
Anne Ullmann (ed.), *Tirzah Garwood: Long Live Great Bardfield & Love to You All*, Fleece Press, Upper Denby, 2012

Vaughan and Harrison, 2005
William Vaughan and Colin Harrison, *Samuel Palmer: Vision and Landscape*, British Museum, 2005

Acknowledgments

The project surrounding this book has generated its own pattern of friendship to which I am deeply indebted. Anne Ullmann has been a vital source of advice and generous encouragement during research into the lives and art of her parents, Tirzah Garwood and Eric Ravilious. Jeremy Greenwood and Christopher Whittick have devoted much care and attention to the emerging manuscript and their deft guidance has buoyed me over almost a decade. Alan Powers has a unique understanding of both Ravilious and the broader currents of English Modernism, and he instantly and generously agreed to contribute an introductory essay. Together with Sara Cooper, Head of Collections at the Towner Gallery, all of the above have also given freely of their time over several years as members of an advisory group to the exhibition that parallels publication of the book.

The process of research led me to approach many descendants and surviving friends and acquaintances of the men and women who feature in the narrative. Without fail, I have met with illuminating responses. I would like to particularly thank Richard and Hattie Bawden for their hospitality and early encouragement, and Peyton Skipwith and Victoria Partridge for their help in relation to Edward Bawden's work; Prudence Bliss for sharing her insights into the life and work of Phyllis Dodd and Douglas Percy Bliss; Ronnie Blythe for his memories of John Nash; Andrew Higgens for sharing his research into Helen Binyon's life and, together with his brother Jonathan, for help in accessing her work; Carol Lockwood for telling me about 'Ginge' Culver, her father; the late Ariel Crittall for her memories of 1942 at Ironbridge Farm; Eleanor Breuning, Matthew Eve and Katia Marsh for illuminating so much about the life and work of Enid Marx; Philippa Price and Miles Tuely for giving me access to the work of their mother Diana Low and shedding light on her story; Carolyn Trant for her encouragement and for her unique understanding of Peggy Angus; and Vincent Freedman for sharing memories and insights about his mother and father, Claudia Guercio and Barnett Freedman. My thanks also to Michael MacLeod and Jessica Kilburn whose knowledge of Thomas Hennell has been of great help, and to Betty Elzea who introduced me to them; to Cristina Toccafondi for her excellent Florentine detective work; and to Rosemary Poole for her research on Col. Garwood's diaries.

I also owe much to the many archive and library staff who have assisted me at the Tate Archives, the British Museum Printings and Drawings Room, the Higgins Gallery, the National Art Library, the British Library and East Sussex Records Office – their role, and that of the institutions they serve, is frequently undervalued but ever more vital for anyone wishing to explore our artistic heritage. I have received exceptional and invaluable assistance from Neil Parkinson at the Royal College of Art and Jeremy Parrett at the Manchester Metropolitan University Special Collections Library. My thanks also to Neil Jennings and Paul Liss for their support in tracking down work and their generous interest in both book and exhibition. Simon Lawrence at the Fleece Press has done much to illuminate the work of many of the principal artists who feature in the present volume; he is another friend to whom I want to extend a big thank you.

The Towner, Eastbourne, is the initiator of the eponymous Ravilious & Co. tour and without its commitment and expertise this book could not have been completed. My thanks to the Director Emma Morris, the Trustees and all the Towner staff. In particular I would like to thank Sara Cooper, co-curator of the exhibition, and her colleague Karen Taylor for all the many dimensions of their support; Svenja Gründler, Anna Winter and Tom Laver for sourcing the images; and Mark Heathcote for his photography.

The enthusiasm of Antonia Harrison at Compton Verney and Sian Brown at Museums Sheffield has been key to organizing the exhibition tour.

No author in the field of art history could hope for a better publisher than Thames & Hudson: my profound thanks to Roger Thorp for commissioning the book, to Sarah Hull, his assistant, in the early stages, to Lisa Ifsits for her beautiful design work and to Jen Moore whose deft judgment as Project Editor has skilfully brought this book to fruition in alliance with Paul Hammond as Production Controller. My thanks to them all, and to Richard Mason for his copy-editing.

Lastly I would like to express my deepest thanks to Jenny Keating for her tolerance, support, love and wisdom and to our children Robin, Lily and Rosa for their love and enthusiasm.

Image credits

The Towner Art Gallery would like to thank all those who have given permission for images to be reproduced and all those who have supplied images, including private collectors and sources who prefer to remain anonymous. Every effort has been made to trace copyright holders and to obtain permission for the use of copyright material; the publisher and the gallery would like to apologize for any unintentional errors or omissions to the list below and would like to be notified of any corrections that should be made in future reprints or editions.

0.1 Manchester Art Gallery, UK / Bridgeman Images; **1.3** Royal College of Art. © Panora Archive; **1.4** © Tate, London 2016; **1.5** Liss Llewellyn Fine Art. © Estate of Percy Horton (1897–1970); **1.6** (left) © Estate of Helen Binyon; (right) East Sussex Records Office. © Estate of Peggy Angus. All Rights Reserved, DACS 2016; **1.7** © Estate of Enid Marx; **1.8** © The Trustees of the British Museum; **1.10** © The Trustees of the British Museum; **1.11** © Estate of Enid Marx; **1.12** Trustees of the Cecil Higgins Art Gallery, Bedford (The Higgins, Bedford). © Estate of Edward Bawden; **1.13b** © Estate of Edward Bawden; **1.13c** © Prudence and Rosalind Bliss; **1.14** Towner Art Gallery, Eastbourne; **1.15** Manchester Museum & the Whitworth. © Estate of John Nash; **1.16** Pallant House Gallery, Chichester, UK; **1.18** Wood Lea Press; **1.19** © Estate of Enid Marx; **2.2** Towner Art Gallery, Eastbourne; **2.3** © Estate of Helen Binyon; **2.4** © Estate of Edward Bawden; **2.8** Fry Art Gallery © Estate of Edward Bawden; **2.9** Wood Lea Press. © Prudence and Rosalind Bliss; **2.11** © Tate, London 2016; **2.12** Amgueddfa Cymru – National Museum Wales; **2.13–15** © Estate of Tirzah Ravilious. All rights reserved, DACS 2016 **2.16** Wood Lea Press; **2.17** © Estate of Tirzah Ravilious. All rights reserved, DACS 2016; **2.18–21**

© Prudence and Rosalind Bliss; **3.1** © Estate of Edward Bawden; **3.2** Towner Art Gallery, Eastbourne; **3.3** © Estate of Edward Bawden; **3.4** East Sussex Records Office; **3.6** Royal College of Art; **3.7** Towner Art Gallery, Eastbourne. © Estate of Edward Bawden; **3.8** Fry Art Gallery. © Estate of Edward Bawden; **3.9** Trustees of the Cecil Higgins Art Gallery, Bedford (The Higgins, Bedford). © Estate of Edward Bawden; **3.10–11** © Estate of Helen Binyon; **3.12** (centre) © Estate of Enid Marx; **3.12** (right) © Estate of Barnett Freedman; **3.13** © Estate of Tirzah Ravilious. All rights reserved, DACS 2016; **3.14** East Sussex Records Office; **3.15** © Estate of Barnett Freedman; **3.16** © Estate of Edward Bawden; **3.17** © Estate of John Nash; **3.19–21** Wood Lea Press; **3.22** Fine Art Society; **3.23** Roe & Moore; **4.2** Towner Art Gallery, Eastbourne; **4.3** Wood Lea Press; **4.6–10** © Estate of Edward Bawden; **4.7** The Scarborough Collections courtesy of Scarborough Museums Trust; **4.12** © Estate of Tirzah Ravilious. All rights reserved, DACS 2016; **4.14** © Desmond Banks; **4.15** Wolverhampton Art Gallery. © Estate of Diana Low; **4.16** © Estate of Tirzah Ravilious. All rights reserved, DACS 2016; **4.17** Fry Art Gallery; **4.18** East Sussex Records Office. © Estate of Peggy Angus. All Rights Reserved, DACS 2016; **4.19** Fry Art Gallery; **4.20** Towner Art Gallery, Eastbourne; **4.21** Towner Art Gallery, Eastbourne; **5.1** Museums Sheffield; **5.2** © Estate of Peggy Angus. All Rights Reserved, DACS 2016; **5.3** Towner Art Gallery, Eastbourne; **5.4** Fry Art Gallery; **5.6** Tullie House Museum and Art Gallery Trust; **5.7–9** © Estate of Helen Binyon; **5.10** © Estate of Peggy Angus. All Rights Reserved, DACS 2016; **5.11–12** East Sussex Records Office. © Estate of Peggy Angus. All Rights Reserved, DACS 2016; **5.13–16** © Estate of Helen Binyon; **5.17** Towner Art Gallery, Eastbourne; **6.1** Towner Art Gallery, Eastbourne; **6.3** © Estate of Edward Bawden; **6.4** Towner Art Gallery, Eastbourne. © Estate of Edward Bawden; **6.6** © Tate, London 2016; **6.7–8** Wood Lea Press; **6.9** © Bethlem Museum of the Mind;

6.10 Towner Art Gallery, Eastbourne; **6.13** Fry Art Gallery; **6.16** © Estate of Edward Bawden; **6.17–19** © Estate of Barnett Freedman; **6.20** BFI National Archive; **6.21** Special Collections, The Manchester Metropolitan University. © Estate of Barnett Freedman; **6.23** Trustees of the Cecil Higgins Art Gallery, Bedford (The Higgins, Bedford). © Estate of Edward Bawden; **6.24** © Estate of Helen Binyon; **6.25** © Estate of John Nash; **6.26** Towner Art Gallery, Eastbourne; **6.27** Wood Lea Press; **7.1** © Norman Parkinson Ltd/courtesy Norman Parkinson Archive; **7.2** © Estate of Edward Bawden; **7.3** © Estate of Barnett Freedman; **7.4** © Estate of Tirzah Ravilious. All rights reserved, DACS 2016; **7.6** Wood Lea Press; **7.7–12** © Estate of Enid Marx; **7.13–15** Towner Art Gallery, Eastbourne; **7.16** Museums Sheffield; **7.18** Towner Art Gallery, Eastbourne; **8.1** Bristol Museum and Art Gallery. © Estate of John Nash; **8.2** Harrogate Museums and Arts, North Yorkshire, UK © Harrogate Museums and Arts/Bridgeman Images; **8.4** ING Wholesale Banking UK. © Estate of John Nash; **8.5** British Council Collection; **8.7–8** © Estate of Diana Low; **8.9** © Estate of Helen Binyon; **8.11** © Getty Images; **8.13** © Estate of Percy Horton (1897–1970); **8.14** Museums Sheffield. © Estate of Percy Horton (1897–1970); **8.16** © Estate of Helen Binyon; **8.17** © Estate of Serge Chermayeff; **8.18** Towner Art Gallery, Eastbourne; **9.1** The Potteries Museum & Art Gallery, Stoke-on-Trent; **9.2** © Estate of Marjorie Tulip (Trekkie) Parsons; **9.3** © Estate of Enid Marx; **9.4** © Estate of Tirzah Ravilious. All rights reserved, DACS 2016; **9.6** © Estate of Helen Binyon; **9.8** © Tate, London 2016; **9.9** Trustees of the Cecil Higgins Art Gallery, Bedford (The Higgins, Bedford); **9.11** Museums Sheffield; **9.12–13** © IWM; **9.14** © Getty Images; **9.15** Laing Art Gallery, Newcastle-upon-Tyne, UK © Tyne & Wear Archives & Museums/Bridgeman Images; **9.16–17** Towner Art Gallery, Eastbourne; **9.18** © Estate of Barnett Freedman; **9.19** © IWM; **9.20** Manchester Museum & the Whitworth; **9.21** Fine Art Society;

9.22 Museums Sheffield; 9.23 Towner
Art Gallery, Eastbourne; 9.24 © IWM;
9.25 © Tate, London 2016; 9.28 ©
Estate of Ariel Crittall; 9.29 Wood
Lea Press; 9.30 © Robin Friend;
10.1 Fry Art Gallery; 10.2 Laing Art
Gallery, Newcastle-upon-Tyne, UK ©
Tyne & Wear Archives & Museums/
Bridgeman Images; 10.3 © Estate of
Tirzah Ravilious. All rights reserved,
DACS 2016

Uncaptioned illustrations by page
number:
2 Paul Nash, *Pattern Paper* for Curwen
Press, 1928; **7** Detail from Eric
Ravilious, *Hansom Cab and Pigeons*,
wood engraving, 1935; **18** Detail from
Paul Nash, *Meeting Place, Buntingford*,
wood engraving, 1921; **54** Gallimaufry
printed cover design by Eric
Ravilious, hand-coloured by another,
1925; **88** Eric Ravilious, *Pattern Paper*
for Curwen Press based on the wood
engraving *Indestructible Beauty of a
Diamond*, 1926; **120** Tirzah Garwood,
Marbled Paper, c. 1934; **148** Detail from
Peggy Angus, *Helen Binyon and Eric
Ravilious at Furlongs*, oil on board,
1940s; **174** Detail from Edward Bawden,
Newhaven No. 2, watercolour drawing,
1935; **208** Eric Ravilious, *British Pavilion
Catalogue Cover*, French version,
Paris International Exhibition, wood
engraving, 1937; **234** Detail from Diana
Low, *Design on Paper*, watercolour, late
1930s; **264** Detail from Eric Ravilious,
HMS Glorious in the Arctic, watercolour
drawing, 1940.

Index

Page numbers in *italics* indicate
illustrations.

Admiralty 263, 267, 273, 287, 303, 306
Air Ministry 267, 274, 294, 297
Aitken, Charles 84, 89, 93, 95–96
Aldridge, John 205, 246
Allinson, Francesca 141, *224*, 225
Alpha Cement Works 150, 151, *151*,
 154, 176
Angus, Peggy 30, 142, 153, 163, 184,
 189, 192, 205, 293, 306
 designs 13
 paintings 142, *151*, *165*
 politics 14, 50, 142, 143, *143*, 144, *168*,
 256
 at RCA 7, 30–31, *32*, 50, 64
 and Jim Richards 157, 167, 205, 260,
 283, 306
 Sussex 142, 149, 150, 164, 260
 teaching 83
Anning Bell, Robert 24, 33, 34, 45
Apocrypha, The 103
Ariel Poems 110–11, *111*, *112*
Armstrong, Martin 114, 141
'Art and Industry' exhibition 1935 218
'Artists of Today' exhibition 1933 117
Artists' International Association
 (AI / AIA) 15, 152, 172, 238, 251,
 252–55, *252*, 256, *256*
Asheham 150, 152, 154, 176
Auden, W. H. 172

Baldwin, Stanley 93, 108
Bank House 163, 166, 167, 266, 267,
 288, 290
Barcombe 67, 81, 102
Barron, Phyllis 11, 58–59
Barman, Christian 219, 225
Barna, da Siena 50
Basnett Gallery 57
Bawden, Charlotte *see* Epton,
 Charlotte
Bawden, Edward 26, 109, 137, 163, 175,
 184, 230, 239, 245
 book designs 11, *42*, 214
 commercial clients 46, 53, 60–61,
 64, 134, 196, 212, 213, 217
 copper engravings: 64, 67; *Branson
 and the Nude 100*; *Country Life
 Gardeners' Diary 212*, 232; *Redcliffe
 Road 99*
 exhibitions 55, 141, 245–46

Furlongs 150, 155
Italy 53, 60–61
line drawings 71, *43*, 103, *111*, *129*, *130*
lino cuts 197, *199*, *216*
Morley murals 89–96, *90*, *92*, *95*
 and Paul Nash 16, 23, 175
 personality 16, 26, 96
 politics 255, 256, *253*
 poster designs 89, 134, *216*
 at RCA 7, 8, 16, 31, 33, 34, 38, 45, 53
 Redcliffe Road 60, *97*
 reputation as painter 14, 121, 122,
 175
 Second World War 266, 267, 270,
 275, 288, 303–4
 teaching 116, 236
 wallpaper designs 15, 116, 231, *233*
 watercolours: 67, 121, 141, 175; *Back
 of Brick House 131*; *The Boy – Eric
 Ravilious in his studio at Redcliffe Road
 97*; *Bulford Mill 68*; *Derelict Cab 131*;
 *Ferryboat entering Newhaven Harbour
 190*; *Moon Rising 178*; *Newhaven
 No. 2 175*, *178*; *September 8.30pm*
 189; *They dreamt not of a perishable
 home, who thus could build 127*;
 Turning While Your Bones Last 129
Bawden, Edward Snr 26, 124
Bawden, Joanna 167
Baynard Press 192, *194*, 305
BBC 13, 83, 98, 107, 134, 213, 217, 257,
 269
Beerbohm, Max 36, 103
Bell, Thomas 38
Bell, Vanessa 251, 255
Belle Tout 242
Berkeley, Lennox *250*, 251
Betjeman, John 265
Bewick, Thomas 131
Binyon, Helen 14, 31, 33, 83, 109, 142,
 153, 157, 179, 257, 267, 276, 283, 286,
 292, 295, 306–8
 children's books 189, 251, 270, *272*
 engravings on copper: 161–62;
 Ferry, The 162, 161, 200; *Player's
 Navy Cut 161*, 200, *202*; *Ste. Cécile,
 The 101*; *Tea Party, The 101*
 engravings on wood: 169–72;
 Angelina 161, 169, *170*; *Brief Candles
 170*; *Pride and Prejudice 201–2*, *171*,
 252; *Walton-on-the-Naze 252*; *Wire
 Fence, The 61*
 lithographs: 252, 257; *Flower Show,
 The 257*, *258*
 Memoir of An Artist 149
 and John Nash 207, 248–52
 politics 14, 207, 210, 252

puppetry 109–10, 162–63, 249–51, *250*, 308
on Ravilious 73, 207, 252
at RCA 7, 10, *32*, 64
relationship with Ravilious 31, 164, 173, 205–7, 252, 306–8
teaching 15, 142, 308
watercolours: *160*, 163; *Farm Bridge 160*; *Pollarded Willow and Shed 160*; *Shaded Stream 249*
Binyon, Laurence 14, 31, 33, 37, 127, 163
Binyon, Margaret 33, 161, 162–63, 169, 249, 251, 270, 308
Blake William 33, 37
Bleriot, Louis 292
Bliss, Douglas Percy 26, 56, 72, 87, 93, 108, 306
as art critic 9, 46, 55, 121–22, 179
book illustration: 212; *Palace of Pleasure, The* 212; *Spanish Lady, The* 114
and Ravilious 82, 93, 121–22, 139, 142
at RCA 7, 26, 36, 38, 41, 45, 49–50, 55–56, 59–60
watercolours: 67, 71; *Highland Cattle 68*
wood engravings: *Border Ballads 43*, 46, 56; *Devil in Scotland, The* 212; *History of Wood Engraving* 46; *Practice of Engraving on Wood, The* 59; *Rasselas* 56; *Story of the Woodcut* 57
Bliss, Phyllis *see* Dodd, Phyllis
Bloomsbury Group 8, 9, 153
Bolt Court 21
Bone, Muirhead 267, *280*, 282
Bowker, Beryl 63, 98, 119, 218, 267
Branson, George *100*, 125
Brick House 11, 119, 123–25, 127, 131, 137, 143–44, 169, 180, 214, 245, 255, 304
Brighton Art College 29
Bristol 232, 235–36, 241, 249
British Museum 33, 45, 127
Britten, Benjamin 196, *250*, 251
Burra, Edward 10

Café Royal 257, 267
Calvert, Edward 33, 37
Campbell, Roy 110, *111*
Capey, Reco 58
Cardew, Michael 16
Carline, Sydney 114
Carrington, Dora 8, 248
Carrington, Noel 202, 221, 232, 266
Carter, Harry 241

Cass Technical Institute 64
Castle Hedingham 150, 155, 163, 164, 172, 191, 206, 235, 242, 246, 257, 259, 267, 276, 277, 283, 287, 288
Central School of Arts and Crafts 29, 64, 98, 109, 161
Cézanne, Paul 121, 172
Chamberlain, Neville 210, 235, 252, 266
Chappell, William 10
Chatham Dockyards 268
Chelsea Arts Ball 98
Cheltenham Ladies' College 125, 139
Chermayeff, Serge 217, 255, 261, *261*
Church, Bob 82, 102, 103, 108, 117, 153, 206
Cimabue, Cenni di Pepi 46
Clark, Jane 296
Clark, Kenneth 12, 196, 265, *280*, 282, 297, 299, 305
Claybury Hospital 180, 183
Coldstream, William 196
Connolly, Cyril 288
Contemporary Lithographs 197, *198*, 199
Cook, Olive 147, 309
Cornmarket Art School 23
Corsham, Bath 15, 309
Cotman, J. S. 33, 36, 37, 294
Council for Art and Industry 210, 213
Cowell, W. S. 286
Coxon, Raymond 33, 49
Crawhall, Joe 57
Crittal, Ariel 291, *298*, 299
Crittal, W. H. ('Pink') 45, 191
Cuckmere Valley 242
Culver, A. C. ('Ginge') 301–2
Curwen, Harold 53, 60, 64, 124, 192, 196, 200
Curwen Press 10, 21, 41, 53, 60, 81, 83, 84, 104, 106, 114, 134, 196, 197, 213, 286

Daily Worker, The 144, 172
Davenport, Nicholas 192
Dawson, Norman 49
Day, Sgt. W. H. R. 302
De Wint, Peter 37
Delacroix, Eugene 153
De Broke, Willoughby 294
Dickey, Edward M O'R D 293, 297
Dodd, Phyllis 33, 56, 72, 96, 109
portraits *85*, *86*
Dodgson, Campbell 56, 59
Duccio, di Buoninsegna 46
Dunbar Hay 12, 212, 215–22, 229–33, *233*, 288, 306
Dürer, Albrecht 57
Duveen, Joseph 84, 87, 89, 93, 95

Eastbourne 25, 36, 55–57, 72–87, 286, 288, 293, 297
Eastbourne College of Art 25, 72, 75–81, 84–87
Elmhirst, Dorothy 155
Empire Marketing Board 105, 119, *119*, 196
Epstein, Jacob 22, 103, 255
Epton, Charlotte (Charlotte Bawden) 15, 63, 98, 124–25, 137, 139, 147, 154, 155, 163, 167, 206, 230, 305
Everyman Prints 252, 257, *258*, 269
Eyrarbakki 302

Faber & Faber 110–13, 213, 214
Festival of Britain 13
Fleming, Joyce 141
Forbes-Sempill, William 306
Ford, Emma (Emma Ravilious) 72–75, 109, 288
Freedman, Barnett 26, *27*, 83, 108, 109, 113, 119, 125, 175, 242, 251, 270, 277, 293, 296–97, 305
book illustrations: 11; *Memoirs of an Infantry Officer* 110, *193*, 192, 210
career 8, 51, 83, 109, 110, 176, 192, 213, 217, 251
designs *Ariel Poems* 110–11, *111*; Curwen calendar 106; *London Ballet* 83, 89, 109
lithography: 176, 192–96; *Baynard Press 194*; *Bowmans Modern Furniture 216*; *Charade 198*, 265; *15 inch Gun Turret, HMS Repulse 285*, 306; *King's Stamp, The* 12, 192, *195*, 196
painting 8, 30
pattern paper *104*
at RCA 7, 26, 34, 41–42, 51
teaching 83, 114, 116, 236, 238, 239
Freedman, Claudia *see* Guercio, Claudia
Friend, Robin *302*
Fry, Alathea 117, 134, 144, 173, 268
Fry, Geoffrey 93, 117, 134, 144, 173, 183, 268, 296
Fry, Maxwell 218
Fry, Roger 8–9
Furlongs 144, 147, 149–73, 179, 191, 205, 260, 267

Gallimaufry 41, *54*, 56, 63, 93
Garnett, David 77, 102
Garwood, Ella 75, *76*, *108*
Garwood, Tirzah (Tirzah Ravilious) 56, 75, 77–78, 81, 82, 83, 93, 102, 128, 132, 142, 149, 153, 154, 158, 161, 169,

INDEX

172, 192, 215, 256, 277, 283, 288, 289, 293, 303–9
autobiography 73, 297
commissions 83, 98, 132, 290
illustrations: *Window Cleaner, The* 76; *Hypochondriac, The* 76
marbling 15, 147, 155, *219*, 231, 288
oil paintings: *Springtime of Flight, The 308*
politics 144
pregnancy 163, 260, 283
relationship with Ravilious 75, 81–83, 87, 158–59, 259–60, 298, 309
watercolours: *Barcombe Mill Interior 80*
wood engravings: *Big Man, The* 132, *133*; *Brick House Kitchen 140*; *Cactus Plants* 134; *Cat into Wife* 102; *Man Who Was Answered by His Own Self, The* 134; *Four Seasons, The* 78, *78*, 82; patterned paper 113; *Relations Series, The* 106, 134, *Husband, The 107*; *Wife, The 107*
Gibbings, Robert 64, 113, 114, 131, 201
Gill, Eric 134, 255
Ginesi, Edna 33, 49
Girtin, Thomas 33, 37
Glasgow School of Art 306
Gleadowe R. D. 13
Golden Cockerel Press 64, 81, 82, 103, 113, 131, 134, 200–1, 238, 241
Golden Hours Press 134
Gordon, Jan 152, 257, 280, 287
Grant, Duncan 153, 251, 255
Graves-Smith, PO N. J. 302
Gray, Basil 157
Gray, Nicolette 14, 157, 169
Gorrell Report 213
Gossop, R. P. 56, 83
Gould, Gerald 107
Gozzoli, Benozzo 49, 50
GPO 192, 196, 217
Great Bardfield 119, 123, 125, 164, 205
Griffits, Thomas 192, 286
Grimsby 276–77
Grynszpan, Herschel 235
Guercio, Claudia (Claudia Freedman) 83, 109, 110, 119, 242, 251
Guernica 212

Hammersmith 117, 163
Hardie, Martin 37–38, 64
Harling, Robert 12, 221, 299, 300
Harris, Henry 218, *219*
Harwich 179
Hay, Athole 213, 214, 218, 222, 239
Heath, Ambrose 128

Hennell, Thomas 14, 125–28, 179–84, *181*, 259, 266, 282, 305, 309
Iceland 305, *307*
and Paul Nash 128, 259
watercolours: 8, 128; *Hampton Row 126*; *HM Submarine Rorqual in dry dock at Portsmouth 285*; *Local Coal Cart and Trawlers, Seydisfjardur, Iceland 307*; *Magpie Bottom 185*; writing: *British Craftsmen* 16; *Change in the Farm* 15, *126*, 128; *Country Relics* 16; *Men of Straw* 128; poems 180–83, *182*; *Witnesses, The* 132, 180, *181*
Henrietta Barnett School 164
Hepher, Evelyn 267, 303
Hepher, Guy 267
Hepworth, Barbara 11, 33, 49, 116, 213
Herbert, George 137
Hill, Oliver 134, 210
Hitchens, Ivon 7
HMS *Ark Royal 279*, 280
HMS *Highlander* 277–82
HMS *Glorious 279*, 280
Holbein, Hans 49, 57
Holloway, Bernard 13
Hope Inn 175, 179, 245
Hopkins, Gerard 46, 183
Horton, Lydia *see* Smith, Lydia
Horton, Percy 7, 8, 29–30, 139, 142, 192, 206, 230, *253*, 248, 267, 306
Furlongs 149, 153, 157
painting 8; *Self-Portrait 28*; *Unemployed Man 254*; *Woman Ironing 254*
politics 14, 29, 252, 256
at RCA 7, 34, 42, 116
teaching 83, 236, 238, 306
Houthuesen, Albert 34
Howell, A. R. 64, 81
Hubback, Eva 84, 89, 286–87
Huxley, Aldous 77

Iceland 164, 221, *283*, 297–302
Imperial Airways 213
Ironbridge Farm 290, 293, 294, 296, *298*, 303, *304*, 309

Jeffries, Richard 77
Jones, Barbara 12
Jonson, Ben 93
Jowett, Percy 240, 267

Kaldadarnes 300–2, *302*, 303
Kelly, Bert 157
Kennard, Frank 250
Kent, Duke of 300

Ker-Seymer, Barbara 10
Keynes, Lydia 150
Keynes, Maynard 150, 255
Kilburn, Cecilia Dunbar (Cecilia Sempill) 12, 38, 72, 82, 96, 213–22, 229–32, 241, 265, 266, 306
Kinnear, Mrs 123, 125
Konody, P. G. 67, 71, 123
Kristallnacht 236
Kuhlenthal, Christine (Christine Nash) 230, 235, 248, 249, 251, 252, 257, 260, 263, 270, 288, 291–92, 299, 300, 305

Lambert, Margaret 141, 222, 226, 307
Lancaster, Osbert 13
Lane, John 201
Larcher, Dorothy 11, 58–59, 105
Le Bas, Edward 245
Leicester Galleries 46, 245
Left Book Club 255
Legion Book 103
lithography 119, 128, 171–72, 192–205, *194*, *198*, *199*, *203*, *204*, *258*, *284*, *285*
Listener, The 98, 179, 265
Little Gallery 15, 105, 128, 154, 155, 222, 228, 288
Lloyd Thomas, Gwyneth 125, 131, 137, 139, 179, 259, 282
London County Council 29, 34, 84, 90
London Passenger Transport Board 46, 134, 192, 210, 213, *216*, 217, 219, 222, 225–28, *227*
Lovat Fraser, Claud 22, 38, 104, 212
Low, Diana (Diana Tuely) 137–38, *138*, 142, 155, 157, 167, 200, 212, 231, 235, 236, 242, 245, 257, 260–61, 266, 283, 288, 306
designs on paper *247*
fabric designs 212, *247*
influence on Ravilious 138
painting: *246*; *Portrait of William Nicholson 138*
Lyon, Mabel *48*, 49
Lyon, Robert 33, *48*, 49

MacDonald, Ishbel 50, 144, 157
MacDonald, Ramsay 50, 144
Mahoney, Charles 89, 95, 137, 217
Manchester City Gallery 152
Mandrake 62, 63, 214
Marlowe, Christopher 93, 103
Martine, Simone 63
Massingham, J. H. 16, 259
Marx, Enid 30, *58*, 106, *270*
book designs: 11; *Bulgy the Barrage Balloon* 269, *271*; *Saar, The 224*, 225

as designer 13, 15, 57, 58–59, *104*, 105, 212, 218, 221, *223*, 225–28
London Underground 12, *216*, 225–28, *227*
and Margaret Lambert 141, 222, 225, 269, 307
Modernism 8, 10, 57, 104
on Paul Nash 19, 53, 222
paintings 8; *Cube-iste Male Nude 52*; *Downs above Plumpton, The 40*; *Grandmere* 105
and Ravilious 30, 36, 46, 225
at RCA 7, 19, 34, 42, 53, 307
teaching 114, 239
wood engravings: *Abstract Pattern 35*; *Back Garden 35*, 34–6, 53; *Lamb in Triumph 224*; *A Childhood 224*
Marriott, Charles 11, 67, 123
Martin, Kingsley 210
Marx, Margueritte (Daisy) 106
Maudsley Hospital 132, 259
McKnight Kauffer, Edward 10, 114
Meadle 242, 249, 259, 270, *273*, 276
Mercury Theatre, The 249, 251
Millington, Walter 74
Moholy-Nagy, László 255
MoMA 'Exhibition of Modern British Crafts' 15
Moore, Henry 11, 33, *48*, 49, 116, 134, 213, 251, 255, 261, 296
Morecambe, Midland Hotel 134–35, *136*
Morison, Stanley 90
Morley College Murals 10, 46, 84, 87, 89–96, *90*, *91*, *92*, *94*, *95*, 108–9, 114, 117, 134, 286–87
Morphet, Richard 162–63
Morris, Henry 197
Morris, William 24, 26
Muggery Poke (Pope) 154, 155, *156*, 206
Munro, Harold 110

Nash, Christine *see* Kuhlenthal, Christine
Nash, John 14, 46, 84, 102, 110, 113, 121, 152, 196, 207, 232, 238–39, 242, 248, 256, 257, 288, 299
book and other illustrations: *Celeste and Other Sketches* 238; *Early Whistler, The 112*; *Flowers and Faces* 238; *Men and Fields 203*; *Shepheard's Calendar, The 114*; *When Thou Wast Naked* 238
First World War 236–37, 261–62; *Cornfield, The* 238; *Oppy Wood* 238; *Over the Top* 238

Second World War 263, 267, 270–71, 277, 290–92, 299, 305
teaching 116, 236
technique 242–43
watercolours: *Chalkpits, Whiteleaf 240*; *Nocturne, Bristol Docks* 235, *237*
wood engravings: *Gloucestershire Cottage* 51; *Poisonous Plants* 134, 212; *Wood Interior* 46, *47*, 51
Nash, Paul 9, 21, 58, 84, 102, 128, 163, 238, 239, 255, 257
commercial art 10, 105, *119*, 217
design philosophy 11, 105, 213
Dymchurch *17*, 22, 46
fabric designs 58–59, 105
First World War 22, 261
illustrations: *Angel and Devil* 293; *Ariel Poems* 110, *112*, 257; *Urne Buriall and The Garden of Cyrus* 114, 212; *St Hercules and Other Stories* 11
and John Nash 239
oil paintings: *Aerial Flowers* 305; *Battle of Berlin* 305; *Battle of Britain* 274, 288, 293; *Defence of Albion* 294; *Sandling Park* 45; *Totes Meer* 274, 288
Second World War 263, 265–66, 267, 273, *275*, *292*, 292–93, 300, 305
teaching 7, 19, 23, 45–46, 51–52, 67, 77, 116, 239–40
watercolours: *Bomber in the Corn* 274; *Liner* 179; *Sea Study* 179; *Shore, The 17*; *Target Area: Whitley Bombers over Berlin 292*; *Tench Pond in a Gale* 70
wood engravings: *Dyke by the Road 47*; *Genesis* 22, 46, 64, *66*; *Meeting Place* 22, *23*, 46; *Proud Paul 20*; *Wagner's Ring* 53, *66*; *Winter Wood* 46
writing: 'Modern English Textiles' 59; 'New Draughtsmen' 7, 10, 175; *Room and Book* 10, 116, 218; *Shell Guide to Dorset* 260; 'Woodcut Patterns' 104, *104*
Nash, William 248
National Gallery, The *280*, *282*, 287
Neve, Christopher 242
New English Art Club 22, 83
Newhaven 155–56, 175–79, 184–91, 216–17, 230, 235, 236, 245, 246, 252, 286, 288
Newton, Eric 14, 259
Nicholson, Ben 7, 11, 251
Nicholson, William 103, 139; *Portrait of Diana Low 138*
Norway 276, *278*, *279*, *281*
Nonesuch Press 241

Oxford University Press 46, 183, 184, 270

Palmer, Samuel 33, 37, 45, 64, 184
Paris 1925 *Exposition Internationale des Arts Décoratifs et Industriels Modernes* 34
Paris 1937 'International Exposition of Arts and Techniques in Modern Life' 12, 207, 209–13, *211*
Parsons, Trekkie *270*
Pattern Papers 104, *104*
Penguin Illustrated Classics 201–2
Picasso, Pablo 121, 212
Pick, Frank 46, 210, 219
Pilkington, Margaret 241
Pilgrim Trust 282
Piper, John 263, 265, *280*, 288, 296
Pitmen Painters 49, 210
Playfair, Nigel 41
Pollitt, Harry 172
Portraits For Spain 238, 256
Powers, Alan 144, 157, 200
Pre-Raphaelites 8, 9
Processes of Graphic Reproduction in Printing 195
Procter, Dod 255

Ravilious, Anne (Anne Ullmann) 288, 290, 291, 297, 299
Ravilious, Catherine 72
Ravilious, Eric:
artistic career 7, 8, 14, 16, 37, 217, 218, 258–59, 277, 299
childhood 25, 73–75
exhibitions: 'British War Artists' National Gallery 1940 *280*, 282; National Gallery 1942 287; Paris 1925 34; Paris 1937 207, 209–13; St George's Gallery 1927 10, 55, 64, 67, 81; Tooth & Sons 1939 236, 241, 257–59, 268; Zwemmer Gallery 1933 121, 139; Zwemmer Gallery 1936 152, 191, 200, 221, 239, 242
family finances 25, 217
influences 37, 53, 67, 123
Italy 33, 46–50
RCA studies 7, 8, 16, 25, 33, 34, 38, 45, 53
Paris 34, 49, 51
photography 25
politics 49, 172–73, 255
relationships 158–61, 179
relationship with: Edward Bawden 26, 38, 96, 109, 175, 188, 235, 245; Helen Binyon 31, 149, 164, 172, 175, 188, 205–7, 241, 246, 248, 251; father

73–75; Tirzah Garwood 75, 81–83, 87, 98, 102–3, 108–9, 117, 161, 205–7, 259–60, 299; Diana Low 138–39, 246–48; John Nash 235–36, 238–39
religion 74
scholarships 25, 36, 45, 51
schooling 25, 74–75
sport 33, 221
teaching: at Eastbourne 46, 55, 75, 77, 84, 87; at RCA 116, 134, 135, 141, 218, 236, 239; at Oxford 114
technique and methods 155, 195, 242–43, 296
as war artist 265–301
Ravilious works:
designs for: fabric *Design for a child's handkerchief* 270, *271*; furniture 218, 219, *219*; glass 218; pattern paper 104; playing cards 232; pottery 34
lithographs 196–7, 257; *Grapehouse* 158, 200, 201; *Grill Room, The* 201; *High Street* 158, 176, 200, 201, 202 268, 286; *Letter Maker, The* 201; *Newhaven Harbour* 175, 176, *186*; *Pharmaceutical Chemist, The* 204; *Plumassier, The* 201; *Submarine Lithographs* 176, *284*, 286
murals: Colwyn Bay 153; De La Warr Pavilion 217; Midland Hotel Morecambe 134–35, *136*; Morley College 84–96; RCA classes 36, 42; Workers' Travel Association 167
pencil drawings: *Blackburn Monoplane* 294, *295*
tempera painting: *Portrait of Edward Bawden* 96, *97*, 226, 277
watercolours: *Alpha Cement Works* 152; *Apples and Walnuts* 139, 155; *Attic Bedroom* 144, *145*; *Barrage Balloons at Sea* 269, *269*; *Barrage Balloons outside a British Port* 269; *Beachy Head* 268; *Brighton Queen at Night, The* 191, 235; *Bristol Quay* 236; *Buoys and Grappling Hook* 142; *Caravans* 156, 157; *Carnation House, The* *243*, 245; *Cement Pit* 152; *Cement Works No. 2 151*; *Chalk Paths* 157; *Channel Steamer Leaving Harbour 187*, 188, *188*; *Convoy passing an Island* 291; *Country House Garden* 67; *Cousin Hilda* 105; *Cross Channel Shelling* 287, *287*; *Cucumber House, The* 158, *159*; *Dangerous work at Low Tide* 268; *Design for a Plant-house* 11, 116, *118*; *Destroyers at Night* 268; *Dolly Engine, The* 152; *Dredger* 176, *177*, 179;

Drift Boat 290, *290*; *Drought* 139; *Dungeness* 248; *Field Elm* 137; *Firle Beacon (1927) 71*; *Firle Beacon (c. 1935)* 158; *Floods at Lewes* 158; *Friesian Bull* 131; *Garden Path* 131, *145*; *Geraniums and Carnations* 245; *HMS Ark Royal in Action No. 1 279*, 287; *HMS Glorious in the Arctic* 264, 279, 280; *Interior at Furlongs* 260; *James and the Foremost Prince, The* 176, *177*, 188; *Leaving Scapa Flow* 277; *Life Boat* 257; *Light Vessel and Duty Boat* 276, 277; *Lighthouse and Fort* 248; *Lighthouses at Newhaven* 184, *185*, 217; *Midnight Sun* 277; *Mount Caburn* 157; *Muggery Poke* 154–55, *156*; *Newhaven Harbour* 175, 184, *186*, 197; *November 5th* 117; *Paddle Steamers at Night* 235, *237*, 268; *Passing the Bell Rock* 277, *278*; *Pilot Boat* 241; *Pond at East Dean Farm* 69; *Prospect from an Attic* 131, 147; *RNAS Sick Bay* 293; *Room at the William the Conqueror* 245; *Rye Harbour* 244, 245; *Shepherd's Cottage* 157, 221; *Ship's Screw on a Railway Truck* 268; *Smoke Floats and Wake* 277; *South Coast Beach* 291; *Stork at Hammersmith, The* 139, *146*; *Storm* 291; *Strawberry Bed, The* 119, *122*, 128; *Talbot-Darracq 122*; *Tea at Furlongs* 260; *Tiger Moth 295*, 296; *Tree at Pink Farm* 137; *View from the Rear Hatch of a Walrus* 293; *View through the Propeller* 292; *Wannock Dewpond* 37, *40*; *Warehouses by a River* 38, *39*; *Waterwheel* 158, *159*; *Waterwheel (1938)* 257; *Westbury Horse, The* 262, 266; *Wilmington Giant, The* 260; *Winter Landscape (Downs in Winter)* 157; *Wreck of a Schooner 71*; *Yellow Funnel* 241
Wedgwood Pottery: 13, 221, 228–29; *Coronation Mug* 212, *228*, 229; *Garden 182*, 230; *Garden Implements* 245; *Harvest Festival* 226; *Persephone* 226
wood engravings: 36, 41, 45, 200; *Atrocities of the Pirates* 103; *Ballad upon a Wedding, A* 64; *Bedroom* 63; bookplates: 125; *Boy Birds-Nesting* 60, *61*, 81, 178; *Boxroom, The* 102, 107; *British Pavilion Paris 1937* 12, *208*, 209; *British Pavilion New York 1939* 12, *233*; *Church under a Hill* 60; *Consequences* 131; *Country Walks* 212, 219, *220*; *Cross to Airmen, A* 183, *301*; *Desert* 63–64,

65, 77, 114; *Dr Faustus Conjuring Mephistopheles* 103; *Elm Angel* 110; *English Wits* 283; *Fifty-Four Conceits* 141; *Galleon Roundel* 36; *Grass and Flowers* 63; *Hansom Cab and Pigeons, The 133*, 134, 166; *for Hennell Poems* 179–83, *182*; *Hermit* 63; *Hovis Mill* 152; *Importunate Ass, The* 107; *Indestructible Beauty of a Diamond, The* 104; *Jew of Malta, The* 103, 134; *Kynoch Press Notebook 1933* 124, 212, 219; *Lanston Monotype Almanack* 90, *91*, 103; *Road near Florence* 51; *San Gimignano* 51; *Selborne, History of* 183, *239*; *Sussex Church* 45, 60; *Thrice Welcome* 166; *Toys 43*; *Twelfth Night* 113–14, *115*, 210, 219; *Twelve Moneths* 79, 81, 161; *Wisden Cricketer's Almanack, The* 7, 12, 221; *Woodland outside Florence* 51, *51*; *Young Men in the Fiery Furnace* 103
Ravilious, Evelyn Mary 72–73, 74, 102
Ravilious, Frank (father) 25, 72–74, 82, 288–89
Ravilious, Frank Clement (brother) 25, 72–73, 74, 102
Ravilious, James 260, 266, 298
Ravilious, John 169, 179, 296, *298*
Rea, Betty 15
Read, Herbert 11, 255
Recording Britain 270, 282
Redfern Gallery 53, 172
Regent Street Polytechnic 127
Reykjavík 300, 301, 302, 303
Rhoades, Geoffrey 137
Rich, Alfred W. 36–37; *Southwick Harbour 39*, 152, 293
Richards, Jim 153, 157, 164, 166, 202, 205, 260, 293, 298, 306, 307
Richardson, Marion 16, 127, 132
Richmond, Royle 29
Ritchie, Andrew C. 14
'Room and Book' exhibition 10, 116
Rose, Millicent 255
Rose, Muriel 15, 105, 128, 154, 222, 266
Rothenstein, John 238, 241, 276
Rothenstein, William 9, 21, 22, 158
 RCA Principal 8, 22, 24, *25*, 33, 41 50, 116, 213
 Morley Murals 84, 87, 89, 90, 95–96
 relationship with: Edward Bawden 56; Cecilia Dunbar Kilburn 72, 213–14; Barnett Freedman 27, 29, 34, 192, 196, 213; Percy Horton 34, 42, 83; Ravilious 24, 56, 173
Second World War 274–6, *275*, 304

works: *Legion Book* 103; *Jews Mourning in the Synagogue* 29
Rossetti, William M. 9
Rowntree, Kenneth 12
Royal College of Art 7, 8, 20, 22
 Architecture School 33
 Convocation *24, 42*
 Design School 21, 26, 36, 116, 213, 307
 Engraving School 22
 Painting School 22, 26, 307
 Sculpture School 22, 213
 Sketch Club 36, 38
 student magazines 30, 36, 41, 214 (see also *Gallimaufry, Mandrake*)
Ruskin, John 26
Ruskin School of Art 114, 306
Rutherston, Albert 22, 104, 106, 109, 110, 114, 212
Rye 242, 244, *244*, 245, 306
Russell, Leonard 283

Sadler, Michael 142, 255
Saintsbury-Green, Diana 77
Sandby, Paul 36
Sandford, Christopher 134, 241
Sargent, John Singer 31
Sayers, Dorothy L. 172
Seddon, Richard 300
Selfoss 300
Seurat, Georges 176, 89, 257
Sheerness 268
Shell 134, 213, 217, 260
Short, Frank 34–36
Simpson, Wallis 230
Simon, Oliver 53, 106–7, 169, 191, 196, 212
Skellern, Victor 229
Slade School of Art, 8, 21, 24, 84
Slater, Montagu 251
Smith, Edwin 309
Smith, Geoffrey 286
Smith, Lydia (Lydia Horton) 29–30, 157, 192, 230, 248
Society of Wood Engravers (SWE) 46, 52–53, 63, 82, 102, 106, 121, 134, 162, 172, 236, 241
Specimen Book of pattern Papers, A 2, 88, 104, *104*
Spencer, Stanley 8, 84
Spender, Humphrey 139
Spender, Stephen 139, 291
Squire, J. C. 116
St George's Gallery 10, 55, 64, 67, 81
Strachey, John 172, 255, 290, 296
Strachey, Lytton 248
Strong, L. A. G. 132–33, *133*, 166

Stuart Crystal 218
Sudbury Hill 259, 266
Surrealism 239
Sutherland, Graham 7, 175, 246, 288, 297
Swanzy, Henry 309

Tagore, Rabindranath 214
Tallents, Stephen 196, 200
Tate Gallery 29, 84, 87
Three Shields Gallery 222
Tonks, Henry 84
Tollesbury 242, 244
Tooth & Sons, Arthur 236, 241
Towne, Francis 33; *Souce of the Arviron, The* 37
Trant, Carolyn 31
Tristram, Ernest 36, 41, 94
Tuely, Clissold 157, 244, 245, 246–47, 283, 290, 306
Tuely, Diana *see* Low, Diana
Tuely, Jane 260, 283, 291
Tuely, Miles 283
Tullie House Gallery 158
Turnbull, Margaret 105, 222
Turner, Joseph Mallord William 189, 236

Underhill Farm 245, 246, 261, 291
Underwood, Leon 34

Victoria and Albert Museum 24, 37, 50, 222, 228, 230
Vincent Brooks, Day & Son 192
Vom Rath, Ernst 236

Wadsworth, Edward 84, 212, 255
Walton, Allan 231
War Artists' Advisory Committee (WAAC) 263, 265–67, 282, 283, 286, 287, 288, 291, 293, 294, 297, 305
Wedgwood, Josiah 221
Wedgwood, Josiah v 221
Wedgwood Pottery 13, 212, 221, *228*, 229, 230, 245
Wedgwood, Tom 221, 229, 230
Wellington, Hubert 49, 84, 95, 215
Wellington, Robert 137, 141, 142, 167, 176, 191, 246
Whistler, Rex 84, 89
White, Gilbert 77, *239*, 241, 259
White Tower, The 296–97
Wilde, Oscar 21
William the Conqueror 245
Wilmot, Horace 153, 167
Wilmot, John 167
Wittersham 245

Woodcut, The 64, 102
Woolf, Virginia 150, 153, 154–55, 172
Workers' Travel Association 167, 192

Youngman, Nan 15

Zwemmer Gallery 10, 116, 117, 121, 128, 137, 150, 152, 155, 175, 191, 200, 221–22